PHOTOGRAPHY
BOOKS INDEX : II

A SUBJECT GUIDE
TO PHOTO ANTHOLOGIES

MARTHA MOSS

THE SCARECROW PRESS, INC.
METUCHEN, N.J., & LONDON 1985

Library of Congress Cataloging in Publication Data

Moss, Martha, 1948-
 Photography books index, II

 Bibliography: p.
 1. Photographs--Catalogs. 2. Photographs--Indexes.
I. Moss, Martha, 1948- . Photography books index.
II. Title.
TR199.M67 1985 779'.01'6 84-23652
ISBN 0-8108-1773-X

FOR
MARCELO
AND HIS
PATIENCE
PERSISTENCE
AND
UNDERSTANDING

Without which, this would not be.

CONTENTS

PREFACE

The premise for and use of the Photography Books Index and
its Supplement is purposely straightforward. It is to provide
access to the increasingly abundant published photographs.
It is intended that this Index will provide librarians, artists,
students, and the general public with access by subject and
photographer to thousands of these photographs.

The list of books indexed was intended to represent
some of the most important and widely held photo anthologies.
This list was further refined by the elimination of purely
technical manuals and those works not classified by the Li-
brary of Congress as photography books, e.g., travelogues,
books on social history, etc.

Verification for photographers' names and dates is from
the information incorporated in Contemporary Photographers
by George Walsh, St. Martin's Press. Use of this information
as an authority file for the Supplement will account for dis-
crepancies between Section I main entries in the main volume
and the supplement.

Some slight alterations in subject headings are due to an
attempt to refine them.

Subsequent supplements are intended; any suggestions,
especially as to sources to include, would be appreciated.

M.M.

USERS' GUIDE

The Index has been divided into three sections: I:
PHOTOGRAPHERS--with an alphabetized listing of their pho-
tographs included in the books indexed; II: SUBJECT matter
of the photographs; III: PORTRAITS--subdivided into "Chil-
dren," "Men" and "Women" and alphabetized by the sitters'
names.

With slight modifications as deemed necessary, the 11th
edition of Sears List of Subject Headings, edited by Barbara
Westby, served as the thesaurus for Section II. Where "See
also" is indicated, the additional subjects should also be con-
sulted, in that they are intended to be unique citations and
not merely repetitions of the original entries.

SAMPLE ENTRIES

*	color reproduction
#	plate number
No.	plate number in book with two numbering systems
a	photo position is upper left on page
b	photo position is lower left on page
c	photo position is upper right on page
d	photo position is lower right on page
/2	multiple volumes by same source
•	numerical sequence of unnumbered plates

Section I: Photographers

Photographer and vital dates]→ BRADY, Mathew B., 1823-
1896
Photo title and its date; fol- General Robert E. Lee,
 lowed by list of sources 1865* (Meredith 112#;
 in parentheses. Full cita- Meredith No. 98; Pollack
 tions found in List of Books 19c; Time-Life/2 58)
 Indexed. Numbers indicate
 pages or plates.
Brackets indicate descriptive [Union soldiers drilling]
 title for untitled photo. (Meredith 83#; Meredith
No. 2)

Section II: Subjects

One of perhaps several sub- DRILL (Military)
 jects under which this photo company of soldiers on
 has been indexed. field in "[Union sol-
Additional descriptive infor- diers drilling]"
 mation. Mathew Brady (Mere-
Title of photo in quotes; fol- dith 83#; Meredith No.
 lowed by photographer and 2)
 source(s).

Section III: Portraits

Name of sitter Brady, Mathew B.
Date photo taken if known; 1864--Alexander Gardner
 followed by photographer (Meredith 56#)
 and source(s).

LIST OF BOOKS INDEXED

Avedon, Richard. Portraits. New York: Farrar, Straus and Giroux, 1976.

Bernard, Bruce. Photodiscovery: Masterworks of Photography, 1840-1940. New York: Abrams, 1980.

Bullock, Wynn. Wynn Bullock. New York: Aperture, 1976.

Cartier-Bresson, Henri. Henri Cartier-Bresson. New York: Aperture, 1976.

Gernsheim, Helmut. The History of Photography From the Earliest Use of the Camera Obscura in the 11th Century Up to 1914. London: Oxford University Press, 1955.

Gernsheim, Helmut./2 The History of Photography From the Camera Obscura to the Beginning of the Modern Era. New York: McGraw-Hill, 1969.

Green, Jonathan. Camera Work: A Critical Anthology. New York: Aperture, 1973.

Gruber, Renate. The Imaginary Photo Museum. New York: Harmony Books, 1981.

Guggisberg, C.A.W. Early Wildlife Photographers. New York: Taplinger, 1977.

Hall-Duncan, Nancy. The History of Fashion Photography. New York: Alpine Books, 1979.

Halsman, Philippe. Halsman Sight and Insight. Garden City, NY: Doubleday, 1972.

Hine, Lewis. America and Lewis Hine Photographs, 1904–1940. New York: Aperture, 1977.

Karsh, Yousuf. Karsh Portraits. Toronto: University of Toronto Press, 1976.

Loke, Margaret. The World As It Was: A Photographic Portrait: 1865–1921. New York: Summit Books, 1980.

Photography: Essays and Images. edited by Beaumont Newhall. New York: Museum of Modern Art, 1980.

Rugoff, Milton. The Wild Places: A Photographic Celebration of Unspoiled America. New York: Harper & Row, 1973.

Sandweiss, Martha A.; Amon Carter Museum of Western Art. Masterworks of American Photography. Birmingham, AL: Oxmoor House, 1982.

Time-Life/7. The Camera. New York: Time-Life, 1970.

Time-Life/8. Color. New York: Time-Life, 1976.

Time-Life/9. Photographing Children. New York: Time-Life, 1971.

Time-Life/10. Photojournalism. New York: Time-Life, 1971.

Time-Life/11. The Art of Photography. New York: Time-Life, 1971.

Time-Life/12. The Print. New York: Time-Life, 1970.

Time-Life/13. The Studio. New York: Time-Life, 1975.

Time-Life/14. Light and Film. New York: Time-Life, 1981.

Time-Life/15. Caring for Photographs. New York: Time-Life, 1972.

Time-Life/16. Special Problems. New York: Time-Life, 1971.

Tournachon, Felix. Nadar. New York: Knopf, 1976.

ABBE, James, 1883-1973
Natasha Rambova in Fortuny
 gown, c. 1924 (Hall-
 Duncan 41)

ABBOTT, Berenice, 1898-
Lewis Hine at his home in
 Hastings-on-Hudson, c. 1935
 (Hine 137)
Murray Hill Hotel Spiral, 1935
 (Gruber 98#)
New York at night, 1933 (Sand-
 weiss 90#)
N.Y.C., Changing New York,
 1937 (Gruber 350#)
News Building, 1938 (Gruber
 371#)
Pennsylvania Station, 1936
 (Sandweiss 94#)

ABRAMSON, Michael
British soldier in Northern Ire-
 land, 1972* (Time-Life/12
 18)

ADAM-SALOMON, Antoine Samuel
Alphonse Karr, c. 1867 (Gern-
 sheim 234#; Gernsheim/2
 205#)
Charles Garnier, 1865 (Gruber
 289#)

ADAMS, Ansel, 1902-1984
Alfred Stieglitz, An American
 place, 1938 (Sandweiss
 149a)
Boards and thistles, 1932 (Pho-
 tography 253d)
Brassaï, Yosemite National
 Park, California, 1974 (Pho-
 tography 276)
Clearing Winter storm, Yosemite
 Valley, California, c. 1936
 (Photography 258)
Dead poplar in the Owens Val-
 ley, California, c. 1940

(Photography 257)
Frozen lake, 1936 (Time-Life/11
 215)
House with fence, 1948 (Gruber
 247#)
Hulls, 1933 (Gruber 80#)
Leaves, Glacier National Park,
 Montana, 1942 (Photography
 256)
Moonrise, Hernandez, New Mexi-
 co, 1941 (Gruber 101#; Sand-
 weiss 125#; Time-Life/7 210)
Mount Williamson, California, 1943
 (Time-Life/7 102)
Rear of church, Cordova, New
 Mexico, 1938 (Photography
 261)
Self-portrait, Monument Valley,
 Utah, 1958 (Sandweiss 149a)
Snowplow, c. 1935* (Bernard
 203#)
Sunrise, Mount McKinley National
 Park, Alaska, 1948 (Sandweiss
 139#)

ADAMS, Edward T.
Execution of a suspected Viet
 Cong terrorist, 1968 (Time-
 Life/7 33)

ADAMS, Robert
Alkali Lake, Albany County,
 Wyoming, 1979 (Sandweiss
 128#)

ADAMSON, Dr. John
Negative and positive calotype of
 an unknown lady, 1841
 (Gernsheim 72#; Gernsheim 2/
 67#)

ADAMSON, Robert, 1821-1848. See
 also HILL & ADAMSON
David Octavius Hill, c. 1843
 (Gernsheim 74#; Gernsheim/2
 71#)

1

AGUADO, Olympe
Admiration, 1860* (Bernard
64#)

AIKINS, John P.
Hamburger grin, 1968 (Time-
Life/9 131)

ALBERT, Josef
Ludwig II of Bavaria and his
Bride, 1867 (Gruber 340#)

ALGIRE, Tom
Early morning light in Lake
Superior Provincial Park*
(Rugoff 104#)

ALINARI, Leopoldo and Giuseppe
from "Album of flowers and
fruits" 1861 (Gruber 5#, 6#)
The Baptistry, Florence, one
of Ghiberti's doors, c. 1855
(Gernsheim/2 160#)

ALVAREZ-BRAVO, Manuel, 1902-
A good reputation, 1938 (Gruber
233#)
The Stooped, 1934 (Gruber 95#)

AMERICAN Stereoscopic Company
Russians taken prisoner after
the siege at Port Arthur
(Loke 87)

ANDERSON, James
Base of Trajan's Column, Rome,
c. 1858 (Gernsheim 198#;
Gernsheim/2 162#)

ANDRIESSE, Emmy, 1914-1953
Juliet Greco, 1950 (Gruber
281#)
Juliet Greco, 1960 (Gruber
281#)
Negroes, 1950 (Gruber 400#)

ANDRIEU, J.
The bridge at Argenteuil, 1870-
71* (Bernard 92#)

ANGERER, Ludwig
The Austrian Imperial family,
1859 (Gernsheim 204#; Gern-
sheim/2 184#)

ANGERER, Victor
The Prater, Vienna, c. 1887

(Gernsheim 209#; Gernsheim/2
235#)

ANNAN, J. Craig
The dark mountains (Green 169)
East & West (Green 308)
Lombardy ploughing team, 1894
(Photography 191b)
The painter and the etcher Sir
William Strang, c. 1900 (Gern-
sheim/2 284#)
The Riva Schiavoni, Venice
(Green 85)
The white house (Green 309)

ANNAN, Thomas
Slums in Glasgow, 1868 (Gern-
sheim/2 256#)

ANONYMOUS see PHOTOGRAPHER
Unknown

ANSCHÜTZ, Ottomar
[Adult stork feeding its young]
1884 (Guggisberg 17b)
[Red deer feeding] 1889 (Guggis-
berg 18)
Stork leaving nest, 1884 (Gern-
sheim 306#; Gernsheim/2
252#)

ANTHONY, D.
Broadway, New York, on a rainy
day, 1859 (Gernsheim 158#;
Gernsheim/2 128#)

ARBUS, Diane, 1923-1971
Amy, 1957 (Time-Life/9 176)
Beach babies, 1969 (Hall-Duncan
181)
Christmas tree, 1962 (Gruber
376#)
Exasperated boy with toy hand
grenade, 1963 (Time-Life/7
222)
Midget friends, 1963 (Time-Life/
11 218)
Patriotic boy with straw hat, but-
ton and flag, waiting to march
in a pro-war-parade, New
York City, 1967 (Gruber 316#)
Teenage couple, New York City,
1963 (Time-Life/7 223)
[Woman with baby macaque] Time-
Life/11 110)
A young man in curlers at home
in West 20th Street, New York,

1956 (Gruber 123#)

ARCHER, Frederick Scott
Leicester buildings, 1851?
(Photography 50)

ARMSTRONG, Neil
Buzz Aldrin on the moon, 1969
(Time-Life/10 23)

ATELIER HELD
Builders, c. 1890* (Bernard
127#)

ATELIER NADAR
Admiral Robert Perry (Tour-
nachon 275c)
Adrien Proust (Tournachon 273c)
Albert Lambert (Tournachon
256b)
Alexander III (Tournachon
263b)
Alexandre Schanne (Tournachon
234d)
Alfred Stevens (Tournachon
221c)
Ambroise Thomas (Tournachon
246a)
Anatole France (Tournachon
234a)
André Messager (Tournachon
243c)
Armand Sully-Prudhomme (Tour-
nachon 227d)
Auguste Rodin (Tournachon
213c)
Auguste Vacquerie (Tournachon
234d)
Auguste Villiers de L'Isle-Adam
(Tournachon 236d)
Camille Saint-Saëns (Tournachon
243a)
'Caran d'ache' (Emmanuel Poiré)
(Tournachon 217d)
Carolus Duran (Tournachon
213d)
Catherine Booth (Tournachon
277a)
Catulle Mendès (Tournachon
232a)
Charles Augustin Sainte-Beuve
(Tournachon 227c)
Charles Cros (Tournachon
235a)
Charles François Daubigny
(Tournachon 218b)
Charles Gounod (Tournachon

240d)
Charles Leconte de Lisle (Tour-
nachon 230b)
Claude Debussy (Tournachon
240a)
Claude Monet (Tournachon 216d)
Cléo de Mérode (Tournachon
257a)
Constant Coquelin (Tournachon
256c)
Dame Nellie Melba (Helen Mitchell)
(Tournachon 239)
Doubs (Tournachon 274c)
Edmond Rostand (Tournachon
233d)
Edmund About (Tournachon 224b)
Edouard Colonne (Tournachon
244a)
Edouard Detaille (Tournachon
213b)
Elie Metchnikoff (Tournachon
270a)
Emile Augier (Tournachon 260c)
Emile Zola (Tournachon 228)
Emma Calvé (Tournachon 144d)
Ernest Alexandre Coquelin (Tour-
nachon 250d)
Ernest Meissonier (Tournachon
214d)
Eugène Chevreul (Tournachon
273a)
Eugène Viollet-le-Duc (Tournachon
219b)
Félix Faure (Tournachon 265c)
Fernand Foureau (Tournachon
274d)
François Coppée (Tournachon
237b)
François de Croisset (Tournachon
235b)
François Sadi-Carnot (Tournachon
265a)
Franz Liszt (Tournachon 242a)
Gabriel Fauré (Tournachon 241d)
Gabrielle Krauss (Tournachon
253d)
Général Georges Boulanger (Tour-
nachon 269d)
General Ulysses Grant (Tournachon
277c)
George Eastman (Tournachon 276c)
George Gapon (Tournachon 266c)
Georges Clemenceau (Tournachon
265d)
Georges Feydeau (Tournachon
251b)
Georges Rouget (Tournachon

(Gernsheim/2 266#)

Faun sculpture, Versailles* (Bernard 159#)

Gif--Old farmhouse, 1924 (Gruber 84#)

Paris interior* (Time-Life/15 51)

Porteuse de Pain, 1899-1900 (Photography 237c)

Ragpicker's dwelling, Porte d'Ivry, c. 1910-14* (Bernard 157#)

St. Cloud, 1921 (Photography 236)

Saint Cloud, 1926 (Gruber 83#)

Tree roots at St. Cloud, c. 1900 (Gernsheim 314#; Gernsheim/2 267#)

Versailles, c. 1900 (Gernsheim 315#)

A windmill, Somme, before 1898* (Bernard 158#)

AUBRY, Charles
Flower study, 1864-70* (Bernard 96#)

AUSTING, Ron
Saw-whet owl* (Rugoff 110#)

AVEDON, Richard, 1923-
Alberto Giacometti, sculptor, 1958 (Avedon 2•)

Alexey Brodovitch, graphic designer, Le Thor, France, 1969 (Avedon 27•)

Alger Hiss, New York City, 1975 (Avedon 21•)

Andy Warhol and members of The Factory, New York City, 1969 (Avedon 33•)

Andy Warhol, artist, New York City, 1969 (Avedon 34•)

Arne Ekstrom, art dealer, New York City, 1976 (Avedon 26•)

Brigitte Bardot, 1959 (Gruber 339#)

Buckminster Fuller, architect, New York City, 1969 (Avedon 47•)

Carson McCullers, writer, Nyack, New York, 1958 (Avedon 61•)

The Chicago Seven, Chicago, 1969 (Avedon 41•)

Dick Hickock, murderer, Garden City, Kansas, 1960 (Avedon 16•)

Dr. Benjamin Spock, pediatrician, Jane Cheney Spock, New York City, 1969 (Avedon 35•)

Dr. Edward Barsky, surgeon, New York City, 1969 (Avedon 36•)

Dr. J. Robert Oppenheimer, physicist, Princeton, New Jersey, 1958 (Avedon 7•)

Dr. Lothar Kalinowsky, psychiatrist, New York City, 1970 (Avedon 38•)

Dr. R.D. Laing, psychiatrist, New York City, 1972 (Avedon 64•)

Donyale Luna in a dress by Paco Rabanne, 1966 (Hall-Duncan 142)

Dovima in an evening gown by Dior with the elephants of the Cirque d'Hiver, 1955 (Hall-Duncan 137)

Dress by Paco Rabanne, 1967 (Time-Life/13 128)

The Duke and Duchess of Windsor, New York City, 1957 (Avedon 8•)

Dwight David Eisenhower, President of the United States, Palm Springs, California, 1964 (Avedon 17•)

Edmund Wilson, writer, Wellfleet, Massachusetts, 1970 (Avedon 39•)

Evelyn Avedon, wife of photographer, New York City, 1975 (Avedon 51•)

The Everly Brothers, singers, Las Vegas, Nevada, 1961 (Avedon 12•)

Ezra Pound, poet, Rutherford, New Jersey, 1958 (Avedon 9•, 10•)

Felix Rohatyn, banker, New York City, 1976 (Avedon 31•)

Gabriel García Márquez, writer, New York City, 1976 (Avedon 32•)

The Generals of the Daughters of the American Revolution, Washington, D.C., 1963 (Avedon 14•)

George Meany, labor official, Washington, D.C., 1976 (Avedon 46•)

Groucho Marx, actor, Beverly

(Avedon 52•)
Walter Hickock, father of Dick
Hickock, Garden City,
Kansas, 1960 (Avedon 15•)
Wedding of Mr. and Mrs. H.E.
Kennedy, New York City,
1961 (Avedon 13•)
Willem de Kooning, artist, The
Springs, Long Island, 1969
(Avedon 19•)
William Burroughs, writer, New
York City, 1975 (Avedon
57•)
William F. Buckley, Jr., journal-
ist, New York City, 1975
(Avedon 45•)

B

BABAYEVA STUDIO
Portrait of the artist Ivan Con-
stantinovich Aivasovski,
1893* (Bernard 126#)

BABBITT, Platt D.
Group at Niagara Falls, c. 1855
(Gernsheim/2 51#; Gruber
3#; Time-Life/14 69a)

BACH, Lawrence
Untitled, 1970 (Time-Life/11 151)

BACHRACH STUDIOS
Selma Strauss, 1919 (Time-Life/9
55)

BACKHOUSE, Arthur
Pots and pans at Nice, 1855*
(Bernard 53#)

BAILEY, David, 1938–
Jean Shrimpton modeling, 1964
(Hall-Duncan 159)
Untitled, 1974 (Hall-Duncan 160)

BAKE, Jr., William A.
Big Santeetlah Creek* (Rugoff
138#)
High shoals in the Appalachee
River* (Rugoff 141#)
Roaring Fork Creek, Great
Smoky Mountains National
Park* (Rugoff 139#)

BALDUS, Edouard-Denis
"An afternoon in the country,"

1857* (Bernard 51#)
Marseille, c. 1858 (Gruber 34#)
Paris, Le Louvre, 1860 (Gruber
346#)
Pont du Gard, c. 1855 (Gern-
sheim 177#; Gernsheim/2 155#)
A private house, Paris, c. 1855*
(Bernard 59#)
Ramparts at Avignon, c. 1851
(Gernsheim 98#; Gernsheim/2
91#)

BALLO, Aldo
Molded plastic furniture, 1969*
(Time-Life/13 213)

BALTZ, Lewis, 1945–
South Wall PlastX, 350 Lear,
Costa Mesa, 1974 (Gruber
364#)
Tract house no. 23, 1970 (Time-
Life/11 123)

BANNISTER, Constance
[Baby banters] 1940–1950 (Time-
Life/9 60-61)

BARBEY, Bruno
Tokyo riot, 1971* (Time-Life/12
14)

BARKER, George
Niagara Falls, 1888* (Bernard
122#; Sandweiss 18#)

BARNARD, George N., 1819–1902
Buen-Ventura, Savannah, Geor-
gia, 1865 (Gruber 262#)
City of Atlanta, Georgia, No. 2,
1864 (Sandweiss 14#)
Ruins in Columbia, South Caro-
lina, 1865 (Gruber 40#)
Ruins of Pickney Mansion,
Charleston, South Carolina,
1865 (Gruber 353#)

BARNETT, Peggy
[Portrait of an old woman]*
(Time-Life/8 113)

BARRE
The active sports silhouette, 1930
(Hall-Duncan 53)

BARRETT, Arthur
Suffragette leaders secretly pho-
tographed at Bow Street

magistrate's court, 1908
(Gernsheim/2 227#)

BARRETT, Charles L.
Spotted cuscus (Guggisberg 33)

BARROW, Thomas F., 1938-
Dine Sphere, 1974 (Gruber
447#)
Untitled, 1969 (Time-Life/11 154)

BARRY, David F.
Sitting bull, c. 1884 (Sandweiss
46#)

BARSTOW, Jim
Dusk, 1970 (Time-Life/16 167)

BARTON, Crawford
Deep creek, 1970 (Time-Life/12
26)
Untitled, 1972 (Time-Life/12
27)

BARTON, Mrs. G.A.
Harvest bounties, 1919* (Time-
Life/8 76c)

BARTON, Hugh G.
Red cabbage, 1970 (Time-Life/
16 163)

BATUT, Arthur
Kite photograph of Labruguière,
1889 (Gernsheim/2 310#)

BAUMANN, Horst H., 1934-
The Lotus Winner, 1963* (Time-
Life/16 148)

BAURET, Jean-François
Woman and child (Nudes), 1971
(Gruber 216#)

BAVAGNOLI, Carlo
Death of a grasshopper, 1967
(Time-Life/16 86)
Soldier ant's mandibles, 1967
(Time-Life/16 87)

BAYARD, Hippolyte, 1801-1887
Garden scene, c. 1850 (Gern-
sheim 100#; Gernsheim/2
94#)
Hippolyte Bayard in his garden,
1845-47 (Gruber 4#)
Portrait of the photographer as

a drowned man, 1840* (Ber-
nard frontispiece)
Self portrait, c. 1855 (Gernsheim
47#; Gernsheim/2 40#)
Windmills at Montmartre, 1839
(Gernsheim 48#; Gernsheim/2
41#)

BAYER, Herbert, 1900-
A glance into life, 1931 (Gruber
440#)
Lonely city dweller, 1932 (Gruber
70#)
Self-portrait, 1932 (Gruber 318#)
Spiral staircase, Marseille, c.
1928 (Photography 247)

BEARD, Richard
[Daguerreotype of a gentleman]
c. 1842 (Gernsheim 59#; Gern-
sheim/2 53#)
[A lady] 1842 (Gernsheim 58#;
Gernsheim/2 52#)

BEATO, Felice A.
Bragière Sikhs, 1857 (Gruber
298#)
The Chatter Menzil Palace, Luck-
now, after its destruction in
the Indian Mutiny, 1857 (Gern-
sheim/2 142#)
Hypostyle Hall at Edfu, after
1862* (Bernard 72#)
The Sphinx and Pyramid of
Cheops in distance, 1865
(Gruber 27#)

BEATON, Cecil, 1904-1980
Aldous Huxley, 1935 (Time-Life/
11 209)
At the Famous Beauties Ball, 1931
(Hall-Duncan 113)
[Chintz bodice and a skirt] 1937
(Hall-Duncan 119c)
Dr. Roy Strong (Gruber 336#)
Dress by Chanel, 1935 (Hall-
Duncan 116)
Eileen Dunne, 1940 (Time-Life/9
76)
Ensemble by Maggy Rouff, 1936
(Hall-Duncan 119a)
Evening gown, 1934 (Time-Life/13
114)
The florist's box, 1937 (Time-Life/
13 115c)
For the Lace Ball, 1936 (Hall-
Duncan 118)

Lady Oxford, 1927 (Gruber 73#)
Nana Beaton, c. 1925 (Gruber
303#)
Polka-dots, 1930 (Hall-Duncan
112)
Salvador Dali, 1935 (Gruber
319#)
[Shadow her] 1935 (Hall-Duncan
114, 115)
Spring fashion, 1949 (Time-Life/
12 115a)
Untitled, 1945 (Hall-Duncan
124)
[A Victorian ruche] 1935 (Hall-
Duncan 117)

BECHER, Bernard, 1931- and
Hilla, 1934-
Half-timbered buildings from the
industrial region of Siegen,
1959-1974 (Gruber 135#)

BECK, Richard
Girl with purple face, 1970*
(Time-Life/11 55)

BEDFORD, Francis
Prince of Wales, Carnak, 1862
(Gruber 23#)
Rivaulx Abbey, Yorkshire
(Photography 102)

BEIDLER, Lloyd
The eye of a fruit fly, magni-
fied, 1968 (Time-Life/7 50)

BELL, Charles M.
Little Big Man, Ogalalla, Dakota,
1877 (Sandweiss 45#)

BELL, William
Perched Rock, Rocker Creek,
Arizona, 1872 (Sandweiss 27#)

BELLMER, Hans, 1902-1975
Doll, Late 1930's* (Bernard
208#)

BELLOCQ, E.J., 1873-1940
Nude, c. 1912 (Gruber 232#)
Storyville portrait, 1912*
(Time-Life/15 52-53)

BENNETT, Henry Hamilton, 1843-
1908
Phyllis, 1900* (Bernard 145#)

BENSON, John
Children at home, 1969 (Time-
Life/9 185)

BENVENISTI, Ron
Child in a strange world, 1971
(Time-Life/9 178)

BERG, Bengt
Abu Markub, 'Father of the shoe'
--a whale-headed stork photo-
graphed in the swampy area
known as the Sudd (Guggis-
berg 88)
Cranes migrating along the White
Nile (Guggisberg 87)
Indian rhinoceros among the ele-
phant grass marshes of the
Jaldapara Reserve (Guggisberg
89)

BERINGER, Louis
Small racing craft on an Alpine
Lake (Time-Life/10 198)

BERMAN, Morris
Y.A. Tittle, 1964 (Time-Life/10
47)

BERNATZIK, H.A.
Home life of the White Pelican,
Lake Malik, Albania (Guggis-
berg 112)
Soemmering's gazelle drinking in
the bed of the Dinder River
(Guggisberg 100b)

BERNHARD, Ruth
In the Box--Horizontal, 1962
(Sandweiss 91#)

BERNHARDT, Reto
Advertisement for Champagne,
1963 (Time-Life/13 219)

BIERMANN, Aenne, 1898-1933
Piano (Gruber 78a-c)

BINZEN, Bill
[Baby at play] (Time-Life/9 118-
119)
Baby sucking thumb, 1960 (Time-
Life/9 112)
Boy on diving board, 1964 (Time-
Life/9 154)
Boy playing croquet, 1962 (Time-
Life/9 152)

[Couple in snowy landscape]
1971* (Time-Life/11 107)
End of the day--Trinidad, 1967*
(Time-Life/16 198)
Football fan, 1960 (Time-Life/9
116)
Îles des Saintes, 1967* (Time-
Life/8 87)
Morning, New Hampshire, 1965*
(Time-Life/8 38)
Puget Sound, 1967* (Time-Life/
8 95)
Seasons, 1968* (Time-Life/8
219)
Sunday in St. Vincent, 1967*
(Time-Life/8 33)
Tenth Street, 1967* (Time-Life/
8 85)
Winter climber, 1969* (Time-Life/
8 218)

BIOW, Hermann
Jakob Venedey, 1848 (Gern-
sheim/2 64#)

BIRKELAND, Anders
Anders Petersen (Time-Life/12
117b)

BIRTLES, J.
W.E. Gladstone, 1885 (Gern-
sheim 317#; Gernsheim/2
271#)

BISBEE, Terry
Batman and Robin, 1970 (Time-
Life/9 140)

BISCHOF, Werner, 1916-1954
Bihar, India, 1951 (Gruber
106#)
Child in distress, 1947 (Gruber
279#; Time-Life/9 175)
Famine in India, 1951 (Time-
Life/7 26)
Hungary, 1947 (Gruber 279#;
Time-Life/9 175)

BISSON, Auguste-Rosalie
Cabane des Grands Mulets,
Savoie, 1861* (Bernard 77#)
Mont Blanc and the Mer de
Glace, 1861 (Gernsheim
184#; Gernsheim/2 174#)

BISSON FRERES
Belltower, Pisa, c. 1860 (Gruber

357#)
Savoy 44, the Crevice, c. 1860
(Gruber 33#)
Temple of Vespasian, Rome, de-
tail of architrave, 1858 (Gern-
sheim/2 158#)

BLACK, James Wallace
Boston, from the balloon "Queen
of the Air" 1860 (Photography
73)

BLACKLOCK, Les
Black ash and white cedar in a
swamp in spring* (Rugoff
106#)
Moss and lichens* (Rugoff 105#)
Winter in northern Minnesota*
(Rugoff 103#)

BLANCHARD, Valentine
Temple Bar, 1862 (Gernsheim
159#; Gernsheim/2 127#)

BLONDEAU, Barbara, 1938-1974
Untitled, 1967 (Time-Life/12 208)

BLUMBERG, Donald, 1935- and
Charles Gill
Untitled, 1966 (Time-Life/11 147)

BLUMENFELD, Erwin, 1897-1969
Fashion is how you wear it, 1945
(Hall-Duncan 97)
[Model on steel girders] 1939
(Hall-Duncan 93)
The Princess of pearls, 1939
(Hall-Duncan 89)
Untitled, c. 1936 (Hall-Duncan
91)
Untitled, c. 1940 (Hall-Duncan
96)
Untitled, 1945* (Hall-Duncan 98)
Untitled, c. 1940's* (Hall-Duncan
95)
What looks new, 1947* (Hall-Duncan
94)
[Woman in large hat] 1930's (Hall-
Duncan 90c)

BOCKRATH, Roger
San Rafael breakout, 1970 (Time-
Life/10 43)

BOLTIN, Lee
Photographic copy of Milton Av-
ery's "Woman and Child"*

(Time-Life/8 128)

BONES, Jim
The central Texas hills in the
Devil's Backbone country in
autumn* (Rugoff 89#)
Foggy dawn over the Edwards
Plateau of central Texas, with
prickly-pear cactus in the
foreground and live oaks and
cedar elms in the background*
(Rugoff 86#)
Texas bluebonnets, the Texas
state flower, on the Edwards
Plateau* (Rugoff 87#)
View near the mouth of Santa
Elena Canyon on the Rio
Grande, Big Bend National
Park, Texas* (Rugoff 85#)
View up Barton Creek Valley
in the Edwards Plateau*
(Rugoff 90#)
Walking stick insect on bark*
(Rugoff 88#)

BORDNICK, Barbara
Jazz singer Helen Humes, 1977*
(Time-Life/14 160)

BOREA, Raimondo
Child lying in water, 1968
(Time-Life/9 156)
Children walking in step, 1966
(Time-Life/9 139)

BORMAN, Frank
Earthrise as seen from Apollo
8, 1968* (Time-Life/7 58)

BOUBAT, Edouard, 1923-
Child with coat of leaves, 1947
(Gruber 113#)
Madras, 1971 (Gruber 392#)

BOUGHTON, Alice
[Portrait of daughter] c. 1909
(Sandweiss 63#)

BOURDIN, Guy
[At Cincecitta] 1976* (Hall-
Duncan 192)
Charles Jourdan shoe advertise-
ment* (Hall-Duncan 185)
Charles Jourdan shoe advertise-
ment, 1975* (Hall-Duncan
190)
Christian Dior gown, 1974

(Hall-Duncan 196)
Classic gown, 1970 (Time-Life/13
31)
L'Horizon du Soir le Noir, 1976*
(Hall-Duncan 197)
Les Robes Drapees de Madame
Grés, 1976* (Hall-Duncan 189)
Ronsard, 1975* (Hall-Duncan 194)
Le Soir, Des Robes Fendues Sur
la Jambe ou Sur un Pantalon,
1976* (Hall-Duncan 186)

BOURKE-WHITE, Margaret, 1904-
1971
Early Russia/Dnieperstroi, c.
1930 (Sandweiss 104#)
Fort Peck Dam, Montana, 1936
(Gruber 97#; Time-Life/10
63a)
Kentucky, 1937 (Time-Life/7 20d)
Life in the cowless cow towns is
lush but not cheap, 1936
(Time-Life/10 64d)
Mahatma Gandhi, Spinning, 1946
(Gruber 297#; Time-Life/10
29c)
A mile underground, 1950 (Gruber
401#)
[Montana Saturday nights] 1936
(Time-Life/10 65a)
[Nelson laundry] 1936 (Time-Life/
10 65d)
The new West's new hot-spot is
a town called 'New Deal', 1936
(Time-Life/10 64a)
The only idle bedsprings in "New
Deal" are the broken ones,
1936 (Time-Life/10 64b)
Russian tractor factory, late
1930's* (Bernard 200#)
10,000 Montana relief workers
make whoopee on Saturday
night, 1936 (Time-Life/10 63c)
Uncle Sam takes care of the In-
dians: the little lady, her-
self, 1936 (Time-Life/10 64c)

BOURNE, Samuel
The Cawnpore Memorial Well, c.
1865* (Bernard 84#)
In the Himalayas, 1868 (Gern-
sheim 189#)
The Scinde River, c. 1864 (Gern-
sheim 188#; Gernsheim/2
170#)

BOYER

Devant Le Boudoir, 1901 (Hall-
Duncan 27)

BOYSEN, Pietro Th.
Elisabeth Jerichau Baumann
with her son in Rome, 1873*
(Bernard 97#)

BRADLEY, Henry W. and RULOF-
SON, William Herman
The Gold Medal Prize Picture,
1874 (Photography 128)

BRADY, Mathew B., 1823-1896
Abraham Lincoln, 1860 (Photog-
raphy 48; Time-Life/10 14)
Execution of the conspirators
against Lincoln, 1865 (Gern-
sheim 172#; Gernsheim/2
147#)
President Ulysses Grant, c.
1865 (Gernsheim 239#)
Ruins of Richmond, 1865 (Gern-
sheim 170#; Gernsheim/2
148#; Gruber 41#)

BRADY STAFF
Dead Confederate soldier, Peters-
burg, Virginia, 1865 (Time-
Life/14 105)
Mathew B. Brady and his wife
and friend, c. 1850 (Photog-
raphy 44)
Mathew Brady, photographed by
an assistant while posing
with General Robert B. Pot-
ter and his staff, 1864
(Time-Life/14 101)
Mathew Brady's photographic van
at Petersburg, Virginia, c.
1864 (Gernsheim 169#; Gern-
sheim/2 145#)

BRAGAGLIA, Anton Giulio
Greeting, 1911 (Time-Life/11
207)

BRAKE, Brian, 1927-
[Monsoon in India]* (Time-Life/
10 87-92)

BRANDT, Bill, 1904-
Air raid shelter, Crypt of Christ
Church, Spitalfields, London,
November, 1940* (Bernard
213#)
Coal searcher going home to

Jarrow, 1937 (Gruber 94#;
Time-Life/11 203)
Halifax, 1937 (Time-Life/11 186)
London child, 1955 (Time-Life/9
84)
Looking for coal, 1936 (Gruber
94#; Time-Life/11 203)
Nude, 1953 (Gruber 129#)
Nude in a room, 1961 (Gruber
224#)
Stonehenge, 1947 (Gruber 270#)
Woman, 1966 (Time-Life/11 33)
Wuthering Heights, 1945 (Time-
Life/12 157)

BRAQUEHAIS
Veiled nude with suit of armor,
1854* (Bernard 26#)

BRASSAÏ, 1899-
Ansel Adams, 1974 (Photography
278a)
Avenue de l'Observatoire, 1934
(Photography 280)
Backstage at the Opera, 1938
(Gruber 396#)
Dance hall, 1932 (Photography
281)
Graffiti (Photography 279)
In Paris, 1933 (Gruber 91#)
Midnight in Paris, 1934 (Time-
Life/10 61)
Nude, 1934 (Gruber 227#)
Picasso, rue de la Boétie, 1932
(Photography 278c)
Salvador Dali, 1932 (Gruber 321#)
Woman with dog (Gruber 413#)

BRAUN, Adolphe, 1811-1877
Le Château de Chillon, 1867
(Time-Life/7 198a)
Garden scene, probably on an
Italian lake, c. 1860 (Gern-
sheim/2 177#)
Grindelwald glacier, c. 1862
(Gernsheim 190#; Gernsheim/
2 173#)
Lake steamers at winter moorings,
Switzerland, c. 1865* (Bernard
83#)
Open-air group, c. 1843 (Gern-
sheim/2 43#)
Panorama of Interlaken, c. 1868
(Gernsheim 191#; Gernsheim/2
176#; Time-Life/14 111)
Pont Neuf, Paris, c. 1860 (Gern-
sheim 151#)

Rue Castiglione and the Ven-
dôme Column, Paris, c.
1858 (Gernsheim/2 178#)
Still life, c. 1855* (Bernard
52#)
Still life with deer and wild fowl,
c. 1865* (Bernard 85#)

BRIDSON, J.
A picnic, c. 1882 (Gernsheim
288#; Gernsheim/2 233#)

BRIGANDI, Phil
George Washington Carver in
his research laboratory at
Tuskegee Institute, Alabama
(Loke 34d)
Peach-canning factory, Visalia,
California (Loke 218b)
Three women, Atlantic City,
New Jersey (Loke 214)
Workers at a tire-manufacturing
plant, Akron, Ohio (Loke
218b)

BRIGMAN, Annie W.
The cleft of the rock (Green
157)

BROKAW, Dennis
Eroded sandstone and tide-
washed pebbles at Pebbly
Beach* (Rugoff 36#)
Limpets and closed anemones in
a tidal area at Pebbly Beach,
Point Lobos* (Rugoff 35#)
Tide pool (middle to lower zone)
showing anemones, sea
urchins, chitons, algae, en-
crusting sponge, and tiny
red spiders* (Rugoff 37#)
Tide pool (upper middle zone)
containing chiefly algae and
periwinkles, Point Lobos,
California* (Rugoff 34#)

BROOKMAN, F.W.
Fashion figure--fashion study,
1903-04 (Hall-Duncan 19)

BROOKS, Ellen
Bread Spread I, 1974 (Time-
Life/12 28)

BROOKS, Richard Weymouth
Standing Rocks on the trail to

Spanish Bottom Crossing,
west of the Colorado River.
Elaterite Butte is in the dis-
tance. (Rugoff 60#)
Storm approaching over the Devil's
Pocket in Canyonlands National
Park. The 'Needles' are in the
background. (Rugoff 59#)

BROOM, Mrs. Albert
Miss Christabel Pankhurst ad-
dressing a Suffragette meeting,
1909 (Gernsheim 323#)

BROWN, Dean, 1936-1973
Beached iceberg in an inlet of
Glacier Bay* (Rugoff 4#)
Goldeneye near Bartlett Cove,
Glacier Bay* (Rugoff 14#)
Iceberg in the northern end of
Glacier Bay* (Rugoff 20#)
Red fox pup lurking in the tundra
near Mt. McKinley National
Park* (Rugoff 10#)
Untitled, 1968 (Time-Life/12 211)

BROWN, Thomas
Kitchen, 1968 (Time-Life/11 122)

BROWN BROS.
Day nursery, 1907 (Loke 144)
William Howard Taft, the 27th
President of the United States,
with his wife, Helen, and
their children, Robert, Charles
and Helen, 1908 (Loke 83)

BRÜCKNER, August
Portrait of a sloth (Guggisberg
114)
The UFA expedition of 1926 at
work in the Amazon Jungle
(Guggisberg 115)

BRUEHL, Anton, 1900-
Gilbert Rhode banishes buttons,
pockets, collars, ties, 1939
(Hall-Duncan 120)
[Woman in sheer gown] 1939*
(Hall-Duncan 99)

BRUEMMER, Fred
Northern sea lion amidst spray*
(Rugoff 19#)
Walrus herd on a beach on Round
Island* (Rugoff 18#)

BRUGUIERE, Francis, 1879-1945
 Daphne, 1915 (Gruber 213#)
 Skyscrapers, 1920 (Gruber
 351#)

BRY, Ed
 Prairie chicken in courtship
 flight (Rugoff 99#)

BUCQUET, M.
 Effet de Pluie, c. 1899 (Gern-
 sheim 338#; Gernsheim/2
 291#)

BULLATY, Sonja and LOMEO,
 Angelo
 Vermont autumn* (Rugoff 114#,
 115#)
 Vermont winter (Rugoff 116#)

BULLOCK, Wynn, 1902-1975
 Barbara, 1956 (Bullock 83)
 Big Sur sunset, 1957 (Bullock
 23)
 The Bird, 1958 (Bullock 57)
 Child among thistles, 1956
 (Bullock 15)
 Child in forest, 1951-54 (Bul-
 lock 49; Gruber 222#; Sand-
 weiss 127#)
 Child on forest road, 1958
 (Bullock 13)
 Christmas, Sandy's (black cat
 on stove), 1956 (Bullock 79)
 Driftwood, 1951 (Bullock 71)
 Erosion, 1956 (Bullock 21)
 Floating logs, 1957 (Bullock 63)
 Florence, trees and sand dunes,
 1959 (Bullock 69)
 The Forest, 1956 (Bullock 45)
 Half-an-apple, 1953 (Sandweiss
 80#)
 Horsetails and log, 1957 (Bul-
 lock 17)
 In the surf, 1968 (Bullock 61)
 Leaves in cobwebs, 1968 (Bul-
 lock 73)
 Let There Be Light, 1954
 (Bullock 33)
 The Limpet, 1969 (Bullock 75)
 Navigation without numbers,
 1957 (Bullock 81)
 Night scene, 1959 (Bullock 51)
 Nude in cobweb window, 1955
 (Bullock 37)
 Nude in dead forest, 1954
 (Bullock 43)

Nude in Sandy's window, 1956
 (Bullock 39)
 Palo Colorado Road, 1952 (Bul-
 lock 47)
 Photogram, 1970 (Bullock 95)
 The Pilings, 1958 (Bullock 55)
 Point Lobos, Tide pools, 1972
 (Bullock 27)
 Point Lobos, Wave, 1958 (Bullock
 25)
 Rattlesnake in tin can, 1972
 (Bullock 53)
 Sea palms, 1968 (Bullock 65)
 Sea, rocks and time, 1966 (Time-
 Life/7 88)
 Ship masts, 1959 (Bullock 35)
 Stark tree, 1956 (Bullock 85)
 Sunken wreck, 1968 (Bullock 67)
 Swamp tree, 1955 (Bullock 89)
 Tail lights, 1968 (Bullock 77)
 Tide pool, 1957 (Bullock 19)
 Tree trunk, 1972 (Bullock 31)
 Twin oaks, 1956 (Bullock 41)
 Unmarked graves, 1969 (Time-
 Life/11 195)
 The Window, 1957 (Bullock
 Frontispiece)
 Woman and dog in forest, 1953
 (Bullock Cover)
 Woman and thistle, 1953 (Bullock
 87)
 Wood, 1972 (Bullock 29)
 Wreck, 1968 (Bullock 59)

BURCHARTZ, Max, 1887-1961
 Rollmops (Gruber 195#)

BURKHARDT, Dominik
 Nicolas Bossard, Lilo Nido, Fam-
 ily portrait, 1969 (Time-Life/9
 181)

BURRELL, Fred
 Anxiety, 1969* (Time-Life/8 227)
 Brooch of amethysts with jade
 pendants, 1968* (Time-Life/13
 217c)
 Brooch of onyx and carved ivory,
 1968* (Time-Life/13 217a)
 Light bulb, 1967* (Time-Life/8
 226)

BURRI, René, 1933-
 Che Guevara, 1963 (Gruber 313#)
 Shadow of a tree, 1963 (Time-
 Life/16 182)

Sir Henry Taylor, 1867 (Gern-
sheim 225#; Gernsheim/2
196#; Gruber 25#)
Sir John F.W. Herschel, 1867
(Gernsheim 49#; Gernsheim/2
42#; Green 160; Gruber 310#;
Photography 138a; Time-Life/
7 177a)
Summer days, c. 1865 (Photog-
raphy 139)
Untitled (Girl) (Gruber 278#)

CAPA, Cornell, 1918-
Scholars of tradition, Brooklyn,
1955 (Time-Life/9 26)

CAPA, Robert, 1913-1954
Artillery is coming into action:
the camera registers the
first shock, 1938 (Time-Life/
10 67a)
The Commander speaks, 1938
(Time-Life/10 66c)
D-Day, 1944 (Gruber 102#)
D-Day plus one: The Dead on
Normandy Beach, 1944
(Gruber 421#)
Falling Spanish soldier, 1936
(Gruber 419#)
In the smoke of battle, 1938
(Time-Life/10 67b)
On the phone to H.Q., 1938
(Time-Life/10 66c)
On their way to the fighting
line, 1938 (Time-Life/10 66d)
Preparing for the attack, 1938
(Time-Life/10 66c)
A prisoner is brought in, 1938
(Time-Life/10 67c)
Speeding the enemy's retreat,
1938 (Time-Life/10 67d)
The staff plans the attack, 1938
(Time-Life/10 66a)
This is war!, 1938 (Time-Life/
10 66-67)
Workers to fortify the position,
1938 (Time-Life/10 67d)

CAPONIGRO, Paul, 1932-
Antique dolls on a hobbyhorse,
1967 (Time-Life/13 220)
Creek and trees, 1968 (Gruber
124#)
Frost window no. 2, 1961
(Time-Life/11 50)
Negative print, 1963 (Time-Life/
12 213)

Pear, 1964 (Time-Life/13 224)
Rock surfaces, 1959 (Time-Life/7
43)
Rock, West Hartford, Connecticut,
1959 (Sandweiss 130#)
Scottish thistle, 1958 (Time-Life/
13 222)
Stonehenge, 1967 (Gruber 272#)
Sunflower, 1965 (Time-Life/13
223)
Tidepool, 1966 (Time-Life/11 36)
Two leaves, 1963 (Time-Life/11
32)

CAPSTAFF, John George
Portrait of George Eastman, c.
1915* (Time-Life/8 62)

CARJAT, Etienne, 1828-1906
Baudelaire, c. 1863 (Gernsheim
233#; Gernsheim/2 202)
Giacomo Rossini, c. 1870 (Gruber
19#)
Léon Gambetta on his deathbed,
1882* (Bernard 112#)
Rossini, c. 1865 (Gernsheim 232#;
Gernsheim/2 201#)

CARMICHAEL, Jr., James H.
American egret in sawgrass
marsh, Everglades National
Park* (Rugoff 161#)

CARRICK, William
[Multiple carte-de-viste] 1863
(Gernsheim 218#; Gernsheim/2
·191#)

CARROLL, James
Lonely practice, 1969 (Time-Life/
9 28)

CARROLL, Lewis, 1832-1898
Alexandra (Xie) Kitchin, 1876
(Gruber 275#)
Alice Liddell, c. 1859 (Time-Life/
7 175)
Angus Douglas, c. 1865 (Time-
Life/9 51)
Beatrice Henley, 1862 (Time-Life/
9 50)
Effie Millais, 1865 (Gernsheim
235#; Gernsheim/2 207#; Time-
Life/9 48)
'It won't come smooth' (Irene Mac-
donald) 1863 (Gernsheim 236#;
Gernsheim/2 206#)

Quai de la Tournelle, Paris, 1933 (Photography 285b)
Quai Saint-Bernard, Paris, 1932 (Cartier-Bresson 31)
Rumania, 1975 (Cartier-Bresson 83)
Seine bargeman, 1957 (Gruber 416#)
Seville, Spain, 1932 (Cartier-Bresson 19)
Seville, Spain, 1933 (Cartier-Bresson 17; Time-Life/9 75)
Simiane la Rotonde, 1970 (Cartier-Bresson 85)
Spain, 1933 (Cartier-Bresson 9; Time-Life/11 127)
Srinagar, Kashmir, 1948 (Cartier-Bresson 67)
Sunday morning errand, Paris, 1958 (Time-Life/9 23)
Taxi drivers, Berlin, 1932 (Cartier-Bresson 11)
Trafalgar Square on the day George VI was crowned, London, 1938 (Cartier-Bresson 53)
Trieste, Italy, 1933 (Cartier-Bresson 41)
Valencia, Spain, 1933 (Cartier-Bresson 37)
Volcano of Popocatepetl, Mexico, 1964 (Cartier-Bresson 75)
William Faulkner, Oxford, Mississippi, 1947 (Cartier-Bresson 73)

CAULFIELD, Patricia
Day lilies on a hill in North Dakota* (Rugoff 98#)
Detail of prairie grass* (Rugoff 2#)
Egrets and spoonbills* (Rugoff 166#)
Prairie grass in South Dakota* (Rugoff 97#, 101#)
Storm over sandhills of central Nebraska* (Rugoff 102#)
Wildflower in Iowa* (Rugoff 100#)

CAVAGNARO, David
Belding ground squirrel, near Lake Ediza, over 9000 feet up in the Minaret Wilderness* (Rugoff 46#)
Female banded garden spider

feeding on prey* (Rugoff 72#)
Fleabane in a granite crack near Itlay Lake in the central Sierra Nevada* (Rugoff 44#)
Snowberry in autumn* (Rugoff 73#)
Sunrise above Lake Ediza in the Minaret Wilderness* (Rugoff 48#)
Thistle seed and its plume in a California valley* (Rugoff 74#)
Water drops on grass blades in Point Reyes National Seashore, California* (Rugoff 70#)
Web of an orb weaver spider in a California valley* (Rugoff 71#)
White heather covers a hillside* (Rugoff 45#)
Whitebark pines reflected in Golden Trout Lake at 10,800-foot elevation in Humphrey Basin* (Rugoff 47#)
Willows in autumn colors at about 8700 feet up in the Minaret Wilderness, California* (Rugoff 43#)

CHAMBI, Martin, 1891-1973
The Gadea wedding, Cuzco, 1930* (Bernard 196#)

CHAMPION, F.W.
Flashlight photograph of a leopard with its kill (Guggisberg 84)
A large gharial (also known as a ghavial) (Guggisberg 86)
Tiger prowling along a jungle path; it took its own picture by touching a trip wire (Guggisberg 83b)
A wild Indian elephant--a big, tuskless bull--squirting water over its body (Guggisberg 85)

CHAMPNEY, J. Wells
A street band, c. 1887 (Photography 148)

CHAPMAN, Frank M.
Breeding flamingos, Andros Island, Bahamas (Guggisberg 34b)
Ocelots photographed on their nightly prowls along jungle tracks (Guggisberg 113)
Osprey settling on nest on Gardiner Island, New York

(Guggisberg 34c)

CHARGESHEIMER, 1924-1972
August Sander, 1956 (Gruber
295#)
Konrad Adenauer, 1956
(Gruber 121#)

CHARNAY, Désiré
Chichén-Itzá, Mexico, c. 1860*
(Bernard 73#)

CHARTIER, Alain
The itinerant groceryman,
1977* (Time-Life/14 151)

CHENAY, R.H.
Guyscliffe, Warwickshire, early
1850's* (Bernard 11#)

CHIM, 1911-1956
Greek girl, 1949 (Time-Life/9
78)
Polish girl, 1948 (Time-Life/9
77)

CHURCH, Ron
California sea lions* (Rugoff
40#)
Garibaldi* (Rugoff 42#)
Moray eel* (Rugoff 38#)
Pacific white perch in kelp bed*
(Rugoff 39#)
Smooth brown turban kelp snail*
(Rugoff 41#)

CLARK, Edward
Weeping for F.D.R., 1945
(Time-Life/10 32)

CLARKE, Henry
Dorian Leigh in a Jacques Heim
dress, 1955 (Hall-Duncan
156)

CLAUDET, Antoine, 1797-1867
Daguerreotype of a lady, c.
1845 (Gernsheim 66#; Gern-
sheim/2 56#)
Fox Talbot, 1844 (Gernsheim
38#; Gernsheim/2 32#)
The geography lesson, 1851
(Gernsheim 140#; Gernsheim/
2 116#; Time-Life/9 45)

CLAUDET, Henri
Antoine Claudet, c. 1865

(Gernsheim 52#; Gernsheim/2
57#)

CLIFFORD, Charles
Palace del Infantado at Guadala-
jara, 1855 (Gernsheim 195#;
Gernsheim/2 166#)
Steps to the lake at Capricho
Palace near Guadalajara, 1855
(Gernsheim 196#; Gernsheim/2
167#)

CLIFT, William, 1944-
Canyon de Chelly, Arizona, White
House Ruins, 1975 (Sandweiss
138#)

COBURN, Alvin Langdon, 1882-1966
Alfred Stieglitz, Esq. (Green 158)
The bridge--sunlight (Green 92)
The bridge, Venice, 1905* (Green
168; Time-Life/12 39)
Broadway and the Singer Building
by night (Green 156)
Cadiz, 1908 (Photography 190)
Ezra Pound, 1917 (Photography
206)
Gertrude Käsebier, c. 1903*
(Bernard 152#)
London Bridge, 1905 (Photography
200c)
New York Ferry, 1910 (Gruber
362#)
Notre Dame (Green 155)
Notre Dame, c. 1908* (Time-Life/
12 38)
The Octopus, 1912 (Gernsheim/2
308#)
Portrait of Gilbert K. Chesteron,
1904 (Photography 200a)
Rodin (Green 159)
St. Paul's from the river, before
1910 (Gruber 361#)
Thames embankment by night, c.
1905-10 (Gruber 58#)
Vortograph, 1917 (Gruber 67#;
Photography 204)

COFFIN, Clifford
Outfits by Robert Piguet and
Jacques Heim (Hall-Duncan
100)
[Women on sand]* (Hall-Duncan
102)

COHEN, Mark, 1943-
Untitled (Gruber 269#)

COLLARD
Roundhouse on the Bourbonnais
Railway, 1862-67* (Bernard
76#)

COLLIE, William
"The Jersey Patriarch" (Aged
102) and his Great-Great-
Granddaughter, c. 1848*
(Bernard 14#)

COLLINS, John D.
Wendell Willkie motorcade, 1940
(Time-Life/10 25)

COLLOT, Staff Surgeon
H.M.S. Victoria sinking after
collision with H.M.S. Camp-
erdown off Tripoli, 1893
(Gernsheim 319#; Gernsheim/
2 270#)

COLLUM, Charles R.
Arrangement with opals, 1969*
(Time-Life/13 216)
Red diamond, 1969* (Time-Life/
13 217b)

CONNELL, Will
Sunkist Baby, 1933 (Time-Life/
9 58)

COOPER, Ed
Before dawn near the entrance
to Mt. McKinley National Park
(Rugoff 8#)
Double Arch in Arches National
Monument, Utah (Rugoff 58#)
Florida cypress trees in Big
Cypress Swamp* (Rugoff
165#)
Kichatna spire in the Alaska
Range at left; a cul de sac
glacier in the center; and
Triple Peaks at right (Rugoff
6#)
Moon over Fisher Towers group,
Utah (Rugoff 57#)
The south face of 12,540-foot
Mt. Deborah in the Alaska
Range with a glacier spread-
ing out over the tundra
plains (Rugoff 7#)

COPLAN, Anni-Siranne
African monsoon, 1978* (Time-
Life/14 41)

CORPRON, Carlotta M., 1901-
Flowing light, c. 1947 (Sandweiss
103#)
Light follows form, 1946 (Sand-
weiss 92#)

COSINDAS, Marie, 1925-
Emily, 1968* (Time-Life/9 224)
Greta, 1965* (Time-Life/8 29)
Louise Nevelson, 1974* (Gruber
171#)
Maria, Mexico, 1966* (Time-Life/
9 62)
Paula, 1966* (Time-Life/9 223)
Paula nude, 1966* (Time-Life/9
222)
Sailors, Key West, 1965* (Gruber
170#; Time-Life/8 28)
Tom Wolfe, 1967* (Time-Life/7
228)

COUNTS, I. Wilmer
Violence in Little Rock, 1958
(Time-Life/10 45)

COWIN, Eileen
San Francisco, No. 3, 1971
(Time-Life/11 155)

COX, George C.
Whitman and the Chomeley-Jones
children, 1887 (Time-Life/15
23)

CRAIG, Gordon
Ninth movement (Green 250)

CRANE, Ralph
Hot rodders, 1949 (Time-Life/7
92)

CROUCH, Steve
Sand dunes near Yuma, Arizona*
(Rugoff 75#)

CUGINI, Thomas
Kitchen in a Swiss dollhouse,
1970 (Time-Life/13 221)

CUNDALL, Joseph and HOWLETT,
Robert
"Crimean Braves" Pub. 1856*
(Bernard 34#)

CUNNINGHAM, Imogen, 1883-1976
Boy in the mountains, 1922
(Time-Life/9 56)

DANKOWSKI, Joseph
Tree bark, 1970 (Time-Life/11
37)

DAVIDSON, Bruce, 1933-
Ballet class, 1963* (Time-Life/9
221)
Child in a Welsh graveyard,
1965 (Time-Life/9 220)
Girl in a meadow, 1961 (Time-
Life/9 219)
London life, 1964 (Gruber 415#)
Mother and child, 1968 (Time-
Life/11 121)
The sun bathers, California,
1964 (Time-Life/11 137)
Teenagers at Coney Island,
1959 (Time-Life/7 30d)
Untitled (Gruber 118#)
View from a Harlem fire escape,
1968 (Time-Life/9 218)
Workman on his way home,
Scotland, 1960 (Time-Life/11
132)

DAVISON, George
Berkshire teams and teamsters
(Green 86)
Group at Ferry House, 1888
(Gruber 44#)
Near Portmadoc, 1920 (Gruber
252#)
The Onion Field, 1890 (Gern-
sheim 329#; Gernsheim/2
283#; Green 91)

DAY, F. Holland, 1864-1933
Mother and child, c. 1905
(Gruber 324#)
Nude youth (Gruber 240#)
Young man in checkered cap
(Gruber 332#)

DAYAL, Lala Deen
Gypsy girl with lion, 1901*
(Bernard 149#)
Hyderabad famine, 1890's (Ber-
nard 135#)

DEAN, Nicholas
Minnesota II, 1968* (Time-Life/
12 225)

DEBENHAM, W.E.
Dr. Richard Leach Maddox, c.
1880 (Gernsheim 249#; Gern-
sheim/2 209#)

DE COCK, Liliane
Storm near Santa Fe, New Mexi-
co, 1965 (Sandweiss 137#)

deFRANCIS, Peter
Counterpoint, 1970 (Time-Life/16
181)

DEGAS, Edgar, Attrib., 1834-1917
Back of a nude, c. 1890-95*
(Bernard 140#)

DELAMOTTE, Philip Henry, 1820-
1889
Opening by Queen Victoria of the
rebuilt Crystal Palace at Sy-
denham, 1854 (Gernsheim/2
135#)
Re-erection of the Crystal Palace
at Sydenham--lunch hours,
1853 (Gernsheim 161#)
The visit of Napoleon III and
Empress Eugénie with Queen
Victoria and Prince Albert to
the Crystal Palace, 1855
(Gernsheim 162#; Gernsheim/2
136#)

DELLACHER, Max
Children's theater, 1965 (Time-
Life/9 141)

DeLORY, Peter
Summer, 1970* (Time-Life/16
195)

DEMACHY, Robert, 1859-1936
Ballet dancer, 1904 (Gernsheim/2
294#)
Contrasts (Green 164)
The crowd, 1910* (Bernard 160#)
Etude d'Eclairage, c. 1903 (Gern-
sheim 336#)
Perplexity, 1906 (Gruber 229#)
Primavera, c. 1896 (Gernsheim
335#; Gernsheim/2 296#)
Struggle (Green 88)
Study (The letter) (Gruber 53#)
Tocques Valley (Green 87)
Untitled, c. 1900 (Gruber 214#,
328#)

de MEYER, Baron Adolphe, 1868?-
1946 [sometimes spelled Adolf]
Dance study, c. 1912* (Bernard
163#)
Dinarzade, 1924 (Hall-Duncan 33)

"Dolores the beautiful, who
 decorates the New York Fol-
 lies, wears this sweeping
 hat from Thurn" 1918 (Hall-
 Duncan 37)
The Dresden China fan (Photog-
 raphy 191a)
["Eager-eyed from under the
 bridal veil..."] 1919 (Hall-
 Duncan 35)
From the shores of the Bosphorus
 (Green 243)
Helen Lee Worthing, 1920 (Hall-
 Duncan 34)
Marchesa Casati (Green 240)
["A Russian blouse of café au
 lait net..."] 1918 (Hall-
 Duncan 38)
Schiaparelli cape from Bergdorf
 Goodman, 1933 (Hall-Duncan
 39c)
Still life (Green 241; Sandweiss
 59#)
["We may wander into gay light
 chiffon..."] 1938 (Hall-
 Duncan 39a)
Woman and lilies (Gruber 286#)

DE MEYER, Gayne
 Fashion illustration, 1920 (Time-
 Life/9 54)
 Jeanne Eagels, 1921 (Time-Life/
 13 109a)
 Male fashion (Time-Life/13
 109c)
 Woman with cup, c. 1910 (Time-
 Life/13 108)
 Woman with oriental plant (Time-
 Life/13 109b)

DENA
 Chewing toes, 1965 (Time-Life/
 9 113d)
 New taste sensation, 1965
 (Time-Life/9 113c)
 Princesses in borrowed finery,
 1964 (Time-Life/9 24)

DERMER, Irwin
 The Whisperers, England, 1966
 (Time-Life/14 29)

DERMID, Jack
 Cottonmouth (Rugoff 143#)
 Diamondback terrapin crossing
 a sandbar in a tidal creek
 (Rugoff 146#)

Ghost crab (Rugoff 147#)
Mallard hen and family (Rugoff
 142#)
Opossum (Rugoff 144#)
Portuguese man-of-war stranded
 on a beach (Rugoff 148#)
Wolf spiders riding the surface
 film of a pond (Rugoff 145#)

DE ZAYAS, Marius
 Benjamin De Casseres (Green
 252)

DIAMOND, Hugh W.
 Roger Fenton, c. 1855 (Gernsheim
 163#; Gernsheim/2 138#)
 Still life, c. 1855 (Photography
 97; (Time-Life/7 183)

Di BIASE, Michael
 Good Friday service, 1963 (Time-
 Life/11 194)

DISDERI, Adolphe Eugène, 1819-
 1890?
 The French Imperial family, 1859
 (Gernsheim 202#; Gernsheim/2
 179#)
 The Marquis of Queensberry, c.
 1860 (Gernsheim 214#)
 Princess Gabrielle Buonaparte, c.
 1862 (Gernsheim 217#)

DIVOLA, John M.
 Zuma Series No. 3, 1977* (Gruber
 164#)

DIXON, Henry
 The Oxford Arms, Warwick Lane,
 1877 (Gernsheim 310#; Gern-
 sheim/2 154#)

DOISNEAU, Robert, 1912-
 Coalman and newlyweds, 1948
 (Gruber 103#)
 Monsieur and Madame Garafino,
 Clochards, 1952 (Gruber 405#)
 The Windowshopper (Gruber
 397#)

DOMINIS, John, 1921-
 [A leopard] (Time-Life/7 209)
 Leopard at sunset, 1965* (Time-
 Life/7 128)
 Mexican schoolgirl, 1968* (Time-
 Life/8 108)
 Oryx in Kenya, 1969* (Time-Life/

16 32
Swamp in Dominica, 1965* (Time-
Life/16 31)

DOMON, Ken, 1909–
Katsura Rikyu, Kyoto, 1974*
(Gruber 161#)
Miyawaki Fan Shop, 1960*
(Gruber 162#)
Waterfall, 1967* (Gruber 143#)

d'ORA, Madame
Anna Pavlova, 1913 (Gruber
301#)

DOREN, A.
Boy with a Morgan, 1967 (Time-
Life/9 203)
Boys on Brooklyn Bridge, 1967
(Time-Life/9 125)
Washington Square, 1967 (Time-
Life/9 202)

DORR, Nell
Happiness, 1940 (Sandweiss
85#)
In a blue moon, 1929 (Time-Life /
9 57)

DOUMANI, George A.
The edge of the Amundsen Sea,
1959* (Time-Life/16 38)
Optical effects of clouds, 1962*
(Time-Life/16 39)

DOWNEY, W. & D.
The Princess of Wales (Alex-
andra) and Princess Louise,
1867 (Gernsheim 206#)

DRAKE, James
Danny McLain at work, 1968*
(Time-Life/16 152)
World Series, 1963 (Time-Life/
16 138-39)

DRAPER, John W.
Dorothy Catherine Draper, 1840
(Gernsheim/2 49#)

DRTIKOL, Frantisek, 1883-1961
The Imaginary Photograph,
1930 (Gruber 220#)
Nude 1929 (Gruber 236#)

DUBOSCQ-SOLEIL
Memento Mori, after 1854*

(Bernard 35#)

DU CAMP, Maxime, 1822-1894
Colossus at Temple at Abu Sim-
bel, 1849-51 (Gernsheim 97#;
Gernsheim/2 89#)
Middle Eastern subject, 1849-51*
(Bernard 12#)

DUGMORE, A.R.
Charging black rhinoceros photo-
graphed at a distance of fif-
teen yards (Guggisberg 55)
Flashlight photograph of a male
lion standing over a zebra
bait, 1909 (Guggisberg 56)
Migrating Newfoundland caribou
crossing a river (Guggisberg
58)
The photographer carrying the
reflex-camera with which he
took all daylight photographs
on his first African expedition
(Guggisberg 54)
Worm-eating warbler feeding her
young on the hand of the
photographer (Guggisberg 52)

DÜHRKOOP, Rudolf
Ilena Luksch-Makowsky with her
children, Peter and Andreas,
c. 1910 (Gruber 50#)

DURANDELLE
Stonemasons at work on the Paris
Opera, Pub. 1876* (Bernard
107#)

DURIEU, Eugène
Figure study, c. 1853 (Time-Life/
7 196a, 197)

DURST, André
[Molyneux's newest trick] 1936
(Hall-Duncan 104)
[Woman by obelisk] 1935 (Hall-
Duncan 105)

DUSEIGNEUR, Edouard
The village tailor, early 1850's*
(Bernard 41#)

DUZE, Harvey
Variation, 1970 (Time-Life/16
188)

DYVINIAK, William W.

Automobile accident, 1945 (Time-Life/10 40)

E

EAKINS, Thomas, 1844-1916
Boy jumping, 1884-5 (Gernsheim/2 251#)
Man running, 1884-5 (Gernsheim/2 250#)
Reclining nude, c. 1880 (Time-Life/7 195)
William H. Macdowell, c. 1884 (Sandweiss 52#)

EARLY, Dennis A.
Apparition, 1970 (Time-Life/16 170)

ECKSTROM, Tom
Dennis Hearne (Time-Life/12 117b)

EDEY, Maitland A.
Amalfi twilight, 1963* (Time-Life/8 90)

EDGERTON, Harold E., 1903-
Splash of a milk drop, c. 1936 (Time-Life/7 48)
Wesley Fesler kicks a football, c. 1937* (Bernard 211#)

EDWARDS, Ernest
Robert Hunt, 1862 (Gernsheim 99#)

EGGLESTON, William, 1937-
Memphis, 1969-70* (Gruber 157#)
Sumner, Mississippi, 1969-1970* (Gruber 173#)

EISENSTAEDT, Alfred, 1898-
Churchill, 1951 (Time-Life/10 117)
[Churchill on contact sheet], 1951 (Time-Life/10 116)
[Circus performers] (Time-Life/12 113a)
Joseph Goebbels, 1933 (Time-Life/7 204)
Leonard McCombe, 1964 (Time-Life/10 171)
Mussolini addressing the crowd in Venice's Piazza San Mar-

co, 1934 (Time-Life/7 29)
Mystic seaport in fog, 1969* (Time-Life/8 93)
Toscanini in Bayreuth, 1932 (Gruber 90#)

ELLARD, John
Warp waste in a spinning factory, 1969* (Time-Life/13 215)

ELLIOTT & FRY
Sir Joseph Wilson Swan, c. 1905 (Gernsheim 257#; Gernsheim/2 272#)

ELLIS, Harry
London pub interior, 1898* (Bernard 136#)

ELSKEN, Ed van der
Africa, 1957 (Gruber 402#)

EMERSON, Paul Henry, 1856-1936
Gathering waterlilies, 1885 (Gruber 273#)
Gunner working up to fowl, 1885 (Gernsheim 324#; Gernsheim/2 279#)
Norfolk cottages, 1888 (Time-Life/7 180)
Rope spinning, 1887* (Bernard 119#)
A rushy shore, 1886 (Photography 158)
A stiff pull, 1888-1890 (Gruber 43#; Photography 161)
Taking up the eel net, 1885 (Gernsheim 325#; Gernsheim/2 278#)

ENGLAND, William, d. 1896
Lake Orta, c. 1864 (Gernsheim 185#; Gernsheim/2 175#)
Train crossing Niagara River, 1859 (Gernsheim 143#; Gernsheim/2 123#)

ENGLISH, Douglas
A harvest mouse photographed in captivity (Guggisberg 62)

EPPRIDGE, Bill
[Heroin addicts] 1965 (Time-Life/10 82-85)
Robert F. Kennedy shot, 1968 (Time-Life/10 30)
Student photographer at the

Rochester Institute of Tech-
nology, 1970 (Time-Life/16
157)

ERFURTH, Hugo, 1874-1948
Fritz Schumacher (Gruber 290#)
Käthe Kollwitz, 1935 (Gruber
309#)
Mother Ey, 1934 (Gruber 86#)
Portrait of an artist, 1905 (Gern-
sheim 343#)
A young woman, 1898 (Gern-
sheim/2 297#)

ERWITT, Elliot, 1928-
New York, 1946 (Gruber 441#)
New York, 1953 (Gruber 443#)

ESTABROOK, Reed
Fenville, Michigan, 1970 (Time-
Life/11 143)
118 North Main Street, Provi-
dence, Rhode Island, 1969
(Time-Life/11 165)
Saugatuck, Michigan, 1970
(Time-Life/11 142)

ESTERHAZY, Count
Count Rinsky jumping, c. 1885
(Gernsheim 305#; Gernsheim/
2 253#)
Man jumping, c. 1885 (Gern-
sheim 305#; Gernsheim/2
253#)

EUGENE, Frank
Adam and Eve, c. 1910* (Green
246; Time-Life/12 42)
Arthur and Guinevere, 1900
(Photography 192)
Frau Ludwig von Hohlwein, c.
1910* (Green 249; Time-Life/
12 43)
Horse (Green 251)
Hortense (Gruber 51#)
Mr. Alfred Stieglitz (Green 248)
Portrait of woman (Gruber
325#)
Professor Adolf Hengeler (Green
247)

EVANS, Frederick H., 1853-1943
Ancient crypt cellars in Provins,
France, 1910 (Gruber 57#)
Aubrey Beardsley, c. 1895
(Gernsheim/2 286#; Gruber
292#)

Deerleigh Woods, c. 1905* (Ber-
nard 154#)
Ely Cathedral: A memory of the
Normans (Green 84)
Gloucester Cathedral: Tomb of
Edward II, at dusk, 1890*
(Time-Life/15 91)
Height and light in Bourges
Cathedral, c. 1901 (Photog-
raphy 181)
Kelmscott Manor: Attics, c.
1896* (Photography 180; Time-
Life/15 92)
Lincoln Cathedral: from the
Castle, 1898* (Time-Life/15
93)
Lincoln Cathedral: A turret
stairway, 1895 (Photography
178)
A Norfolk piscina, Little Snoring
Church, c. 1905* (Bernard
153#)
Sea of steps, Wells Cathedral,
1903 (Gernsheim 333#; Gern-
sheim/2 288#; Gruber 360#;
Time-Life/11 198)
Sunlight and shadow, Mont St.
Michel, 1906 (Photography
183)
Westminster Abbey: The Sanc-
tuary, 1911* (Time-Life/15
71)
York Minster: In Sure and Cer-
tain Hope, c. 1904* (Time-Life/
12 32)

EVANS, Walker, 1903-1975
Allie May Burroughs, Hale Coun-
ty, Alabama, 1936 (Sandweiss
82#)
Bed and stove, 1931 (Gruber
373#)
Bedroom dresser, shrimp fisher-
man's house, Biloxi, Missis-
sippi, 1945 (Photography 316)
Ben Shahn, 1934 (Sandweiss
149d)
Billboard--Minstrel show, 1936
(Sandweiss 106#)
Cabin in Alabama, 1935 (Time-Life/
10 124)
Citizen in Downtown Havana, 1932
(Gruber 409#)
Corrugated tin facade, 1936
(Photography 310)
Flood refugees, Forrest City,
Arkansas, February 1937

(Photography 266a)
42nd Street, 1929 (Gruber 91#)
Graveyard, houses, and steel
mill, Bethlehem, Pennsyl-
vania, November 1935
(Photography 268)
Man sleeping on Brooklyn
Bridge, c. 1919* (Bernard
192#)
Phillipsburg, New Jersey, 1936
(Photography 315; Time-
Life/7 24)
The Queen Mary, c. 1940
(Sandweiss 118#)
Self-portrait, curtain for hat,
1928 (Sandweiss 150c)
Storefront and signs, Beau-
fort, South Carolina, 1936
(Photography 319)
Tenant farmer's wife, 1936
(Gruber 330#)
[Untitled, Subway series] 1938
(Sandweiss 124#)
West Virginia coal miner's
house, 1936 (Gruber 375#)

F

FAULKNER, Douglas
Cotton-candy vendor in twilight
colors, Mexico, 1969* (Time-
Life/8 79)
Fortunetelling monkey, 1967*
(Time-Life/15 96)
Graveyard in Chiapas, Mexico,
1969* (Time-Life/8 89)
Juvenile bluehead wrasses feed-
ing, Molasses Reef, Upper
Key Largo* (Rugoff 129#)
Life on piling near Gloucester*
(Rugoff 132#)
Lobster in a cove near Glouces-
ter, Massachusetts* (Rugoff
131#)
Parrot fish and remora, Mo-
lasses Reef, Upper Key
Largo, Florida (Rugoff 128#)
Shorthorn sculpin in a cove at
Gloucester, Massachusetts*
(Rugoff 127#)
Spiny boxfish in White Rock
Bank, Upper Key Largo*
(Rugoff 130#)

FEDER, Joel
Dinarzade in gown by Lucille,

Ltd., c. 1916 (Hall-Duncan
42)

FEIN, Nat
Babe Ruth bows out, 1948 (Time-
Life/10 46)

FEININGER, Andreas, 1906-
The Family of Man, 1955 (Time-
Life/15 161)
Navy rescue helicopter, 1949
(Time-Life/7 89)
Photojournalist, c. 1955 (Time-
Life/7 61)
Water lilies on a Louisiana bayou*
(Rugoff 92#)

FELIX STUDIO, Paris
Mlle. Mistinguett modeling cos-
tumes by various designers,
1911 (Hall-Duncan 20)

FENTON, Roger, 1819-1869
The children of Victoria and Al-
bert, 1854 (Time-Life/9 37)
Clouds, c. 1859* (Bernard 63#)
The cookhouse of the 8th Hus-
sars, 1855 (Gernsheim 166#;
Gernsheim/2 139#; Time-Life/
14 86)
Domes of the Cathedral of the
Resurrection, the Kremlin,
1852 (Gernsheim 93#; Gern-
sheim/2 82#; Time-Life/14
109)
Encampment of Horse Artillery,
the Crimea, 1855 (Time-Life/
14 87)
Field kitchen of the 8th Hussars,
the Crimea, 1855 (Gernsheim
166#; Gernsheim/2 139#; Time-
Life/14 86)
Furness Abbey, The transepts
from the Northwest,
c. 1856 (Gruber 352#)
Odalisque, 1858* (Bernard 61#)
Ordnance Wharf, Balaclava,
Crimean War, 1855 (Gernsheim
164#; Gernsheim/2 140#)
Sir John Campbell, c. 1855
(Gruber 21#)
Still life, c. 1858 (Gernsheim
130#; Gernsheim/2 112#)
Still life (Fruit and flowers) c.
1860 (Gruber 200#)
Still life, c. 1860* (Bernard 70#)

FERNANDEZ, Benedict J.
Chicago suburb, 1966 (Time-
Life/7 21c)

FERORELLI, Enrico
Gregory Hines, New York City,
1981* (Time-Life/14 219)
A new lens design print-out
in the computer room of an
optical manufacturer*
(Time-Life/12 87)
St. Peter's Cathedral, Rome,
1978* (Time-Life/14 192)

FEURER, Hans
Magazine illustration, 1970*
(Time-Life/12 17)
Portrait for a calendar, 1973*
(Time-Life/12 16)
Portrait for an advertisement,
1970* (Time-Life/12 15)

FINK, Larry
Boy looking in mirror, 1967
(Time-Life/9 145)
Studio 54, 1977 (Gruber 408#)
[Taxicab] 1971 (Time-Life/11
102)

FINSLER, Hans, 1891-1972
Fabric, c. 1930 (Gruber 187#)

FISKE, George
Vernal Fall, 350 feet, c. 1879-
81 (Sandweiss 29#)

FITZGERALD, David
[Dandelions] (Time-Life/10
196a)

FONG, A.
Street scene, Canton, 1885-90*
(Bernard 121#)

FONTAINE, Jean-Max
Periyar National Park, 1966*
(Time-Life/8 83)

FONTANA, Franco, 1933-
[Beach cabins]* (Time-Life/
12 123)
[Beach scene]* (Time-Life/12
121)
[Grassy, rolling hills]* (Time-
Life/12 124)
Landscape, 1974* (Gruber
147#, 148#)

[Sea breaking gently on beach]*
(Time-Life/12 125)
[Sky, highway, center stripe and
guardrail]* (Time-Life/12 122)

FOSTER, Nick
Orchid, 1970 (Time-Life/11 57c)
Tropical leaf, 1970* (Time-Life/11
56a)

FOSTER, Steven
From "Gloria Sequence 1969"
(Time-Life/12 209)

FRANK, Robert, 1924-
Bar--Gallup, New Mexico, 1955
(Time-Life/11 135)
Bar--New York City, 1955 (Time-
Life/11 140)
Indianapolis, 1955 (Gruber 398#)
London street, 1951 (Time-Life/
11 213)
Long Beach, California, 1955
(Gruber 182#)
Rooming house in Los Angeles,
1955 (Time-Life/11 208)
St. Petersburg, Florida, 1958
(Gruber 116#)
U.S. 1, South Carolina, 1955
(Gruber 377#)

FREED, Arthur
Erin in the shower, 1970 (Time-
Life/9 174)
Paul and Eric, 1968 (Time-Life/9
144)

FREED, Leonard, 1929-
[Couple embracing in the elevator]
1971 (Time-Life/11 105)
Jewish wedding party, New York,
1960 (Time-Life/14 35)
Portrait of a champion, 1966
(Time-Life/9 180)

FREEDMAN, Lionel
Beach house, 1970* (Time-Life/13
67)
Fabric display, 1960* (Time-Life/
13 42)

FRENI, Al
Bicycle race, 1969* (Time-Life/16
147)

FRIEDLANDER, Lee, 1934-
Child on TV, 1962 (Gruber 378#)

Hotel room, Portland, Maine,
1962 (Time-Life/7 25)
Los Angeles, 1967 (Time-Life/
7 221b)
New York City, 1965 (Time-
Life/7 220b)
New York City, 1967 (Time-
Life/7 220a)
Revolving doors, 1963 (Time-
Life/11 136)
Route 9W, N.Y. State, 1969
(Time-Life/7 221a)
Self-portrait. Woman with
shadow, 1973 (Gruber 134#)

FRIEDMAN, Benno, 1945-
Untitled, 1969* (Time-Life/16
192, 193)

FRIEDMAN, Sy
Arturo Toscanini retires, 1954
(Time-Life/10 48)

FRISSELL, Toni, 1907-
Bikini, 1946 (Time-Life/13 120)
Boom for brown beavers, 1939
(Hall-Duncan 74)
Costume trunk, 1964* (Time-
Life/12 35)
Jerome Buttrick, 1965* (Time-
Life/9 63)
[Model in evening dress under-
water] 1941 (Hall-Duncan
76)
Shirtwaist, 1938* (Time-Life/13
121)
Stephanie White, 1961 (Time-
Life/9 177)
[Taking the sun in a bikini]
1947 (Hall-Duncan 75)

FRITH, Francis, 1822-1899
Aswan, Egypt, 1856 (Time-Life/
14 115)
Colossus at Temple of Abu
Simbel, 1857 (Gernsheim
192#; Gernsheim/2 169#)
Convent of Mar-Saba, near
Jerusalem, c. 1862 (Photog-
raphy 114a)
Egypt, 1858 (Gruber 370#)
Entrance to the Great Temple,
Luxor, 1857 (Photography
114b)
Osiride Pillars and Great Fallen
Colossos, 1858 (Gruber 29#)
The Pyramids of Dahshoor from

the Southwest, 1857-58 (Gru-
ber 245#)
Windsor from the railway (Pho-
tography 118)

FROISSART
Flood at Lyons, 1856* (Bernard
36#)

FUKUDA, Nob
Still life, 1970* (Time-Life/13 37)

FUNKE, Jaromir, 1896-1945
Corners (Gruber 432#)
Shadows, 1927 (Gruber 429#)

G

GAGLIANI, Oliver, 1917-
White door, Eureka, Nevada, 1973
(Sandweiss 81#)

GARDNER, Alexander, 1821-1882
Battery B, First Pennsylvania
Light Artillery, Petersburg,
Virginia, 1864 (Time-Life/14
104)
Confederate dead by a fence on
the Hagerston Road, Antietam,
September 17, 1862 (Photogra-
phy 72a)
Execution of the conspirators
against Lincoln, 1865 (Gern-
sheim 172#; Gernsheim/2 147#)
Gathered for burial at Antietam
after the Battle of September
17, 1862 (Photography 72b)
President Lincoln and General
McClellan at Antietam, 1862
(Time-Life/7 20a)
President Lincoln visiting the
Army of the Potomac, 1862
(Gernsheim 171#; Gernsheim/2
144#)
Ruins of paper mill, Richmond,
Virginia, 1865 (Gruber 39#)
Ruins of the Gallego Flour Mill,
Richmond, Virginia, 1865
(Time-Life/14 107)

GARDNER, George W.
First death, 1965 (Time-Life/9
80)

GARNETT, William A., 1916-
Androscoggin River, Maine, ice-

GLADSTONE, Gary
HCA-Martin, Inc. annual re-
port, 1973* (Time-Life/12
69)

GLEASON, Judie
Toilet bowl, 1967 (Time-Life/
16 172)

GLINN, Burt, 1925-
PepsiCo ski meet, 1973* (Time-
Life/12 64)

GLOEDEN, Baron Wilhelm von
Youth as faun* (Bernard 150#)

GNANT, Robert
Shepherd, Switzerland, c. 1960
(Time-Life/14 28)

GOODMAN, Robert B.
Fountains of lava, 1959* (Time-
Life/16 28)
Lava pool at night, 1959*
(Time-Life/16 29)

GORDON, Seton
Golden eagle watching the eaglet
in a Scottish eyrie (Guggis-
berg 68)

GORNY, Hein
Pages of a book (Gruber 206#)

GORO, Fritz, 1901-
Laser surgery, 1961* (Time-
Life/14 229)

GOWIN, Emmet, 1941-
Barry, Dwayne and turkeys,
1969 (Time-Life/9 209)
Elijah Gowin, 1969 (Time-Life/
11 201)
Maggie and Donna Jo, 1966
(Time-Life/11 120)
Nancy, 1965 (Time-Life/9 147)
Richie and car, 1967 (Time-
Life/9 208)
See what I can do with eggs,
1969 (Time-Life/9 130)

GRACE, Arthur
Minor White, 1974 (Time-Life/
12 35)

GRAFF, Philipp
Group portrait (Time-Life/7 171)

GRAINER, Franz
[Chamois in the Bavarian Alps]
c. 1895 (Guggisberg 43)
Nude (Gruber 211#)

GRANIRER, Martus
Untitled in space, 1964 (Time-
Life/11 214)

GRAVES, C.H.
Candy vendors in Kingston,
Jamaica, 1899 (Loke 57a)
Execution chamber and garrote,
Manila, 1899 (Loke 43d)
A group of Manchu noblewomen
and a maidservant, Peking,
China, 1902 (Loke 188)
Peking Mission School children at
play, China, 1902 (Loke 121)
Salon of American Embassy, Rus-
sia (Loke 69c)
A street barber, Peking, China,
1902 (Loke 126b)
A street in the Arab quarter of
Algiers, Algeria (Loke 167)

GRAVES, Kenneth
Defensive Back, George Washing-
ton High Eagles, 1970 (Time-
Life/12 24)

GREEN, Roy O.
Anhinga* (Rugoff 164#)

GREEN-ARMYTAGE, Stephen
Two boys fishing, 1970* (Time-
Life/16 202)

GREHAN, Farrell
Cactus for a bee, 1968* (Time-
Life/8 125)
David Alfaro Siqueiros, 1966
(Time-Life/7 86)
Martha's Vineyard, 1963* (Time-
Life/8 94)
Mt. Olympus, 1967* (Time-Life/8
40)
Trout lily* (Time-Life/8 124)

GROMIER, E.
Bull bongo crossing the Aina
River, Cameroon (Guggisberg
100c)
West African forest elephant try-
ing to get the photographer's
scent (Guggisberg 99)

GROS, Baron Jean-Baptiste Louis
 The Propylaea from inside the
 Acropolis, 1850* (Bernard
 17#)

GROSKINSKY, Henry
 Temple of Dendur, the Metro-
 politan Museum of Art, New
 York, 1978* (Time-Life/14
 163)

GROSSBARD, Henry
 New Hampshire, 1969* (Time-
 Life/8 220)
 Untitled, 1970* (Time-Life/11
 157)

GROTZ, Paul
 Before the races, late 1920's
 (Sandweiss 89#)

GUIBERT, Maurice
 Henri Toulouse-Lautrec, c.
 1896 (Gernsheim 351#)

GUIDALEVITCH, Victor
 Still life (Gruber 201#)

GÜLER, Ara
 Turkey, Edirne, 1956 (Gruber
 428#)

GURNEY, Jeremiah & Son
 Portrait of a child, 1868 (Pho-
 tography 130)

GUTMANN, John
 "The World's Egg Basket" Peta-
 lume, California, 1938 (Sand-
 weiss 88#)

H

HAAS, Ernst, 1921-
 Bird taking off, peeled poster,
 1969* (Time-Life/8 163)
 Bird taking off, Reality, 1964*
 (Time-Life/8 162)
 Brooklyn Bridge, 1952* (Time-
 Life/8 131)
 Bullet holes in rusted pot,
 1962* (Time-Life/8 164)
 Bullfight, 1957* (Time-Life/7
 96)
 Bullfight, Madrid, 1956* (Time-
 Life/8 147)

Calf roper, Madison Square Gar-
 den, 1958* (Time-Life/8 144)
Corner of 38th Street, New York,
 1952* (Gruber 154#)
Curling weed, 1965* (Time-Life/8
 161a)
Droplets on an autumn leaf, 1964*
 (Time-Life/8 157d)
Ecuadorian leaves, 1964* (Time-
 Life/8 159)
Face in peeling wall paint, 1961*
 (Time-Life/8 165)
Forest fire, Nevada, 1962* (Time-
 Life/8 154)
Golden translucent leaf, 1963*
 (Time-Life/8 156)
Gondolas at San Marco, 1955*
 (Time-Life/8 140)
Growing and wilting cactus leaves,
 1963* (Time-Life/8 161d)
Guggenheim Museum, 1965*
 (Time-Life/8 135)
Highway to Las Vegas, 1960*
 (Time-Life/8 153)
Malibu beach runners, 1958*
 (Time-Life/8 146)
Monument Valley from the air,
 1967* (Time-Life/8 149)
New York (Blurred skyscrapers),
 1952* (Gruber 153#)
New York (Sunset silhouette),
 1952* (Gruber 155#)
Oil spot, 1952* (Time-Life/8 136)
Pigeons in Piazza San Marco,
 1955* (Time-Life/8 143)
Pine needles in ice, 1967* (Time-
 Life/8 157c)
Point Lobos Tree, California,
 1960* (Time-Life/8 155)
Poster painter, Times Square,
 1952* (Time-Life/8 137)
Rainbow in the Ecuadorian Andes,
 1965* (Time-Life/14 40)
Rainy night, Times Square, 1952*
 (Time-Life/8 138)
Red red rose, 1962* (Time-Life/
 8 160)
Reflections, 1965* (Time-Life/8
 133)
Rowing gondolier's shadow, 1955*
 (Time-Life/8 142)
Rushing traffic, 1964* (Time-
 Life/8 139)
Sailboats, 1958* (Time-Life/7 95)
Serenading gondoliers, 1955*
 (Time-Life/8 141)
Squashed beer-can Buddha, 1963*

John Huston (Halsman 112)
John Steinbeck (Halsman 158)
Judge Learned Hand (Halsman 69)
Konstantin Paustovsky (Halsman 122)
Larry Evans (Halsman 51)
Louis Armstrong (Halsman 52)
Lyndon B. Johnson, 1963 (Halsman 27)
The Mad Isolde (Halsman 109)
Mae West (Halsman 64)
Maharishi Mahesh Yogi, 1967* (Halsman 104; Time-Life/7 130)
Mai Zetterling (Halsman 113)
Marc Chagall (Halsman 102)
Marc Chagall and Pablo Picasso (Halsman 100)
Marcel Duchamp (Halsman 51)
Marian Anderson (Halsman 58)
Marilyn Monroe (Halsman 36)
Marilyn Monroe, 1954 (Halsman 34)
Marina Vladi (Halsman 76)
Martha Graham (Halsman 167)
Mia Farrow (Halsman 148)
Muhammad Ali (Halsman 16)
Nude with face (Halsman 169)
Pablo Casals (Halsman 53)
Patty Duke (as Helen Keller), 1959 (Halsman 96)
Philippe and Yvonne Halsman (Halsman 188)
Pierre Teilhard De Chardin (Halsman 126)
Pregnant girl (Halsman 129)
Richard Nixon, 1955 (Halsman 31)
Richard Nixon, 1967 (Halsman 30)
Robert F. Kennedy (Halsman 48)
Sammy Davis, Jr. (Halsman 130)
Salute to Op-Art (Halsman 168)
Scenes from CALIGULA, a play by Albert Camus (Halsman 136-7)
Sen. Barry Goldwater (Halsman 33)
Sergei Konienkov (Halsman 155)
Sharon Tate (Halsman 13)
Sinclair Lewis (Halsman 144)
Tallulah Bankhead (Halsman 135)
Ultra Violet (Halsman 99)

Vivien Leigh and Laurence Olivier (Halsman 138)
Vladimir Nabokov (Halsman 23)
Walter Gropius (Halsman 59)
Wanda Landowska (Halsman 82)
Wendell Willkie (Halsman 119)
William F. Buckley, Jr. (Halsman 125)
The Windsors (Halsman 70, 72)
Winston Churchill (Halsman 38, 41)
Woody Allen (Halsman 12)

HALUS, Siegfried
 Untitled, 1970 (Time-Life/12 43)

HALUSKA, Andre
 Untitled landscape, 1969* (Time-Life/11 158)

HAMAYA, Hiroshi, 1915–
 Snowcountries children, 1956 (Gruber 386#)
 Toyama, Japan, 1955 (Gruber 114#)

HANFSTAENGL, Franz
 Frau Schwanthaler, widow of the sculptor, c. 1855 (Gernsheim/ 2 87#)
 Untitled, 1855 (Gruber 234#)

HANLON, John
 [Basketball game] (Time-Life/12 113c)

HARBUTT, Charles, 1935–
 Blind boy, New York City, c. 1960 (Time-Life/14 27)
 Girl crying, 1964 (Time-Life/9 81)
 My secret place in Central Park, New York, 1969 (Time-Life/9 31)

HARDIE, Fred
 Berber entertainers, Tangiers, 1870's* (Bernard 98#)

HARDY, Dr. A. and MONTMEJA, Dr. A. de
 Sycosis, a skin disease, 1872* (Bernard 100#)

HARRIS & EWING
 Calvin Coolidge (Time-Life/13 23a)

Dwight D. Eisenhower (Time-
Life/13 23b)
Franklin D. Roosevelt (Time-
Life/13 23c)
Harry S Truman (Time-Life/13
23b)
Herbert Hoover (Time-Life/13
23a)
John F. Kennedy (Time-Life/
13 23d)
Theodore Roosevelt (Time-Life/
13 22a)
Warren G. Harding (Time-Life /
13 22d)
William Howard Taft (Time-Life/
13 22c)
Woodrow Wilson (Time-Life/13
22b)

HARRISON, Howard
Floodlights, spotlights and re-
flectors, 1968 (Time-Life/
14 189)

HASKELL, Jonathan
Lightstruck, 1969 (Time-Life/
16 165b)
Silhouettes, 1969 (Time-Life/16
165d)

HAURON, Louis Ducos du
The Angoulème countryside,
1877* (Gruber 139#; Time-
Life/8 59)
Tekmni District, Algiers, 1884*
(Gruber 138#)

HAUSNER, Edward
Felix H. Man and Stefan Lorant,
1971 (Photography 272)

HAVILAND, Paul B.
Passing steamer (Green 310)

HAWARDEN, Lady
The Toilet, c. 1864 (Gernsheim
132#; Gernsheim/2 113#)

HAWBECKER, Edwin
Manhattan Island from an alti-
tude of 8,000 feet, 1956
(Time-Life/7 53)

HAWES, J.J.
Donald McKay (Gernsheim/2
50#)

HAYNES, Frank Jay
Gibbon Falls, 84 feet, Yellow-
stone National Park, c. 1884
(Sandweiss 20#)

HEARNE, Dennis
[Braided horse's mane] (Time-
Life/12 151)
[Haystack in field] (Time-Life/12
150)
[A mule in the fields] (Time-Life/
12 154)
[Petting a white sow] (Time-Life/
12 147)

HEATH, David, 1931-
Untitled, 1956 (Time-Life/9 214)
Untitled, 1958 (Time-Life/9 215)

HEGE, Walter
Propyläen, East Wing, 1928-29
(Gruber 348#)

HEGG, Eric A.
The Scales, Chikoot Pass, Alaska,
1897 (Time-Life/15 57)

HEINECKEN, Robert F., 1931-
From "Are you Rea," 1964-68
(Time-Life/12 205)
Figure sections/Beach, 1966
(Time-Life/11 161)

HENDERSON, Alexander
Queen Victoria at breakfast with
Princess Henry of Battenberg,
her youngest daughter, and
Princess Helena Victoria of
Schleswig-Holstein, a grand-
daughter, in Nice, April 1895
(Loke 38b)

HENNEBERG, Hugo
Poplar Alley* (Gruber 146#)
Villa Falconieri (Green 79)

HENRI, Florence, 1893-
Composition no. 76, 1929 (Pho-
tography 249a)
Portrait, 1930 (Gruber 322#)
Reflecting ball, 1930 (Gruber
178#)

HERRICK, Francis H.
Cedar waxwing at nest (Guggis-
berg 36)
First use of an uncamouflaged

tent as a photographer's
hide (Guggisberg 35)

HERSCHEL, Sir J.F.W., 1792-1871
[The earliest extant photograph
on glass] 1839 (Gernsheim
50#; Gernsheim/2 39#)

HERZOG, F. Benedict
The banks of Leithe (Green
165)

HEYMAN, Ken
Dahlia Kibbutz, Israel, 1964
(Time-Life/7 31)
Invalides Bridge in Paris, 1967*
(Time-Life/12 13)

HILL, David Octavius, 1802-1870
Portrait--The gown and the
casket (Green 162)
Robert Adamson, c. 1843 (Gern-
sheim 73#; Gernsheim/2 68#)

HILL, David Octavius, 1802-1870
and ADAMSON, Robert R.,
1821-1848
Bonaly Tower (Time-Life/12
84b)
David Octavius Hill, 1845 (Time-
Life/7 172)
Dr. Alexander Monro III, c.
1845 (Time-Life/7 173a)
Hugh Miller, c. 1845 (Time-
Life/7 173b)
James Fillans and daughters,
c. 1845 (Time-Life/7 173d)
John Brown, M.D. (Time-Life/
12 84d)
John Stevens and bust, 1843-5
(Gernsheim 77#; Gernsheim/
2 72#)
Lady Mary Ruthven, c. 1845
(Gernsheim 78#; Gernsheim/
2 73#; Green 170; Hall-
Duncan 16b)
A minnow pool, the Finlay chil-
dren, 1843-48 (Gruber 276#)
Miss McCandish, c. 1843 (Gern-
sheim/2 70#)
Mrs. Anne Rigby and her
daughter Elizabeth, c. 1844
(Photography 82)
The Newhaven pilot, c. 1844*
(Bernard 9#)
Portrait of a lady (Gruber
285#)

Rev. George Gilfillan and Dr.
Samuel Brown, 1843-5 (Gern-
sheim 76#)
Rev. James Fairbairn and New-
haven fishwives, c. 1845
(Gernsheim 79#; Gernsheim/2
74#)
Reverend Peter Jones (Kajkewa-
quonaby), c. 1844-46 (Sand-
weiss 2#)
Self-portrait, c. 1843 (Gruber
17#)
William Leighton Leitch (Time-Life/
12 84c)

HILLERS, John K.
Albino Zuñi Indians, c. 1879*
(Bernard 109#)
San Francisco Mountains, c.
1870's (Sandweiss 19#)
Three Patriarchs, Zion Canyon,
Rio Virgen, Utah, 1872 (Sand-
weiss 37#)
A Zuñi eagle cage, 1879 (Sand-
weiss 43#)

HINDSON, Bradley
Amanda, 1968 (Time-Life/9 111)
Amanda, 1969 (Time-Life/9 115)

HINE, Lewis W., 1874-1940
Beggar, New York City, 1910
(Hine 67)
Blind beggar in Italian market
district, Chicago, 1911 (Hine
64)
Bowery mission bread line, 2
a.m., New York, 1907 (Gruber
389#)
Boy picking berries, Baltimore,
July, 1909 (Hine 88)
Breaker boys in coal chute, South
Pittston, Pennsylvania, Janu-
ary, 1911 (Hine 59)
Breaker boys inside coal breaker,
1909 (Time-Life/9 70)
Cannery workers preparing beans,
c. 1910 (Hine 85)
Children at the dump, Boston, c.
1909 (Hine 45)
Children in New Jersey glass fac-
tory, 1909 (Hine 33)
Children on street, Lower East
Side, New York City (Hine 94)
Children stringing milk tags,
Newark, 1923 (Hine 84)
Cigar makers, Tampa, 1909 (Hine

cago, 1911 (Hine 49)
Retarded children, New Jersey, 1924 (Hine 90)
River boy, Beaumont, Texas, November, 1913 (Hine 47)
Rock driller, New York City, 1930 (Hine 105)
A Russian family at Ellis Island, 1905 (Sandweiss 105#)
School, Ash Grove, Oklahoma, 1916 (Hine 41)
Serbian refugees returning home, 1918* (Bernard 174#)
Sleeping quarters of immigrant workers, construction camp, New York State Barge Canal, 1909 (Hine 61)
Slovak group, Ellis Island, 1906 (Hine 98)
[Steamfitter] 1921 (Sandweiss 113#)
Steelworkers at Russian boarding house, Homestead, Pennsylvania, 1907-1908 (Hine 62)
Street children, New York City, c. 1908 (Hine 80)
Street market, Homestead, Pennsylvania, 1907-08 (Hine 73)
Switching crew, freight yard, Pennsylvania, 1907-08 (Hine 103)
T.E.R.A. Camp Green Haven, New York State, 1936-37 (Hine 93)
Tenement homework, Lower West Side, New York City, December, 1911 (Hine 95)
Tenement house and yard, Pittsburgh, 1907-08 (Hine 56)
Tenement, New York City, 1910 (Hine 70)
Tracks at coal mine, Scott's Run, West Virginia, 1936-37 (Hine 104)
Unloading potatoes on the street, c. 1912 (Hine 31)
Vacant lot playground, New York City, c. 1910 (Hine 92)
West Virginia coal mine, 1908 (Hine 60)
Workers leaving factory, 1910 (Hine 86)
Workers outside Pittman Handle

Factory, Denison, Texas, September 1913 (Hine 71)
Young German steelworker, Pittsburgh, 1908 (Hine 100)
Young girls knitting stockings in Southern hosiery mill, 1910 (Hine 48)
Young Russian Jewess at Ellis Island, 1905 (Hine 43)
Young waitress, c. 1915* (Bernard 170#)
Young workers at cotton mill, Kosciusko, Mississippi, November 1913 (Hine 46)
Young workers at cotton mill, Scotland Neck, North Carolina, November 1914 (Hine 99)

HINKLE, Don
Wet motorcycle, 1970* (Time-Life/8 96)

HIRO, 1930–
[Bold venture into night], 1963* (Hall-Duncan 167)
[Bull's hoof and diamond necklace], 1963* (Hall-Duncan 165)
Disposable paper shoes, 1967* (Time-Life/7 226)
High-fashion fabrics, 1967* (Time-Life/13 132)
Jamaica good time, 1966 (Hall-Duncan 168)
Luxury earrings, 1969* (Time-Life/7 227)
Mercury at Big Sur, 1970* (Time-Life/13 41)
[Moonset] 1969* (Hall-Duncan 170)
The power of the print, 1957* (Hall-Duncan 166)
[The sky is an accessory] 1963* (Hall-Duncan 168)
Untitled, 1972* (Hall-Duncan 164)

HÖCH, Hannah
The Cocette (Photography 249b)

HOCKMAN, Mark
Scottsville, New York, 1970 (Time-Life/16 169b)

HOEPFFNER, Marta
Still life with wine bottle, 1945 (Gruber 190#)

HOFER, Evelyn

[Aproned man in delicatessen]*
(Time-Life/8 114)
Composite portrait using films
of fast ... medium ... and
slow speeds, 1969 (Time-
Life/14 125)
Enlargement from a 35mm nega-
tive, 1969 (Time-Life/12 87)
A fully developed 35mm frame,
printed in negative form,
1969 (Time-Life/12 53)
Interior of Baptistery in Flor-
ence, 1959 (Time-Life/16
91)
[Kiki Kogelnick in her studio]*
(Time-Life/8 115d)
[Mystic Seaport, Connecticut]
(Time-Life/10 146-151)
Portrait in windowlight, 1969*
(Time-Life/8 101)
[Tintype studio]* (Time-Life/
12 50-51)
Tools for a picture story, 1970
(Time-Life/10 137)

HOFMEISTER, Theodor and Oskar
Cypress Alley, 1903 (Gruber
251#)
Dutch canal, 1909* (Gruber
140#)
The solitary horseman (Green
72)
Swampflowers, 1897* (Gruber
142#)

HOLLYER, Frederick
Aubrey Beardsley, 1896 (Gern-
sheim 345#)

HOLMES, Oliver Wendell
Barn (Photography 62)

HÖLTZER, Ernst
The Governor of Isfahan Province
and his son, c. 1880 (Time-
Life/14 118)
The Governor's bodyguards, c.
1880 (Time-Life/14 120)
Nun, woman and child, c. 1880
(Time-Life/14 119)
A Persian barber and customers,
c. 1880 (Time-Life/14 121)
Persian gymnasts, c. 1880 (Time-
Life/14 122)
State prisoners in chains, c.
1880 (Time-Life/14 117)

HOOGERWERF, A.

Great stone curlew (Guggisberg
92d)
A herd of banteug in the Ud-
jung Kulon Reserve (Gug-
gisberg 91b)
Javanese rhinos (Guggisberg
91a)
Portrait of a dragon: the giant
monitor lizard of Komondo
Island (Guggisberg 92a)

HÖPKER, Thomas, 1936-
Leprosy in Ethiopia, 1964
(Gruber 402#)

HOPPE, Emil Otto, 1878-1972
Alice Meynell, 1908 (Gernsheim
350#; Gernsheim/2 289#)
Lady Lavery, 1914 (Gruber 326#)
Romance of steel, 1911 (Gruber
65#)
Triangles, Magic, 1926 (Gruber
406#)
Untitled, c. 1915 (Hall-Duncan
40)

HORST, Horst P., 1906-
Ensemble by Hattie Carnegie,
1937 (Time-Life/13 125)
From Paris--the new Detolle cor-
set with back lacing, 1939
(Hall-Duncan 65)
Gabrielle (Coco) Chanel, 1937
(Time-Life/13 124)
In the news today, 1939 (Hall-
Duncan 67)
Untitled, 1938 (Hall-Duncan 66)

HORVAT, Frank, 1928-
Two little boys, 1961 (Gruber
274#)

HOSOE, Eikoh
Nude (Gruber 221#)

HOWLETT, Robert, d. 1858-
I.K. Brunel, designer of the
steamship Great Eastern, be-
fore the ship's launching, 1857
(Gernsheim/2 134#)
J. Stevenson, 1857 (Gruber 22#)

HOYNINGEN-HUENE, George, 1900-
1968
Evening gown, 1934 (Time-Life/
13 113)
Gary Cooper, 1935* (Bernard

202#)
Housecoat by Chanel, 1931
(Time-Life/13 112)
Pacquin dress modeled by Pac-
quin house-mannequin,
1934 (Hall-Duncan 64)
Push ball, 1930 (Hall-Duncan
62)
Two-piece swimming-suit, 1930
(Hall-Duncan 61)
Untitled, c. 1930 (Hall-Duncan
60)
Vionnet gown 'Sonia,' 1931
(Hall-Duncan 63)

HUBBACK, T.R.
Sumatran rhinoceros visiting a
salt lick in Pahang, Malaya
(Guggisberg 90c)
Wild Malayan elephant on a
fallen tree polished by the
feet of many elephants play-
ing the same game (Guggis-
berg 90d)

HUFFMAN, Laton Alton
The mess wagon, c. 1890's
(Sandweiss 47#)

HUGHES, Alice
The Archduchess Stephanie,
1905 (Gernsheim/2 290#)
The Princess of Wales (Alex-
andra) c. 1889 (Gernsheim
348#)

HUGO, Leopold
California scene, c. 1910-20
(Sandweiss 76#)

HULJACK, Greg
Geometric pattern, 1969 (Time-
Life/16 165a)

HUNT, Keith
Inner glow, 1970 (Time-Life/
16 165c)

HUNT, Robert
Photogenic drawing, 1840's*
(Bernard 2#)

HUNT, Robert (attribution)
Suzanna, c. 1845* (Bernard
5#)

HURRELL

Joan Crawford and Franchot
Tone, c. 1936* (Bernard 205#)

HYDE, Philip
Lake near Denali Highway in the
Alaska Range* (Rugoff 9#)

HYDE, Scott, 1926-
The Astor Place Luncheonette
with "The Judgement of Paris"
by Rubens, 1968* (Time-Life/
12 222)

I

IKKO, 1931-
Sky through twin window (Gruber
442#)

IMAI, Hisae
A lass of Spring, 1969 (Time-
Life/12 139)

INGBER, Mel
Beach patterns, 1969 (Time-Life/
14 153)

INGERSOLL, T.W.
A Japanese soldier taking a bath,
Manchuria (Loke 89d)
A Norwegian family (Loke 108b)

IOOSS, Jr., Walter
Giants' defense, 1963 (Time-Life/
16 135)
Hawaii, 1966 (Time-Life/16 197)
John Stallworth's winning catch
at the Super Bowl, 1980*
(Time-Life/14 148)

IVES, Frederic E.
Still life, c. 1900* (Time-Life/8
57)

J

JACKSON, William Henry, 1843-1942
Cañon of the Rio Las Animas, c.
1884 (Sandweiss 23#)
Cathedral Spires in the Garden
of the Gods, Colorado, 1873
(Time-Life/14 90)
Chipeta Falls, Black Cañon of the
Gunnison, 1883 (Sandweiss 17#)
Embudo, New Mexico, c. 1880's

(Sandweiss 38#)
A glimpse of Guanajuato, Mexico, c. 1883-84 (Sandweiss 35#)
Hercules' Pillars--Columbia Rover, Oregon River, Oregon (Sandweiss 31#)
Pueblo de Taos, New Mexico, c. 1883 (Sandweiss 36#)
Shoshone tepee, c. 1870 (Time-Life/14 93)
Tower of Babel, Garden of the gods, c. 1880's (Sandweiss 13#)

JACOBS, Roel
Nude, 1978* (Gruber 175#)

JACOBSON, Gerald
Double exposure portrait, 1969 (Time-Life/16 101)
Musicians' shadows, 1968 (Time-Life/16 85)

JAEGER, Hugo
Hitler's birthday present, 1939* (Time-Life/15 65)

JAMES, Ron
Plea for reassurance, 1963 (Time-Life/9 19)

JAMES, William
Cherry Beach, Toronto, 1912 (Time-Life/7 11)

JEFFREY, Richard
Melon slice with grapes, 1968* (Time-Life/14 157)

JOEL, Yale, 1919-
[Buildings and crane] (Time-Life/12 177)
Howard Da Silva (Time-Life/10 100-1)
Illusion of speed, 1965 (Time-Life/16 75)
[Light plane and bicycle] (Time-Life/12 173)
[Marsh grass] (Time-Life/12 166)
Pope Paul VI entering St. Patrick's Cathedral, New York City, 1965* (Time-Life/14 224)
Self-portrait, some of its tones reversed by solarization and,

lightened by treatment with chemical reducer, 1969 (Time-Life/12 163)
Time & Life Building, 1961 (Time-Life/16 71)
[Winter woodland] (Time-Life/12 169)
[Young man and skyscrapers] (Time-Life/12 183)

JOHNSON, David
The Jane Tudor (Photography 100)

JOHNSON, Martin and Osa
The photographers with an old-time cine-camera and ... an Akeley Panoramic Camera (Guggisberg 104)
Zebra and wildebeest at an East African waterhole (Guggisberg 105)

JOHNSTON, Alfred Cheney
Gloria Swanson, 1920 (Gruber 300#)

JONES, Rev. Calvert
Florence, 'The Rape of the Sabines,' 1845-46* (Bernard 4#)

JONES III, Harold H.
Primeval dress, 1968* (Time-Life/12 228)

JONES GRIFFITHS, Philip
Bashing a piano, 1962 (Time-Life/9 153)

JOSEPHSON, Kenneth, 1932-
Chicago, 1961 (Time-Life/14 44)
A door is for swinging, 1965 (Time-Life/9 17)
I am a camera, 1970 (Time-Life/9 132)
Matthew, 1965 (Time-Life/9 143)
Matthew, 1966 (Time-Life/9 142)
Polapan, 1973 (Gruber 439#)
Postcard visit, Stockholm, Sweden, 1967 (Time-Life/11 162)
Season's Greetings, 1963 (Time-Life/16 183)
Wyoming, 1971 (Gruber 449#)

JOUSSON, Pierre
Nude, Lausanne, Switzerland, 1963 (Time-Life/14 37)

K

KELLERHOUSE, Karen
Texture, 1970 (Time-Life/16
164a)

KEPES, Gyorgy, 1906-
Photodrawing, 1938 (Time-Life/
12 210)

KERTESZ, André, 1894-
Cellist, 1916* (Bernard 175#)
Dew (Gruber 184#)
The fork, 1928 (Gruber 76#)
Goose girl, 1918 (Time-Life/9
72)
Melancholy tulip, 1939 (Time-
Life/11 192)
Midsummer audacities, 1934
(Hall-Duncan 79)
Satiric dancer, 1926 (Gruber
345#; Time-Life/11 177)
Touraine, France, 1930 (Time-
Life/11 128)

KESSEL, Dmitri, 1902-
[Interior of a modern building
in Germany] (Time-Life/12
109)
[Interior of Wells Cathedral]
(Time-Life/12 106)
Water lilies, Giverny, France,
1979* (Time-Life/14 39)
[Wells Cathedral] (Time-Life/
12 107)

KEYSTONE VIEW COMPANY
A bamboo-basket seller sharing
a joke with his customer,
Japan, 1904 (Loke 126c)
A bride and groom with their
attendants halting by the
wayside en route to the wed-
ding, Japan, 1906 (Loke
106)
A Chinese family (Loke 213)
Chinese schoolchildren and their
teacher at an American Board
of Missions school, Peking
(Loke 150c)
A company of French military cy-
clists (Loke 201a)
Famine victims receiving aid,
India, c. 1901 (Loke 185c)
A fruit seller, Jaipur, India,
1902 (Loke 129a)
A game of Turkish backgammon
in Palestine, 1900 (Loke 66b)
Stereoscopic view of a group

of Japanese women taking
turns viewing stereo cards
through a stereoscope (Loke
18)
A woman carrying a bucket of
grapes on her head, Rüde-
sheim, Germany, 1905 (Loke
130a)

KILBURN, B.W.
Amber Palace, India (Loke 175c)
Atlantic City beach, New Jersey,
1891 (Loke 67d)
Boer farmers and boys on their
way to the front, South Africa
(Loke 44a)
Boxers guarded by Italian soldiers
(Loke 45d)
A British doctor operating on a
wounded soldier, Boer War
(Loke 44d)
Children in Warsaw, Poland (Loke
149)
A Chinese woman and her chil-
dren outside their cabin in
Olympia, Washington (Loke 60)
Convicts and their guards, At-
lanta, Georgia (Loke 59a)
Cossacks dancing, Russia, c.
1896 (Loke 67a)
Execution of a Boxer leader,
China, 1900 (Loke 45c)
Laborers transporting pots to the
interior, Chosan, Korea (Loke
136a)
A lemonade vendor and his cus-
tomer, Cairo, Egypt (Loke
129d)
Market scene in Warsaw, Poland,
c. 1896 (Loke 57b)
Members of the royal families of
Russia and Europe at the
coronation of Tsar Nicholas
II, 1896 (Loke 48)
An old woman of Seattle, Washing-
ton (Loke 182d)
Russian peasant families, c. 1896
(Loke 49)
The Samaritans, Palestine (Loke
191c)
Three generations, Pretoria,
South Africa (Loke 101)
Train passing over a trestle, 1891
(Loke 32)
Tsar Nicholas II, with the Tsarita
Alexandra Feodorovna and
members of the imperial family,

St. Petersburg, c. 1896
(Loke 38c)
Turkish military officers, Jeru-
salem, 1899 (Loke 47)
Water station in Moscow, Rus-
sia, c. 1896 (Loke 72)
A woman at the spinning wheel,
India (Loke 135b)

KILBURN, W.E.
Sir Charles Wheatstone, c.
1855 (Gernsheim 136#; Gern-
sheim/2 115#)

KILJAN, Gerardus
Barstool, c. 1930 (Gruber 430#)

KIMURA, Ihei
Horse (Gruber 444#)

KIRK, Charles
Kittiwakes at Ailsa Craig (Gug-
gisberg 30)

KIRKLAND, Charles D.
Wyoming cowboy, c. 1895
(Sandweiss 40#)

KIRMAN, Charles
Woodland girl, 1970 (Time-Life/
16 171)

KLEIN, William, 1928-
Lunch on the grass, Rome,
1956 (Gruber 119#)
Rome (Looks), 1956 (Gruber
411#)
St. Laurent's modern French
history, 1963 (Hall-Duncan
178)
[Woman smoking], 1956 (Hall-
Duncan 176)
[Woman walking by painting],
1960 (Hall-Duncan 177)

KLIČ
Mungo Ponton, c. 1879 (Gern-
sheim 255#; Gernsheim/2
215#)

KNIGHT, C.W.R.
Sacred ibis on a South African
bird island (Guggisberg
67)
Sparrow hawk and young (Gug-
gisberg 63)

KÖHLER, Werner
Patterns in nature, 1966 (Time-
Life/14 155)

KOPPITZ, Rudolf
Motion study, 1926 (Gruber 219#)

KOPPMAN, G. & Co.
Houses on a canal, Hamburg,
Germany, 1884 (Time-Life/14
113)

KOUDELKA, Josef, 1938-
Gypsy children, 1964 (Gruber
382#)
Gypsy in Eastern Slovakia, 1965
(Gruber 374#)

KRAUSE, George, 1937-
Baby crawling, 1966 (Time-Life/
9 114)
Comedy and Tragedy, 1964 (Time-
Life/9 212)
Fog--Nova Scotia, 1968 (Time-
Life/12 143)
Fountainhead, 1969 (Time-Life/11
224)
Katy at Mont-St.-Michel, 1968
(Time-Life/9 210)
[Marble columns] 1971 (Time-Life/
11 100)
[Pigeons] (Time-Life/7 83)
A safe grip, 1963 (Time-Life/9
18)
Sanctuary, 1958 (Time-Life/9 213)
The Shadow, Seville, Spain, 1963
(Time-Life/14 43)
Submariner, 1958 (Time-Life/9
211)

KRIMS, Les, 1943-
[Mother love] 1971 (Time-Life/11
109)

KRONE, Hermann
Album, 1874 (Gruber 35#)

KRUKOWSKI, Dennis
Midnight mist, 1970 (Time-Life/16
166)

KÜHN, Heinrich, 1866-1944
Alfred Stieglitz, 1904 (Gruber
288#)
The Kühn children, 1912 (Time-
Life/11 200)
On the shore (Green 76)

Portrait of a girl, 1905-6
(Gruber 54#)
Still life, 1908 (Photography
195)
Still life, after 1911* (Bernard
167#)
Still life with oranges, 1903
(Gruber 203#)
Venice, 1897 (Gernsheim/2 299#)

KUYKENDALL, William
[Prosecuting Attorney Byron
Athey] (Time-Life/10 110-11)

L

LABROT, Syl, 1929-1977
Pink truck, 1960* (Time-Life/
8 49)

LAMB, John Graham
Threatening outhouse, 1970
(Time-Life/16 189)

LANDRY, Bob
The U.S. 28th Division march-
ing down the Champs-
Elysées, 1944 (Time-Life/7
21a)

LANDSHOFF, Herman
[Elephant charming] 1936 (Hall-
Duncan 82)
[Riding bicycles] (Hall-Duncan
81)
[Roller skating] (Hall-Duncan
80)
[Two tennis dresses] 1942 (Hall-
Duncan 83)

LANE, Whitney L.
Sea Nymph, 1970* (Time-Life/
16 199)

LANGE, Dorothea, 1895-1965
Bringing home the first born,
1952 (Time-Life/9 14)
Cars going west, 1936 (Time-
Life/10 127)
Charles M. Russell, c. 1924-26
(Sandweiss 79#)
Ex-tenant farmer on relief grant
in the Imperial Valley, Cali-
fornia, 1937 (Gruber 93#)
Headed west, Texas, 1937
(Time-Life/10 126)

Kern County, California, 1936
(Time-Life/9 74)
Lettuce pickers, Salinas Valley,
1938* (Bernard 209#)
May Day, 1934* (Bernard 198#)
Migrant girl, 1936 (Time-Life/10
131)
Migrant mother, 1936 (Photography
262, 264, 265)
Near Los Angeles, California, c.
1938 (Photography 270)
Northern California, 1944 (Sand-
weiss 121#)
Okie family, 1936 (Time-Life/10
123)
Okie homes in California, 1936
(Time-Life/10 129)
Old man, California, 1936 (Time-
Life/10 121c)
Old men, California, 1937 (Time-
Life/10 130)
Once a Missouri farmer, now a
migratory farm worker in
California, 1936 (Gruber 317#)
Sharecroppers, Eutaw, Alabama,
c. 1936 (Photography 266b;
Time-Life/10 133)
Shaving on the road, California,
1937 (Time-Life/10 128)
"She's a Jim-Dandy." Tulare
County, California, 1938
(Sandweiss 111#)
Woman of the High Plains, "If
you die, you're dead--That's
all." Texas Panhandle, 1938
(Sandweiss 86#)

LANGENHEIM, William and Frederick
Eight Feet Driver Locomotive,
1850* (Time-Life/15 33)

LANGLOIS, Jean-Charles
The Battlefield of Sebastopol,
1855* (Bernard 33#)

LARSEN, Lisa
Kennedy wedding, 1953 (Time-
Life/10 50)

LARSON, William G., 1942-
Image garden, 1969* (Time-Life/
11 173a)
Small talk, 1971* (Time-Life/11
173b)

LARTIGUE, Jacques-Henri, 1894-
Bibi Lartigue and Denise Grey

on deck, c. 1926* (Bernard
186#)
Day at the Drag Races at Auteuil,
1910 (Hall-Duncan 44)
A Delage racer at the Grand
Prix, 1912 (Time-Life/7 163)
Equestrienne, 1912 (Time-Life/
9 73)
Nanny Dudu and balloon, 1904
(Time-Life/11 187)
One page from the album, 1921*
(Gruber 174#)
Paris, Avenue des Acacias,
1912 (Time-Life/7 20c)
Paris, Florette, 1944 (Gruber
305#)

LAUGHLIN, Clarence, 1905–
And tell of time ... cobwebed
time, 1947 (Time-Life/12 49)
Bird of the death dream, 1953
(Time-Life/12 54)
Elegy for Moss Land, 1947
(Gruber 446#)
The enigma, 1941 (Time-Life/
12 48)
Haveth childers everywhere,
1952 (Time-Life/12 53)
Milwaukee nostalgic still life,
1964 (Time-Life/12 52)
The repulsive bed, 1941 (Time-
Life/12 47)

LAURENTS, Gene
Found color, 1959-69* (Time-
Life/8 47)
Pears in a Paris window, 1961*
(Time-Life/13 229)

LAZARNICK, Nathan
Three bareback riders* (Ber-
nard 180#)

LEAVITT, Carl
Untitled, 1973 (Time-Life/12
36)

LEBECK, Robert, 1929–
Funeral of Robert F. Kennedy,
1968 (Gruber 381#; Time-
Life/14 149)
Kennedy's burial, 1968 (Gruber
381#; Time-Life/14 149)

LE BLONDEL, A.
Post-mortem picture, c. 1850*
(Bernard 16#)

Wine drinkers, 1850's* (Bernard
31#)

LEE, C. Robert
Pacific Ocean Park, Santa Monica,
1960 (Time-Life/7 27)

LEE, Russell, 1903–
Aftermath of flood, Mount Ver-
non, Indiana, 1937 (Photogra-
phy 269)
Iowa homesteader's wife, 1936
(Time-Life/10 119)

LEEN, Nina
Okapi, 1970* (Time-Life/8 230)
Sheepdog, 1964* (Time-Life/8
120)
Whippet, 1964* (Time-Life/8 121)

LE GRAY, Gustave
Brig upon the water, 1856 (Gern-
sheim 152#; Gernsheim/2
131#)
French military maneuvers, Camp
de Châlons: The guard be-
hind a breastwork, 1857*
(Bernard 55#)
A picture taken at Camp de
Châlon, 1857 (Gruber 417#)
Seascape, c. 1857 (Gruber 264#)
Seascape of Sète, c. 1857 (Gruber
26#)
Study of trees (Gruber 32#)

LEIFER, Neil
Billy Kidd at Val Gardena, 1970*
(Time-Life/16 146)
Hawaiian surf, 1968* (Time-Life/
16 150)
Victor and vanquished, Lewiston,
Maine, 1965* (Time-Life/14
221)

LEIGHTON, Henri
New York, 1953 (Time-Life/7
30c)

LENART, Jr., Branko, 1948–
Actor on the deck of the ferry-
boat Veneto* (Time-Life/12
11)

LENDVAI-DIRCKSEN, Erna
Miner from Upper Silesia (Gruber
333#)
Nude, 1921 (Gruber 212#)

LEONIAN, Phillip
Man in motion, 1916 (Time-Life/
16 127)

LERMERCIER ET CIE, Paris
Reproduced in an unidentified
French pattern book, 1881
(Hall-Duncan 21c)

LERSKI, Helmar
Self-portrait, 1912 (Gruber
60#)
Typist, before 1931 (Gruber
334#)

LE SECQ, Henri
Detail of Chartres Cathedral,
1852* (Bernard 20#)
Harbour scene, c. 1852 (Gern-
sheim/2 90#)
Public bathhouse or swimming
school, Paris, c. 1852-53*
(Bernard 21#)
Still life, c. 1850 (Time-Life/7
184)
Still life, c. 1850 (Time-Life/7
185)
Still life, 1850's* (Bernard 40#)

LEWIS, George
The Graf Zeppelin flying over
the pyramids of Gizeh (Loke
220)
Mahatma Gandhi (Loke 211d)

LICHTSTEINER, Rudolf, 1938-
Moment. Self-portrait, 1972
(Gruber 434#)

LINE, Les
Wood lily and hayscented ferns*
(Rugoff 108#)

LISSITZKY, El
Self-portrait (Photography 243)

LIST, Herbert, 1903-1975
Hamburg, 1931 (Gruber 71#)
Munich, 1945 (Gruber 354#)
Training in the State Ballet
School, East Berlin, 1966
(Time-Life/7 91)

LITTLEJOHN, R.T.
Yellow robins (Guggisberg 32)

LLOYD OF NATAL

Zulu girl, 1885-90* (Bernard
134#)

LÖCHERER, Alois
Montage of the Bavaria, 1850
(Gruber 388#)
Transport of the colossal statue
of 'Bavaria' from the foundry
to its site in Munich, 1850
(Gernsheim/2 88#)

LODGE, R.B.
Little bittern (Guggisberg 19b)
Purple heron at nest (Guggisberg
19a)

LOENGARD, John
Portrait of Bill Cosby, 1969
(Time-Life/12 133)
Street child, 1968 (Time-Life/9
165)

LOESCHER & PETSCH
H.W. Vogel, c. 1895 (Gernsheim
253#; Gernsheim/2 214#)

LOEWY AND PUISEUX
The moon, 1894 (Time-Life/7 47)

LONDON STEREOSCOPIC COMPANY
Presumably the couturier J.P.
Worth trapped in the hoop he
designed, 1870's (Hall-Duncan
16c)
The Strand, c. 1890 (Gernsheim
294#; Gernsheim/2 239#)

LOORI, John
Asian's moment, 1973 (Time-Life/
12 42)

LOPEZ, André A.
Gypsy child in a van, 1968
(Time-Life/9 168)

LUBOSHEZ, Nahum
Famine in Russia, 1910 (Gern-
sheim/2 262#)
George Eastman, 1922 (Gernsheim
265#)

LUKAS, Jan
Sculpture, Expo '67, Montreal,
1967* (Time-Life/14 25)

LUMIERE, Auguste and Louis
Still life, 1899 or 1900* (Ber-

nard 144#)
Untitled, c. 1895* (Bernard
130#)

LUMIERE, Louis
Autochrome color transparency
of Yvonne Lumière and her
dolls, 1913* (Time-Life/8
53)
Mme. Antoine Lumière and
granddaughter, c. 1915*
(Time-Life/8 72)
On the road to La Ciotat, 1907*
(Time-Life/8 71)
Young lady with an umbrella,
1907* (Time-Life/8 73)

LYNES, George Platt, 1907-1955
[The hooded robe] 1945 (Hall-
Duncan 110)
Jean Cocteau, 1930 (Gruber
320#)
Male nude, legs lifted (Gruber
241#)
Nude in a room (Gruber 238#)
Ruth Ford modeling (Hall-Duncan
111)
Untitled, c. 1940 (Hall-Duncan
106a, 106b, 107, 109)

LYON, Danny, 1942-
Andrew Sanchez watching TV,
1971 (Time-Life/9 170)
Boys with a crab, 1964 (Time-
Life/9 188)
Long summer afternoon, 1967
(Time-Life/9 32)
On a porch, 1967 (Time-Life/9
186)
Sparky and Cowboy, 1965
(Time-Life/7 23)
Truck in the desert near Yuma,
Arizona, 1962 (Sandweiss
126#)

M

McAVOY, Tom
Franklin D. Roosevelt, 1938
(Time-Life/10 29d)

McCARTHY, Tom
Blue lion, 1969* (Time-Life/8
213)

McCOMBE, Leonard

[A day-care center] (Time-Life/
10 174-190)
[The private life of Gwyned
Filling] (Time-Life/10 68-71)
Storm surf at Cape Ann, 1963*
(Time-Life/16 34)
[Texas cowboy] (Time-Life/12
108)

McCOSH, John
Burmese girl, 1852* (Bernard
13#)

McDOWALL, Roddy
Birgit Nilsson, 1966 (Time-Life/
13 26)

MACH
Mr. and Mrs. John Locicero,
1926* (Bernard 185#)

MACPHERSON, Robert
Bas-relief on the interior of the
Arch of Titus, Rome, c. 1865*
(Bernard 88#)
Cascades at Tivoli, 1857 (Gern-
sheim 201#; Gernsheim/2 157#)
The falls of Terni, before 1867*
(Bernard 87#)
Temple of Antoninus Pius and
Faustina, Rome, c. 1857
(Gernsheim 197#; Gernsheim/2
159#)

McQUADE, John
Illusion, 1969 (Time-Life/16 164c)

MacWEENEY, Alen
Gypsy child, Ireland, 1966 (Time-
Life/9 159)
I can see you, but you can't see
me, 1966 (Time-Life/9 133)
Nude in bathtub, 1962 (Time-Life/
11 182)
On Lansdowne Road, 1965 (Time-
Life/9 187)
Winter day, 1969* (Time-Life/13
140)

MADDEN, Robert W.
Mother and daughter, Pleasant
Valley, Maryland, 1973*
(Time-Life/14 34)

MAISEL, Jay
Boy with a bicycle (Time-Life/9
179)

Confrontation, 1968 (Time-Life/
9 117)
Health-tex knitting plant, 1973*
(Time-Life/12 68)
New York, 1969* (Time-Life/8
39)
Nude, 1965* (Time-Life/8 30)
PepsiCo World Headquarters,
Purchase, New York* (Time-
Life/12 57)
Soccer player, 1966* (Time-Life/
8 32)
Young New Yorker, 1964* (Time-
Life/8 106)

MAN, Felix H.
Benito Mussolini in his office
in the Palazzo Venezia,
Rome, 1931 (Photography
273; Time-Life/10 60)
The Dictator at work, 1931
(Time-Life/10 60a)
Igor Stravinsky conducting a
rehearsal, 1929 (Photography
274)
In the temple of Fascism, 1931
(Time-Life/10 60c)
The man without the mask, 1931
(Time-Life/10 60d)
Maxim Gorki, Sorrento, 1932
(Gruber 87#)

MAN RAY, 1890-1976
[Against his surrealist painting]
1936 (Hall-Duncan 86)
Augustabernard's new line, 1934
(Hall-Duncan 87c)
Charnaux Caslis, c. 1927 (Hall-
Duncan 88)
A comb entering a gyroscope,
1922 (Photography 229a)
Composition of objects selected
with both eyes closed, 1922
(Photography 229d)
Fashion rayograph, 1934 (Time-
Life/13 117)
Fashions by radio, 1936 (Hall-
Duncan 87a)
Gown by Schiaparelli, 1935
(Time-Life/13 116)
Imitation of the gyroscope by
the glass magnifying glass,
1922 (Photography 229c)
Lee Miller, 1930 (Gruber 302#)
Louis Aragon and André Breton,
c. 1924* (Bernard 179#)
The lovers (Gruber 72#)

[Model in a wheelbarrow] 1937
(Hall-Duncan 85)
Rayograph (Gruber 425#)
Solarization, 1931 (Gruber 306#)
A torn letter, a spool of wire and
a watch fob, 1922 (Photogra-
phy 229b)
Violon d'Ingres, 1924 (Time-Life/
12 198)
Woman, 1903 (Gruber 291#)
Woman, 1929 (Gruber 69#)

MANTZ, Werner, 1901-
Study in a private villa, 1928-29*
(Bernard 190#)

MARCEAU, T.C.
Portrait of a lady (Time-Life/13
52)
[T.C. Marceau's posh Fifth
Avenue photo gallery]* (Time-
Life/12 52-53)

MAREY, Etienne Jules, 1830-1904
Flight of a duck, c. 1890 (Time-
Life/7 157)
Man jumping and duck flying, c.
1882 (Gernsheim 302#; Gern-
sheim/2 248#)

MARK, Mary Ellen, 1940-
Boy catching insects, 1970*
(Time-Life/9 199)
Girl coloring sculpture, 1970*
(Time-Life/9 198)
Movie extras near Zagreb, Yugo-
slavia, 1970 (Time-Life/9 201)
Schoolgirls in Trabzon, Turkey,
1965* (Time-Life/9 200)
Wedding day, 1965 (Time-Life/11
130)

MARSH, W.P.
Stormy sea at Bognor, c. 1900
(Gernsheim 287#; Gernsheim/2
234#)

MARTENS, Friedrich von
Panoramic view of Paris from the
Louvre, 1846 (Gernsheim/2
46#; Time-Life/7 150)

MARTIN, Ira
Still life, c. 1921 (Sandweiss 64#)

MARTIN, Paul
Street vendor, London, 1892-4

(Gernsheim/2 263#)
Yarmouth beach, 1892 (Gern-
sheim 312#; Gernsheim/2
264#)

MARVILLE, Charles
The Church of the Pantheon
under repair, c. 1870*
(Bernard 93#)

MAULL & POLYBLANK
Rev. J.B. Reade, F.R.S., c.
1856 (Gernsheim 46#; Gern-
sheim/2 38#)

MAXWELL, Marcuswell
Buffalo herd in thick cover on
Oldonyo Sabuk, a mountain
not far from Nairobi (Guggis-
berg 103)
Elephants drinking at a water-
hole near Namanga, Kenya
(Guggisberg 102)
Serengeti lions settling down to
their digestive siesta (Gug-
gisberg 101)

MAXWELL, Marius
Bull elephant photographed at
a distance of approximately
eight yards (Guggisberg 96)
A snapshot taken from a car in
order to illustrate the various
phases of the giraffe's gait
(Guggisberg 95)
A troop of hippopotami on the
banks of the Uaso Nyiro
(Guggisberg 94)

MAYALL, John Edwin, 1810-1901
L.J.M. Daguerre, 1848 (Gern-
sheim 24#; Gernsheim/2
28#)
Queen Victoria and Prince Al-
bert, 1861 (Gernsheim 205#;
Gernsheim/2 183#)

MAYER & PIERSON
From album of 288 photographs
of the Countess de Castig-
lione, her son, and member
of the court of Napoleon III,
1853-57 (Hall-Duncan 15)
The Prince Imperial, Paris, c.
1859 (Time-Life/9 65)

MEATYARD, Ralph Eugene,

1925-1972
Christopher and the rebuilding
of America, 1961 (Time-Life/9
162)
Madonna, 1969 (Time-Life/11 219)
Renitent nature, 1963 (Time-Life/
9 217)
Rimose meeting, 1962 (Time-Life/
9 216)
Sound, 1970 (Time-Life/11 206)
Untitled (Gruber 117#)
Untitled, c. 1960 (Gruber 372#)

MEEK, Dick
[Apples]* (Time-Life/8 123)

MEERSON, Harry
Untitled, 1934 (Hall-Duncan 58)

MERRITT III, Vernon
View on Park Avenue, 1969*
(Time-Life/8 109)

MERTIN, Roger, 1942-
Breast and hair (after E.W.),
Rochester, 1973 (Gruber 130#)
From "Plastic love-dream," 1968
(Time-Life/12 137)
Rochester, New York, 1975
(Gruber 448#)

MESAROS, Ron
Baby in the sink, 1970 (Time-
Life/9 120)
Baby on pool table, 1970 (Time-
Life/9 85)
Dog and ball, 1969 (Time-Life/11
210)
Muscle Beach, 1968 (Time-Life/9
155)

MESPOULET AND MIGNON
Boy with donkey carrying peat,
Connemara, Ireland, 1913*
(Bernard 169#)

MESSER, William
Peter under the lamppost, 1973
(Time-Life/12 32)

METZ, Gary and MOORE, John
From "Song of the Shirt," 1967*
(Time-Life/12 226)

METZKER, Ray K., 1931-
Composite, 1966 (Time-Life/7 44)
Juniper Street, 1966-7 (Time-

Life/11 170)
Untitled, 1965 (Time-Life/12
216)
Untitled, 1969 (Time-Life/11
166)
Untitled, 1972 (Gruber 365#)

MEYEROWITZ, Joel, 1938-
New Jersey home, 1966 (Gruber
438#)

MICHALS, Duane, 1932-
Death comes to the old lady,
1969 (Time-Life/11 217b)
[Headless mannequin] 1971
(Time-Life/11 97)
The Illuminated Man, 1969
(Time-Life/12 160)
Ray Barry, 1963 (Gruber 314#)
Ray Barry, 1977 (Gruber 315#)
Things are queer (Gruber
137#)
The young girl's dream, 1969
(Time-Life/11 217a)

MICHAUD, Roland
Afghani Chopendoz horseman,
1973* (Time-Life/14 156)

MIGLIORI, Antonio
from "The Cemeteries," 1952
(Gruber 436#)

MILES, Reid
The Flag, 1966* (Time-Life/8
46)

MILI, Gjon, 1904-1984
Avon Long as Sportin' Life,
1942 (Time-Life/7 213)
Centaur by Picasso, Vallauris,
France, 1949 (Time-Life/14
230)
Centaurs--Charles Weidman,
José Limón and Lee Sherman,
1939 (Time-Life/7 212)
Nora Kaye, 1947 (Time-Life/7
49)

MILITO, Sebastian
Chimney, 1969 (Time-Life/11
45)
Doorknob, 1970 (Time-Life/11
53)
[Man in hard hat] (Time-Life/
10 98-99)
[Newborn infant in hospital

bassinet] (Time-Life/9 95-97)
Pears, 1970 (Time-Life/11 42)
Pipes, 1970 (Time-Life/11 31)
[Preparation for a wedding]
(Time-Life/10 152-155)
Prism and spectrum, 1970* (Time-
Life/8 11)

MILLER, Lee
[Mme. Beaurepaire in her pony
cart] 1944 (Hall-Duncan 123)

MILLER, Wayne
Morning repose, 1957 (Time-Life/
9 189)

MILROD, Glenda
Shin Sugino (Time-Life/12 117c)

MINSHALL, John
A child is born, 1964 (Time-Life/
9 11)

MISONNE, Léonard
Gilly, 1898 (Gruber 45#)

MISRACH, Richard
Boojum II, 1977 (Gruber 267#)

MITTELHOLZER, Walter
Elephants crossing the Nile
(Guggisberg 106)

MODOTTI, Tina, 1896-1942
Edward Weston, c. 1923-24 (Sand-
weiss 150b)

MOHOLY, Lucia
Bauhaus, 1925-26 (Gruber 356#)

MOHOLY-NAGY, László, 1895-1946
From the Radio Tower, 1928
(Time-Life/12 202)
From the Transporter Bridge,
Marseilles, 1929 (Photography
240c)
Love Thy Neighbor, 1925 (Pho-
tography 238)
Nude, c. 1935 (Gruber 243#)
Oskar Schlemmer (Photography
245)
Photogram* (Bernard 204#)
Photogram, 1926 (Photography
240a)
Self-portrait, c. 1922 (Gruber
68#)
Self-portrait, 1925 (Time-Life/12

203a)
Two nudes, 1927-29 (Gruber
244#)
Untitled (Gruber 358#)

MOLARD, Humbert de
His assistant, Louis Dodier, as
a prisoner, 1847* (Bernard
6#)
Old farmhouse, 1852 (Gern-
sheim/2 96#)
Portrait of the photographer's
wife, Henriette-Renée Patu,
c. 1847* (Bernard 10#)

MOMATIUK, Yvona and Momo
Dinner Pond, Okefenokee*
(Rugoff 160#)
Minnies Lake, Okefenokee Na-
tional Wildlife Refuge,
Georgia* (Rugoff 159#)

MONSEN, Frederick Imman
Mohave Indian children, c.
1890's (Sandweiss 68#)

MONTASTIER, E.
Pierre Loti dressed as Osiris
for a fancy dress ball, c.
1880* (Bernard 108#)

MONTIZON, Count de
The hippopotamus at the Zoo-
logical Gardens, Regent's
Park, 1855* (Bernard 45#)

MONTMEJA, Dr. A. de
Linear incision of the eye, pub.
1871 (Bernard 95#)

MOON, Karl
A Navajo youth, 1907* (Bernard
155#)

MOON, Sarah, 1940-
Beauty contest, 1973 (Hall-
Duncan 212)
Mirror man, 1971 (Hall-Duncan
208)
[They have faces which are
pure] 1973* (Hall-Duncan
210)

MOORE, Charles
Death Valley, 1970* (Time-Life/
16 27)

MOORE, David, 1927-
Torchlight procession of skiers,
Australia, 1966* (Time-Life/16
194)

MORAL, Jean
[Dinarzade modeling in Paris]
(Hall-Duncan 78)

MORAN, John
Island, Limon Bay, 1871 (Sand-
weiss 16#)
[U.S. Observatory] c. 1870-1871
(Sandweiss 15#)

MORATH, Inge, 1923-
[Pigeons by the New York Public
Library] 1971 (Time-Life/11
103)

MORGAN, Barbara, 1900-
Beaumont Newhall and Ansel
Adams jumping, 1942 (Sand-
weiss 151)
Charles Sheeler and his favorite
beech tree, 1945 (Sandweiss
152a)
Martha Graham--Letter to the
World, 1940 (Sandweiss 100#;
Time-Life/13 27)
Pregnant, 1940 (Time-Life/11 41)
Pure energy and neurotic man,
1941 (Sandweiss 101#)
Singing and drinking rain, 1950
(Time-Life/9 79)

MORSE, Ralph
Artillery practice at Fort Sill,
1970 (Time-Life/16 81)
The Papal Mass at Yankee Stadi-
um, New York City, 1965*
(Time-Life/14 225)
Sixty-yard dash, Madison Square
Garden, New York City, 1956
(Time-Life/14 217)
Space-age man, 1954 (Time-Life/
14 215)
A teacher's tasks, 1954 (Time-
Life/16 89)

MOTAY, Cyprian Tessié du
Young woman, c. 1867* (Bernard
90#)

MUDD, James
Floods at Sheffield, 1864 (Gern-
sheim 186#)

MYDANS, Carl, 1907–
 Farm child in Tennessee, 1936
 (Time-Life/10 120)

N

N.D. (Neurdien)
 Detail of the Eiffel Tower,
 1889* (Bernard 125#)

NADAR (Gaspard Félix Tourna-
 chon) 1820–1910
 A. Léon-Noel, c. 1860 (Tour-
 nachon 229b)
 Adelina Patti, 1863 (Tournachon
 245c)
 Adolphe Crémieux, c. 1858
 (Tournachon 143)
 Adolphe Monod, c. 1856 (Tour-
 nachon 266a)
 Adolphe Thiers, c. 1870 (Tour-
 nachon 264a)
 Alexandre Becquerel (fils), c.
 1870 (Tournachon 201)
 Alexandre Dumas (fils), c.
 1864 (Tournachon 181)
 Alexandre Dumas (père), 1857
 (Tournachon 119)
 Alfred de Vigny, c. 1854 (Tour-
 nachon 51)
 Alfred Musard (fils), c. 1856
 (Tournachon 101)
 Allon, c. 1860 (Tournachon
 267d)
 Alphonse Daudet, c. 1866
 (Tournachon 191)
 Alphonse Karr, c. 1858 (Tour-
 nachon 141)
 Antoine Barye, c. 1860 (Tour-
 nachon 216a)
 Antoine Samuel Adam-Salomon,
 c. 1865 (Tournachon 187)
 Armand Barbès, 1862 (Tourna-
 chon 169)
 Arsène Houssaye, c. 1860
 (Tournachon 231b)
 Athanase-Laurent Coquerel, c.
 1858 (Tournachon 131)
 Auguste Clésinger, c. 1860
 (Tournachon 165)
 Auguste Préault, c. 1854
 (Tournachon 61)
 Baron Taylor, c. 1865 (Gern-
 sheim 229#; Gernsheim/2
 197#)
 The basket of 'Le Géant' after

the wreck, 1863 (Tournachon
 16)
Bertrand de Lesseps (Tournachon
 285c)
Carlotta Grisi, c. 1865 (Tourna-
 chon 183)
Catacombs of Paris, c. 1861
 (Gernsheim/2 229#)
Celestin Nanteuil, c. 1868 (Tour-
 nachon 215a)
Chaix d'Est Ange, c. 1857 (Tour-
 nachon 267b)
'Cham' (Amédée Noé) c. 1870
 (Tournachon 217c)
Charles Asselineau, c. 1857
 (Tournachon 224c)
Charles Baudelaire, c. 1855
 (Photography 111; Tournachon
 67)
Charles Baudelaire, c. 1860
 (Tournachon 237a)
Charles Garnier, c. 1877 (Tour-
 nachon 207)
Charles Philipon, c. 1854 (Tour-
 nachon 59)
Claude Genoux, c. 1857 (Tourna-
 chon 233c)
Claude Monet, 1899 (Tournachon
 21)
Commerson with his paper 'Le
 Tintamarre,' c. 1856 (Tourna-
 chon 4)
Constans Troyon, c. 1856 (Tour-
 nachon 218d)
Constantin Guys, c. 1855 (Tour-
 nachon 97)
Daniel François Auber, c. 1870
 (Tournachon 245b)
Edmond and Jules de Goncourt,
 c. 1855 (Tournachon 76)
Edouard Lefèbre-Laboulaye, c.
 1859 (Tournachon 145)
Edouard Manet, c. 1865 (Tourna-
 chon 189)
Elisée Reclus, c. 1870 (Tourna-
 chon 203)
Emile de Girardin, c. 1856
 (Tournachon 234b)
Emile Littré, c. 1860 (Tournachon
 225b)
Emma Livry, c. 1859 (Tournachon
 151)
Ernest Alexandre Coquelin (Tour-
 nachon 250d)
Ernest Feydeau, c. 1859 (Tour-
 nachon 253b)
Ernest Legouvé, c. 1861 (Tour-

nachon 159)
Ernesto Camillo Sivori, c. 1860
(Tournachon 153)
Eugène Delacroix, 1855 (Pho-
tography 109)
Eugène Delacroix, 1858 (Tour-
nachon 133)
Eugène Isabey, c. 1860 (Tour-
nachon 214b)
Eugène Pelletan, c. 1855
(Tournachon 71)
Eugène Scribe, c. 1858 (Tour-
nachon 257b)
Farouk Khan, c. 1857 (Tour-
nachon 117)
Felicien David, c. 1855 (Tour-
nachon 240b)
Ferdinand de Lesseps, c. 1869
(Tournachon 271d)
François Guizot, c. 1857
(Tournachon 129)
François-Louis Lesueur, c. 1855
(Tournachon 81)
François-Louis Lesueur, c. 1854
(Tournachon 260b)
George Sand, 1864 (Gernsheim/
2 200#; Tournachon 179,
224a)
Georges Feydeau (Tournachon
251b)
Gérard de Nerval, 1855 (Tour-
nachon 75)
Giacomo Meyerbeer, 1860
(Tournachon 163)
Gill (Gosset de Guines) (Tour-
nachon 212)
Gioachino Rossini, c. 1856
(Tournachon 111)
Giuseppe Garibaldi, c. 1870
(Tournachon 269b)
Giuseppe Verdi, c. 1866 (Tour-
nachon 197)
Gustave Courbet, c. 1866
(Tournachon 193)
Gustave Doré, c. 1855 (Tour-
nachon 95)
Hand of M.D. ... Banker, c.
1860* (Bernard 75#)
Hector Berlioz, c. 1863 (Tour-
nachon 177)
Henri Monnier, c. 1860 (Tour-
nachon 229a)
Henri Mürger, c. 1854 (Tour-
nachon 53)
Honoré Daumier, 1855 (Photog-
raphy 108; Tournachon 91)
Horace Vernet, c. 1858

(Tournachon 219c)
[Interior, 35 Boulevard des
Capucines] c. 1860 (Tournachon
10)
Isidore Severin, Baron Taylor,
c. 1858 (Tournachon 103)
Jacques François Halévy, c. 1855
(Tournachon 246c)
Jacques Offenbach, c. 1860
(Tournachon 243d)
Jacques Offenbach, c. 1875
(Tournachon 205)
Japanese actor (Tournachon 254c)
Japanese actress (Tournachon
255a)
Jean Guillaume Viennet, c. 1859
(Tournachon 149)
Jean Journet, c. 1857 (Tourna-
chon 127)
Jean-Baptiste Camille Corot, c.
1855 (Tournachon 79)
Jean-François Berthelier, c.
1858 (Tournachon 137)
Jean-François Millet, c. 1857-
1858 (Gruber 18#; Tournachon
121)
Joseph Darcier, 1854 (Tournachon
83)
Joseph Pietri, c. 1866 (Tourna-
chon 267c)
Jules Champfleury, c. 1865
(Tournachon 185)
Jules Favre, c. 1865 (Tournachon
268b)
Jules Janin, c. 1855 (Tournachon
107)
Jules Michelet, 1856 (Tournachon
199)
Jules Renard, c. 1859 (Tournachon
147)
Juliette Adam, c. 1858 (Tourna-
chon 135)
Laréveillière-Lepeaux, c. 1865
(Tournachon 231d)
Léon Gambetta, c. 1870 (Tourna-
chon 265b)
Leon Gérôme, c. 1860 (Tourna-
chon 220d)
Léon Gozlan, c. 1855 (Tournachon
87)
Léopold I, c. 1860 (Tournachon
263c)
Léopold II, c. 1875 (Tournachon
263d)
Louis Blanc, c. 1858 (Tournachon
268d)
Louis Boulanger, c. 1854 (Tour-

113)
Théophile Thoré, c. 1865
(Tournachon 220a)
Thérèse Tournachon, c. 1855
(Tournachon 93)
Unknown girl, c. 1855 (Tour-
nachon 65)
Unknown old woman, c. 1860
(Tournachon 155)
Vautier and Garnier in Offen-
bach's ORFEE AUX EN-
FERS, 1858 (Tournachon 238)
Victor Capoul and Mlle Ritter
in 'Paul et Virginie' 1878
(Tournachon 251a)
Victor Cousin, c. 1858 (Tour-
nachon 235d)
Victor Hugo on his deathbed,
1885 (Gernsheim 231#; Gern-
sheim/2 199#; Tournachon
209)
Victorien Sardou, c. 1856
(Tournachon 250c)
View of Paris from a balloon,
c. 1859 (Gernsheim 156#)
A view of the Arc de Triomphe
taken from a balloon, 1868
(Tournachon 17)
Workmen in the Paris catacombs,
1861 (Tournachon 36)

NADAR, Paul
Albert, Duc de Broglie (Tour-
nachon 279b)
Alexander III with Olga, Xenia,
the Tsarevitch, Marie Feo-
dorovna, George and Michael,
c. 1886 (Tournachon 280b)
Arlette Dorgère, c. 1909 (Tour-
nachon 294b)
Bertrand de Lesseps (Tourna-
chon 285c)
Cléo de Mérode, c. 1890 (Tour-
nachon 290a)
Comtesse de Paris (Tournachon
288a)
The daughters of Théophile
Gautier, c. 1862 (Tourna-
chon 294c)
The de Lesseps family (Tour-
nachon 284a)
Dom Pedro II of Alcantara,
1891 (Tournachon 286b)
Don Carlos (Tournachon 293d)
A dress from Maison Lanvin
(Tournachon 290c, 293c)
Duchesse de Medina Coeli, c.

1855 (Tournachon 295c)
Edward, Prince of Wales (Tour-
nachon 279a)
Empress of Brazil, Teresa Chris-
tina Maria (Tournachon 286a)
Eugène, Vicomte de Vogue, c.
1888 (Tournachon 292d)
First photo-interview, 1886 (Ber-
nard 115#; Gernsheim 230#;
Gernsheim/2 269#)
Grand Duke Constantine of Rus-
sia (Tournachon 280c)
Grand Duke Vladimir (Tournachon
280a)
A hat from Maison Lanvin (Tour-
nachon 291c)
King George V of Hanover (Tour-
nachon 279d)
Japanese visitors to Paris, c.
1865 (Tournachon 290b)
Lady Randolph Churchill (Tour-
nachon 282a)
Liane de Pougy (Tournachon 278)
Lolla Montes (Tournachon 287d)
Lord Randolph Churchill (Tour-
nachon 282c)
Mme de Montgolfier, c. 1860
(Tournachon 282d)
Madame Dréau, displaying a
Hausard hat (Tournachon
292b)
Mlle G. Réjane (Tournachon 296)
Mlle Jenny (Tournachon 289c)
Mlle Lauzeski (Tournachon 288c)
Mlles Musard, c. 1862 (Tournachon
287c)
Maison Reveillon dress, c. 1900
(Tournachon 283c)
Maison Toré hat, c. 1905 (Tour-
nachon 283b)
Master Porel (Tournachon 289a)
Michel Chevreul on his 100th
birthday, at an interview with
Nadar, 1886* (Bernard 115#;
Gernsheim 230#; Gernsheim/2
269#)
Nadar, aged 65 (Tournachon 27)
Nassr-ed-Din, Shah of Persia
(Tournachon 291d)
Negro servant (Tournachon 283a)
Nicholas II (Tournachon 281b)
Paul Nadar, son of Félix, c.
1862 (Tournachon 289d)
Photo-interview of F.T. Nadar
with the centenarian scientist
Chevreul, 1886 (Bernard
115#; Gernsheim 230#; Gern-

sheim/2 269#)
The Polaire children (Tourna-
chon 284d)
Prince Albert of Monaco
(Tournachon 291a)
Prince Anatole Demidoff, c.
1869 (Tournachon 281a)
Prince George Bibesco (Tour-
nachon 295a)
Prince Henri d'Orléans, c.
1867 (Tournachon 295d)
Prince Joseph Bonaparte and
sons Victor and Louis
(Tournachon 286c)
Prince Kung Pao-yun (Tourna-
chon 288b)
Prince Troubetskoy (Tournachon
281c)
Princess Frederika (Tournachon
293c)
Queen Isabelle II of Spain
(Tournachon 283d)
Queen of Portugal, Marie-
Amélie (Tournachon 287a)
Renée Maupin, c. 1897 (Tour-
nachon 294d)
Santos Dumont in an experi-
mental flying-machine
(Gruber 296#; Tournachon
33a)
Solange de Lesseps (Tournachon
285d)

NAGAO, Yasushi
Inejiro Asanuma and assassin,
1960 (Time-Life/10 31)

NANSEN, Fridtjof
Walrus on an ice floe off Franz
Josef Land, c. 1894 (Guggis-
berg 76)

NAYSMITH, Terence
Landscape, 1969* (Time-Life/
11 58)

NEGRE, Charles, 1820-1880
Arles, the Ramparts, 1852
(Gruber 30#)
Gothic sculpture, St. Gilles du
Gard Abbey, 1852 (Gern-
sheim/2 92#)
Place aux Aires, Grasse, c.
1852* (Bernard 22#)
Les Ramoneurs (chimney-
sweeps, Paris), 1852 (Gern-
sheim/2 93#)

Woman of Arles, 1852 (Gruber
287#)
Young girl with basket and baby,
early 1850's* (Bernard 23#)

NEGRETTI & ZAMBRA
Visit of Napoleon III and Empress
Eugénie with Queen Victoria
and Prince Albert to the
Crystal Palace on 20 April
1855 (Gernsheim 162#)

NESENSOHN, Carl
Morro Castle aground, 1934
(Time-Life/10 39)

NEWBOLD, C.
Challenger expedition: Photo-
graph of rockhopper penguins
on Inaccessible Island, c.
1874 (Guggisberg 15)

NEWHALL, Beaumont
Portrait of Henri Cartier-Bresson,
1946 (Photography 282)

NEWMAN, Arnold, 1918-
Alfried Krupp von Bohlen und
Halbach, Germany, 1963*
(Time-Life/14 222)
Christianity, the Fifth Station of
the Cross, 1967 (Time-Life/13
91)
Igor Stravinsky, 1946 (Gruber
110#)
Isamu Noguchi, 1947 (Time-Life/
13 21)
Louis Kahn, Connecticut, 1964*
(Time-Life/14 223)
Stravinsky, 1949 (Time-Life/7 41)

NEWTON, Helmut, 1920-
Fur-power, 1974 (Hall-Duncan
206)
[A long sheath in patterned black
jersey] 1976 (Hall-Duncan 205)
[A long two-part dress of crepe]
1976 (Hall-Duncan 204)
[Of an insurpassable cut] 1975
(Hall-Duncan 207)
Paloma Picasso in Karl Lagerfeld
dress, 1973 (Hall-Duncan 202)
Photographed in Senegal* (Hall-
Duncan 199)
[Women in bikinis] 1975 (Hall-
Duncan 203)
[Woman on zebra-striped couch]*

1973 (Hall-Duncan 200)

NEWTON, Sir William J.
Burnham beeches (Photography 78)

NIELSON, H.F. attrib.
Niagara Falls frozen, 1880's* (Bernard 111#)

NIEPCE, Joseph Nicephore, 1765-1833
[World's first photograph] (Gernsheim 18#; Gernsheim/2 21#)

NILSSON, Lennart, 1922-
Eleven-week-old human fetus, 1963* (Time-Life/7 52)

NISHAYAMA, Kiyoshi
Grapes (Gruber 19#)

NOOIJER, Paul de
Self-portrait, 1976* (Gruber 172#)

NOTHMANN, E.
In the garden, c. 1903 (Gernsheim 344#; Gernsheim/2 303#)

NOTMAN, William McFarlane (active 1880 or earlier)
Seated woman, 1869 (Photography 131)
Victoria Bridge over the River St. Lawrence, 1859* (Bernard 68#)

NUNLEY, Robert R.
Byrd Land Camp, 1967* (Time-Life/16 41)

NYGARDS, Leif-Erik
Washington Square Park, 1967* (Time-Life/8 97)

O

OEHME, Gustav
Three girls, Berlin, 1843* (Bernard 7#)

OGAWA, Takayuki
Display window (Gruber 445#)

OLLMAN, Arthur
Untitled, 1976* (Gruber 158#)

OLSON, John
S.S. Manhattan heading for Alaska, 1969* (Time-Life/16 37)

OLSON, Lennart
Ste. Agnès, Provence, France, 1955 (Time-Life/11 189)

OLSON, Oskar
Reticulated giraffe and Grévy's zebra posing side by side for the cine-camera (Guggisberg 97)

OSBORNE, Walter D.
Starting gate at Aqueduct, 1964* (Time-Life/16 154)

O'SULLIVAN, Timothy H., 1840-1882
Canyon de Chelle, New Mexico, 1873 (Gernsheim/2 172#; Gruber 249#; Sandweiss 32#)
Dead Confederate soldier, 1865* (Bernard 81#)
Dead Confederate soldier in trenches of Fort Mahone at Petersburg, Virginia, April 3, 1865 (Gruber 420#)
The Gould and Curry Mill, Virginia City, Nevada, 1867 (Photography 120)
Harvest of Death. Battlefield of Gettysburg, 1863 (Gernsheim/2 146#; Gruber 42#)
Headquarters Guard (114th Pennsylvania Zouaves), Army of the Potomac, Culpeper, Virginia, c. 1863 (Time-Life/14 102)
The photographer's wagon and mules in the Nevada Desert, 1868 (Time-Life/14 89)
Pyramid Lake, 1867 (Photography 123)
Shifting sand dunes, 1867 (Photography 125)
Shoshone Falls, 1867 (Photography 126)
View of General Ulysses S. Grant in a council of war with General George Meade, Virginia, May 1864 (Loke 16d)

OTT, Charlie

Barren ground with caribou
bull on the ice of glacial
stream* (Rugoff 17#)
Willow ptarmigan hen in May*
(Rugoff 12#)

OUTERBRIDGE, Jr., Paul, 1896–
1958
Consciousness, 1931 (Gruber
75#)
Fruit in a Majolica dish, 1921
(Gruber 191#)
Peppers, c. 1923 (Sandweiss
58#)
Piano, 1924 (Gruber 205#)
Torso, 1923 (Gruber 218#)
Torso, c. 1936* (Bernard 210#)

OWENS, Bill, 1938–
"Our house is built with the
living room in the back so
in the evenings we sit out
front of the garage and
watch the traffic go by"
1972 (Gruber 131#)

P

PABEL, Hilmar, 1910–
Volunteers in Bolivia, 1975
(Gruber 383#)

PACH, G.W.
Ulysses S. Grant, U.S. soldier
and 18th President of the
United States, with his
wife, Julia, and youngest
son, Jesse, c. 1872 (Loke
50)

PACKO, Robert
Fisheye view, 1968 (Time-Life/
7 126)

PARDOE, Dr. J.B.
Waiting for the train, 1923*
(Bernard 177#)

PAREE, Paul
The Psycho House, 1968* (Time-
Life/8 211)

PARKER, Bert
Highway A1A, 1968 (Time-Life/
12 219)

PARKS, Gordon, 1912–
Comfortless child, exhausted
father, Rio de Janeiro, 1961
(Time-Life/9 21)
Red Jackson, 1948 (Gruber 331#)
The window, 1960* (Time-Life/8
34)

PECK, Mary
Laura Gilpin, 1978 (Sandweiss
152c)

PELHAM, Lynn
Jai Alai rebound, 1965 (Time-Life/
16 142)

PENN, Irving, 1917–
American Ballet Theatre, 1947
(Gruber 299#)
Asaro mudmen, New Guinea,
1970* (Time-Life/13 102)
Children in Peru, 1948 (Time-Life/
9 86)
Dahmoney, five girls, 1967*
(Time-Life/13 101)
A Florentine child, Elisabetta
Cristina Giuffrida-Ruggeri,
1948 (Time-Life/12 34)
Girl behind wine bottle (Hall-
Duncan 151)
Girl in black and white, 1950
(Time-Life/13 127)
Girl with tobacco on the tongue,
1950 (Hall-Duncan 152)
A group of Hell's Angels, 1967
(Time-Life/7 217)
Harlequin dress, 1950 (Hall-
Duncan 153)
Mermaid dress, 1950 (Hall-Duncan
145)
[New romantics] 1949 (Hall-
Duncan 150)
New York child, 1953 (Time-Life/
7 216)
New York still life with food,
1947 (Time-Life/13 199)
Pablo Picasso, 1957 (Gruber 120#;
Time-Life/7 40)
Rowboat on the Seine, 1951*
(Gruber 141#)
Trees along French canal, 1951*
(Gruber 152#)
Truman Capote, 1965 (Gruber
128#)
Twelve most photographed models,
1947 (Hall-Duncan 148; Time-
Life/13 126)

Two Guedras, Morocco, 1971
(Hall-Duncan 155)
Woman in Moroccan palace, 1952
(Hall-Duncan 146)
Yellow rose and skyscraper,
1950* (Gruber 166#)

PERCY, John
An old oak (Photography 98)

PERKINS, H.J.
Easy harvest from Wisconsin
earth, 1895 (Time-Life/10
95)

PERRON, Robert
Aerial view of bayous in a
marsh of the Mississippi
delta* (Rugoff 96#)
Aerial view of sunset on a tidal
flat in the Mississippi delta*
(Rugoff 1#)

PERSCHEID, Nicola
Young girl (Gruber 283#)

PETERHANS, Walter, 1897-1960
Portrait (Photography 244)

PETERSEN, Anders, 1944-
[Dance pavilion at amusement
park] (Time-Life/12 133)
[Doorkeeper bars the door]
(Time-Life/12 134)
[Embrace under a dart board]
(Time-Life/12 136)
[Shy, sensitive Rickard] (Time-
Life/12 137)

PETERSON, Willis
Harris' Hawk on yucca, Baja
California* (Rugoff 80#)

PETIT, Pierre
Alphonse Poitevin, c. 1861
(Gernsheim 256#; Gern-
sheim/2 216#)

PETRILLO, Thomas
Untitled, 1971 (Time-Life/11
150)

PHOTOGRAPHER Unknown
After a day's hunt in the
Yangtze River Valley, China
(Loke 132c)
Aftermath of Triangle Fire,

1911 (Hine 123)
The All-British Globe of Death,
1930's* (Bernard 197#)
Ambrotype of a lady, c. 1858
(Gernsheim 111#; Gernsheim/2
99#)
Ambrotype of an old gentleman,
c. 1857 (Gernsheim 112#;
Gernsheim/2 98#)
An American soldier guarding a
prisoner, Spanish-American
War, Cuba (Loke 41)
An American soldier with a
French woman and child,
Brest, France (Loke 206b)
[Armistice Day in London] 1918
(Time-Life/10 57)
[Army Secretary Stevens and
Private G. David Schine],
1954 (Time-Life/10 114-15)
Arrest of a hobo, New York,
1897 (Gernsheim 313#; Gern-
sheim/2 259#)
The arrest of Mrs. Pankhurst,
1914 (Time-Life/10 44)
Asylum patient suffering from
melancholia, 1876* (Bernard
104#)
At Peter Britt's studio, c. 1860
(Time-Life/7 133)
Automatic camera recording of the
atomic test at Bikini, 1946
(Time-Life/10 21)
Baby on a rug, c. 1900 (Time-
Life/9 52)
Ballroom scene, c. 1855 (Gern-
sheim 145#; Gernsheim/2
124#)
Barnardo boy, 1876* (Bernard
106#)
The battleship Hatsuse on the
Tyne at Newcastle, 1900*
(Bernard 141#)
Benito Mussolini, 1938 (Time-Life/
10 28)
Bereaved Queens, 1952 (Time-
Life/10 33)
Blacks picking cotton in Texas
(Loke 141)
Blacksmiths, 1850's* (Bernard
24#)
Bodies of unidentified Commu-
nards, 1871 (Gernsheim/2
152#)
The burial of Leo Tolstoy, 1910*
(Bernard 165#)
Burial place of son of Henry

German brother and sister
(Time-Life/9 41)
The German prisoners' club
room, Brest, France (Loke
200)
German soldiers among the ruins
of Messines, near Ypres,
Belgium (Loke 202d)
[Gibraltar] c. 1865 (Time-Life/
12 77b)
Gold miners, California, c.
1850* (Bernard 57#)
[Gold mining scene] c. 1850's
(Sandweiss 9#)
Guglielmo Marconi, the inventor
of wireless telegraphy (Loke
34b)
An H.C. White stereographer
perched with his camera on
a steel column of a new
skyscraper, New York City
(Loke 13)
Harry Wiekler, 1901 (Sandweiss
42#)
Henry Wadsworth Longfellow in
his study in Cambridge,
Massachusetts, c. 1876
(Loke 62c)
Hindu Priest from southern In-
dia with attendants, 1870's*
(Bernard 101#)
Immigrants arriving at Ellis Is-
land (Hine 124)
Irish rebellion leaders in Clon-
mell Jail, 1848 (Gernsheim
160#)
Jacob Byerly (Time-Life/7 138a)
A Jamaican couple (Loke 108d)
[James Knox Polk] c. 1849
(Sandweiss 7#)
Jane Addams (Hine 122)
Jefferson Davis, U.S. soldier,
statesman and only President
of the Confederate States of
America, with his wife,
Varina, daughter Maggie
Hayes and her three children,
c. 1885 (Loke 51)
[Jesse James on horseback] c.
1870 (Sandweiss 48#)
Karl Liebknecht speaking at the
mass grave of fallen Sparta-
cists, Berlin, 1919* (Bernard
176)
King Albert of Belgium with
Mrs. Woodrow Wilson tour-
ing a Belgian battlefield,

1919 (Loke 209)
Lady in lawn chair, 1908* (Time-
Life/8 75)
Lake Louise and the glacier of
Mount Victoria, Alberta, Can-
ada (Loke 158)
Launching a balloon (Tournachon
292a)
Laying the Atlantic Cable(?)
1858* (Bernard 67#)
Leopold Mannes and Leopold
Godowsky, Jr., 1922 (Time-
Life/8 64)
Lewis Hine playing tennis, c.
1927 (Hine 8)
Li Hung-chang, Chinese states-
man and diplomat, 1900 (Loke
39)
London Zoo's last quagga, c.
1870 (Guggisberg 14)
Long-haired goats on a Swiss
highway (Loke 56)
Lord Robert's army, 84th Battery
and Balloon Corps, Boer War,
1901 (Gernsheim 320#)
Louis Ducos de Hauron (Time-
Life/8 58a)
Mahe, a Brave, c. 1850* (Time-
Life/15 39)
Main library of the University of
Prague, Czechoslovakia (Loke
176)
"The Mammoth" c. 1900 (Time-
Life/7 144)
Man with hat and coat, c. 1850-
55* (Bernard 28#)
Mannequin from designer pavilion
at Decorative Arts Exposition,
1925 (Hall-Duncan 49)
Maori mothers with their babies,
New Zealand (Loke 104)
Mark Kauffman (Time-Life/16 92)
Mary McGee, Jersey City, 1926
(Time-Life/9 53)
Mathew Brady, c. 1863 (Gern-
sheim 238#; Gernsheim/2 204#)
Men working at a quartz-sorting
table, Robinson Mine, Jo-
hannesburg, South Africa
(Loke 140a)
Mexican boy captured by Co-
manches, c. 1871 (Sandweiss
51#)
Mexican family, c. 1847 (Sand-
weiss 8#)
A Moroccan cavalryman with the
French troops at the front

(Loke 203d)

Mounted warriors with chain armor and metal breast-plates, Delhi, India (Loke 90)

Mrs. Albert Broom's permit to photograph Edward VII's funeral, 1910 (Gernsheim 322#)

Mrs. Wilson's Nurse, c. 1890's (Sandweiss 54#)

Mungo Ponton, c. 1879 (Gernsheim 255#; Gernsheim/2 215#)

The music lesson, c. 1857 (Gernsheim 146#; Gernsheim/2 125#)

Nazis on parade, 1937 (Time-Life/10 27)

New Leyland tipper at Wavertree, Liverpool, 1914* (Bernard 166#)

New York children (Time-Life/9 40)

Niagara Falls with group and tower, c. 1860* (Bernard 66#)

[A 19th century portrait parlor]. (Time-Life/12 48-49)

Nomination of election candidates, 1863-1865 (Gernsheim 173#; Gernsheim/2 129#)

Nude, c. 1850* (Bernard 42#)

Nude, 1850's* (Bernard 43#)

Nude model (Bernard 128#)

Page from a documentation album of Worth ballgowns, 1903-4 (Hall-Duncan 31)

Paris International Exhibition: at the Eiffel Tower, 1889 (Gernsheim 292#)

Paul Kellogg (Hine 125)

Peter von Voigtländer (Time-Life/7 140a)

Photographers covering Ohio River flood, 1937 (Time-Life/10 11)

The Photographic Society's exhibition, 1884 (Gernsheim 108#; Gernsheim/2 101#)

Pink peau de soie gown with embroidery by House of Worth (Hall-Duncan 30)

Placer mining near the Yukon River, Alaska (Loke 142c)

Police at the scene of a crime, c. 1910* (Bernard 161#)

Portrait, Late 1840's* (Bernard 8#)

Portrait of a gentleman, c. 1845 (Gernsheim 67#; Gernsheim/2 59#)

Portrait of a soldier, c. 1863* (Time-Life/8 55)

Portrait of a young man (Time-Life/15 47)

Portrait of an actress, c. 1912* (Time-Life/8 76a)

Portrait of an Indian, c. 1860 (Time-Life/14 80)

Portrait of an old woman, c. 1850-60* (Bernard 49#)

Portrait of Mrs. Klah Sewall and family, c. 1840 (Time-Life/7 138c)

Portrait-taking at Niagara Falls, c. 1875 (Gernsheim 211#)

Postcard, 1920's* (Bernard 183#)

Practical poses for the practical artist, 1912* (Bernard 164#)

Pres. Theodore Roosevelt's inaugural address outside the Capitol, Washington, 1905 (Gernsheim 321#; Gernsheim/2 276#)

Private Charles N. Lapham, Civil War amputee, 1863* (Bernard 79#)

Prof. E.J. Marey, c. 1890 (Gernsheim 295#; Gernsheim/2 245#)

Queen Marie of Rumania with her eldest daughter, Elizabeth, outside the Hotel Ritz, Paris (Loke 210c)

Rally, New York City (Hine 123)

The riding master, c. 1860 (Time-Life/14 79a)

Roger Fenton's photographic van, 1855 (Gernsheim 165#; Gernsheim/2 137#)

Samuel Renshaw, sickle grinder, 1854 or 1857* (Bernard 46#)

Sarah Bernhardt listening to her voice on phonograph, 1891 (Gernsheim 318#)

A schoolboy giving a contribution to an itinerant Buddhist priest who carries on his back a portable altar equipped with his religious paraphernalia, Japan (Loke 126a)

Shirley Temple, 1932 (Time-Life/9 59)

Siamese boy musician, c. 1875*
(Bernard 102#)
Silk-weaving plant, Kiryu,
Japan (Loke 122)
Soldier, c. 1860 (Time-Life/14
79d)
[Stan Wayman, hip-deep in
water] (Time-Life/16 16)
Statuary in a museum, 1880's*
(Bernard 113#)
Street scene, Rochester, N.Y.,
c. 1888 (Photography 153)
Studio of the Photographer
Bourgeois, Paris, c. 1870
(Time-Life/14 49)
"Study for artists," c. 1900*
(Bernard 142#)
Talbot's photographic studio, c.
1845 (Gernsheim 82#; Gern-
sheim/2 78#; Time-Life/7
142)
Tennis match at Smith College,
Northampton, Mass., 1901*
(Bernard 143#)
Tokyo fine-arts class (Loke
116a)
[A Tommy in a gas mask] 1915
(Time-Life/10 56)
Two burglars, 1860* (Bernard
74#)
Two Guns White Calf, the
Blackfoot chief, one of the
three models for the profile
composite on the buffalo
nickel (Loke 59d)
[Two jolly gentlemen, one with
Kodak in hand] (Time-Life/7
155)
Two reclining nudes with mir-
ror, c. 1850* (Bernard 15#)
Two standing nudes, c. 1850*
(Bernard 58#)
Underwood photographer James
Ricalton shown with two
giants of Kashmir at the
Great Durbar of 1903, Delhi,
India (Loke 14)
An Underwood stereographer
preparing to take a view of
the crater of Asosan, cen-
tral Kyushu, Japan, 1904
(Loke 15)
[Unloading wood from box car]
(Loke 138)
View of Rome from the Monte
Pincio, c. 1862 (Time-Life/
14 112)

View of Statue of Liberty from
ship bearing immigrants (Hine
124)
A Visayan family, Cebu, Philip-
pines (Loke 98)
A warrior of New Guinea (Loke
186c)
Watermelon party (Photography
153a)
The Wehrmacht at the Feldherrn-
halle, Munich, 1935* (Bernard
199#)
William Henry Jackson, with his
20 x 24-inch view camera,
photographing Zuñi Pueblo
near Laguna, New Mexico,
c. 1877 (Time-Life/14 83)
[Woman and child], c. 1850's
(Sandweiss 10#)
A woman and her children iron-
ing clothes, Island of Luzon,
Philippines (Loke 124a)
A woman of Guadeloupe, West
Indies (Loke 183)
Woman playing cards, c. 1860
(Time-Life/7 188d)
A woman spinning silk from
cocoons, Japan (Loke 123)
Women fencers, Japan (Loke
116c)
Women sorting coffee beans,
Nicaragua, 1902 (Loke 130b)
Work in progress at Gatun Locks.
The pit dug was about a mile
and a quarter long, 600 feet
wide and about 50 feet deep
(Loke 97)
Wrecked German troop train near
Mezières, Franco-Prussian
War, 1870 (Gernsheim 174#;
Gernsheim/2 150#)
Zeughausplatz, Berlin, with
Crown Prince's palace on
right, c. 1855 (Gernsheim/2
84#)

PIKE, Oliver G.
Black-necked grebe on nest
(Guggisberg 27)
Cuckoo backing out of meadow
pipit's nest after laying--and
leaving with egg stolen from
fosterers' nest (Guggisberg
29)
A young cuckoo brought up by
robins is seen being fed by
a sedge warbler perched on

its back (Guggisberg 28)

PITT, Frances
Puffin bringing home a good
catch on Skomer (Guggisberg
66)

POHLMAN STUDIOS
Snowmobile, 1970* (Time-Life/
13 69)

POLAK, Richard
Photograph in the style of
Pieter de Hoogh, 1914
(Gernsheim/2 293#)

POLIAK, Leslie
Untitled, 1973 (Time-Life/12
30, 31)

POLLOCK, A.I.
Grandmother's present (Pho-
tography 103)

POLLOCK, Henry
The dark blue sea. Breakers
on the coast (Photography
101)
A viaduct on the South Eastern
Railway (Photography 96)

PONTI, Carlo
Courtyard of the Doge's Palace,
Venice, 1862 (Gernsheim
200#; Gernsheim/2 163#)
Greek bronze horses, Basilica
di San Marco, Venice, c.
1860 (Gernsheim/2 161#)
Piazza San Marco, Belltower,
Venice, c. 1860 (Gruber
31#)
Piazza San Marco, Venice, c.
1862 (Gernsheim 199#;
Gernsheim/2 164#)

PONTING, H.G.
Antarctic skua feeding its chick
(Guggisberg 81)
The photographer among Adélie
penguins (Guggisberg 80)
Photographer photographing
sacred 'muggers' (marsh
crocodiles) in India (Guggis-
berg 78)
Weddell seal and pup (Guggis-
berg 79)

PONTING, Herbert
The Terra Nova in the Antarctic,
1912 (Gernsheim/2 268#)

PORETT, Tom
Untitled, 1969 (Time-Life/11 152)

PORTER, Eliot, 1901-
Bush and yellow grass, Adiron-
dacks, 1965* (Gruber 145#)
Fractured basalt and lichens*
(Rugoff 117#)
Parula warbler* (Rugoff 121#)
Rose petals and shells on beach*
(Rugoff 119#)
Sea urchins and starfish*
(Rugoff 118#)
Winter wren* (Rugoff 120#)
Woodland stream, Pittsburgh,
New Hampshire, 1965* (Gruber
144#)

PORTER, William Southgate and
FONTAYNE, Charles
Cincinnati waterfront, 1848
(Time-Life/14 69d)

PRATHER, Gary L.
Stable on Route 128, 1966 (Time-
Life/11 185)

PRATT, Charles
Comfortable snack, 1957 (Time-
Life/9 121)
The pleasures of privacy, 1964
(Time-Life/9 30)
Schoolboys on tour, 1966 (Time-
Life/9 184)

PRICE, William Lake
Dead game, c. 1855 (Gernsheim
131#; Gernsheim/2 111#)
Don Quixote in his study, 1855
(Gernsheim 119#; Gernsheim/2
102#)

PRIMOLI, Giuseppe
Attendants at the wedding of Vit-
torio Emanuele III, 1896
(Time-Life/14 95)
Balancing act, c. 1895* (Bernard
137#)
Girl fixing her hair, c. 1895
(Time-Life/14 97c)
A reception at the Quirinal Palace,
1893 (Time-Life/14 94)
Rome Commissioner of Public Safety

and Carabinieri, c. 1884
(Time-Life/14 97a)

PROUT, Victor Albert
New Lock, Hurley, c. 1862*
(Bernard 71#)

PRÜMM
A lady, c. 1878 (Gernsheim
349#)

PUTNEY, Harrison
The Great Layton, circus per-
former, 1885 (Sandweiss
38#)
H. Lissik, circus performer,
twirling baton, 1886 (Sand-
weiss 39#)

PUTZ, M.
'Die Burgmusik,' c. 1887 (Gern-
sheim 289#)

PUYO, C.
Montmartre, c. 1900 (Gern-
sheim 337#; Gernsheim/2
295#)

PUYO, Emile Joachim Constant
Woman, c. 1896 (Gruber 284#)
Woman with sunshade by the
waterside, c. 1896 (Gruber
46#)

R

RANDALL, Betty
Rain forest in the Hoh River
area of Olympic National
Park, Washington* (Rugoff
21#)
Trees covered with mosses,
lichens and ferns in rain
forest, Olympic National
Park* (Rugoff 22#)

RATCLIFFE, Bill
Hedgehog cactus in Arizona's
Painted Desert* (Rugoff
84#)

RAU, William Herman
East Rush, L.V.R.R., c. 1900
(Sandweiss 34#)
Geronimo, the Apache chief
(Loke 58)
Irish peasant women carrying

peat, Ireland, 1903 (Loke 137a)
The White Salon in the Winter
Palace, St. Petersburg, Rus-
sia (Loke 69c)

RAWLINGS, John
All year coat, 1944* (Hall-Duncan
133)
[Color photograph transmitted by
radio] 1946* (Hall-Duncan 135)
Coming ... Parma Blue, 1944*
(Hall-Duncan 134)
In the Daguerreotype manner,
1941* (Hall-Duncan 131)
[Woman in multi-colored jacket]
1944* (Hall-Duncan 132)

RAY, Bill
Little girl in the rain, 1959
(Time-Life/9 166)

RAY, Man see MAN RAY

RAY-JONES, Tony, 1941-1972
[Honeymooners] 1971 (Time-Life/
11 106)
Ramsgate, England, 1967 (Time-
Life/12 151)

RAYMOND, Lilo, 1922-
Children at play, 1968 (Time-
Life/9 182)
Children playing, 1968 (Time-
Life/16 177)
Leaf, 1965* (Time-Life/11 56c)

REAU, Adolphe
Gentleman's coat and top hat,
front and back views, c.
1860's (Hall-Duncan 17)

REECE, Jane
Lorado Taft: The Man and his
Work, 1917 (Sandweiss 66#)

REED, Terry
Untitled, 1972 (Time-Life/12 40)

REJLANDER, Oscar G., 1813-1875
The Evening Sun, c. 1860 (Time-
Life/7 167)
Hands and vase, c. 1860 (Gern-
sheim 123#; Gernsheim/2 103#)
Infant art, 1856 (Time-Life/7
168)
Lewis Carroll holding a lens,
1863 (Gernsheim/2 210#)

Out of work, c. 1860 (Gruber
38#)
Rejlander the artist introducing
Rejlander the volunteer, c.
1871 (Photography 106)
Self portrait, 1872 (Gernsheim
124#; Gernsheim/2 106#)
Street urchins, c. 1860 (Gern-
sheim 122#; Gernsheim/2
105#)
Two ways of life, 1857 (Gern-
sheim 120#, 121#; Gern-
sheim/2 104#; Gruber 36#;
Photography 104; Time-Life/
7 190)

RENAUD, Gary
New York City subway, 1965
(Time-Life/14 193)

RENGER-PATSZCH, Albert, 1897-
1966
The Copper Beech, 1925
(Gruber 266#)
Echeveria, 1922 (Time-Life/11
44)
Praying hands, c. 1927*
(Bernard 189#)
Still life with utensils (Gruber
77#)
Street (Gruber 254#)
Street in Essen, 1932 (Gruber
355#)

RENNER, Eric
Ticul, Yucatán, 1969 (Time-
Life/11 169)

RENTMEESTER, Co
[Army camp in Vietnam at dawn]
(Time-Life/12 112)
Java monsoon, 1970* (Time-Life/
16 33)

REUTLINGER STUDIO
Chinchilla coat by Bechoff-
David, 1906* (Hall-Duncan
22a)
Dinner dress by Panem* (Hall-
Duncan 23)
Outdoor scene taken in Paris,
c. 1895 (Hall-Duncan 26)
Reproduced in "La Mode Pra-
tique," 1901* (Hall-Duncan
22c)
Revue de la Famille, 1894?
(Hall-Duncan 21a)

Vionnet gown, c. 1930's (Hall-
Duncan 57)

RIBOUD, Marc, 1923-
Neger Barroros, 1963 (Gruber
399#)
Radjastan, India, 1956 (Gruber
115#)

RICALTON, James
An Admiral of the River Fleet
with his wife and daughter,
China, c. 1901 (Loke 103)
A Chinese woman with her maid-
servants, Hong Kong, c. 1901
(Loke 100)
A sumo wrestler and a child,
Japan (Loke 180b)
Vietnamese soldiers near a boat
landing in Saigon, Cochin,
China (Loke 92d)
A wealthy Japanese family out-
side their home, Japan (Loke
210b)

RICHARDSON, Bob
[Children] (Hall-Duncan 174)
A la Conquete de l'intimate
Grecque (Hall-Duncan 175)
Giggling, 1965 (Hall-Duncan 172)

RIFFAUT, A.
Abel Niepce de Saint-Victor, 1856
(Gernsheim 356#; Gernsheim/2
319#)

RIIS, Jacob A., 1849-1914
Baxter Street Alley in Mulberry
Bend, New York, 1888 (Hine
128; Photography 154)
Blind man, 1888* (Bernard 124#)
Lodger in police station (Hine
128)
Ludlow Street, New York, c.
1890 (Gruber 63#)
The Short Tail Gang, under pier
at foot of Jackson Street, later
Corlears Hook Park, 1888
(Photography 157c)
Street Arabs in sleeping quarters
at night, 1888 (Photography
157a)
Tailor's workshop employing
sweated labour, New York,
1888 (Gernsheim/2 258#)

RISS, Murray

Elly and Shanna, 1970 (Time-
Life/11 144)
Girl and brick wall, 1967
(Time-Life/11 141)

RIZZO, Alberto
Belts, 1970* (Time-Life/13 136)

ROBERT, Louis
Tree at La Verrerie, c. 1850*
(Bernard 19#)

ROBERTSON, James ?
The fortress of Malta, c. 1860
(Gernsheim/2 149#)
Interior of the Redan, 1855
(Gernsheim 167#; Gernsheim/
2 141#)

ROBINSON, Henry Peach, 1830-
1901
Fading away, 1858 (Gernsheim
126#; Gernsheim/2 108#;
Gruber 37#; Time-Life/7
188c)
The Lady of Shalott, 1861
(Gernsheim 127#; Gernsheim/
2 110#; Time-Life/7 179c)
[Study for a composition photo-
graph] c. 1862 (Gernsheim
129#)

ROBINSON, Ralph W.
Henry Peach Robinson, 1897
(Gernsheim 125#; Gernsheim/
2 107#)

ROBUCHON, Jules
Saint-Jouin-des-Marnes, Poitou,
Ruins of the cloisters, c.
1885* (Bernard 114#)

RONDON, Hector
Chaplain and soldier, 1962
(Time-Life/10 37)

ROOSEVELT, Kermit
A white rhino of the northern
sub-species in the West-Nile
Province of Uganda (Guggis-
berg 71)

ROSE, Ben
Box, ring and woman, New York
City, 1979* (Time-Life/14
232)

ROSE-PULHAM, Peter
Advertisement for Victor Stiebel,
1934 (Hall-Duncan 101)

ROSS, Don
Color-enhanced x-ray of a human
skull, 1968* (Time-Life/7 57)

ROSS, James
Rabbit-shooting in the studio, c.
1865 (Gernsheim 212#)

RÖSSLER, Jaroslav, 1902-
Cigarette, 1929 (Gruber 431#)
Glass, 1923 (Gruber 189#)

ROTHSCHILD, Norman
Flowers, 1964* (Time-Life/8 215)
Hose connection, 1965* (Time-
Life/8 214)
New York snowstorm, 1968*
(Time-Life/8 98)

ROTHSTEIN, Arthur, 1915-
Dust storm in Oklahoma, 1936
(Sandweiss 110#; Time-Life/10
125)
Farmer and sons walking in the
face of a dust storm (Sand-
weiss 110#; Time-Life/10 125)

ROUGIER, Michael
Fishing in Rajang River Delta,
1964* (Time-Life/16 30)

ROUSSEAU, Louis
Envoy from Cochin China in
Paris, 1863* (Bernard 78#)

ROUTH, Robert D.
The bouquet, 1967* (Time-Life/8
224)
The white shirt, 1968* (Time-Life/
8 225)

ROYAL ENGINEERS, Chatham Military
School
Study of plants, c. 1860 (Gern-
sheim/2 156#)

RUBARTELLI, Franco
Experimental girl, 1970* (Time-
Life/8 207)
Facial contours, 1969* (Time-Life/
8 210a)
Painted colors, 1968* (Time-Life/
8 210c)

Veruschka, 1965* (Time-Life/8
212)

RUBEL, Philipp
Arrest of Gavrillo Princip, as-
sassin of the Archduke
Franz Ferdinand, Sarajevo,
1914 (Gernsheim/2 274#)

RUBINCAM, Harry C.
Circus rider, 1905 (Gernsheim/
2 205#; Green 90; Time-Life/
12 31)
In the circus, 1905* (Gern-
sheim/2 205#; Green 90;
Time-Life/12 31)

RUBINSTEIN, Eva, 1933-
New York, 1972 (Gruber 209#)
Old man on steps, 1973 (Gruber
359#)

RUE, Leonard Lee
Alaskan brown bear (Time-Life/
10 199)

RUE III, Leonard Lee
Young cattle egret climbing
back to nest* (Rugoff 158#)

RUSSELL, Andrew Joseph, 1831-
1876
Union soldier at an arsenal near
Washington, D.C., 1865*
(Bernard 80#)

S

ST. JOHN, Lynn
Kitchen sink, 1967* (Time-Life/
13 230)

SALOMON, Erich, 1886-1944
Aristide Briand, 1929 (Gruber
74#)
The King of Indiscretion--
There He Is! (Gruber 380#)
Meeting of diplomats at Lugano,
1928 (Time-Life/7 164b)
The photojournalist caught in
the act, 1931 (Time-Life/10
53)
Self-portrait (Gruber 337#)

SALZMANN, Auguste
Cactus on column of Porte

Judicaire, Jerusalem, 1854*
(Bernard 30#)
North Wall, Jerusalem, 1854*
(Bernard 29#)

SANDBANK, Henry
Cosmetics containers, 1968*
(Time-Life/13 38)
Earthenware utensils with a spoon,
1967* (Time-Life/13 212)
Egg and milk, 1968* (Time-Life/
13 227)

SANDER, August, 1876-1964
Jockey, 1932 (Gruber 342#)
Laborer, 1927 (Time-Life/11 118)
Parliamentarian, 1928 (Gruber
88#)
The right eye of my daughter
Sigrid, 1926 (Photography
232b)
Siebengebirge, c. 1936 (Gruber
261#)
Tailors' workshop, Germany, c.
1924* (Bernard 178#)
Unemployed, 1932 (Gruber 344#)

SANDER, Gerd
Wenzel Square, Prague, 1969
(Time-Life/11 167b)

SANNES, Sanne
Nude back (Gruber 230#)

SARONY, Napoleon
Oscar Wilde, c. 1892 (Gruber
20#)

SAUDEK, Jan, 1935-
Female torso (Gruber 217#)
Man and baby (Gruber 215#)

SAUNDERS, A.
Bull elephant seals fighting, Liv-
ingston Island, South Shet-
lands (Guggisberg 83a)
Wandering albatross on nest on
Campbell Island, New Zealand
(Guggisberg 82)

SAVAGE, Naomi, 1927-
Child, 1965* (Time-Life/8 223)
I am a mushroom, 1968 (Time-
Life/12 220)

SAWYER, Lyddell
In the twilight, 1888 (Gernsheim

327#; Gernsheim/2 280#;
Time-Life/7 189)

SCAÏONI, Egidio
Untitled, c. 1930's (Hall-Duncan
56)

SCHACK, Wilhelm
Herring gulls at play (Guggis-
berg 110)

SCHAD, Christian, 1894-1982
Schadograph, 1918 (Gruber
66#; Time-Life/12 196)

SCHELLER, Donald
London, 1970 (Time-Life/16
168)

SCHERSCHEL, Joe
Climbing 707, 1958 (Time-Life/
16 73a)

SCHILLINGS, C.G.
Flashlight photograph of a big
male leopard (Guggisberg
48a)
Lioness rushing at a bullock
(Guggisberg 48b)
Male lion approaching a waterhole
(Guggisberg 49)
One of his telephoto-cameras
(Guggisberg 46)
The photographer in his safari
kit (Guggisberg 44)

SCHMID, William
On the way from school, c. 1887
(Photography 150)

SCHOLTEN, John A.
General George Armstrong Cus-
ter, 1872 (Photography 132)

SCHRIER, Jack
Staircase at the French Pavil-
ion, Expo '67, Montreal,
1967 (Time-Life/11 133)
Turning off, 1970 (Time-Life/9
137)

SCHUHMACHER, Eugen
A little anteater or tamandua
tearing apart a tree ter-
mites' nest (Guggisberg 116)
The photographer with his Eyemo
Camera (Guggisberg 117)

SCHUITEMA, Paul
Lampshades, 1929 (Gruber 192#)

SCHULTHESS, Emil, 1913-
The start of a white-out, 1958*
(Time-Life/16 42)
Sunset from the rolling icebreak-
er, 1958* (Gruber 176#)

SCHUTZER, Paul
Meeting father's friends, Hun-
gary, 1963 (Time-Life/9 20)
Serious conversation, Romania,
1963 (Time-Life/9 34)

SCHWARTZ, C.
The German sculptor Christian
Rauch, c. 1856 (Gernsheim
237#; Gernsheim/2 208#)

SCHWEIKARDT, Eric
Broad jumper, 1969* (Time-Life/
16 143)

SCHWEITZER, Martin
Eggs and cartons, 1968* (Time-
Life/11 56d)
Persimmons, 1959* (Time-Life/11
56b)

SCOLAMIERO, Peter
Notions on slate, 1968* (Time-
Life/13 39)

SCURANI, Williams
Luigi Ghirri (Time-Life/12 117a)

SEEBERGER FRERES, Paris
Photographs of society women
wearing their own designer
clothing at the races, 1909-10
(Hall-Duncan 28-29)

SEELEY, George H.
Blotches of sunlight and spots of
ink (Green 148)
The burning of Rome, 1906
(Green 150; Time-Life/11 220)
The firefly (Green 147)
The painter, 1907 (Photography
196)

SEMAK, Michael, 1934-
Italian village, 1962 (Time-Life/14
180)
Italy, 1961 (Time-Life/11 126)
[Toronto street parade]* (Time-

Life/10 104-5)

SENN, Paul
Hog traders, 1951 (Gruber 391#)
Volcanic landscape, Mexico,
1951 (Gruber 265#)

SENNETT, Tomas
For rent, 1973* (Time-Life/12
20)
Stop sign, 1972* (Time-Life/12
21)

SENZER, John
[Mannequin on toilet seat] 1971
(Time-Life/11 93)

SESCAU, P. ?
Henri Toulouse-Lautrec, c. 1896
(Gernsheim 351#)

SHACKELFORD, J.B.
The wild ass of the Gobi Desert,
also known as the dziggetai
(Guggisberg 93)

SHAHN, Ben, 1898-1969
Daughter of Mr. Thaxton,
farmer, near Mechanicsburg,
Ohio, Summer, 1938 (Sand-
weiss 123#)
Destitute, 1935 (Gruber 89#;
Time-Life/10 121a)
Keep Me Close, c. 1938 (Sand-
weiss 122#)
The Mulhall children, Ozark
Mountain family, 1935*
(Bernard 201#)
Urbana, 1938 (Gruber 410#)

SHAW, George Bernard
Portrait of Alvin Langdon Co-
burn (Green 93)

SHEELER, Charles, 1883-1965
Bleeder stacks, Ford Plant,
Detroit, 1927 (Sandweiss
112#)
Bucks County barn, 1918
(Sandweiss 109#)
Fuel tanks, Wisconsin (Gruber
180#)
The open door, c. 1932 (Sand-
weiss 119#)
Production foundry, Ford
Plant, Detroit, 1927
(Sandweiss 114#)

United Nations Building, c. 1950
(Gruber 125#)

SHERE, Sam
Explosion of the Hindenburg,
Lakehurst, NJ, 1937 (Time-
Life/7 28)

SHINOYAMA, Kishin, 1930-
Nude (Gruber 226#)

SHIRAS, George
Bull moose on the bank of Loon
River, a flashlight photograph
(Guggisberg 41)
Doe white-tailed deer with twin
fawns ('midnight' series of
flashlight photographs) 1896
(Guggisberg 39)
Lynx at Loon Lake, a flashlight
photograph, 1909 (Guggisberg
40)

SHORE, Stephen, 1947-
El Paso Street, El Paso, Texas,
1975* (Gruber 159#)
Fort Lauderdale Yankee Stadium,
Fort Lauderdale, Florida,
1978* (Gruber 160#)
Green County Court House, 1976*
(Gruber 169#)

SHULL, Henry A.
Autumn leaves, 1970* (Time-Life/
16 201)

SIEFF, Jeanloup, 1933-
Homage to Seurat, 1965 (Gruber
208#)
Jetty in the reeds (Gruber 250#)
Kirk Douglas, 1967 (Time-Life/14
147)
Portrait d'une Dame en Noir, 1964
(Hall-Duncan 182)

SIEGEL, Arthur, 1913-1978
France, 1953* (Gruber 156#)
Untitled, 1946 (Time-Life/12 214)

SIEWERT, Horst
Black stork at nest (Guggisberg
111)

SILANO, William
Handbag, 1967* (Time-Life/13
134)
Ski boot, 1967* (Time-Life/13 135)

SILBERSTEIN, Ludwig
 Mother and son, 1913 (Time-
 Life/9 44)

SILK, George, 1916-
 Detectives inspect the corpse
 of Albert Anastasia, 1957
 (Time-Life/10 42)
 Fawn and trout, Montana, 1961*
 (Time-Life/14 227)
 Hurdlers, 1959 (Time-Life/16
 141)
 Johansson-Patterson bout, 1961
 (Time-Life/16 137)
 Nagasaki, 1945 (Time-Life/10
 35)
 Nefertiti, 1962* (Time-Life/16
 153)
 [A snow-level view of a skier
 flashing down a slope]
 (Time-Life/7 202)
 Surfers, 1963* (Time-Life/16 151)

SILVY, Camille
 Miss Susie Forster, c. 1860
 (Gernsheim 207#; Gernsheim/
 2 187#)
 Proclamation of the Army for
 Italy, 1859 (Gernsheim 359#;
 Gernsheim/2 322#)
 River scene, c. 1860 (Time-
 Life/7 187)
 Street musicians in Porchester
 Terrace, London, c. 1860*
 (Bernard 69#)
 Unknown lady, c. 1862 (Gern-
 sheim 208#; Gernsheim/2
 186#)

SIMART, Charles, Attrib.
 Female nude, c. 1856* (Bernard
 37#)
 Male nude, c. 1856* (Bernard
 38#)

SIMONSSON, Ulf
 A private game for two, Swe-
 den, 1966 (Time-Life/9 29)

SINGLETARY, Caulion
 Anhinga seizing a fish* (Rugoff
 162#)

SINSABAUGH, Art, 1924-
 Chicago landscape, 1964 (Time-
 Life/12 127)

SIPPRELL, Clara
 Adobe Walls, Taos, New Mexico,
 c. 1920 (Sandweiss 75#)
 Portrait of Gertrude Käsebier,
 1914 (Sandweiss 153c)

SISKIND, Aaron, 1903-
 Acolman 5, Mexico, 1955 (Photog-
 raphy 304a)
 Chicago, 1952 (Photography 304b)
 Feet, 1957 (Time-Life/11 40)
 Gloucester I, 1944 (Gruber 185#)
 Martha's Vineyard, Seaweed, 1944
 (Gruber 109#)
 Rome hieroglyph 8, 1963 (Time-
 Life/11 148)
 Savoy dancers, Harlem, 1936*
 (Bernard 206#)
 Wedged rock, 1954 (Gruber 181#)

SKEEN, W.L.H. and Co.
 Tamil girl, c. 1880* (Bernard
 103#)

SKYLAR
 Guard at Polson Prison, Montana,
 with Gatling gun, c. 1892*
 (Bernard 133#)

SLAVIN, Neal, 1941-
 Coney Island, New York, 1964
 (Time-Life/14 31)
 [Moveable mannequin] 1971 (Time-
 Life/11 95)
 On the Staten Island Ferry, 1967
 (Time-Life/14 181)
 Road builders, 1968 (Time-Life/
 11 119)

SLINGSBY, Robert
 Domestic interior, 1889 (Gern-
 sheim 282#; Gernsheim/2 231#)

SMITH, A.G. Dew
 R.L. Stevenson, 1885 (Gernsheim
 347#)

SMITH, Gordon
 Beach and barnacled rock (Rugoff
 126#)
 Fresh-water pond with rushes
 (Rugoff 125#)
 Provincetown dune (Rugoff 122#)
 Salt marsh estuary of the Herring
 River (Rugoff 124#)
 Sea wrack on Harding Beach,
 Chatham (Rugoff 123#)

SMITH, John Shaw
 Notre Dame, Paris, negative,
 1850 (Gernsheim 91#; Gern-
 sheim/2 81#)
 Relief on temple at Thebes,
 1851 (Gernsheim 90#; Gern-
 sheim/2 83#)

SMITH, Keith A.
 Brian at Point Lobos, 1970*
 (Time-Life/11 174)
 Untitled, 1966* (Time-Life/12
 227)

SMITH, Michael
 Cedar Breaks National Monu-
 ment, Utah, 1975 (Sandweiss
 136#)

SMITH, Rev. Theophilus
 The great steam-hammer, Atlas
 Works, Sheffield, 1858
 (Gernsheim/2 133#)

SMITH, W. Eugene, 1918-1978
 Albert Schweitzer, 1949 (Gruber
 105#; Photography 288)
 A Christening, 1951 (Time-
 Life/10 79c)
 Country doctor, 1948 (Photogra-
 phy 294)
 Dividing the ground, 1951
 (Time-Life/10 76a)
 Family dinner, 1951 (Time-Life/
 10 78b)
 First Communion dress, 1951
 (Time-Life/10 72)
 Guardia Civil, 1951 (Time-Life/
 10 78a)
 Haggling over lots, 1951 (Time-
 Life/10 76b)
 His wife, daughter, grand-
 daughter and friends have
 their last earthly visit with
 a villager, 1951 (Time-Life/7
 219; Time-Life/10 81)
 "El Medico," 1951 (Time-Life/10
 75c)
 On the outskirts, 1951 (Time-
 Life/10 73)
 Plowboy for hire, 1951 (Time-
 Life/10 77d)
 Pride Street (Gruber 387#)
 Seeding time, 1951 (Time-Life/
 10 77a)
 "Señor Cura," 1951 (Time-Life/
 10 75b)

Small boy's work, 1951 (Time-
 Life/10 75a)
 Spanish village, 1951 (Photogra-
 phy 292; Time-Life/10 79d)
 Spanish wake, 1951 (Time-Life/7
 219; Time-Life/10 81)
 The thread maker, 1951 (Photog-
 raphy 292; Time-Life/10 79d)
 Village school, 1951 (Time-Life/
 10 78d)
 Welsh miners, 1960 (Time-Life/11
 221)
 Winnowing grain, 1951 (Time-Life/
 10 77b)
 Young woman's work, 1951 (Time-
 Life/10 74)

SMYTH, Charles Piazzi
 "Looks-on taken unconsciously,
 Novgorod," 1859* (Bernard
 62#)

SNYDER, Joel
 Inner Drive, Chicago, 1970 (Time-
 Life/16 83)
 Janis Joplin, c. 1970 (Time-Life/
 10 112-13)

SNYDER, Norman
 A diffident entrance, 1969 (Time-
 Life/9 135)
 [Old cobblestone street being
 torn up] 1971 (Time-Life/11
 99)

SOKOLSKY, Mel
 Double image, 1963* (Time-Life/
 13 131)
 Suspended model, 1962 (Time-
 Life/13 30)

SOMERS, Lord
 Julia Margaret Cameron, c. 1860
 (Gernsheim 223#; Gernsheim/2
 193#)

SOMMER, Frederick, 1905-
 Still life, 1940* (Bernard 212#)

SOMMER, Giorgio
 Ancient Roman horn, 1870's*
 (Bernard 117#)
 Pulling in a boat, Naples, c.
 1875* (Bernard 118#)
 Shoeshine and pickpocket, 1870's*
 (Bernard 116#)

SORCE, Wayne
Dr. Soter's drape in living
room, 1976* (Gruber 163#)
Dr. Soter's pink couch, 1976*
(Gruber 167#)

SORGI, I. Russell
Suicide, 1942 (Time-Life/10
41)

SOUGEZ, Emmanuel
Linens, 1935 (Gruber 79#)
Masks (Gruber 186#)
The white quill, 1939 (Gruber
207#)

SOUTHWORTH, Albert Sands,
1811-1894
Self-portrait, c. 1848 (Photog-
raphy 36)

SOUTHWORTH, Albert, 1811-1894
and HAWES, Josiah, 1808-
1901
Charles Sumner, c. 1855 (Pho-
tography 38)
John Quincy Adams, c. 1848
(Time-Life/14 63)
[Portrait of a young girl], c.
1853-1862 (Sandweiss 11#)
Unidentified lady, c. 1855
(Photography 39, 42)
Unidentified old woman, 1850's*
(Bernard 18#)
A vessel Boston dry dock, c.
1850 (Gernsheim/2 48#)
Young girl, 1850's* (Bernard
54#)

SPEAIGHT, Richard N.
Victoria Sackville-West in cos-
tume for the Shakespeare
Ball, 1911* (Bernard 168#)

SPURIS, Egons, 1931-
Inertia, 1968 (Time-Life/11
197)

STALLER, Eric
Window dressing, New York
City, 1979* (Time-Life/14
231)

STALLER, Jan
A tribute to Steichen, New
York City, 1978* (Time-Life/
14 46)

STECKEL, Max
[Chamois mother and her kid]
(Guggisberg 61)

STEFANI, Bruno
The Galeria, Milan, 1930 (Gruber
366#)
Milan, 1938 (Gruber 367#)

STEICHEN, Edward, 1879-1973
Art Deco gown photographed in
the apartment of Nina Price,
New York, 1925 (Hall-Duncan
45)
Athens, 1921 (Gruber 349#)
Auguste Rodin with his sculpture
of Victor Hugo as 'The Think-
er,' 1902 (Gernsheim/2 304#;
Green 78)
Bakou et Patre, 1911 (Hall-Duncan
47a)
Bartholomé (Green 75)
The big white cloud, Lake
George, 1903 (Time-Life/7 36)
Black, 1935 (Hall-Duncan 52)
The Black Vase, 1901 (Photog-
raphy 174)
The bride at her second marriage,
1926 (Hall-Duncan 54)
Byzance, 1911 (Hall-Duncan 46a)
Clarence H. White, 1903 (Green
81; Sandweiss 153a)
Country clothes and town clothes,
the Belmont Park races, 1926
(Hall-Duncan 55)
Cover design (Green 98)
Cyclamen--Mrs. Philip Lydig
(Green 237)
Dawn flowers (Green 71)
Dolor, c. 1922 (Gruber 228#)
An early fashion photograph of
a dress by designer Paul
Poiret, Paris, 1911 (Time-Life/
13 105)
The Flatiron-Evening (Green 77)
G. Bernard Shaw* (Green 167)
George Washington Bridge, New
York, 1931 (Gruber 368#)
Gloria Swanson, 1924 (Sandweiss
102#)
Heavy roses, Voulangis, France,
1914 (Gruber 56#)
In memoriam (Green 73)
Marion Morehouse, 1927 (Time-
Life/13 110)
Mary and her mother, 1905 (Time-
Life/9 46, 47)

Mirror, 1911 (Hall-Duncan 47c)

Moonlight impression from the Orangerie, Versailles Series, 1908 (Photography 197)

Nocturne, Orangerie Staircase, Versailles, c. 1910 (Gruber 55#; Time-Life/12 44)

Pacquin gown, 1933 (Hall-Duncan 51)

Pastoral moonlight (Green 83)

The photographer's best model: George Bernard Shaw, 1907 (Gruber 293#; Time-Life/12 41)

Platinum print of Alfred Stieglitz and his daughter, Kitty, 1905 (Time-Life/12 11)

Pompon, 1911 (Hall-Duncan 46c)

Portrait--Lady H., 1907* (Green 166; Time-Life/12 40)

Portrait of Frits Thaulow, c. 1901 (Photography 175)

Portraits--Evening (Green 74)

Primo Carnera, 1933 (Gruber 99#)

Princess Youssoupoff, 1924* (Bernard 182#)

Richard Strauss, 1906 (Time-Life/11 202)

Rodin with sculpture of Eve, 1907* (Bernard 156#)

Sadakichi Hartmann (Green 89)

Self portrait with brush and palette, 1901 (Green 70; Photography 172)

Self-portrait with photographic paraphernalia, 1929 (Time-Life/13 11)

Skyscrapers at night, 1925* (Bernard 181#)

Steeplechase Day, Paris: After the races, 1907* (Time-Life/12 45)

Steeplechase Day, Paris: Grand Stand (Green 238)

Study of an artist, c. 1900 (Gernsheim 339#)

Summer fashions and some Benda masks, 1926 (Hall-Duncan 48)

Wheelbarrow with flowerpots, 1920 (Time-Life/11 49)

White evening wrap, 1929 (Hall-Duncan 50)

White fashions, 1935 (Time-Life/13 111)

STEINER, Ralph, 1899–
Nehi sign on A. Esposito's Grocery, 1929 (Sandweiss 97#)

Typewriter, 1921-2 (Photography 233)

Wicker chair, 1929 (Sandweiss 107#)

STEINERT, Otto, 1915-1978
Magic boat, 1957 (Time-Life/12 212)

Paris pedestrian, 1951 (Time-Life/11 188)

Saar Landscape 2, 1953 (Gruber 246#)

Still life with fish, 1958 (Gruber 188#)

Walking on one foot, 1950 (Gruber 112#)

STEINHACKER, Charles
Bison in a storm* (Rugoff 56#)

Forest of lodgepole pines* (Rugoff 54#)

Grizzly bears in Hayden Valley* (Rugoff 53#)

Water from Grand Prismatic Spring overflow onto a terrace covered with colorful algae* (Rugoff 55#)

STELLA, Carlo
Franco Fontana (Time-Life/12 117d)

STELZNER, Carl Ferdinand
Burned-out ruin and the Nicolai Church, 1842 (Gruber 1#)

Burned-out ruin with the new Stock Exchange, 1842 (Gruber 2#)

Daguerreotype group, c. 1842 (Gernsheim/2 65#)

Hamburg, 1842 (Gernsheim/2 63#; Time-Life/14 85)

Outing of Hamburg art club, 1843 (Gernsheim/2 66#)

Ruins of Hamburg after the great fire, 1842 (Gernsheim/2 63#; Time-Life/14 85)

STERN, Bert, 1929–
Bread and wine, 1953 (Time-Life/13 226)

Butterfly eyes, 1964* (Hall-Duncan 163)

Marilyn Monroe, 1968* (Time-

SWANSON, Dick
Follow the leader, 1961 (Time-
Life/9 190)

SWINERS, Jean-Louis
Portrait of a boy, 1960 (Time-
Life/12 134)

SZASZ, Suzanne
Girl painting, 1971 (Time-Life/
9 82)
The swing, 1966 (Time-Life/9
151)

SZCZYGIELSKI, Anthony
12th Street, Brooklyn, 1970
(Time-Life/16 187)
Varsity Club, Palmyra, New
York, 1970 (Time-Life/16
186)

T

TABER, I.W., Publisher
A chinese bagnio, San Fran-
cisco, c. 1880's (Sandweiss
49#)
Yosemite Stage by the Fallen
Monarch, Mariposa Grove,
1894 (Sandweiss 21#)

TALBOT, William Henry Fox, 1800-
1877
Articles of china (Gruber 11#)
Avenue des Capucines, c. 1843
(Gruber 16#)
Botanical specimen, 1839 (Pho-
tography 29)
The breakfast table, 1840
(Photography 26)
The Bust of Patroclus, 1843
(Gruber 15#)
Calotype negative of leaves and
grasses, c. 1841 (Time-Life/
15 25)
Cameraless shadow picture of
field flowers, 1839 (Time-Life/
12 189)
Carpenters on the Lacock Es-
tate, 1842* (Bernard 1#)
The chess players, c. 1842
(Time-Life/14 74)
The cloisters at Lacock Abbey,
with the Rev. Calvert Jones,
1843 (Gernsheim 86#; Gern-
sheim/2 80#; Gruber 13#)

The courtyard at Lacock Abbey,
1841-2 (Gernsheim 88#)
Elm tree at Lacock (Gruber 14#)
A fruit piece, c. 1844 (Gruber
202#)
The fruit sellers, group portrait
taken in cloister courtyard of
Lacock Abbey, c. 1842 (Gru-
ber 394#)
Lacock Abbey, North Court, c.
1845* (Time-Life/15 31)
The ladder, 1844 (Gernsheim
87#; Gernsheim/2 79#; Gruber
393#)
Lady at the harp, c. 1843 (Pho-
tography 35)
Lady Caroline Mount Edgcumbe,
c. 1846 (Time-Life/14 73)
The library, c. 1845 (Photogra-
phy 32)
Loch Katrine, c. 1845 (Gruber
263#)
Man with a telescope from the
Battlements of Mount Edge-
comb, Plymouth (Gruber 12#)
Oats, 1839 (Photography 22)
Photogenic drawing of a leaf, c.
1836-39 (Gruber 9#, 10#)
The photographer's daughter,
Rosamund, 1843-44* (Bernard
3#)
Portal of St. Trophime, Arles,
1866 (Gernsheim 354#; Gern-
sheim/2 317#)
Portrait of Claudet (Gruber 8#)
Wind Street in Swansea, Wales,
1845 (Time-Life/14 75)

TALBOT STUDIO, Paris
Untitled, c. 1900's (Hall-Duncan
24, 25)

TANAKA, Kojo
Bighorn sheep in Jasper National
Park* (Rugoff 49#)
Brown bear with salmon in the
McNeil River* (Rugoff 15#)
Brown bears in the McNeil River*
(Rugoff 16#)
Clark's nutcracker in Rocky
Mountain National Park* (Rug-
off 50#)
Golden-mantled squirrel in Jasper
National Park* (Rugoff 51#)
Musk oxen* (Rugoff 3#)
Osprey in the Everglades* (Rug-
off 163#)

Red-necked grebe in Banff National Park* (Rugoff 52#)

TAS, Filip, 1918–
Long avenue without Leentjie (Little Helen), 1979 (Gruber 255#)
Think-alone house, 1979 (Gruber 347#)

TAYLOR, Paul S., 1895–
Dorothea Lange, 1935 (Sandweiss 154a)

TELBERG, Val
Men listening, 1962 (Time-Life/12 218)

TELFER, William
Coloured daguerreotype of a lady, c. 1848 (Gernsheim 68#; Gernsheim/2 58#)

TESKE, Edmund, 1911–
Greetings from San Francisco, 1971 (Time-Life/11 159)
Untitled, 1939 (Time-Life/12 206)

TEYNARD, Félix
Colossus, decoration on northeast side of throne, c. 1851–52* (Bernard 25#)
Karnak, c. 1850 (Gruber 369#)
Thebes, Medînet-Habou, 2nd courtyard, Southeast Gallery, c. 1851 (Gruber 28#)

THALL, Garry
Faceless boy, 1970 (Time-Life/16 169a)

THERSIQUEL, Michel
Buvette, Keritz, France, 1975* (Time-Life/14 32)

THIEME, Lars Werner
Ash Wednesday, Munich, Germany, 1967 (Time-Life/14 45)

THOMSON, John
Bargemen on the Thames, c. 1877 (Time-Life/14 99f)
The Bridge at Foo Chow, 1873* (Bernard 99#)
"Caney the Clown" recaning a

chair, c. 1877 (Time-Life/14 99g)
Chimney sweep, c. 1877 (Time-Life/14 99i)
Flower seller at Covent Garden, c. 1877 (Time-Life/14 99b)
'Ha'penny ices,' 1876–7 (Gernsheim 308#)
London nomads, c. 1877 (Time-Life/14 99e)
Old woman with baby, 1876–7 (Gernsheim 309#; Gernsheim/2 255#)
One of the "Crawlers," minding a child, c. 1877 (Time-Life/14 99c)
Outside the pub, c. 1876 (Gernsheim/2 257#; Time-Life/14 99a)
A patent-medicine man, c. 1877 (Time-Life/14 99h)
Shoeshine boy, c. 1877 (Time-Life/14 99d)
Three men in a pub, c. 1877 (Gernsheim/2 257#; Time-Life/14 99a)

THE 3 (Nyholm, Phillips, and Lincoln)
Two on a terrace, 1932 (Hall-Duncan 59)

TICE, George, 1938–
Aspen grove in Colorado, 1969 (Time-Life/11 205)
Cemetery gates, 1965 (Gruber 248#)
Country road, Lancaster, Pennsylvania, 1961 (Time-Life/12 153)
Picnic on Garret Mountain, 1968* (Time-Life/15 85a)
Roaring Fork River, 1969* (Time-Life/15 85d)
Rooftops, Paterson, New Jersey, 1969* (Time-Life/15 83)
Tombstone, Catherine Holland, Bodie, California, 1965* (Time-Life/15 84)
Tree no. 4, New Jersey, 1964 (Time-Life/11 34)
Tree no. 19, California, 1965 (Time-Life/11 35)

TOURNACHON, Adrien
Charles Debureau, c. 1854 (Tournachon 46)

Charles Debureau, celebrated
mime, c. 1858 (Tournachon
38)
Emile Blavier, c. 1853 (Tour-
nachon 44)
[Illustration for a book on cat-
tle-breeding] c. 1853 (Tour-
nachon 41c)
A music-hall turn, c. 1853
(Tournachon 41a)
Nadar, c. 1854 (Tournachon 39)
Richard Wagner, c. 1853 (Tour-
nachon 43)

TOURNASSOU, Jean
French soldiers in the field, c.
1915* (Time-Life/8 74)

TRAGER, George
The Medicine Man--taken at the
Battle of Wounded Knee,
South Dakota, 1891 (Sand-
weiss 50#)

TRAGER, Philip, 1935-
Mission church, 1970 (Time-Life/
11 199)

TRAUB, Charles, 1945-
Showing off the big leaf, 1971
(Time-Life/9 134)
Sliding board, 1970 (Time-Life/
9 150)

TREMEAR, Charles
William Henry Jackson, c. 1939
(Sandweiss 154c)

TRESS, Arthur, 1940-
Boy at sea gate, 1968 (Time-
Life/9 207)
Boy in a fire-bombed store,
1969 (Time-Life/9 205)
Boy with duck and colander,
1970 (Time-Life/9 87)
Boy with ice hockey gloves,
1970 (Time-Life/9 204)
Boy with root hands, 1970
(Time-Life/9 206)
Dead to the world, 1971 (Time-
Life/9 122)
Hall of mirrors, 1971 (Time-
Life/9 83)
Masked boy, 1968 (Time-Life/
9 88)
Mountain girl and flowers, 1970
(Time-Life/9 171)

TRIOLO, Tony
Off the springboard, 1963 (Time-
Life/16 73c)

TRIPE, Linnaeus
Temple Fort, Southern India,
before 1858* (Bernard 60#)

TROST, Tassilo
Couple, 1972* (Time-Life/12 19)

TRUTMANN, B.
Still life with fish, 1965 (Time-
Life/13 225)

TSCHICHOLD, Jan
Film poster (Photography 248)

TUGGENER, Jakob, 1904-
Lathe in the Oerlikon Engineering
Works, 1935 (Gruber 179#)
Ticinesi Ball, Grand Hotel Dolder,
Zürich, 1948 (Gruber 412#)

TURBEVILLE, Deborah, 1937-
Advertisement for Calvin Klein
(Hall-Duncan 221)
Jean Muir and models, c. 1973
(Hall-Duncan 214)
Shoe advertisement for Andrew
Geller, 1975 (Hall-Duncan 216)
Still from a promotional fashion
film for a line of Andrew
Geller shoes, 1976 (Hall-
Duncan 220)
[Untitled] 1977 (Hall-Duncan 222)
Window design for Charles Jour-
dan shoes (Hall-Duncan 215)
[You can live in a bikini all day]
1975 (Hall-Duncan 218)

TURNER, Benjamin Brecknell
Sunken road, c. 1856* (Bernard
48#)
The willow walk, Bredicot, c.
1856* (Bernard 47#)

TURNER, E.L.
Young bittern, 1911 (Guggisberg
65)

TURNER, Pete
Cannon ball, 1970* (Time-Life/8
217)
Cruets with a lemon, 1968* (Time-
Life/13 228)
Hot lips, 1966* (Time-Life/11 56a)

Magenta horse, 1969* (Time-Life/8 216)
New Guinea faces, 1967* (Time-Life/8 27)
Silverware, 1968* (Time-Life/8 43)

TYRRELL, J.B.
Concentration of barren-ground caribou at Carey Lake, Canada, 1893 (Guggisberg 77)

U

UEDA, Shoji, 1913–
Procession (Gruber 422#)

UELSMANN, Jerry N., 1934–
Birth image, 1968* (Time-Life/8 222)
Equivalent, 1964 (Gruber 223#)
Ritual ground, 1964 (Gruber 126#)
Small woods where I met myself, 1967 (Time-Life/7 45)
Untitled, 1968 (Time-Life/11 153)
Untitled, 1968 (Time-Life/12 215)
Untitled, 1969 (Time-Life/11 181)
Untitled, 1971 (Gruber 271#)

ULMANN, Doris, 1882-1934
Old woman with a pipe, 1920's* (Bernard 188#)

UMBO, 1902-1980
Artists' rehearsal room, 1930* (Bernard 194#)

UNDERWOOD, Bert
A band of insurgents, Greco-Turkish war, 1897 (Loke 46a)
Bedouin robbers, wilderness of Judea, Palestine, 1896 (Loke 46d)
Russian soldiers viewing the bodies of Japanese war dead in a trench, Port Arthur (Loke 84)

UNDERWOOD, Elmer
The Acropolis and Likavittós from Philopappus Hill,
Athens, Greece (Loke 64)

UNDERWOOD AND UNDERWOOD
Aboriginal huntsmen with their boomerangs, Healesville, Victoria, Australia (Loke 186b)
Africans beside a crocodile that was shot by a white hunter, Uganda, 1909 (Loke 133d)
Aftermath of the Johnstown (Pennsylvania) flood of 1889 which took 2,300 lives (Loke 16c)
Alfonso XIII, King of Spain, in the royal palace, Madrid, Spain (Loke 82a)
An Algerian home (Loke 109b)
Ali bin Hamed bin Mohammed, Sultan of Zanzibar and Pemba (Loke 181d)
An American couple (Loke 102)
American soldiers going home in a transport vessel (Loke 207)
American soldiers training with gas masks, Fort Dix, New Jersey (Loke 205)
An amusement park in Coburg, Germany (Loke 66c)
Andrew Carnegie with his pet dog (Loke 29d)
Artisans restoring an old Persian rug, Constantinople, Turkey, 1912 (Loke 134)
At a mission school for girls, Lydda, Palestine (Loke 150d)
Bank vaults cracked during earthquake, their contents gutted by fire, 1906 (Loke 171a)
Belgian infantrymen, 1914 (Loke 199)
Bicycle riding in the city, c. 1890's (Loke 67b)
Birth of the Cuban Republic, May 20, 1902, Governor-General's palace, Havana (Loke 43a)
Boatmen inflating bullock-skin boats, Sutlej River, India, 1903 (Loke 133c)
Booker T. Washington, founder of Tuskegee Institute, and family, 1905 (Loke 147a)
Boys picking slate in a breaker in an anthracite coal mine in Pittsburgh, Pennsylvania (Loke 28b)

British infantry fording the
Vet River in its advance on
Pretoria, March 1900 (Loke
44c)
Cable cars demolished by the
disaster, stored east of Hyde
Street on California, 1906
(Loke 170b)
A chief, wearing a necklace of
leopards' teeth, with two
retainers and an interpreter
visiting Basoko, the Belgian
Congo (Loke 187)
A child afloat on a victoria
regia, Como Park, St. Paul,
Minnesota (Loke 119)
Coinage presses, the U.S. Mint
(Loke 218a)
Colonel Esteban Huertas, com-
manding officer of the Panama
garrison in November 1903
(Loke 96d)
Coronation dinner for London's
poor, 1902? (Loke 80)
Culebra Cut, Panama, looking
northwest toward the Atlantic
(Loke 96a)
The Daisy Chain carried by
sophomores ushering out
the year's graduating class,
Commencement Day, Vassar
College, Poughkeepsie, New
York, c. 1906 (Loke 146)
Edward VII and Queen Alexandra
in their coronation robes,
1902 (Loke 81c)
Elephant tusks ready for ship-
ment to New York, Membas,
Kenya, 1909 (Loke 132b)
Excavating for gold ore, Village
Deep Gold Mines, South
Africa (Loke 140b)
Exposition park, Louisiana
Purchase Exposition, St.
Louis, Missouri, 1904? (Loke
155)
Ezra Meeker with the wagon
and ox team he drove across
the continent to promote
the commemorative marking
of the Oregon Trail, through
which he had traveled in the
1850s; New York City, 1907
(Loke 165)
Fathers and sons, the Congo
(Loke 105)
A fisherman and his family,

Island of Markham, the Nether-
lands (Loke 108c)
Fishermen mending nets, Hast-
ings, England (Loke 143a)
French troops resting before an
attack, Verdun, France, 1916
(Loke 202a)
A German on a rubber plantation
counting the strokes at a beat-
ing of a native, East Africa
(Loke 95)
Government officials and staff,
Seoul, Korea (Loke 92c)
The great durbar hall in the
palace of the Maharaja of
Gwalior, India (Loke 174)
Gym class, Tuskegee Institute,
Alabama, 1905 (Loke 147b)
A hammock carriage, Funchal,
Madeira (Loke 162a)
Henrik Ibsen in his home in Oslo,
Norway (Loke 62d)
Hessian schoolgirls in their holi-
day costume, Mengsburg, near
Treysa, Germany, 1908 (Loke
148)
High school domestic-science
room, Rockford, Illinois (Loke
216)
High school workshop, Rockford,
Illinois (Loke 217)
Immigrants at Ellis Island under-
going examinations by Public
Health officers (Loke 61)
Indian troops encamped on the
grounds of Hampton Court
Palace for the coronation
(Loke 81d)
"Joan of Arc" among the suffra-
gists, coronation procession,
London, 1911 (Loke 164b)
King Ferdinand of Rumania taking
leave of his Prime Minister,
Ionel Bratianu before leaving
for the front, 1916 (Loke
201c)
A Korean couple, Seoul, 1904
(Loke 107d)
Lady Curzon, American heiress
and wife of the Viceroy of
India, on the terrace of a
bungalow in Kashmir, India
(Loke 52)
Luna Park by night (Loke 112c)
Luna Park, Coney Island, by day
(Loke 112a)
Mark Twain in the billiard room

of his house in Hartford,
Connecticut (Loke 63)
Medicines offered by a Bhutan-
ese woman, Darjeeling, In-
dia, 1903 (Loke 128d)
Medieval gateway to the town
of Lübeck, Germany (Loke
161)
Men with bundles of hay, Sim-
la, India, 1903 (Loke 137b)
Mr. and Mrs. James Ward and
family, Creggs, Ireland,
1905 (Loke 99)
A monastery, Portugal (Loke
177)
A monument destroyed by the
earthquake, 1906 (Loke
171b)
Natives of Uganda beside a
mammoth rock, 1909 (Loke
94)
Niagara Falls, New York (Loke
159)
Officials of Kandy, Ceylon
(Loke 184)
One-wheeled cart of a Korean
general, Seoul, Korea, 1904
(Loke 162d)
The only woman soldier in the
Russian army, killed here a
few hours after the stereo-
graph was taken (Loke 88a)
The Opera House, Paris, 1901
(Loke 164a)
A palanquin in Calcutta, India
(Loke 163c)
Pastoral Masai women with their
shaven heads and clothes of
dressed skins, Kenya (Loke
186a)
A peasant's home in Santiago
de Cuba (Loke 55)
Portuguese peasants standing
below Pena Castle in Sintra,
Portugal (Loke 142b)
President Roosevelt on the
stump (Loke 40c)
Pres. Theodore Roosevelt's in-
augural address outside the
Capitol, Washington, 1905
(Gernsheim 321#; Gernsheim/
2 276#)
Princes Street, Edinburgh,
Scotland (Loke 160)
Rough Riders saluting President
McKinley in a reception in Los
Angeles, 1901 (Loke 40b)

A Russian couple at a hospice,
Jerusalem, Palestine (Loke
190)
A Salish family of western Mon-
tana, 1907 (Loke 110)
A schoolmaster and his pupil,
Monaghan County, Ireland
(Loke 151)
Sculptor at work, Acropolis Mu-
seum, Athens, Greece (Loke
117c)
Shah Muzaffar ad-Din of Persia
and Persian Prime Minister
Amin as-Sultan, with Prince
Arthur of Connaught and Earl
Roberts at Edward VII's coro-
nation, 1902? (Loke 82b)
Shau chiefs from Burma at the
Great Durbar of 1903 held in
honor of Edward VII's corona-
tion, Delhi, India, 1903 (Loke
185a)
Sheik el-Sadaat, Egypt, 1910
(Loke 180d)
The slave quarters of the Hermi-
tage Plantation near Savannah,
Georgia (Loke 73)
A sombrero store, Mexico City,
Mexico, 1903 (Loke 124c)
Street scene, Bakuba village,
the Congo, Africa (Loke 166)
Thomas Alva Edison with his wife,
Mina, daughter Madeline, and
sons Theodore and Charles at
their home in Llewellyn Park,
New Jersey (Loke 35)
A twenty-woman team working on
a highway, Darjeeling, India,
1903 (Loke 143b)
Two girls on the bridge across
the River Ouse, near Ely,
England, 1911 (Loke 157)
Two Sinai women and their chil-
dren (Loke 111)
Wa-Kikuyu spearmen (Loke 179)
Wa-Kikuyu women and young girl,
highlanders of south-central
Kenya (Loke 178)
A wealthy Cuban family (Loke 54)
A woman and her daughters,
Bretton Woods, New Hampshire
(Loke 109a)
A woman carried in a palanquin,
Botanical Gardens, Darjeeling,
India (Loke 163a)
A woman of New York City, 1909
(Loke 182a)

A woman of Zanzibar holding a
suni (Loke 182c)
Women of Tehuantepec, Oaxaca,
Mexico (Loke 189)
Women of Zanzibar (Loke 212)
Women playing dominoes, Palm
Beach, Florida (Loke 115d)
Women's lounge at a paper fac-
tory, Bangor, Maine (Loke
219)
Worcestershire Regiment charg-
ing a hill during the Boer
War, 1899-1900 (Gernsheim/2
273#)
Working at the salt mines, San
Fernando, Spain (Loke 131)
Yun Wong-Niel, Korean Minister
of War in a game of Go with
a friend in his home in
Seoul, Korea, 1904 (Loke
115c)
Zebra hunting in Tanganyika
Territory, Africa (Loke 132a)

UNITED PRESS INTERNATIONAL
Senator Joseph McCarthy on
television, 1954 (Time-Life/
7 21b)

UZZLE, Burk, 1938-
Andy in Europe, 1966 (Time-
Life/9 146)

V

VACHON, John, 1914-1975
Ozark mountain family, 1940
(Time-Life/10 122)

VALENTINE, James P.
Aquatic plants in a fresh-water
swamp on Big Cumberland
Island, Georgia* (Rugoff
155#)
Desert on Big Cumberland Is-
land* (Rugoff 156#, 157#)
Swamp on Ossabaw Island,
Georgia* (Rugoff 154#)

van der ELSKEN, Ed, 1925-
St. Germain, c. 1952 (Gruber
122#)

van der WEYDE, William
Man in the electric chair, c.
1900* (Bernard 147#)

VAN DEVEER, David
Excursion boat, 1968 (Time-Life/
14 179)

VANDIVERT, William
London Blitz, 1940* (Time-Life/
15 67)

VAN DYKE, Willard
Ventilators, c. 1930 (Sandweiss
117#)
Whalebone and sky, c. 1932
(Photography 253c)

VERONESI, Luigi, 1908-
Photogram on motion picture film,
1936 (Gruber 424#)
Photography, 1938 (Gruber 433#)

VESTAL, David, 1924-
Untitled, 1969 (Time-Life/12 131)

VIDAL, Léon
Study of ringworm of the scalp,
c. 1878* (Bernard 110#)

VISHNIAC, Roman, 1897-
Jewish child, 1938 (Gruber 384#)

VOGT, Christian
Male nude, 1969 (Gruber 242#)

VON WANGENHEIM, Chris
Fetching is your Dior, 1976*
(Hall-Duncan 198)

VOZENILEK, Zdeněk
Winter in Prague, 1961 (Time-Life/
11 222)

VUILLARD, Edouard
A departure, c. 1901* (Bernard
139#)
Misia and Thadée Natanson at
home, c. 1900* (Bernard 138#)

W

WALCH, Robert
[Couple playing guitars] (Time-
Life/10 106-7)

WALDACK, Charles
The Mammoth Caves, Kentucky,
1866 (Gernsheim 281#; Gern-
sheim/2 230#)

WALDMAN, Max
Actor Robert Lloyd in the role
of the Violent Inmate in
MARAT/SADE, 1966 (Time-
Life/14 150)

WALLIHAN, A.G.
Cougar--also known as puma
or mountain lion--photo-
graphed after having been
treed by a pack of hounds
(Guggisberg 38)
Portrait of a young wapiti stag
(Guggisberg 37)

WANTLAND, Henry
Photo studio in Stillwater, Okla-
homa, c. 1895 (Time-Life/
13 173)

WARRINGTON, Ann
Kale, 1968 (Time-Life/11 39)

WASHBURN, Bradford
The Barnard Glacier flowing
through the Natazhat and
Bear Mountains (Rugoff 5#)
Climbers in the snow at 11,500
feet, the Doldenhorn,
Switzerland, 1960 (Time-Life/
16 11)

WATKINS, Carleton E., 1829-1916
Cling peaches, Kern County,
California, c. 1889* (Bernard
131#)
The Half-Dome from Glacier
Point, Yosemite, c. 1866
(Sandweiss 26#)
Inverted in the tide stand the
grey rocks, 1861 (Photogra-
phy 69)
Mount Shasta from Sheep
Rocks, 1870 (Sandweiss 22#)
Self-portrait, Geyser Springs,
The Witch's Cauldron, 1860's*
(Bernard 91#)
The summit of Lassen's Butte,
1870 (Sandweiss 30#)
Washington's Column, Yosemite
Valley, 1867 (Gernsheim/2
171#)
[Watkins' photographic wagon
along the C.P.R.R. tracks,
Utah] c. 1884 (Sandweiss
24#)
The wreck of the Viscata, 1868

(Sandweiss 1#)

WATSON, George
Exxon USA magazine, 1973*
(Time-Life/12 70)

WATZEK, Hans
A peasant, 1894 (Gernsheim 331#;
Gernsheim/2 298#)
Portrait, 1898* (Bernard 146#)
Wineglass and apple, 1896* (Gru-
ber 165#)

WEED, Charles Leander, Attrib.
U.S. Grant, 80ft. circ., Mariposa
Grove, 1872 (Sandweiss 53#)

WEEGEE, 1899-1968
A couple driven out, 1945 (Gru-
ber 404#)
The Critic, 1943 (Time-Life/10
49)
Man killed in an accident, 1945
(Gruber 104#)

WEINER, Dan, 1919-1959
Russian child in a train, 1957
(Time-Life/9 169)

WEISS, Frederic
Boy jumping, 1968 (Time-Life/7
90)

WEISS, Ralph
Dandelion (Rugoff 135#)
Forest landscape, Catskill Moun-
tains, New York (Rugoff 133#)
Frozen twigs (Rugoff 137#)
Indian poke or false hellebore
(Rugoff 136#)
Marsh in the Hudson Highlands
(Rugoff 134#)
Oyster mushrooms, 1969 (Time-
Life/11 11)
Two leaves, 1970 (Time-Life/11
52)

WEISS, Sabine
Sylvie and Canary, 1962 (Time-
Life/9 163)

WELLS, Alice
Robert Fichter, 1967 (Time-Life/
11 167a)
Untitled, 1970 (Time-Life/12 207)

WELPOTT, Jack, 1923-

Anna in her room, 1964 (Time-
Life/12 145)

WERGE, John
Richard Kennett, 1887 (Gern-
sheim 250#)

WEST, Larry
Luna moth on oak tree* (Rugoff
109#)
Paper birch* (Rugoff 111#)
Southern lady fern* (Rugoff
140#)
Twilight* (Rugoff 107#)
White birch at twilight* (Rugoff
113#)
White-tailed deer in woods*
(Rugoff 112#)

WESTON, Brett, 1911-
[Branch against flowering hill-
side], 1951 (Sandweiss
132#)
Garapata Beach, California, 1954
(Time-Life/12 121)
[Grasses in Water], 1960 (Sand-
weiss 131#)
Hand and ear, 1928 (Photogra-
phy 232a)

WESTON, Edward, 1886-1958
Ansel Adams, 1943 (Sandweiss
154d)
Armco Steel, Ohio, 1922 (Pho-
tography 226)
Attic, 1921 (Photography 222)
Church door, Hornitos, Cali-
fornia, 1940 (Time-Life/14
36)
Cypress, Point Lobos, 1929
(Photography 252)
The Goldfish [Yvonne Ver-
laine], 1917 (Sandweiss 67#)
Gulf Oil, Port Arthur, 1941
(Sandweiss 95#, 96#)
Neil, nude, 1924 (Time-Life/11
183)
Nude, 1927 (Gruber 231#)
Nude, 1933 (Sandweiss 116#)
Nude on sand, 1936 (Gruber
100#)
Pepper No. 30, 1930 (Time-
Life/7 39)
Powerlines and telephone poles,
1939 (Gruber 253#)
Reflected sunlight on torso,
1922 (Photography 224)

Ruth Shaw, 1922 (Gruber 323#)
The Sharpshooter--Manuel Her-
nandez Galvan, 1924 (Photog-
raphy 246)
Shell, 1927 (Gruber 81#)
Wind erosion, dunes--Oceano,
1936 (Sandweiss 134#)

WHIPPLE, John Adams
The Moon, 1851 (Photography
75)

WHITE, Clarence H., 1871-1925
Alvin Langdon Coburn and his
mother (Green 242)
Boys going to school (Green
152)
The chiffonier, 1904 (Photography
199)
The kiss, 1904 (Gruber 52#)
Lady in black, c. 1907 (Gern-
sheim 342#; Gernsheim/2
300#; Green 153)
Master Tom, c. 1905 (Green
149; Time-Life/9 49)
Morning (Green 154)
Nude (Gruber 210#)
The orchard, c. 1900 (Green
80; Gruber 49#; Hine 119;
Sandweiss 61#)
Ring toss, 1899* (Green 69;
Gruber 277#; Time-Life/12
29)

WHITE, H.C.
The Ainus of Japan, 1906 (Loke
107c)
At the edge of the crater of
Asosan, central Kyushu,
Japan, 1906 (Loke 156a)
Craftsmen making bronze lanterns
for a temple, Kyoto, Japan,
1907 (Loke 135c)
A crowd gathered around an
American phonograph in a
Tokyo park, 1906 (Loke 114)
The Eiffel Tower and exposition
grounds, Paris Exposition,
1900 (Loke 37)
Fountains in front of the Palace
of Electricity, Paris Exposition,
1900 (Loke 36)
Genoa, Italy (Loke 169)
[Great sand dunes along the
Columbia River, Oregon] (Loke
152)
Home of a wealthy merchant in

Moscow, Russia (Loke 70c)
Homeless beggars of Naples,
Italy (Loke 57c)
Homestead workers' homes over-
looking the steel plant (Loke
30)
Homestead workers waiting to
be paid (Loke 28c)
Jamaican schoolchildren and their
teacher, Jamaica, 1904 (Loke
150b)
Lepers begging outside the walls
of Jerusalem (Loke 191a)
The Louisiana Purchase Exposi-
tion, St. Louis, Missouri,
1904 (Loke 154)
A man on a bed of nails, India,
1907 (Loke 185d)
Naples, Italy (Loke 168)
New York Herald Building at
Broadway and Thirty-fourth
Street, New York City (Loke
71c)
Russian officers, prisoners of
war, at lunch in a garden in
Matsuyama, Japan (Loke 85c)
The shattered leg of a soldier
about to be amputated in the
operating room of the Military
Reserve Hospital in Hiro-
shima, Japan, c. 1904 (Loke
88c)
Song Ying Lo, a chop suey house
in Chicago, Illinois (Loke
69d)
Statue of Bismarck in front of
the Reichstagsgebände, Ber-
lin, Germany (Loke 70a)
A toy seller's stock, Tokyo,
Japan, 1906 (Loke 125c)
View of Homestead Steel works,
Pennsylvania (Loke 27)
Wilbur Wright flying over Gov-
ernors Island, New York at
45 miles per hour, 1909
(Loke 172)
A woman camping by the road-
side, 1906 (Loke 170c)
A zoo keeper and his laughing
monkey, 1907 (Loke 118)

WHITE, Henry
A cornfield, 1856 (Gernsheim
187#; Gernsheim/2 153#)
The river at Bettws-y-Coed,
North Wales, c. 1856*
(Bernard 50#)

WHITE, Minor, 1908-1976
Burned mirror, 1959 (Photogra-
phy 308a)
Cobblestone house, Avon, New
York, 1958 (Time-Life/14 159)
Dry stream bed, 1967 (Time-Life/
11 46)
Fog bank, c. 1947 (Sandweiss
133#)
Fog over city, 1951 (Time-Life/
11 204)
Ice in light and shadow, 1960
(Time-Life/11 38)
Knothole, 1967 (Time-Life/11 47)
Long form moving away, 1950
(Time-Life/11 48)
Moment of revelation, 1951 (Time-
Life/12 129)
Peeled paint, 1959 (Gruber 127#)
Rings and roses, 1973 (Time-Life/
12 44)
Torso (Green 151)
Windowsill and daydreaming,
Rochester, New York, 1958
(Photography 308b)

WIGHTMAN, Norman
Afghan "Shah" 1970 (Time-Life/
13 33)

WILKINSON, B. Gay
Sand dunes, 1890 (Gernsheim
326#; Gernsheim/2 282#)

WILSON, Charles A.
Oxford Street, 1885-7 (Gernsheim
293#; Gernsheim/2 238#)

WILSON, George Washington
Loch of Park, 1856 (Gernsheim
153#; Gernsheim/2 132#)
Operation by Sir Alexander Og-
stone, c. 1883 (Gernsheim
316#; Gernsheim/2 275#)
Princes Street, Edinburgh, 1859
(Gernsheim 154#; Gernsheim/2
126#)
Waiting for the boat, Greenwich,
1857 (Gernsheim 155#; Gern-
sheim/2 130#)

WILSON, Steven C.
Cape Johnson in Olympic National
Park on the Washington coast*
(Rugoff 31#)
Child's game, 1965* (Time-Life/7
93)

Coastal area of Olympic National
Park* (Rugoff 33#)
Desert toad and string of eggs
she has just laid in one of
the Dead End Canyons, Lake
Powell, Utah* (Rugoff 82#)
Female salmon holding in the
current over a redd, or
nest, in the river bottom*
(Rugoff 24#)
Salmon eggs with newly hatched
alevins still attached to the
yolk mass* (Rugoff 25#)
Salmon eggs with alevins*
(Rugoff 26#)
Sockeye salmon in Adams River,
British Columbia* (Rugoff
23#)

WINOGRAND, Garry, 1928-
Taxicab, London, 1969 (Time-
Life/11 138)

WINQUIST, Rolf, 1910-1968
Feather, 1950 (Gruber 204#)

WITTMER, Albert
[Beach scene] 1936* (Time-Life/
8 66)

WOLCOTT, Alexander ?
Henry Fitz (Time-Life/7 139d)

WOLCOTT, Marion Post, 1910-
Entrance to Miami Beach Hotel,
1939 (Time-Life/10 134)

WOLF, Bernard
Ambalangoda, Ceylon, 1969*
(Time-Life/9 197)
Bangkok, Thailand, 1969* (Time-
Life/9 196)
Kingston, Jamaica, 1968* (Time-
Life/9 193)
Pico Island, Azores, 1970*
(Time-Life/9 195)

WOLFF, Anthony
Helpless and beloved, 1965
(Time-Life/9 15)
A world inside the window,
1967 (Time-Life/9 16)

WONG, H.S.
Chinese baby, 1937 (Time-Life/
10 36)

WOOD, John
Miss Annie Oakley (Little Sure
Shot), c. 1880's (Sandweiss
55#)

WOOD, John
John Herdman, 1969 (Time-Life/
11 163)
Untitled, 1969 (Time-Life/12 221)

WOODBRIDGE, Louise Deshong
Yellowstone National Park, c.
1912 (Sandweiss 65#)

WORDEN, Willard
Flooded meadow, c. 1902 (Sand-
weiss 33#)

WORTH, Don, 1924-
Coastal redwoods in Santa Cruz
County, California (Rugoff
30#)
Eroded rock on the shore near
Pescadero, California (Rugoff
32#)
Redwoods on the northern Cali-
fornia coast (Rugoff 29#)

WORTH, Peter
Still life, 1967* (Time-Life/8 45)

WORTHINGTON, A.M.
A milk splash caused by a falling
ball, c. 1900 (Gernsheim 307#)

WOTTON, Michael
Arctic loon brooding in the Yukon-
Kuskokwim Delta* (Rugoff
13#)
Whimbrel in Mt. McKinley National
Park* (Rugoff 11#)

WYNFIELD, David Wilkie
Henry W. Philipps, c. 1862
(Gernsheim 224#; Gernsheim/2
194#)

Y

YANG, John
Blindman's bluff, Strasbourg,
1960 (Time-Life/9 22)
School's out, Antigua, 1968
(Time-Life/9 27)

YLLA

Chinchilla cat, 1952 (Time-
Life/13 32)

YOKOSUKA, Noriaki
Male nude (Gruber 239#)

YOUNG, R.Y.
An old woman who was shot
through the leg while car-
rying ammunition to the
insurgents, Manila hospital
(Loke 42)

Z

ZALON, Jules
The Montauk Point, Long Is-
land Lighthouse (Time-Life/
12 111)

ZAREMBER, Sam
Flower vendor, 1968* (Time-
Life/8 110)
Indications of motherhood,
1969* (Time-Life/8 111)

ZEHRT, Jack
Hawaiian surfer (Time-Life/10
196a)

ZEL, Oscar van
Skating, c. 1887 (Gernsheim
291#; Gernsheim/2 236#)

ZIMMERMAN, John
Greyhound races, 1962* (Time-
Life/16 145)

ZWART, Paul
Cabbage with hoarfrost, 1930
(Gruber 194#)

ACCORDIONS
Black man weeping while playing in "Weeping for F.D.R." 1945 Edward
Clark (Time-Life/10 32)
ACROBATS AND ACROBATICS
man balancing on large ball in "Balancing act" c. 1895* Count Giuseppe
Primoli (Bernard 137#)
ACROPOLIS
and Likavittós seen from Athens in "The Acropolis and Likavittós from
Philopappus Hill, Athens, Greece" Elmer Underwood (Loke 64)
looking out toward the Propylaea in "The Propylaea from inside the
Acropolis" 1850* Jean-Baptiste Louis Gros (Bernard 17#)
ACTORS AND ACTRESSES
man in white face paint in "Actor on the deck of the ferryboat Veneto"*
Branko Lenart Jr. (Time-Life/12 11)
ADVERTISEMENTS
face of the "Sunkist Baby" in "Sunkist Baby" 1933 Will Connell (Time-Life/
9 58)
for Camel cigarettes, on road in "[Cardboard camel]"* Luigi Ghirri (Time-
Life/12 140)
giant pair of legs with sunburst at entrance to tent in "[Giant pair of
legs with sunburst for body]"* Luigi Ghirri (Time-Life/12 139)
man and woman by snowmobile in "Snowmobile" 1970* Pohlman Studios
(Time-Life/13 69)
old man with beard carrying sandwich board in "The sandwich man" Paul
Strand (Green 320)
woman beside corset poster in "Spain" or "Cordoba, Spain" 1933 Henri
Cartier-Bresson (Cartier-Bresson 9; Time-Life/11 127)
AFGHANIS
a bearded man with fur trimmed cap in "Afghani Chopendoz horseman"
1973* Roland Michaud (Time-Life/14 156)
AFRICANS
boys on street lined with rush walls in "Street scene, Bakuba village,
the Congo, Africa" Underwood and Underwood (Loke 166)
chief with necklace of leopards' teeth posing with others in "A chief,
wearing a necklace of leopards' teeth, with two retainers and an in-
terpreter visiting Basoko, the Belgian Congo" Underwood and Under-
wood (Loke 187)
Masai women with shaven heads and clothes of dressed skins in "Pastoral
Masai women with their shaven heads and clothes of dressed skins,
Kenya" Underwood and Underwood (Loke 186a)
men and women by large rock in "Natives of Uganda beside a mammoth
rock" 1909 Underwood and Underwood (Loke 94)
native hunters with spears in "Wa-Kikuyu spearmen" Underwood and
Underwood (Loke 179)
native women and young girl in their finery in "Wa-Kikuyu women and
young girl, highlanders of south-central Kenya" Underwood and Un-

derwood (Loke 178)

portrait of five Aizo market girls in "Dahomey, five girls" 1967* Irving
Penn (Time-Life/13 10)

standing by captured crocodile in "Africans beside a crocodile that was
shot by a white hunter, Uganda" 1909 Underwood and Underwood
(Loke 133d)

watching as man on ground is whipped in "A German on a rubber planta-
tion counting the strokes at a beating of a native, East Africa" Un-
derwood and Underwood (Loke 95)

Zulu girl posing on draped table in "Zulu girl" 1885-1890* Lloyd of Natal
(Bernard 134#)

AGED see ELDERLY

AGRICULTURAL LABORERS. See also MIGRANT LABOR; PEASANTRY

Black men, women and children picking cotton in "Blacks picking cotton
in Texas" Photographer Unknown (Loke 141)

AIRPLANES

first flight at Kitty Hawk in "The first airplane flies" 1903 John D.
Daniels (Time-Life/10 22)

707 taking off in "Climbing 707" 1958 Joe Scherschel (Time-Life/16 73a)

single-engine plane taking off on runway curved upwards, followed by
man on bicycle in "[Light plane and bicycle]" Yale Joel (Time-Life/12
173)

AIRSHIPS

dirigible bursting into flames after hitting tower in "Explosion of the
Hindenburg, Lakehurst, New Jersey" 1937 Sam Shere (Time-Life/7 28)

ALBATROSS

bird on nest in "Wandering albatross on nest on Campbell Island, New
Zealand" A. Saunders (Guggisberg 82)

ALGAE

in tidal pool with periwinkles in "Tide pool (upper middle zone) contain-
ing chiefly algae and periwinkles, Point Lobos, California"* Dennis
Brokaw (Rugoff 34#)

red-colored water and hot spring in "Water from Grand Prismatic Spring
overflow onto a terrace covered with colorful algae"* Charles Stein-
hacker (Rugoff 55#)

ALGERIANS

men by their home in "An Algerian home" Underwood and Underwood
(Loke 109b)

on narrow street in "A street in the Arab quarter of Algiers, Algeria"
C.H. Graves (Loke 167)

the Tekmni District in "The Tekmni District, Algiers" 1884* Louis Ducos
du Hauron (Gruber 138#)

ALLEYS

children playing in alley with clothesline between houses in "Playground
in tenement alley, Boston" 1909 Lewis Hine (Hine 75)

laundry hanging on line in tenement alley in "Tenement house and yard,
Pittsburgh" 1907-08 Lewis HIne (Hine 56)

people in alley between buildings in "Slums in Glasgow" 1868 Thomas An-
nan (Gernsheim/2 256#)

with fire escape and wooden staircase in "Baxter Street Alley in Mulberry
Bend, New York" 1888 Jacob A. Riis (Hine 128; Photography 154)

ALPS

panoramic view of mountains, town and lake in "Interlaken" c. 1868
Adolphe Braun (Time-Life/14 111)

AMUSEMENTS PARKS

boy in center of hall of mirrors in "Hall of mirrors" 1971 Arthur Tress
(Time-Life/9 83)

crowd of people by amusements in "An amusement park in Coburg, Germany" Underwood and Underwood (Loke 66c)
ferris wheel and boardwalk in snowstorm in "Coney Island, New York" 1964 Neal Slavin (Time-Life/14 31)
people screaming on roller coaster in "Pacific Ocean Park, Santa Monica" 1960 C. Robert Lee (Time-Life/7 27)

ANEMONES
in tidal pool in "Tide pool (middle to lower zone) showing anemones, sea urchins, chitons, algae, encrusting sponge, and tiny red 'spiders'"* Dennis Brokaw (Rugoff 37#)

ANGELS
child with wings and clasped hands in "The rising of the new year" c. 1872 Julia Margaret Cameron (Time-Life/9 42)
girl with wings in "Cupid reposing" 1872 Julia Margaret Cameron (Time-Life/9 43)

ANGOULEME, FRANCE
panoramic view of the town in "The Angoulême countryside" or "View of Angoulême, France" 1877* Louis Ducos du Hauron (Gruber 139#; Time-Life/8 59)

ANHINGAS
bird swimming with fish in beak in "Anhinga seizing a fish"* Caulion Singletary (Rugoff 162#)
bird with wings spread, on tree limb in "Anhinga"* Roy O. Green (Rugoff 164#)

Animals see Anteaters; Asses; Banteug; Bison; Bongos; Buffaloes; Camels; Caribou; Cats; Cattle; Chamois; Chimpanzees; Cougars; Cows; Crocodiles; Curlews; Cuscus; Deer; Dogs; Donkeys; Ducks; Elephants; Foxes; Gazelle; Giraffes; Goats; Hippopotami; Horses; Hyraxes; Lambs; Leopards; Lions; Lizards; Mice; Monkeys; Moose; Mules; Musk oxen; Ocelots; Opossums; Oryx; Oxen; Quaggas; Rabbits; Rhinoceros; Seals; Sheep; Shorthorn Sculpin; Sloths; Squirrels; Suni; Tigers; Toads; Walruses; Wapiti; Water Buffaloes; Wildebeest; Zebras.

ANTEATERS
digging apart a termite nest in "A little anteater or tamandua tearing apart a tree termites' nest" Eugen Schuhmacher (Guggisberg 116)

ANTS
army ant on the back of a grasshopper in "Death of a grasshopper" 1967 Carlo Bavagnoli (Time-Life/16 86)
mandibles of soldier ant in "Soldier ant's mandibles" 1967 Carlo Bavagnoli (Time-Life/16 87)

APPLES
as still life in "Still life" 1850's* Henri Le Secq (Bernard 40#)
a red and a yellow one in "[Apples]"* Dick Meek (Time-Life/8 123)
view of an apple cut in half in "Half-an-apple" 1953 Wynn Bullock (Sandweiss 80#)

AQUEDUCTS
across a lake in "Pont du Gard" c. 1855 E. Baldus (Gernsheim 177#; Gernsheim/2 155#)

ARCH OF TITUS
bas-relief 'Spoils from the Temple in Jerusalem' in "Bas-relief on the interior of the Arch of Titus, Rome" c. 1865* Robert Macpherson (Bernard 88#)

ARCHES NATIONAL MONUMENT
a double arch of rock in "Double Arch in Arches National Monument, Utah" Ed Cooper (Rugoff 58#)

ARCHITECTURE, AZTEC
carved structure of the Aztecs in "Chichén-Itzá, Mexico" c. 1860* Désiré

Charney (Bernard 73#)
ARCHITECTURE, EGYPTIAN
 entryway with hieroglyphics in "Egypt" 1858 Francis Frith (Gruber 370#)
 rows of columns with hieroglyphics in "Hypostyle Hall at Edfu" after
 1862* Felice A. Beato (Bernard 72#)
ARCTIC REGIONS
 helicopters and tents in Antarctica in "Byrd Land Camp" 1967* Robert
 R. Nunley (Time-Life/16 41)
 ice shelf in Antarctica in "The edge of the Amundsen Sea" 1959* George
 A. Doumani (Time-Life/16 38)
 man walking in Antarctic "white-out" in "The start of a white-out" 1958*
 Emil Schulthess (Time-Life/16 42)
 rainbow effect in clouds in "Optical effects of clouds" 1962* George A.
 Doumani (Time-Life/16 39)
 sailing ship in icy water in "The Terra Nova in the Antarctic" 1912
 Herbert Ponting (Gernsheim/2 268#)
 tanker going through ice floes in "S.S. Manhattan heading for Alaska"
 1969* John Olson (Time-Life/16 37)
ARMS
 and leg sticking out through cell bars in "Cell in a modern prison in the
 U.S.A." 1975 Henri Cartier-Bresson (Cartier-Bresson 81)
 holding ruler up to view of Grand Tetons in "Wyoming" 1971 Kenneth
 Josephson (Gruber 449#)
ARMS AND ARMOR
 veiled nude reclining near suit of armor in "Veiled nude with suit of
 armor" 1854* Braquehais (Bernard 26#)
ARTICHOKES
 brooch of amethysts and jade on artichoke half in "Brooch of amethysts
 with jade pendants" 1968* Fred Burrell (Time-Life/13 217c)
ARTISANS
 men making bronze lanterns by hand in "Craftsmen making bronze lan-
 terns for a temple, Kyoto, Japan" 1907 H.C. White (Loke 135c)
 on floor restoring a Persian rug in "Artisans restoring an old Persian
 rug, Constantinople, Turkey" 1912 Underwood and Underwood (Loke
 134)
ARTISTS
 woman sitting in garden with sketchpad and paints in "Georgia O'Keeffe
 with paints" c. 1916-1917* Alfred Stieglitz (Bernard 171#)
ASSASSINATIONS
 Asanuma and assassin in "Inejiro Asanuma and assassin" 1960 Yasushi
 Nagao (Time-Life/10 31)
 Robert F. Kennedy after being shot in "Robert F. Kennedy shot" 1968
 Bill Eppridge (Time-Life/10 30)
ASSES
 a wild ass on the run in the desert in "The wild ass of the Gobi Desert,
 also known as the dziggetai" J.B. Shackelford (Guggisberg 93)
ASTRONAUTS
 on surface of moon in "Buzz Aldrin on the moon" 1969 Neil Armstrong
 (Time-Life/10 23)
ASWAN, EGYPT
 boats docked in "Aswan, Egypt" 1856 Francis Frith (Time-Life/14 115)
ATHLETES
 fish-eye view of boxing ring after knockout (Sonny Liston and Muhammad
 Ali) in "Victor and vanquished, Lewiston, Maine" 1965* Neil Leifer
 (Time-Life/14 221)
 start and finish of 60-yard dash in "Sixty-yard dash, Madison Square
 Garden, New York City" 1956 Ralph Morse (Time-Life/14 217)

two Persian men lifting weights in "Persian gymnasts" c. 1880 Ernst
Holtzer (Time-Life/14 122)

ATLANTA, GEORGIA
city street by railroad tracks in "City of Atlanta, Georgia, No. 2" 1864
George Barnard (Sandweiss 14#)

ATLANTIC CITY, NEW JERSEY
people on the beach in "Atlantic City beach, New Jersey" 1891 B.W. Kil-
burn (Loke 67d)

ATOMIC BOMB
mushroom cloud over water in "Automatic camera recording of the atomic
test at Bikini" 1946 Photographer Unknown (Time-Life/10 21)
rubble of Nagasaki in "Nagasaki" 1945 George Silk (Time-Life/10 35)

ATTICS
empty room with wooden beams in "Kelmscott Manor; Attics" c. 1896*
Frederick H. Evans (Photography 180; Time-Life/15 92)

AUSTRALIANS
aboriginal men with boomerangs, seated on ground in "Aboriginal hunts-
men with their boomerangs, Healesville, Victoria, Australia" Under-
wood and Underwood (Loke 186b)

AUTOMOBILE ACCIDENTS see TRAFFIC ACCIDENTS

AUTOMOBILE RACING
blurred image of elongated race car in "The Lotus Winner" 1963* Horst
Baumann (Time-Life/16 148)
a Delage at the Grand Prix in "A Delage racer at the Grand Prix" 1912
Jacques-Henri Lartigue (Time-Life/7 163)
a racing car alongside of a bicyclist in "Paris, Avenue des Acacias" 1912
Jacques-Henri Lartigue (Time-Life/7 20c)

AUTOMOBILES
couple traveling in Peugeot Phaeton on country road, referring to map in
"On the road to La Ciotat" 1907* Louis Lumière (Time-Life/8 71)
young men and women in hot rod in "Hot rodders" 1949 Ralph Crane
(Time-Life/7 92)

AUTUMN
tree-lined creek in autumn in "Big Santeetlah Creek"* William A. Bake,
Jr. (Rugoff 138#)
trees in the Texas hills in "The central Texas hills in the Devil's Back-
bone country in autumn"* Jim Bones (Rugoff 89#)
Vermont trees in autumn colors in "Vermont autumn"* Sonja Bullaty and
Angelo Lomeo (Rugoff 114#, 115#)
willows in autumn colors at base of mountains in "Willows in autumn colors
at about 8700 feet up in the Minarets Wilderness, California"* David
Cavagnaro (Rugoff 43#)

B

BABIES see CHILDBIRTH; INFANTS

BAKING
girl carrying on her head unbaked loaves of bread in "Young woman's
work" 1951 W. Eugene Smith (Time-Life/10 74)

BALCONIES
maid with feather duster leaning over in "Montmartre" c. 1900 C. Puyo
(Gernsheim 337#)

BALLET DANCERS
Ballerina in costume in "Emma Livry" c. 1859 Nadar (Tournachon 151)
girls practicing at bar in "Ballet class" 1963* Bruce Davidson (Time-Life/
9 221)

male and female dancers practicing in "Training in the State Ballet
School, East Berlin" 1966 Herbert List (Time-Life/7 91)
multiple exposure of movement of ballet dancer in "Nora Kaye" 1947 Gjon
Mili (Time-Life/7 49)
troupe posed on and near ladders in "American Ballet Theatre" 1947
Irving Penn (Gruber 299#)
two women talking to man in formal attire in "Backstage at the Opera"
1938 Brassaï (Gruber 396#)
young woman fixing her costume in "Ballet dancer" 1904 Robert Demachy
(Gernsheim/2 294#)

BALLOONS
filled balloon in large square in "The Neptune in the Place Saint Pierre"
1870 Nadar (Tournachon 19)
group of men holding ropes of balloon about to be launched in "Launch-
ing a balloon" Photographer Unknown (Tournachon 292a)

BANDS (MUSIC)
musicians marching in town in "Die Burgmusik" c. 1887 M. Putz (Gern-
sheim 289#)
musicians marching on cobblestone street in "A street band" c. 1887 A.
Wells Champney (Photography 148)

BANFF NATIONAL PARK
snow-covered mountains and lake in "Red-necked grebe in Banff National
Park"* Kojo Tanaka (Rugoff 52#)

BANTEUG
several in water in "A herd of banteug in the Udjung Kulon Reserve" A.
Hoogerwerf (Guggisberg 91b)

BAPTISTRY, FLORENCE
one of the doors in "The Baptistry, Florence, one of Ghiberti's doors"
c. 1855 Leopoldo and Giuseppe Alinari (Gernsheim/2 160#)

BARBEQUE COOKING see COOKERY, OUTDOOR

BARBERSHOPS
body covered with towels on floor in "Detectives inspect the corpse of
Albert Anastasia" 1957 George Silk (Time-Life/10 42)
man having head shaved by street barber in "A street barber, Peking"
1902 C.H. Graves (Loke 126b)
Persian man being shaved in "A Persian barber and customers" c. 1880
Ernst Holtzer (Time-Life/14 121)

BARNS. See also FARMS AND FARMING
of cobblestone in "Bucks County barn" 1918 Charles Sheeler (Sandweiss
109#)
peaks of wooden buildings in "Barns and sheds" 1936 Paul Strand (Gruber
363#)

BASEBALL
children playing in alley with laundry hanging between tenements in
"Playground in tenement alley, Boston" 1909 Lewis Hine (Hine 75)
fans and Yankees and back of Babe Ruth in "Babe Ruth bows out" 1948
Nat Fein (Time-Life/10 46)
Maury Wills stealing second base in "World Series" 1963 James Drake
(Time-Life/16 138-9)
pitched ball stopped in mid-air, viewed from behind umpire in "Denny
McLain at work" 1968* James Drake (Time-Life/16 152)
team doing calisthenics in "Fort Lauderdale Yankee Stadium, Fort Lauder-
dale, Florida" 1978* Stephen Shore (Gruber 160#)

BASKETBALL
boy shooting ball into hoop in "Lonely practice" 1969 James Carroll (Time-
Life/9 28)
professional teams playing in "[Basketball]" John Hanlon (Time-Life/12 113c)

BASKETS
around men and fishwives in "Rev. James Fairbairn and Newhaven fish-
wives" c. 1845 Hill & Adamson (Gernsheim 79#; Gernsheim/2 74#)
baby in basket near young girl in "Young girl with basket and baby"
early 1850's* Charles Nègre (Bernard 23#)
in a still life of objects in "Still life" c. 1921 Ira Martin (Sandweiss 64#)
Japanese man pulling cart filled with baskets in "A bamboo-basket seller
sharing a joke with his customer, Japan" 1904 Keystone View Company
(Loke 126c)
large basket used as advertisement in "'The World's Egg Basket' Peta-
luma, California" 1938 John Gutmann (Sandweiss 88#)
BATHROOMS
girl standing naked in bathtub by sink in "Erin in the shower" 1970
Arthur Freed (Time-Life/9 174)
toilet bowl from above in "Toilet bowl" 1967 Judie Gleason (Time-Life/16
172)
BATHS
baby in kitchen sink in "Baby in the sink" 1970 Ron Mesaros (Time-Life/
9 120)
French infantry men washing in stream in "French soldiers in the field"
c. 1915* Jean Tournassou (Time-Life/8 74)
infant being bathed in "[Infant being bathed]" Wolf von dem Bussche
(Time-Life/9 122)
man bathing outdoors in "A Japanese soldier taking a bath, Manchuria"
T.W. Ingersoll (Loke 89d)
man in bathhouse water and several people waiting by side in "Public
bathhouse or swimming school, Paris" c. 1852-53* Henri Le Secq
(Bernard 21#)
nude woman lying in water in tub in "Nude in bathtub" 1962 Alen Mac-
Weeney (Time-Life/11 182)
woman washing children who are standing in buckets in "Miss Despit
teaching mothers how to care for babies, Skoplie, Turkey" 1918 Lewis
Hine (Hine 44)
women with floral wreaths in hair, in creek in "Deep creek" 1970 Craw-
ford Barton (Time-Life/12 26)
BATTLESHIPS see WARSHIPS
BAUHAUS
view of building in "Bauhaus" 1925-26 Lucia Moholy (Gruber 356#)
BAYOUS
covered with green growth and overhanging Spanish moss in "Duckweed
covers the water and Spanish moss hangs from the trees in a Louisiana
bayou near the Mississippi River"* Thase Daniel (Rugoff 91#)
with water lilies and grasses in "Water lilies on a Louisiana bayou"*
Andreas Feininger (Rugoff 92#)
BEACHES
beached rowboats on sandy shore in "Iles des Saintes" 1967* Bill Binzen
(Time-Life/8 87)
cabins on blue sand in "[Beach cabins]"* Franco Fontana (Time-Life/12
123)
footsteps in sand, by wooden fence in "Beach patterns" 1969 Mel Ingber
(Time-Life/14 153)
group of people in swim suits in "Cherry Beach, Toronto" 1912 William
James (Time-Life/7 11)
gulls on misty beach in "Cape Johnson in Olympic National Park on the
Washington coast"* Steven C. Wilson (Rugoff 31#)
in solarized print of a photograph in "Untitled" 1969 Jerry N. Uelsmann
(Time-Life/11 181)

men and women sunbathing by low wall in "The sun bathers, California" 1964 Bruce Davidson (Time-Life/11 137)

pebbles and eroded sandstone in "Eroded sandstone and tide-washed pebbles at Pebbly Beach"* Dennis Brokaw (Rugoff 36#)

people in street clothes, lying on beach in "Yarmouth beach" 1892 Paul Martin (Gernsheim 312#; Gernsheim/2 264#)

sand and sea in winter superimposed with hibiscus in "Season" 1968* Bill Binzen (Time-Life/8 219)

sandy beach filled with sea wrack in "Sea wrack on Harding Beach, Chatham" Gordon Smith (Rugoff 123#)

surrounded by mountains in "Garapata Beach, California" 1954 Brett Weston (Time-Life/12 121)

BEARS

three grizzly bears, two standing on hind legs facing forward in "Grizzly bears in Hayden Valley"* Charles Steinhacker (Rugoff 53#)

BEAUTY CONTESTS

women in swim suits on television set in "Beauty contest" 1973 Sarah Moon (Hall-Duncan 212)

BED OF NAILS

man lying naked on bed of nails in "A man on a bed of nails, India" 1907 H.C. White (Loke 185d)

BEDOUINS

armed men near tent in "Bedouin robbers, wilderness of Judea, Palestine" 1896 Bert Underwood (Loke 46d)

two veiled women and their children in "Two Sinai women and their children" Underwood and Underwood (Loke 111)

BEDS

boy in leather jacket sitting on bed in "Andrew Sanchez watching TV" 1971 Danny Lyon (Time-Life/9 170)

brass bed with doll-sized mansion at pillow in "Untitled" 1970* Henry Grossbard (Time-Life/11 157)

couple seated on round bed in "[Honeymooners]" 1971 Tony Ray-Jones (Time-Life/11 106)

dead bird over metal headboard and bed frame in "Untitled" c. 1960 Ralph Eugene Meatyard (Gruber 372#)

empty room with rumpled bed and tossed slippers in "Untitled" 1968 Jerry Uelsmann (Time-Life/11 153)

hairpins on unmade bed in "The unmade bed" 1954 Imogen Cunningham (Gruber 183#)

nude mother and child seated on bed in "Mother and child" 1968 Bruce Davidson (Time-Life/11 121)

portrait over wooden headboard in "Gypsy in Eastern Slovakia" 1965 Josef Koudelka (Gruber 374#)

two people embracing in "Mexico" 1934 Henri Cartier-Bresson (Cartier-Bresson 33)

two tiers in immigrants' sleeping quarters in "Sleeping quarters of immigrant workers, construction camp, New York State Barge Canal" 1909 Lewis Hine (Hine 61)

with metal frame, in room with stove in "Bed and stove" 1931 Walker Evans (Gruber 373#)

BEECH TREES

trunk of tree with many limbs in "The Copper Beech" 1925 Albert Renger-Patzsch (Gruber 266#)

BEGGARS

blind man in street with cigar box and pencils in "Blind man" 1888* Jacob Riis (Bernard 124#)

blind man with hand organ in market place in "Blind beggar in Italian

market district, Chicago" 1911 Lewis Hine (Hine 64)
children with musical instruments at iron fence in "Street musicians in
 Porchester Terrace, London" c. 1860* Camille Silvy (Bernard 69#)
homeless families in street in "Homeless beggars of Naples, Italy" H.C.
 White (Loke 57c)
old man in bonnet and shawl standing near ad for razor in "Beggar, New
 York City" 1910 Lewis HIne (Hine 67)
BERLIN, GERMANY
plaza with palace in "Zeughausplatz, Berlin, with Crown Prince's palace
 on right" c. 1855 Photographer Unknown (Gernsheim/2 84#)
statue of Bismarck in front of the Reichstagsgebände in "Statue of Bis-
 marck in front of the Reichstagsgebände, Berlin, Germany" H.C.
 White (Loke 70a)
BERLIN WALL
men standing on platform, looking across wall to apartment houses in "The
 Berlin Wall" 1963 Henri Cartier-Bresson (Cartier-Bresson 49)
BERRIES
white berries on stem in "Snowberry in autumn"* David Cavagnaro (Rugoff
 73#)
BEVERAGES
bottles of champagne in wooden barrel, in unfurnished apartment in "We-
 just-moved-in party" 1970 Rudy Muller (Time-Life/13 97)
boys with hot chocolate whispering a secret in "Paul and Eric" 1968
 Arthur Freed (Time-Life/9 144)
glass filled with champagne bubbles in "Advertisement for champagne"
 1963 Reto Bernhardt (Time-Life/13 219)
man holding partially filled glass in "Aran Islander" 1966* Humphrey Sut-
 ton (Time-Life/8 105)
men playing cards at cafe tables, with bottles of wine in "Buvetta, Ker-
 itz, France" 1975* Michel Thersiquel (Time-Life/14 32)
old men holding mugs in "Three men in a pub" c. 1877 John Thomson
 (Time-Life/14 99a)
Seltzer bottles in case in "Found color" 1959-1969* Gene Laurents (Time-
 Life/8 47)
BIBLES
open Bible on the Via Dolorosa in "Christianity, The Fifth Station of the
 Cross" 1967 Arnold Newman (Time-Life/13 91)
BICYCLES AND BICYCLING
and boys on bridge in "Boys on Brooklyn Bridge" 1967 A. Doren (Time-
 Life/9 125)
a bicyclist riding alongside of a racing car in "Paris, Avenue des Acacias"
 1912 Jacques-Henri Lartigue (Time-Life/7 20c)
boy on bicycle near stop sign and fire hydrant in "Stop sign" 1972*
 Tomas Sennett (Time-Life/12 21)
boy on park bench, with bicycle in "Boy with a bicycle" Jay Maisel (Time-
 Life/9 179)
boy with cap riding bicycle in "Boy on a bike" 1970 Armen Kachaturian
 (Time-Life/9 148)
by doorway of house with mother and adult sons in "The Family, Luz-
 zara, Italy" 1953 Paul Strand (Time-Life/11 113)
French soldiers in rows, on bicycles in "A company of French military
 cyclists" Keystone View Company (Loke 201a)
man pushing bicycle on dirt path in "Looking for coal" or "Coal searcher
 going home to Jarrow" 1937 Bill Brandt (Gruber 94#; Time-Life/11 203)
man riding behind single-engine plane taking off on runway curved up-
 wards in "[Light plane and bicycle]" Yale Joel (Time-Life/12 173)
man with child on rear seat in "[A day care center]" Leonard McCombe

(Time-Life/10 178a)
men and women riding on cobblestone street in "Bicycle riding in the
 city" c. 1890's Underwood and Underwood (Loke 67b)
men riding in race in "Bicycle race" 1969* Al Freni (Time-Life/16 147)
mosaic of room with bicycle in "118 North Main Street, Providence, Rhode
 Island" 1969 Reed Estabrook (Time-Life/11 165)
women on bicycle built for two in "Outdoor scene taken in Paris" c. 1895
 Reutlinger Studio (Hall-Duncan 26)
young children's tricycles near swings in "[A day care center]" Leonard
 McCombe (Time-Life/10 174)
young women riding bicycles in "[Riding bicycles]" Herman Landshoff
 (Hall-Duncan 81)
BILLIARDS
 man with cuestick at billiards table in "Mark Twain in the billiard room
 of his house in Hartford, Connecticut" Underwood and Underwood
 (Loke 63)
BINOCULARS
 woman looking over couple sleeping on sand in "Untitled" 1969 Ray K.
 Metzker (Time-Life/11 166)
BIRCH TREES
 in snow in "Winter in northern Minnesota"* Les Blacklock (Rugoff 103#)
 peeling bark of paper birch in "Paper birch"* Larry West (Rugoff 111#)
 white birch in snow in "White birch at twilight"* Larry West (Rugoff
 113#)
BIRD HOUSES
 birds on top of cage, with man holding one bird in "Henri Matisse,
 Vence" 1944 Henri Cartier-Bresson (Cartier-Bresson 57)
 eagle on cage of wood and mud near Zuni man in "A Zuni eagle cage"
 1879 John K. Hillers (Sandweiss 43#)
 woman by two filigreed cages in "Sportswear in Tunisia" 1950 Louise
 Dahl-Wolfe (Time-Life/13 93)
BIRDS. See also Albatross; Anhingas; Bitterns; Cedarwaxing; Cormorants;
 Cranes; Cuckoos; Eagles; Egrets; Flamingos; Frigates; Gallinules;
 Geese; Grebes; Gulls; Hawks; Herons; Ibis; Kittiwakes; Loons; Os-
 prey; Owls; Pelicans; Penguins; Pigeons; Prairie Chickens; Puffins;
 Skuas; Spoonbills; Storks; Warblers; Whimbrels; Whitethroats; Willow
 Ptarmigans; Woodpeckers; Wrens
 flying in formation, casting shadows on lake in "Snow geese over water,
 Buena Vista Lake, California" c. 1953 William Garnett (Time-Life/14 38)
 hanging upside down, dead in "Dead game" c. 1855 William Lake Price
 (Gernsheim 131#; Gernsheim/2 111#)
 stuffed bird in box with flowers of ribbon in "Bird of the death dream"
 1953 Clarence John Laughlin (Time-Life/12 54)
BIRDS--EGGS AND NESTS
 adult stork near young in nest in "Black stork at nest" Horst Siewert
 (Guggisberg 111)
 adults feeding at nest in "Yellow robins" R.T. Littlejohn (Guggisberg 32)
 albatross on nest in "Wandering albatross on nest on Campbell Island,
 New Zealand" A. Saunders (Guggisberg 82)
 Arctic loon on nest in "Arctic loon brooding in the Yukon-Kuskokwim
 Delta"* Michael Wotton (Rugoff 13#)
 at base of old octagonal clock in "And tell of time ... cobwebed time"
 1947 Clarence John Laughlin (Time-Life/12 49)
 cedar waxwing feeding young at nest in "Cedar waxwing at nest" Francis
 H. Herrick (Guggisberg 36)
 cormorants in a dead tree in lake in "Cormorants nesting in a dead tree
 in Lake Naivasha" Cherry Kearton (Guggisberg 72)

young girl holding woman's hand in "A safe grip" 1963 George Krause
(Time-Life/9 18)
youth in dark cap in "From the shores of the Bosphorus" Baron Adolphe
De Meyer (Green 243)
BLACKSMITHING
men at anvil and bellows in "Blacksmiths" 1850's Photographer Unknown
(Bernard 24#)
BLIND
beggar with hand organ in marketplace in "Blind beggar in Italian market
district, Chicago" 1911 Lewis HIne (Hine 64)
boy feeling streak of light on wall in "Blind boy, New York City" c.
1960 Charles Harbutt (Time-Life/14 27)
man in street with cigar box filled with pencils in "Blind man" 1888*
Jacob Riis (Bernard 124#)
old man in dark glasses, walking in "[Blind man on dark street]" Shin
Sugino (Time-Life/12 128)
woman with sign saying 'Blind' in "Blind woman" Paul Strand (Green
322)
BOATS AND BOATING
couple on river bank, by rowboat in "In the twilight" 1888 Lyddell Saw-
yer (Gernsheim 327#; Gernsheim/2 280#; Time-Life/7 189)
fishing boat, negative print in "Magic boat" 1957 Otto Steinert (Time-
Life/12 212)
girl in rowboat on lake filled with lily pads; ferris wheel in background
in "Exposition Park, Louisiana Purchase Exposition, St. Louis, Mis-
souri" 1904? Underwood and Underwood (Loke 155)
hunter in rowboat in marsh in "Gunner working up to fowl" 1885 Peter
Henry Emerson (Gernsheim 324#; Gernsheim/2 279#)
looking to deck of ship from top of mast in "Nefertiti" 1962* George Silk
(Time-Life/16 153)
man in rowboat on river in "Rowboat on the Seine" 1951* Irving Penn
(Gruber 141#)
man in rowboat on wide, dammed river in "New Lock, Hurley" c. 1862*
Victor Albert Prout (Bernard 71#)
men inflating bullock-skin boats in river in "Boatmen inflating bullock-
skin boats, Sutlej River, India" 1903 Underwood and Underwood (Loke
133c)
naked boys leaning on beached boat in "Natives of these isles" 1885 Frank
M. Sutcliffe (Gruber 385#; Time-Life/9 69)
rowboats beached on sandy shore in "Iles des Saintes" 1967* Bill Binzen
(Time-Life/8 87)
rowing on lake in "Loch of park" 1856 George Washington Wilson (Gern-
153#; Gernsheim/2 132#)
sailboats in race in "Sailboats" 1958* Ernst Haas (Time-Life/7 95)
sailboats in small canal in "Dutch canal" 1909* Theodor and Oskar Hof-
meister (Gruber 140#)
two hulls of small boats, upside down in "Hulls" 1933 Ansel Adams
(Gruber 80#)
two men in rowboat in the fog "Fog--Nova Scotia" George Krause (Time-
Life/12 143)
BOER WAR, 1899-1902 see SOUTH AFRICAN WAR, 1899-1902
BOMBS
baby crying in rubble in "Chinese baby" 1937 H.S. Wong (Time-Life/10
36)
London bus in hole after Blitz in "London Blitz" 1940* William Vandivert
(Time-Life/15 67)

BONGOS
 bull crossing a river in "Bull bongo crossing the Aina River, Cameroon"
 E. Gromier (Guggisberg 100c)
BOOKS
 on four shelves in "The library" c. 1845 William Henry Fox Talbot (Pho-
 tography 32)
 open pages and spine in "Pages of a book" Hein Gorny (Gruber 206#)
BOSTON
 seen from a balloon in "Boston, from the balloon 'Queen of the Air'" 1860
 James Wallace Black (Photography 73)
BOURGES CATHEDRAL
 interior view in "Height and light in Bourges Cathedral" c. 1901 Fred-
 erick H. Evans (Photography 181)
BOWLING
 pin boys setting up bowling pins in "Pin boys in Subway Bowling Alley,
 New York City" 1909 Lewis Hine (Hine 78)
BOWLS
 close-up of their shape in "Pattern made by bowls" 1916* Paul Strand
 (Time-Life/12 48)
BOXER REBELLION
 Chinese men holding arms of man about to be executed in "Execution of
 a Boxer leader, China" 1900 B.W. Kilburn (Loke 45c)
 Italian soldiers with guns guarding Chinese prisoners in "Boxers guarded
 by Italian soldiers" B.W. Kilburn (Loke 45d)
BOXING
 boxer's face distorted by blow from glove in "Johansson-Patterson bout"
 1961 George Silk (Time-Life/16 137)
 fish-eye view of ring, after knockout (Sonny Liston and Muhammad Ali)
 in "Victor and vanquished, Lewiston, Maine" 1965* Neil Leifer (Time-
 Life/14 221)
 gloves on man in "Muhammad Ali" Philippe Halsman (Halsman 16)
BREAD
 and bottle of wine in "Bread and wine" 1953 Bert Stern (Time-Life/13
 226)
 slices of bread on cloth in "Bread Spread I" 1974 Ellen Brooks (Time-Life/
 12 28)
BREASTFEEDING
 mother and nursing infant in "Helpless and beloved" 1965 Anthony Wolff
 (Time-Life/9 15)
 mother being watched by father and son in "Dahlia Kibbutz, Israel" 1964
 Ken Heyman (Time-Life/7 31)
 woman nursing infant in "F. Holland Day" c. 1905 F. Holland Day (Gru-
 ber 324#)
BRICKS
 looking through a viaduct in "A viaduct on the South Eastern Railway"
 Henry Pollock (Photography 96)
 man with load of bricks on shoulder in "Laborer" 1927 August Sander
 (Time-Life/11 118)
 a roadway in "Halifax" 1937 Bill Brandt (Time-Life/11 186)
BRIDGES
 against city skyline in "Brooklyn Bridge" 1952* Ernst Haas (Time-Life/8
 131)
 at Argenteuil in total collapse in "The bridge at Argenteuil" 1870-1871*
 J. Andrieu (Bernard 92#)
 bus going over bridge with sculpture in "Invalides Bridge in Paris" 1967*
 Francisco Hidalgo (Time-Life/12 13)
 cables of upper level in "George Washington Bridge, New York" 1931

Edward Steichen (Gruber 368#)
filled with pedestrians and traffic in "The bridge--sunlight" Alvin Langdon Coburn (Green 92)
group of women crossing over small stone bridge in "The Bridge" 1906 Alexander Keighley (Gernsheim 334#; Gernsheim/2 287#)
part of a suspension bridge, at night in "Bay Bridge, New York" c. 1912-1913 Karl Struss (Sandweiss 73#)
small one into railroad town in "Phillipsburg, New Jersey" 1936 Walker Evans (Photography 315; Time-Life/7 24)
stone bridge over river in "St. Paul's from the river" before 1910 Alvin Langdon Coburn (Gruber 361#)
to Gibraltar, fortified with cannons in "[Gibraltar]" c. 1865 Photographer Unknown (Time-Life/12 77b)
under construction in "Construction of the Forth Bridge" c. 1884* Photographer Unknown (Bernard 120#)
underside of Victoria Bridge in "Victoria Bridge over the River St. Lawrence" 1859* William Notman (Bernard 68#)
woman crossing canal in "The Bridge, Venice" 1905* Alvin Langdon Coburn (Green 168; Time-Life/12 39)
BROOKLYN BRIDGE
against New York skyline in "Brooklyn Bridge" 1952* Ernst Haas (Time-Life/8 131)
man asleep on bench on bridge in "Man sleeping on Brooklyn Bridge" c. 1929* Walker Evans (Bernard 192#)
BROOMS
straw broom near clay pots and pitchers in "Pots and pans at Nice" 1855* Arthur Backhouse (Bernard 53#)
BRYCE CANYON
rock formations in "Bryce Canyon #2" 1930 Laura Gilpin (Sandweiss 129#)
BUFFALOES
a herd in a thick forest in "Buffalo herd in thick cover on Oldonyo Sabuk, a mountain not far from Nairobi" Marcuswell Maxwell (Guggisberg 103)
BUILDING
construction of the locks of the Panama Canal in "Work in progress at Gatun Locks" Photographer Unknown (Loke 97)
BUILDINGS/LANDMARKS see Acropolis; Canyon de Chelly; Chartres Cathedral; Doge's Palace; Flatiron Building; Furness Abbey; Gloucester Cathedral; Guggenheim Museum; Lacock Abbey; Lincoln Cathedral; Louisiana Purchase Exposition, St. Louis, Mo.; Louvre, Paris; Notre Dame de Paris; Palace del Infantado; Panama Canal; Pennsylvania Station; Sphinx; Stonehenge; Temple of Antonius Pius; Trajan's Column; Vendôme Column; Versailles; Washington Square; Westminster Abbey; World Trade Center; Yankee Stadium
BULLFIGHTS
blurred picture of matador, his cape and the bull in "Bullfight, Madrid" 1956* Ernst Haas (Time-Life/8 147)
bull glistening with blood in "Bullfight" 1957* Ernst Haas (Time-Life/7 96)
BURMESE
Shau chiefs in traditional dress in "Shau chiefs from Burma at the Great Durbar of 1903 held in honor of Edward VII's coronation Delhi, India" 1903 Underwood and Underwood (Loke 185a)
BUSES
going over bridge with sculpture in "Invalides Bridge in Paris" 1967* Francisco Hidalgo (Time-Life/12 13)
on snow-covered city street at night in "A tribute to Steichen, New York City" 1978* Jan Staller (Time-Life/14 46)

C

CABBAGES
 half of a red cabbage in "Red cabbage" 1970 Hugh G. Barton (Time-Life/
 16 163)
 with frost on edges in "Cabbage with hoarfrost" 1930 Paul Zwart (Gruber
 194#)
CACTI
 Echeveria from Mexico in "Echeveria" 1922 Albert Renger-Patzsch (Time-
 Life/11 44)
 flowers with bumblebee in "Cactus for a bee" 1968* Farrell Grehan (Time-
 Life/8 125)
 in tree shape in field of yellow flowers in "Spring flowers with the vol-
 canic crest of the Ajo Mountains in the distance, Organ Pipe Cactus
 National Monument, Arizona"* David Muench (Rugoff 76#)
 on ridge overlooking small mountain town in "A glimpse of Guanajuato,
 Mexico" c. 1883-1884 William Henry Jackson (Sandweiss 35#)
 on stone column in "Cactus on column of Porte Judiciaire, Jerusalem"
 1854* Auguste Salzmann (Bernard 30#)
 prickly-pear cactus, oaks and cedar elms in fog in "Foggy dawn over the
 Edwards Plateau of central Texas, with prickly-pear cactus in the
 foreground and live oaks and cedar elms in the background"* Jim
 Bones (Rugoff 86#)
 red bloom of hedgehog cactus in "Hedgehog cactus in Arizona's Painted
 Desert"* Bill Ratcliffe (Rugoff 84#)
 saguaro cactus in bloom with white flowers in "Saguaro cactus in April
 in southern Arizona"* Thase Daniel (Rugoff 83#)
 woodpecker feeding young in nest in cactus in "Gila woodpecker feeding
 young in saguaro cactus, Sonoran Desert"* Jerry Gentry (Rugoff 81#)
CALLAS
 two flowers in "Two callas" c. 1929 Imogen Cunningham (Photography
 254; Time-Life/11 43)
CAMELS
 and men and goats, congregating in "Radjastan, India" 1956 Marc Riboud
 (Gruber 115#)
 cardboard head peering over advertisement for Camel cigarettes in "[Card-
 board camel]"* Luigi Ghirri (Time-Life/12 140)
CANALS
 of Venice in "Venice" 1897 Heinrich Kühn (Gernsheim/2 299#)
 sailboat on canal in "Dutch canal" 1909* Theodor and Oskar Hofmeister
 (Gruber 140#)
 woman walking over small bridge in "The Bridge, Venice" 1905* Alvin
 Langdon Coburn (Time-Life/12 39)
CANNERIES
 women in line by troughs of peaches in "Peach-canning factory, Visalia,
 California" Phil Brigandi (Loke 218b)
CANNONS AND CANNONBALLS
 in piles near ship in "Ordance Wharf, Balaclava, Crimean War" 1855
 Roger Fenton (Gernsheim 164#; Gernsheim/2 140#)
 in trench in "Battery No. 1, near Yorktown, Virginia" 1862 Wood and Gib-
 son (Time-Life/12 81)
 lined up in preparation for battle in "Battery B, First Pennsylvania Light
 Artillery, Petersburg, Virginia" 1864 Alexander Gardner (Time-Life/14
 104)
 on fortified bridge to Gibraltar in "[Gibraltar]" c. 1865 Photographer Un-
 known (Time-Life/12 77b)
 soldier by rows of cannons in "Union soldier at an arsenal near Washing-

ton, D.C." c. 1865* A.J. Russell (Bernard 80#)
CANTON, CHINA
 narrow, sign-filled street in "Street Scene, Canton" 1885-90* A. Fong
 (Bernard 121#)
CANYON DE CHELLY
 from the floor of the canyon in "Cañon de Chelle, walls of the Grand
 Cañon about 1200 feet in height" 1873 Timothy H. O'Sullivan (Sand-
 weiss 32#)
 a panoramic view in "Canyon de Chelle, New Mexico" 1873 Timothy H.
 O' Sullivan (Gernsheim/2 172#; Gruber 249#)
 people on horseback on canyon floor in "Cañon de Chelly" 1904 Edward
 S. Curtis (Sandwiss 78#)
 view of the cliff from its base in "Canyon de Chelly, Arizona, White
 House Ruins" 1975 William Clift (Sandweiss 138#)
CANYONLANDS NATIONAL PARK
 moon over towering rocks in "Moon over Fisher Towers group, Utah"
 Ed Cooper (Rugoff 57#)
 storm clouds over Devil's Pocket and 'Needles' in "Storm approaching
 over the Devil's Pocket in Canyonlands National Park" Richard Wey-
 mouth Brooks (Rugoff 59#)
CANYONS
 in colors of sunset in "Sunset over the Grand Canyon as seen from
 Bright Angel point looking toward South Rim and San Francisco
 Peaks"* David Muench (Rugoff 62#)
 river going through deep canyons in "Colorado River below Toroweap
 View, Grand Canyon National Monument, Arizona"* David Muench
 (Rugoff 61#)
 vertical walls from river in "View near the mouth of Santa Elena Canyon
 on the Rio Grande, Big Bend National Park, Texas"* Jim Bones (Rug-
 off 85#)
CAPITAL PUNISHMENT
 by pistol, of man in street in "Execution of a suspected Viet Cong ter-
 rorist" 1968 Edward T. Adams (Time-Life/7 33)
 Chinese men holding arms of man about to be executed in "Execution of
 a Boxer leader, China" 1900 B.W. Kilburn (Loke 45c)
 man being strapped into electric chair in "Man in the electric chair" c.
 1900* William van der Weyde (Bernard 147#)
 man with head locked into garrote in "Execution chamber and garrote,
 Manila" 1899 C.H. Graves (Loke 43d)
 men being prepared to be hanged in "Execution of the conspirators against
 Lincoln" 1865 Mathew Brady or Alexander Gardner (Gernsheim 172#;
 Gernsheim/2 147#)
 woman in electric chair in "Electrocution of Ruth Snyder" 1928 Photogra-
 pher Unknown (Time-Life/10 19)
CARD GAMES
 groups of men at cafe tables in "Buvette, Keritz, France" 1975* Michel
 Thersiquel (Time-Life/14 32)
 men playing cards around a bed in "Inside workers' quarters, New York
 State Barge Canal Construction Camp" 1909 Lewis Hine (Hine 65)
 mini-skirted model seated on window sill above card-playing men in "Win-
 ter day" 1969* Alen MacWeeney (Time-Life/13 140)
 woman at table in "Woman playing cards" c. 1860 Photographer Unknown
 (Time-Life/7 188d)
CARDINALS
 man in crowd, kissing hand of Cardinal in "Cardinal Pacelli at Montmartre,
 Paris" 1938 Henri Cartier-Bresson (Cartier-Bresson 45)
CARDS, PLAYING see CARD GAMES

CARIBOU
bull on frozen stream in "Barren ground with caribou bull on the ice of
glacial stream"* Charlie Ott (Rugoff 17#)
herd on barren ground in "Concentration of barren-ground caribou at
Carey Lake, Canada" 1893 J.B. Tyrrell (Guggisberg 77)
swimming across river in "Migrating Newfoundland caribou crossing a
river" A.R. Dugmore (Guggisberg 58)
CARNIVALS (CIRCUS)
motorcyclists by round metal cage in "The All-British Globe of Death"
1930's* Photographer Unknown (Bernard 197#)
sideshow and gathering crowd in "The Prater, Vienna" c. 1887 Victor
Angerer (Gernsheim 290#; Gernsheim/2 235#)
CARPENTERS
two men sawing a plank, near ladders in "Carpenters on the Lacock Es-
tate" 1842* William Henry Fox Talbot (Bernard 1#)
CARRIAGES AND CARTS
bicycle and horse-drawn wagon on cobblestone intersection in "Touraine,
France" 1930 André Kertész (Time-Life/11 128)
covered wagon and team of oxen by Flatiron Building in "Ezra Meeker
with the wagon and ox team he drove across the continent..." 1907
Underwood and Underwood (Loke 165)
girl pushing younger children in carriage, near barefoot children on
sidewalk in "Street children, New York City" c. 1908 Lewis Hine
(Hine 80)
horse-drawn carriages on city street in winter in "The Street, design
for a poster" c. 1900* Alfred Stieglitz (Time-Life/12 30)
on street in winter in "The Street, Fifth Avenue" 1896 Edward Steichen
(Photography 198)
horse-drawn in city street in "Oxford Street" 1885-7 Charles A. Wilson
(Gernsheim 293#; Gernsheim/2 238#)
horse-drawn vegetable and fruit wagons in "Street market, Homestead,
Pennsylvania" 1907-08 Lewis Hine (Hine 73)
man in horse-drawn buckboard on sand dunes in "[Great sand dunes
along the Columbia River, Oregon]" H.C. White (Loke 152)
mule-drawn wagon in desert in "The photographer's wagon and mules in
the Nevada Desert" or "Shifting sand dunes" c. 1867 Timothy H.
O'Sullivan (Photography 125; Time-Life/14 89)
Navaho family in a covered wagon in "The covered wagon" 1934 Laura
Gilpin (Sandweiss 120#)
on city street in "The Strand" c. 1890 London Stereoscopic Co. (Gern-
sheim 294#; Gernsheim/2 239#)
refugees on flat-bed horse-drawn wagon in "French refugees fleeing from
the Somme to Amiens" Photographer Unknown (Loke 201d)
stagecoach by large fallen tree in "Yosemite Stage by the Fallen Monarch,
Mariposa Grove" 1894 I.W. Taber, Publisher (Sandweiss 21#)
wicker baby carriage with umbrella on beach in "Atlantic City beach,
New Jersey" 1891 B.W. Kilburn (Loke 67d)
woman in cart pulled by pony in "[Mme. Beaurepaire in her pony cart]"
1944 Lee Miller (Hall-Duncan 123)
woman wheeling two children in baby carriage in "London" 1970 Donald
Scheller (Time-Life/16 168)
CASTLES
Lismore in Ireland in "Lismore Castle, Ireland" F.W. Cwerey (Photography
99)
on hill above woman carrying large sack on her head, near man on burro
in "Portuguese peasants standing below Pena Castle in Sintra, Portu-
gal" Underwood and Underwood (Loke 142b)

CATACOMBS
 man pulling wagon filled with skulls and bones in "Workmen in the Paris
 catacombs" 1861 Nadar (Tournachon 36)
 several skulls and human bones in "Catacombs of Paris" c. 1861 Nadar
 (Gernsheim/2 229#)
CATHEDRALS
 domes of a Moscow Cathedral in "Domes of the Cathedral of the Resur-
 rection, the Kremlin" 1852 Roger Fenton (Gernsheim 93#; Gernsheim/2
 82#; Time-Life/14 109)
 exterior view of Wells in "[Wells Cathedral]" Dmitri Kessel (Time-Life/12
 107)
 Papal procession to altar of Cathedral in "Pope Paul VI entering St. Pat-
 rick's Cathedral, New York City" 1965* Yale Joel (Time-Life/14 !24)
 partial view into Ely Cathedral in "Ely Cathedral: A memory of the Nor-
 mans" Frederick H. Evans (Green 84)
 ribbing on ceiling of Wells Cathedral in "[Interior of Wells Cathedral]"
 Dmitri Kessel (Time-Life/12 106)
CATS
 children in field of flowers with kitten in "Happy days" Gertrude Käse-
 bier (Green 97)
 kitten on wooden floor with baby in "Confrontation" 1968 Jay Maisel
 (Time-Life/9 117)
 portrait of chinchilla cat in "Chinchilla cat" 1952 Ylla (Time-Life/13 32)
 young person with sleeping bag, holding kitten in "London life" 1964
 Bruce Davidson (Gruber 415#)
CATTLE
 man holding animal by rope in "[Illustration for a book on cattle-breed-
 ing]" c. 1853 Adrien Tournachon (Tournachon 41c)
CAVALRY
 men at rest in "Lord Robert's army, 84th Battery and Balloon Corps,
 Boer War" 1901 Photographer Unknown (Gernsheim 320#)
 a Moroccan cavalryman with sword in "A Moroccan cavalryman with the
 French troops at the front" Photographer Unknown (Loke 203d)
 uniformed men with swords, looking at plane in "French cavalry officers
 looking up at a scout fighter plane" Photographer Unknown (Loke
 208)
CAVES
 interior of the Mammoth Caves in "The Mammoth Caves, Kentucky" 1866
 Charles Waldack (Gernsheim 281#; Gernsheim/2 230#)
CEDAR BREAKS NATIONAL MONUMENT
 view of rock formations in "Cedar Breaks National Monument, Utah"
 1975 Michael Smith (Sandweiss 136#)
CEDAR WAXWING
 feeding young at nest in "Cedar waxwing at nest" Francis H. Herrick
 (Guggisberg 36)
CELLOS
 man playing cello in park in "Cellist" 1916* André Kertész (Bernard
 175#)
 trio of women playing piano, cello, and violin in "The Prelude" 1917
 Laura Gilpin (Sandweiss 57#)
CEMETERIES
 girl singing by tombstone in "Child in a Welsh graveyard" 1965 Bruce
 Davidson (Time-Life/9 220)
 lone rock-covered grave with cross pushed over in "Volcano of Popo-
 catepetl, Mexico" 1964 Henri Cartier-Bresson (Cartier-Bresson 75)
 moon rising over cemetery in "Moonrise, Hernandez, New Mexico" 1941
 Ansel Adams (Gruber 101#; Sandweiss 125#; Time-Life/7 210)

old headstone with fresh magnolia blossom in "Unmarked graves" 1969
Wynn Bullock (Time-Life/11 195)

simple cross at gravesite in "Burial place of son of Henry Clay in Mexi-
co" 1847 Photographer Unknown (Sandweiss 3#)

single tombstone at foot of hills in "Tombstone, Catherine Holland" 1965*
George A. Tice (Time-Life/15 84)

small graveyard by wooden houses in "Graveyard, houses, and steel
mill, Bethlehem, Pennsylvania, November 1935" Walker Evans (Photog-
raphy 268)

view of above-ground tombs in cemetery in "Graveyard in Chiapas,
Mexico" 1969* Douglas Faulkner (Time-Life/8 89)

with large tomb in churchyard in "The Mackenzie Tomb, Greyfriars
Churchyard" c. 1855 Thomas Keith (Gernsheim 95#; Gernsheim/2 86#)

workman with flowers walking by graves in "Workman on his way home,
Scotland" 1960 Bruce Davidson (Time-Life/11 132)

CEREMONIES see RITES AND CEREMONIES

CEYLONESE

officials in traditional dress in "Officials of Kandy, Ceylon" Underwood
and Underwood (Loke 184)

CHAIRS

a bentwood rocker in a living room in "Misia and Thadée Natanson at
home" c. 1900* Edouard Vuillard (Bernard 138#)

couple sitting on bean bag chairs, surrounded by other plastic furniture
in "Beach house" 1970* Lionel Freedman (Time-Life/13 67)

family around woman sitting in rocking chair in "A Navaho family" 1953
Laura Gilpin (Sandweiss 87#)

in rows, and woman seated on bench in "Hyde Park, London" 1938 Henri
Cartier-Bresson (Cartier-Bresson 51)

ornate wicker rocking chair on porch in "Wicker chair" 1929 Ralph Steiner
(Sandweiss 107#)

overhead view of pairs of chairs in "Before the races" late 1920's Paul
Grotz (Sandweiss 89#)

rocking chair of bent wood sticks in "West Virginia coal miner's house"
1936 Walker Evans (Gruber 375#)

three around small table with tablecloth in "[Three garden chairs around
small covered table]" Shin Sugino (Time-Life/12 127)

women sitting in wicker rocking chairs in "Women's lounge at a paper
factory, Bangor, Maine" Underwood and Underwood (Loke 219)

wooden one superimposed over grass in "New Hampshire" 1969* Henry
Grossbard (Time-Life/8 220)

CHAMOIS

mother and her kid on rocky ledge in "[Chamois mother and her kid]"
Max Steckel (Guggisberg 61)

on a mountain slope in "[Chamois in the Bavarian Alps]" c. 1895 Fr.
Grainer (Guggisberg 43)

CHARLESTON, SOUTH CAROLINA

a mansion in ruins in "Ruins of Pickney Mansion, Charleston, South
Carolina" 1865 George N. Barnard (Gruber 353#)

CHARTRES CATHEDRAL

detail of sculpture in "Detail of Chartres Cathedral" 1852* Henri Le Secq
(Bernard 20#)

CHESS

two men playing chess at small table in "Portrait of Claudet" or "The
chess players" c. 1842 William Henry Fox Talbot (Gruber 8#; Time-
Life/14 74)

two men with chess board near lake in "Marcel Duchamp" Philippe Hals-
man (Halsman 51)

CHILD LABOR
boy and men outside shop, by pile of wood in "Workers outside Pittman
Handle Factory, Denison, Texas" 1913 Lewis Hine (Hine 71)
boy squatting by berry bush in "Boy picking berries, Baltimore" 1909
Lewis Hine (Hine 88)
boys bending over bins of coal in "Coal breakers, Pennsylvania" 1910
Lewis Hine (Hine 101)
boys making cigars in "Cigar makers, Tampa" 1909 Lewis Hine (Hine 68)
boys pushing logs down river in "River boy, Beaumont, Texas" 1913
Lewis Hine (Hine 47)
children stringing tags in "Children stringing milk tags, Newark" 1923
Lewis Hine (Hine 84)
children working at glass blowing in "Children in New Jersey glass fac-
tory" 1909 Lewis Hine (Hine 33)
factory filled with children seated on baskets, preparing beans in "Can-
nery workers preparing beans" c. 1910 Lewis Hine (Hine 85)
family sewing and ironing in small room in "Finishing clothing, tenement
homework, New York City" 1906 Lewis Hine (Hine 32)
girls posing in cotton mill in "Young workers at cotton mill, Scotland
Neck, North Carolina" 1914 Lewis Hine (Hine 99)
group of boys in coal mine in "Breaker boys inside coal breaker" 1909
Lewis Hine (Time-Life/9 70)
pin boys setting up bowling pins in "Pin boys in Subway Bowling Alley,
New York City" 1909 Lewis Hine (Hine 78)
rows of boys in coal mine in "Boys picking slate in a breaker in an
anthracite coal mine in Pittsburgh, Pennsylvania" Underwood and Un-
derwood (Loke 28b)
woman and child making lace in apartment in "Making pillow lace, New
York City" 1911 Lewis Hine (Hine 72)
young boy in glassmaking factory in "Factory boy, glassworks" 1909
Lewis Hine (Hine 55)
young boys posing in coal mine in "Breaker boys in coal chute, South
Pittston, Pennsylvania" 1911 Lewis Hine (Hine 59)
young girls knitting stockings in mill in "Young girls knitting stockings
in Southern hosiery mill" 1910 Lewis Hine (Hine 48)
CHILDBIRTH
mother holding newborn in "A child is born" 1964 John Minshall (Time-
Life/9 11)
CHILDREN. See also CHILD LABOR; CHILDBIRTH; INFANTS; PARENT AND
CHILD
and mothers in poor clinic in "Volunteers in Bolivia" 1975 Hilmar Pabel
(Gruber 383#)
around cart of an ice seller in "Ha'penny ices" 1876-7 John Thomson
(Gernsheim 308#)
asleep in outgrown stroller in "Dead to the world" 1971 Arthur Tress
(Time-Life/9 122)
at half-opened window in "Gypsy child in a van" 1968 André A. López
(Time-Life/9 168)
at wood frame window of train in "Russian child in a train" 1957 Dan
Weiner (Time-Life/9 169)
back of girl looking across sand in "Kay at Mont-St.-Michel" 1968
George Krause (Time-Life/9 210)
back of pig-tailed girl in polka dot dress in "Victoria" 1969 Ernst Haas
(Time-Life/9 173)
backs of boys in school uniforms in "Schoolboys on tour" 1966 Charles
Pratt (Time-Life/9 184)
barefoot children standing on sidewalk near girl pushing young children

in carriage in "Street children, New York City" c. 1908 Lewis Hine (Hine 80)

being bathed while standing in buckets in "Miss Despit teaching mothers how to care for babies, Skoplie, Turkey" 1918 Lewis Hine (Hine 44)

being taught to read Hebrew by Hasidic Jew in "Scholars of tradition, Brooklyn" 1955 Cornell Capa (Time-Life/9 26)

Black boy covered by water from fountain in "Fountainhead" 1969 George Krause (Time-Life/11 224)

Black boy with arm around white boy in "New York" 1953 Henri Leighton (Time-Life/7 30c)

Black children on street corner in "Pride Street" W. Eugene Smith (Gruber 387#)

blur of child coming down slide in "Sliding board" 1970 Charles Traub (Time-Life/9 150)

boy at end of porch in "Morning, New Hampshire" 1965* Bill Binzen (Time-Life/8 38)

boy by fence of hollow tubes in "Child in a strange world" 1971 Ron Benvenisti (Time-Life/9 178)

boy carrying bottles of wine in "Sunday morning errand, Paris" 1958 Henri Cartier-Bresson (Time-Life/9 23)

boy curled up in cardboard box in "Matthew" 1966 Ken Josephson (Time-Life/9 142)

boy diving into water in "Kingston, Jamaica" 1968* Bernard Wolf (Time-Life/9 193)

boy expanding his chest in show of strength in "Portrait of a champion" 1966 Leonard Freed (Time-Life/9 180)

boy hiding in bush in "My secret place in Central Park, New York" 1969 Charles Harbutt (Time-Life/9 31)

boy holding hand grenade, making faces in "Exasperated boy with toy hand grenade" 1963 Diane Arbus (Time-Life/7 222)

boy holding large leaf in "Showing off the big leaf" 1971 Charles Traub (Time-Life/9 134)

boy in center of hall of mirrors at amusement park in "Hall of mirrors" 1971 Arthur Tress (Time-Life/9 83)

boy in corner of room with eyes covered in "Rimose meeting" 1962 Ralph Eugene Meatyard (Time-Life/9 216)

boy in cowboy hat playing croquet in "Boy playing croquet" 1962 Bill Binzen (Time-Life/9 152)

boy in leather jacket sitting on bed in "Andrew Sanchez watching TV" 1971 Danny Lyon (Time-Life/9 170)

boy in sailor suit sitting on heart-shaped staircase in "Jerome Buttrick" 1965* Toni Frissell (Time-Life/9 63)

boy in street in "Street child" 1968 John Loengard (Time-Life/9 165)

boy jumping off wooden diving board into lake in "Boy on diving board" 1964 Bill Binzen (Time-Life/9 154)

boy leaning against Morgan sports car in "Boy with a Morgan" 1967 A. Doren (Time-Life/9 203)

boy looking out window onto quiet street in "Andy in Europe" 1966 Burk Uzzle (Time-Life/9 146)

boy making faces in mirror in "Boy looking in mirror" 1967 Larry Fink (Time-Life/9 145)

boy on sidewalk crying in pain in "Untitled" 1956 David Heath (Time-Life/9 214)

boy posing in burnt-out store in "Boy in a fire-bombed store" 1969 Arthur Tress (Time-Life/9 205)

boy running in surf to abandoned pier in "Boy at sea gate" 1968 Arthur Tress (Time-Life/9 207)

boy shooting basketball into hoop in "Lonely practice" 1969 James Carroll (Time-Life/9 28)

boy standing on broken piano ready to hurl rock at it in "Bashing a piano" 1962 Philip Jones Griffiths (Time-Life/9 153)

boy sweeping up manure to be used for fertilizer in "Small boy's work" 1951 W. Eugene Smith (Time-Life/10 75a)

boy swinging on swing in "Inertia" 1968 Egons Psuris (Time-Life/11 197)

boy with bicycle, seated on park bench in "Boy with a bicycle" Jay Maisel (Time-Life/9 179)

boy with cap riding a bicycle in "Boy on a bike" 1970 Armen Kachaturian (Time-Life/9 148)

boy with dirty face at picnic table in "Turning off" 1970 Jack Schrier (Time-Life/9 137)

boy with roots as hands in "Boy with root hands" 1970 Arthur Tress (Time-Life/9 206)

boy wrapped up in comic pages in "Matthew" 1965 Ken Josephson (Time-Life/9 143)

boys covered with feathers? standing on steps in "Gastonia, North Carolina" 1908 Lewis Hine (Hine 50)

boy's dirty T-shirt and mouth in "12th Street, Brooklyn" 1970 Anthony Szczygielski (Time-Life/16 187)

boys fighting in paper masks and shields in "Knights in paper armor" 1960 Henri Cartier-Bresson (Time-Life/9 25)

boys huddled together, holding crab in "Boys with a crab" 1964 Danny Lyon (Time-Life/9 188)

boys in corner of building in "Washington Square" 1967 A. Doren (Time-Life/9 202)

boys in knit caps by tree in "Boys going to school" Clarence White (Green 152)

boys in mock pose in front of wall with graffiti in "Boys with graffiti" 1955 Henri Cartier-Bresson (Time-Life/9 129)

boys playing pool in "Pool hall interior, St. Louis" 1910 Lewis Hine (Hine 96)

boys playing with ball on open field in "A private game for two, Sweden" 1966 Ulf Simonsson (Time-Life/9 29)

boys seated around card tables in "Newsboys' reading room, Boston" 1909 Lewis Hine (Hine 37)

boys standing in front of wooden plank fence in "Keep Me Close" c. 1938 Ben Shahn (Sandweiss 122#)

boys wearing striped shirts wearing masks in "Jamaica good time" 1966 Hiro (Hall-Duncan 168)

boys with bicycles on bridge in "Boys on the Brooklyn Bridge" 1967 A. Doren (Time-Life/9 125)

boys with hands on eyes in front of brick wall in "I am a camera" 1970 Ken Josephson (Time-Life/9 132)

boys with hot chocolate whispering secrets in "Paul and Eric" 1968 Arthur Freed (Time-Life/9 144)

by ruins of Greek temple in "Girl in a meadow" 1961 Bruce Davidson (Time-Life/9 219)

child lying naked on floor of forest in "Child in forest" 1951-54 Wynn Bullock (Bullock 49; Gruber 222#; Sandweiss 127#)

Chinese child in silk, holding tulip in "Tang Yung-Mei" 1942 Louise Dahl-Wolfe (Time-Life/9 167)

Chinese children holding each others pigtails in "Pigtail parade, San Francisco" c. 1897 Arnold Genthe (Time-Life/9 68)

circle of girls in traditional Hessian dress in "Hessian schoolgirls in their holiday costume, Mengsburg, near Treysa, Germany" 1908 Underwood

and Underwood (Loke 148)
covered by straw mats, walking in snow in "Snowcountries children"
 1956 Hiroshi Hamaya (Gruber 386#)
crying in rubble after bombing in "Chinese baby" 1937 H.S. Wong (Time-
 Life/10 36)
deformed boy and girl in "Retarded children, New Jersey" 1924 Lewis
 Hine (Hine 90)
digging in garbage dump in "Children at the dump, Boston" c. 1909
 Lewis Hine (Hine 45)
dressed in ornate costumes from trunk in "Costume trunk" 1964* Toni
 Frissell (Time-Life/12 35)
eating at table in room lined with newspapers in "Miner's family, Scott's
 Run, West Virginia" 1936-37 Lewis Hine (Hine 38)
face of boy in darkness in "Submariner" 1968 George Krause (Time-Life/
 9 211)
fishing from stone steps in "A minnow pool, the Finlay children" 1843-
 1848 Hill & Adamson (Gruber 246#)
following policeman as he walks with 'hobo' in "Arrest of a hobo, New
 York" 1897 Photographer Unknown (Gernsheim 313#; Gernsheim/2
 259#)
four holding hands in "The Kühn children" 1912 Heinrich Kühn (Time-
 Life/11 200)
four naked children seated in room in "Children at home" 1969 John Ben-
 son (Time-Life/9 185)
girl crying at edge of bed in "Girl crying" 1964 Charles Harbutt (Time-
 Life/9 81)
girl dragging empty sack along dirt road in "Kern County, California"
 1936 Dorothea Lange (Time-Life/9 74)
girl drawing on blackboard in "Polish girl" 1948 David Seymour (Time-
 Life/9 77)
girl in First Communion dress by family's village shack in "First Com-
 munion dress" 1951 W. Eugene Smith (Time-Life/10 72)
girl in torn dress trying on large new shoes in "Greek girl" 1949 David
 Seymour (Time-Life/9 78)
girl lying on grass with dolls in "Nancy" 1965 Emmet Gowin (Time-Life/9
 147)
girl painting on easel on wall in "Girl painting" 1971 Suzanne Szasz
 (Time-Life/9 82)
girl posed with feathers and flag in "Paula" 1966* Marie Cosindas (Time-
 Life/9 223)
girl posed with lilies and toy dog in "Fashion illustration" 1920 Gayne de
 Meyer (Time-Life/9 54)
girl singing by tombstone in "Child in a Welsh graveyard" 1965 Bruce
 Davidson (Time-Life/9 220)
girl sitting on grass with lap full of young goslings in "Goose girl" 1918
 André Kertész (Time-Life/9 72)
girl standing by open door in "Diffident entrance" 1969 Norman Snyder
 (Time-Life/9 135)
girl standing naked in bathtub near sink in "Erin in the shower" 1970
 Arthur Freed (Time-Life/9 174)
girl walking near dog, in front of stores in "Ramsgate, England" 1967
 Tony Ray-Jones (Time-Life/12 151)
girl watching boys in puppet theater in "Children's theater" 1965 Max
 Dellacher (Time-Life/9 141)
girl with bandaged head holding doll in hospital bed in "Eileen Dunne"
 1940 Cecil Beaton (Time-Life/9 76)
girl with braids sitting in field in "The pleasures of privacy" 1964

Charles Pratt (Time-Life/9 30)
girl with doll and straw hat in "Emily" 1968* Marie Cosindas (Time-Life/9 224)
girl with hands folded in lap, sitting amongst flowers in "Mountain girl and flowers" 1970 Arthur Tress (Time-Life/9 171)
girl with hat looking through window with raindrops in "Little girl in the rain" 1959 Bill Ray (Time-Life/9 166)
girl with straw flowers on hat, holding bouquet in "Mexican schoolgirl" 1968* John Dominis (Time-Life/8 108)
girls holding hats as they run through street in "School's out, Antigua" 1968 John Yang (Time-Life/9 27)
girls in school uniforms in "Schoolgirls in Trabzon, Turkey" 1965* Mary Ellen Mark (Time-Life/9 200)
girls playing dress-up in bedroom in "Princesses in borrowed finery" 1964 Dena (Time-Life/9 24)
girls playing in dirt of vacant lot in "Vacant lot playground, New York City" c. 1910 Lewis Hine (Hine 92)
girls playing ring toss indoors in "Ring toss" 1899* Clarence H. White (Green 69; Gruber 277#; Time-Life/12 29)
group of boys and girls playing together in "Gypsy children" 1964 Josef Koudelka (Gruber 382#)
holding hands and spinning in circle in "Child's game" 1965* Steven C. Wilson (Time-Life/7 93)
in make-believe army costumes in "Children at play" 1968 Lilo Raymond (Time-Life/9 182)
in raincoats and hats standing in rain with open mouths in "Singing and drinking rain" 1950 Barbara Morgan (Time-Life/9 79)
in tableau vivant in "The children of Victoria and Albert" 1854 Roger Fenton (Time-Life/9 37)
jumping rope by front stoop of apartment house in "[A street scene on New York's Lower East Side]"* Marcia Keegan (Time-Life/10 102-3)
leaning over porch railing in "On a porch" 1967 Danny Lyon (Time-Life/9 186)
line of boys leaning over wall in "Excitement" 1888 Frank M. Sutcliffe (Gernsheim 328#; Gernsheim/2 281#; Gruber 423#; Time-Life/9 66)
lying in front of car in "Richie and car" 1967 Emmet Gowin (Time-Life/9 208)
lying in puddle on sidewalk in "Child lying in water" 1968 Raimondo Borea (Time-Life/9 156)
mother holding hand of child trying to roller skate in "Untitled" 1958 David Heath (Time-Life/9 215)
naked boys leaning on beached boat in "Natives of these isles" 1885 Frank M. Sutcliffe (Gruber 385#; Time-Life/9 69)
naked child on tree limb in "In a blue moon" 1929 Nell Dorr (Time-Life/9 57)
naked child standing among tall thistles in "Child among thistles" 1956 Wynn Bullock (Bullock 15)
naked girl with flowers in hair in "Paula nude" 1966* Marie Cosindas (Time-Life/9 222)
naked young boy near cliff in "Boy in the mountains" 1922 Imogen Cunningham (Time-Life/9 56)
near straw animals in "Ambalangoda, Ceylon" 1969* Bernard Wolf (Time-Life/9 197)
Nepalese boy squatting in dirt field in "Boy catching insects" 1970* Mary Ellen Mark (Time-Life/9 199)
Nepalese girl at small colored statues in "Girl coloring sculpture" 1970* Mary Ellen Mark (Time-Life/9 198)

portrait of three girls in "Three girls, Berlin" 1843* Gustav Oehme (Bernard 7#)

portrait of young Burmese girl in "Burmese girl" 1852* John McCosh (Bernard 13#)

portrait with mother in "Portrait of Mrs. Klah Sewall and family" c. 1840 Photographer Unknown (Time-Life/7 183c)

profile of child seated in church pew in "Sanctuary" 1958 George Krause (Time-Life/9 213)

posing outside white, wood-frame schoolhouse in "School, Ash Grove, California" 1916 Lewis Hine (Hine 41)

a row of boys looking over wall in "Stern realities" or "Excitement" 1888-1900 Frank M. Sutcliffe (Gernsheim 328#; Gruber 423#; Time-Life/9 66)

seated boy holding flag and undressed doll in "Christopher and the rebuilding of America" 1961 Ralph Eugene Meatyard (Time-Life/9 162)

seated on stone wall in "Siminae la Rotonde" 1970 Henri Cartier-Bresson (Cartier-Bresson 85)

shirtless boy with hamburger in mouth in "Hamburger grin" 1968 John P. Aikins (Time-Life/9 131)

shoes of children standing around dead rabbit in "First death" 1965 George W. Gardner (Time-Life/9 80)

silhouettes of children and dog under tree in "Childhood" 1967 Harald Sund (Time-Life/16 179)

small Black girl holding mother's hand in "A safe grip" 1963 George Krause (Time-Life/9 18)

small boy wearing large hockey gloves in playground in "Boy with ice hockey gloves" 1970 Arthur Tress (Time-Life/9 204)

small child on dirt road in "Child on forest road" 1958 Wynn Bullock (Bullock 13)

small child swinging by door knobs in "A door is for swinging" 1965 Ken Josephson (Time-Life/9 17)

small girl with finger in mouth, hiding under torn drapes in "Tenement child" 1953 Rae Russel Gescheidt (Time-Life/9 164)

small shirtless child among adults in "Plea for reassurance" 1963 Ron James (Time-Life/9 19)

smiling boy carrying bottles of wine in "Sunday morning errand, Paris" 1958 Henri Cartier-Bresson (Time-Life/9 23)

smiling boy with men in "Meeting father's friends, Hungary" 1963 Paul Schutzer (Time-Life/9 20)

smiling girl in thongs in "Pico Island, Azores" 1970* Bernard Wolf (Time-Life/9 195)

standing on limbs of leafless trees in "On Lansdowne Road" 1965 Alen MacWeeney (Time-Life/9 187)

swinging each other in "Peking Mission School children at play, China" 1902 C.H. Graves (Loke 121)

three girls in soiled dresses, standing on dirt road in "Young workers at cotton mill, Kosciusko, Mississippi" 1913 Lewis Hine (Hine 46)

two boys playing in capes in "Batman and Robin" 1970 Terry Bisbee (Time-Life/9 140)

two boys, two buckets and two turkeys in "Barry, Dwayne and turkeys" 1969 Emmet Gowin (Time-Life/9 209)

two girls on bridge across river in "Two girls on the bridge across the River Ouse, near Ely, England" 1911 Underwood and Underwood (Loke 157)

two girls standing by wooden steps in "Lacy, twelve years old, and Savannah, eleven years old, Gastonia, North Carolina" 1908 Lewis Hine (Hine 87)

two sitting on street in "Street urchins" c. 1860 Oscar Rejlander (Gern-

sheim 122#; Gernsheim/2 105#)
walking five abreast on street in "On the way from school" c. 1887 Wil-
liam Schmid (Photography 150)
walking in step by baby carriage in "Children walking in step" 1966
Raimondo Borea (Time-Life/9 139)
with goats by cottage in "Children in Warsaw, Poland" B.W. Kilburn
(Loke 149)
with intertwined arms holding eggs in "See what I can do with eggs"
1969 Emmet Gowin (Time-Life/9 130)
with outstretched arms playing blindman's buff in "Blindman's bluff,
Strasbourg" 1960 John Yang (Time-Life/9 22)
with paper over face in "I can see you, but you can't see me" 1966 Alen
MacWeeney (Time-Life/9 133)
with sad faces, held by madonna-like woman in "Mary Hillier with two
children" 1864 Julia Margaret Cameron (Time-Life/12 83b)
with tears on cheeks in "Child in distress" 1947 Werner Bischoff (Time-
Life/9 175)
with wind-swept hair, in shirt in "Amy" 1957 Diane Arbus (Time-Life/9
176)
with wings and clasped hands in "The rising of the new year" c. 1872
Julia Margaret Cameron (Time-Life/9 42)
young boys seated on man's lap in "Beach babies" 1969 Diane Arbus
(Hall-Duncan 181)
young child wrapped in blankets in "Jewish child" 1938 Roman Vishniac
(Gruber 384#)
young girl by screen door in "Daughter of Mr. Thaxton, farmer near
Mechanicsburg, Ohio, Summer" 1938 Ben Shahn (Sandweiss 123#)
young girl crying near sleeping man in "Comfortless child, exhausted
father, Rio de Janeiro" 1961 Gordon Parks (Time-Life/9 21)
young girl in party dress holding flowers in "Maria, Mexico" 1966* Marie
Cosindas (Time-Life/9 62)
young girl in soiled dress in "Gypsy child, Ireland" 1966 Alen MacWeeney
(Time-Life/9 159)
young girl on swing in "The swing" 1966 Suzanne Szasz (Time-Life/9
151)
young girl seated with legs crossed, in white gown in "New York child"
1953 Irving Penn (Time-Life/7 216)
young girl with hat and coat, sitting on pony in "Mary McGee, Jersey
City" 1926 Photographer Unknown (Time-Life/9 53)
young girl with wings in "Cupid reposing" 1872 Julia Margaret Cameron
(Time-Life/9 43)
young girls in pink dresses and white hats in "Sunday in St. Vincent"
1967* Bill Binzen (Time-Life/8 33)
young red-headed boy in sweater and jacket in "Galway boy" 1966*
Humphrey Sutton (Time-Life/8 107)
CHILLON CASTLE
view from lake in "Le Château de Chillon" 1867 Adolphe Braun (Time-Life/
7 198a)
CHIMNEYS
dark smoke from brick smokestack in "Milan" 1938 Bruno Stefani (Gruber
367#)
tilted and of brick in "Chimney" 1969 Sebastian Milito (Time-Life/11 45)
CHIMPANZEES
sitting on man's lap in "The photographer with 'Toto,' his famous pet
chimpanzee" Cherry Kearton (Guggisberg 74)
CHINESE
children seated at long tables in classroom in "Chinese schoolchildren and

their teacher at an American Board of Missions school, Peking" Keystone View Company (Loke 150c)

hunters near game hanging on poles in "After a day's hunt in the Yangtze River Valley, China" Photographer Unknown (Loke 132c)

man eating from bowl at wooden table in "The last days of the Kuomintang, Peking" 1949 Henri Cartier-Bresson (Cartier-Bresson 63)

man having head shaved by street barber in "A street barber, Peking" 1902 C.H. Graves (Loke 126b)

Manchu noblewomen seated by windows in "A group of Manchu noblewomen and a maidservant, Peking, China" 1902 C.H. Graves (Loke 188)

old man in silk robe in "Li Hung-chang, Chinese statesman and diplomat" 1900 Photographer Unknown (Loke 39)

parents posing with their young children in "A Chinese family" Keystone View Company (Loke 213)

portrait of a young Chinese man in "Envoy from Cochin China in Paris" 1863* Louis Rousseau (Bernard 78#)

soldiers seated in group, holding rifles in "China" 1958 Henri Cartier-Bresson (Gruber 418#)

woman and children seated on wooden steps in "A Chinese woman and her children outside their cabin in Olympia, Washington" B.W. Kilburn (Loke 60)

CHRISTMAS

tree decorated, in corner of room with television in "Christmas tree" 1962 Diane Arbus (Gruber 376#)

tree ornaments in box in "Found color" 1959-1969* Gene Laurents (Time-Life/8 47)

CHRYSLER BUILDING, NEW YORK CITY

and boarded-up apartment building in "News Building" 1938 Berenice Abbott (Gruber 371#)

CHURCHES

adobe building in "Church, Ranchos De Taos, New Mexico" 1930 Paul Strand (Sandweiss 93#)

children playing in grass by small white church in "Puget Sound" 1967* Bill Binzen (Time-Life/8 95)

profile of child seated in church pew in "Sanctuary" 1958 George Krause (Time-Life/9 213)

white clapboard building in "Church" 1944 Paul Strand (Photography 302)

CIGARS

silhouette of man with glasses, smoking in "Portrait of Bill Cosby" 1969 John Loengard (Time-Life/12 133)

CINCINNATI, OHIO

steamboats at the docks in "Cincinnati waterfront" 1848 Southgate & Hawes (Time-Life/14 69d)

CIRCUS

girl standing on back of horse in ring in "In the circus" or "Circus rider" 1905* Harry C. Rubincam (Gernsheim/2 205#; Green 90; Time-Life/12 31)

man twirling baton in "H. Lissik, circus performer, twirling baton" 1886 Harrison Putney (Sandweiss 39#)

performer on white horse in "Circus" 1967* Marcia Keegan (Time-Life/16 191)

performer with baton in "H. Lissisk, circus performer, twirling baton" 1886 Harrison Putney (Sandweiss 39#)

tent with giant pair of legs at entrance in "[Giant pair of legs with sunburst for body]"* Luigi Chirri (Time-Life/12 139)

three men standing on bare backs of horses, near tent in "Three bareback riders" Nathan Lazarnick (Bernard 180#)

CITIES see Berlin, Germany; Canton, China; Charleston, South Carolina;
 Cincinnati, Ohio; Coney Island, New York; Edinburgh, Scotland;
 Hamburg, Germany; Jerusalem, Israel; Lubeck, Germany; Luxor,
 Egypt; Milan, Italy; Mont St. Michel; Moscow, Soviet Union; Naga-
 saki, Japan; New York City; Paris, France; Prague, Czechoslovakia;
 Richmond, Virginia; San Francisco, California
CITIES AND TOWNS, RUINED, EXTINCT, ETC.
 ancient Greek ruins in "Propylaen, East Wing" 1928-29 Walter Hege (Gru-
 ber 348#)
 buildings of Richmond in rubble in "Ruins of Richmond" 1865 Mathew B.
 Brady (Gruber 41#)
 burned-out building in "Burned-out ruin with the new Stock Exchange"
 1842 Carl Ferdinand Stelzner (Gruber 2#)
 burned-out building in "Burned-out ruin and the Nicolai Church" 1842
 Carl Ferdinand Stelzner (Gruber 1#)
 Hamburg after the fire in "Ruins of Hamburg after the great fire" 1842
 Carl F. Stelzner (Gernsheim/2 63#; Time-Life/14 85)
 Richmond, Virginia in ruins in "Ruins of Richmond" 1865 Mathew Brady
 (Gernsheim 170#; Gernsheim/2 148#; Gruber 41#)
 rubble of a mill in "Ruins of paper mill, Richmond, Virginia" 1865
 Alexander Gardner (Gruber 39#)
 rubble of buildings in "Munich" 1945 Herbert List (Gruber 354#)
 rubble of large building in "Ruins in Columbia, South Carolina" 1865
 George N. Barnard (Gruber 40#)
 statues and walls with hieroglyphics in "Karnak" c. 1850 Félix Teynard
 (Gruber 369#)
CIVIL RIGHTS
 black man being kicked by white mob in "Violence in Little Rock" 1958
 I. Wilmer Counts (Time-Life/10 45)
CIVIL WAR--U.S. see U.S.--HISTORY--CIVIL WAR, 1861-1865
CLARINETS
 boy holding instrument in "Portrait of a boy" 1960 Jean-Louis Swiners
 (Time-Life/12 134)
CLASSROOMS
 boys at lathes in "High school workshop, Rockford, Illinois" Underwood
 and Underwood (Loke 217)
 children standing and holding books in "Jamaican schoolchildren and their
 teacher, Jamaica" 1904 H.C. White (Loke 150b)
 Chinese children seated at long tables in "Chinese schoolchildren and
 their teacher at an American Board of Missions school, Peking" Key-
 stone View Company (Loke 150c)
 class of student artists in "Tokyo fine-arts class" Underwood and Under-
 wood (Loke 116a)
 girls doing exercises in gymnasium in "Gym class, Tuskegee Institute,
 Alabama" 1905 Underwood and Underwood (Loke 147b)
 girls in aprons in cooking class in "High school domestic-science room,
 Rockford, Illinois" Underwood and Underwood (Loke 216)
 same teacher in many areas of the room in "A teacher's tasks" 1954
 Ralph Morse (Time-Life/16 89)
 young children seated around long tables and on floor in "Day nursery"
 1907 Brown Bros. (Loke 144)
 young girls' sewing class in "At a mission school for girls, Lydda, Pales-
 tine" Underwood and Underwood (Loke 150d)
CLOCKS AND WATCHES
 bird nest at base of octagonal clock in "And tell of time ... cobwebed
 time" 1947 Clarence John Laughlin (Time-Life/12 49)
 on moon-like surface in "Moonset" 1969* Hiro (Hall-Duncan 170)

CLOUDS
 in tones of gold in "Clouds" c. 1859* Roger Fenton (Bernard 63#)
 small patches, low in deep blue sky in "Landscape with clouds, vicinity
 of Hartsel, Colorado" 1969* Harald Sun (Time-Life/14 23)
 small puffs filling sky over ships' masts in "Ship masts" 1959 Wynn Bul-
 lock (Bullock 35)
 various types in "Equivalents" 1930 Alfred Stieglitz (Gruber 85a-c#)
COBWEBS
 and bird nest at base of octagonal clock in "And tell of time ... cob-
 webed time" 1947 Clarence John Laughlin (Time-Life/12 49)
COCONUTS
 red diamond ring inside half of coconut in "Red diamond" 1969* Charles
 R. Collum (Time-Life/13 217b)
COMBING HAIR see HAIR
COMBS
 and gyroscope in "A comb entering a gyroscope" 1922 Man Ray (Photog-
 raphy 229a)
COMMENCEMENTS
 young women carrying chain of daisies in "The Daisy Chain carried by
 sophomores ushering out the year's graduating class, Commencement
 Day, Vassar College, Poughkeepsie, New York" c. 1906 Underwood and
 Underwood (Loke 146)
COMPUTERS
 room with computer hardware in "A new lens design print-out in the
 computer room of an optical manufacturer"* Enrico Ferorelli (Time-
 Life/12 87)
CONDUCTORS (MUSIC)
 and musicians at a rehearsal in "Igor Stravinsky conducting a rehearsal"
 1929 Felix H. Man (Photography 274)
CONEY ISLAND, NEW YORK
 ferris wheel and boardwalk in snowstorm in "Coney Island, New York"
 1964 Neal Slavin (Time-Life/14 31)
 Luna Park during the daytime in "Luna Park, Coney Island, by day"
 Underwood and Underwood (Loke 112a)
 Luna Park electrified at night in "Luna Park by night" Underwood and
 Underwood (Loke 112c)
CONGOLESE
 fathers and sons by their homes in "Fathers and sons, the Congo" Un-
 derwood and Underwood (Loke 105)
CONSTRUCTION WORK see BUILDING
CONTAINERS
 of cardboard and eggs in "Eggs and cartons" 1968* Martin Schweitzer
 (Time-Life/11 56d)
CONVERSATIONS
 barefoot girls standing and talking in kitchen in "All the time in the
 world" 1964 William Gedney (Time-Life/9 33)
 between boy and girl at wire fence in "Serious conversation, Romania"
 1963 Paul Schutzer (Time-Life/9 34)
 men listening intently, around small table in "Meeting of diplomats at
 Lugano" 1928 Erich Salomon (Time-Life/7 164b)
 of two men in "Photo-interview of F.T. Nadar with the centenarian scien-
 tist Chevreul" 1886 Paul Nadar (Bernard 115#; Gernsheim 230#)
COOKERY, OUTDOOR
 children watching an ox-roast in "Ox-roasting at Stratford-on-Avon 'Mop'"
 c. 1898 Benjamin Stone (Gernsheim 311#; Gernsheim/2 265#)
 clothesline over men at campsite in "T.E.R.A. Camp Green Haven, New
 York State" 1936-37 Lewis Hine (Hine 93)

COOKING UTENSILS see HOUSEHOLD EQUIPMENT AND SUPPLIES
CORMORANTS
 nesting in a dead tree in lake in "Cormorants nesting in a dead tree in
 Lake Naivasha" Cherry Kearton (Guggisberg 72)
COSMETICS
 eyes surrounded by butterfly wings and feathers in "Butterfly wing
 eyes" 1964* Bert Stern (Hall-Duncan 163)
 lipsticks and cosmetic containers as still life in "Cosmetics containers"
 1968* Henry Sandbank (Time-Life/13 38)
COSTUMES
 children dressed in ornate costumes from trunk in "Costume trunk" 1964*
 Toni Frissell (Time-Life/12 35)
 man dressed as Osiris for costume ball in "Pierre Loti dressed as Osiris
 for a fancy dress ball" c. 1880* E. Montastier (Bernard 108#)
COTTON
 Black men, women and children picking cotton in "Blacks picking cotton
 in Texas" Photographer Unknown (Loke 141)
COTTON-CANDY
 on peddlers pushcart in "Cotton-candy vendor in twilight colors, Mexico"
 1969* Douglas Faulkner (Time-Life/8 79)
COUCHES
 woman lying on small couch in "Satiric dancer" 1926 André Kertész (Time-
 Life/11 177)
 ornate loveseat with two floral pillows in "Dr. Soter's pink couch" 1976*
 Wayne Sorce (Gruber 167#)
COUGARS
 on branches of tree in "Cougar ... after having been treed by a pack
 of hounds" A.G. Wallihan (Guggisberg 38)
COUPLES
 asleep in train, with arms around each other in "Rumania" 1975 Henri
 Cartier-Bresson (Cartier-Bresson 83)
 boy with arm around girl in "Teenage couple, New York City" 1963 Diane
 Arbus (Time-Life/7 223)
 man and woman in formal attire, lying on pillows in "Untitled" c. 1930
 George Hoyningen-Huene (Hall-Duncan 60)
 man and woman in swim suits, on beach in "Two-piece swimming-suit"
 1930 George Hoyningen-Huene (Hall-Duncan 61)
 poor man and woman in truck in "Ex-tenant farmer on relief grant in the
 Imperial Valley, California" 1937 Dorothea Lange (Gruber 93#)
 two nudes walking away in "The Imaginary Photograph" 1930 Frantisek
 Drtikol (Gruber 220#)
 woman on lounge chair by man at small table in "Two on a terrace" 1932
 The 3 (Hall-Duncan 59)
COURTS
 judge's seat and witness stand in "Green County Court House" 1976*
 Stephen Shore (Gruber 169#)
COWBOYS see COWHANDS
COWHANDS
 in bar in "Bar--Gallup, New Mexico" 1955 Robert Frank (Time-Life/11
 135)
 man in chaps, gun and holster in "Wyoming cowboy" c. 1895 Charles D.
 Kirkland (Sandweiss 40#)
 man with hat and neckerchief in "[Texas Cowboy]" Leonard McCombe
 (Time-Life/12 108)
 on horse, roping calf in "Calf roper, Madison Square Garden" 1968* Ernst
 Haas (Time-Life/8 144)
 riding horses on open range in "Western homecoming" 1958* Ernst Haas

(Time-Life/8 151)
COWS
 resting outside of car window in "Fenville, Michigan" 1970 Reed Estabrook
 (Time-Life/11 143)
CRABS
 ghost crab on beach in "Ghost crab" Jack Dermid (Rugoff 147#)
CRANES
 flock in flight in "Cranes migrating along the White Nile" Bengt Berg
 (Guggisberg 87)
 standing by water faucet in "New York" 1946 Elliot Erwitt (Gruber 441#)
CREEKS
 small falls and green rocks by creek in "Roaring Fork Creek, Great
 Smoky Mountains National Park"* William A. Bake, Jr. (Rugoff 139#)
 tree-lined creek in autumn in "Big Santeetlah Creek"* William A. Bake,
 Jr. (Rugoff 138#)
CRIMEAN WAR, 1853-1856
 encampment of tents and horses in valley in "Encampment of Horse Artil-
 lery, the Crimea" 1855 Roger Fenton (Time-Life/14 87)
 Hussar soldiers eating from big pots in "The cookhouse of the 8th Hus-
 sars" or "Field kitchen of the 8th Hussars, the Crimea" 1855 Roger
 Fenton (Gernsheim 166#; Time-Life/14 86)
 piles of cannonballs near ship in "Ordnance Wharf, Balaclava, Crimean
 War" 1855 Roger Fenton (Gernsheim 164#)
 sandbagged fortification and cannons in "The Battlefield of Sebastopol"
 1855* Jean-Charles Langlois (Bernard 33#)
 three uniformed soldiers with rifles in "'Crimean Braves'" Pub. 1856*
 Joseph Cundall and Robert Howlett (Bernard 34#)
CRIMINALS
 deputy surrendering to men with guns in "San Rafael breakout" 1970
 Roger Bockrath (Time-Life/10 43)
CRIPPLED PEOPLE see HANDICAPPED
CROCODILES
 at feet of group of African men in "Africans beside a crocodile that was
 shot by a white hunter, Uganda" 1909 Underwood and Underwood
 (Loke 133d)
 emerging from water in "Photographing sacred 'muggers' (marsh croco-
 diles) in India" H.G. Ponting (Guggisberg 78)
CROQUET
 boy with cowboy hat playing croquet in "Boy playing croquet" 1962 Bill
 Binzen (Time-Life/9 152)
CROWDS
 at opening ceremonies of Crystal Palace in "Opening by Queen Victoria
 of the rebuilt Crystal Palace at Sydenham" 1854 P.H. Delamotte (Gern-
 sheim/2 135#)
 backs of group kneeling in forest in "The burial of Leo Tolstoy" 1910*
 Photographer Unknown (Bernard 165#)
 Black man being kicked by white mob in "Violence in Little Rock" 1958
 I. Wilmer Counts (Time-Life/10 45)
 circle of people photographed with fisheye lens in "Fisheye view" 1968
 Robert Packo (Time-Life/7 126)
 gathered at large open grave in "Karl Liebknect speaking at the mass
 grave of fallen Spartacists, Berlin" 1919* Photographer Unknown
 (Bernard 176#)
 in China watching execution of man in "Execution of a Boxer leader,
 China" 1900 B.W. Kilburn (Loke 45c)
 lining street to watch motorcade in "Wendell Willkie motorcade" 1940 John
 D. Collins (Time-Life/10 25)

man kissing Cardinal's hand in "Cardinal Pacelli at Montmartre, Paris" 1938 Henri Cartier-Bresson (Cartier-Bresson 45)

men reading notice on wall in "Proclamation of the Army for Italy" 1859 C. Silvy (Gernsheim 359#)

of immigrants aboard ship in "The Steerage" 1907 Alfred Stieglitz (Gernsheim 341#; Gernsheim/2 306#; Green 307; Gruber 61#; Hine 119; Sandweiss 74#; Time-Life/12 37)

people seated in stadium in "The white shirt" 1968* Robert D. Routh (Time-Life/8 225)

Polish peasants in marketplace in "Market scene in Warsaw, Poland" c. 1896 B.W. Kilburn (Loke 57b)

seated around altar in baseball stadium in "The Papal Mass at Yankee Stadium, New York City" 1965* Ralph Morse (Time-Life/14 225)

standing above man sleeping in newspapers in "Trafalgar Square on the day George VI was crowned, London" 1938 Henri Cartier-Bresson (Cartier-Bresson 53)

standing with umbrellas in front of platform in "Nomination of election candidates" or "Election meeting at Dover" 1863-1865 Photographer Unknown (Gernsheim 173#; Gernsheim/2 129#)

waiting at pier in "Waiting for the boat, Greenwich" 1857 George Washington Wilson (Gernsheim 155#; Gernsheim/2 130#)

watching parade of men on horseback in "Nicholas II" Paul Nadar (Tournachon 281b)

waving hands and flags in "May Day celebration, Havana" 1961 Paolo Gasparini (Time-Life/12 148)

white-helmeted police jousting with shielded demonstrators in "Tokyo riot" 1971* Bruno Barbey (Time-Life/12 14)

with upraised arms in "Gymnastics in a refugee camp at Kurukshatra, Punjab, India" 1948 Henri Cartier-Bresson (Cartier-Bresson 69)

CRYING

baby crying in rubble after bombing in "Chinese baby" 1937 H.S. Wong (Time-Life/10 36)

boy on sidewalk crying from pain in "Untitled" 1956 David Heath (Time-Life/9 214)

child with tears on cheeks in "Child in distress" or "Hunger" 1947 Werner Bischof (Gruber 279#; Time-Life/9 175)

girl crying at edge of bed in "Girl crying" 1964 Charles Harbutt (Time-Life/9 81)

Japanese men and women with handkerchiefs to eyes in "Funeral of a Kabuki actor, Japan" 1965 Henri Cartier-Bresson (Cartier-Bresson 79)

man weeping in "Arturo Toscanini retires" 1954 Sy Friedman (Time-Life/10 48)

young girl near sleeping man in "Comfortless child, exhausted father, Rio de Janeiro" 1961 Gordon Parks (Time-Life/9 21)

CRYSTAL PALACE

crowds at opening ceremonies in "Opening by Queen Victoria of the rebuilt Crystal Palace at Sydenham" 1854 P.H. Delamotte (Gernsheim/2 135#)

the visit of Napoleon III and Queen Victoria in "The visit of Napoleon III and Empress Eugenie with Queen Victoria and Prince Albert to the Crystal Palace" 1855 P.H. Delamotte (Gernsheim 162#; Gernsheim/2 136#)

CUBANS

poor Black family cooking in shack in "A peasant's home in Santiago de Cuba" Underwood and Underwood (Loke 55)

waving arms and flags in "May Day celebration, Havana" 1961 Paolo Gasparini (Time-Life/12 148)

wealthy family seated in lush garden in "A wealthy Cuban family" Under-
wood and Underwood (Loke 54)
CUCKOOS
bird on branch being fed by bird on its back in "A young cuckoo brought
up by robins is here seen being fed by a sedge warbler perched on
its back" Oliver G. Pike (Guggisberg 28)
CURLEWS
a great stone curlew in "Great stone curlew" A. Hoogerwerf (Guggisberg
92d)
CUSCUS
spotted cuscus on branch in "Spotted cuscus" Charles L. Barrett (Gug-
gisberg 33)
CYPRESS TREES
identical trees lining a dirt road in "Cypress Alley" 1903 Theodor and
Oskar Hofmeister (Gruber 251#)
in swamp in "Florida cypress trees in Big Cypress Swamp"* Ed Cooper
(Rugoff 165#)

D

D DAY see NORMANDY, ATTACK ON, 1944
DAISIES
in seated woman's hat in "Lady in lawn chair" 1908* Photographer Unknown
(Time-Life/8 75)
young women carrying chain of daisies in "The Daisy Chain carried by
sophomores ushering out the year's graduating class, Commencement
Day, Vassar College, Poughkepsie, New York" c. 1906 Underwood
and Underwood (Loke 146)
DALMATIANS
and woman in polka dot dress in "Blotches of sunlight and spots of ink"
George H. Seeley (Green 148)
model in fur coat, holding dog on leash in "Boom for brown beavers"
1939 Toni Frissell (Hall-Duncan 74)
DAMS
the Fort Peck Dam on the cover of Life in "[Fort Peck Dam]" 1936 Mar-
garet Bourke-White (Gruber 97#; Time-Life/10 63a)
DANCERS AND DANCING
Cossack men dancing in "Cossacks dancing, Russia" c. 1896 B.W. Kilburn
(Loke 67a)
couples in a nightclub in "Studio 54" 1977 Larry Fink (Gruber 408#)
couples in ballroom in "Ballroom scene" c. 1855 Photographer Unknown
(Gernsheim 145#; Gernsheim/2 124#)
couples of all ages in "10,000 Montana relief workers make whoopee on
Saturday night" 1938 Margaret Bourke-White (Time-Life/10 63c)
Egyptian dancer and musicians in "Egyptian dancer and musicians" c.
1890* Photographer Unknown (Bernard 132#)
group of dancing seminarians in "Seminarians dancing" 1965 Mario Gia-
comelli (Time-Life/11 129)
in the Savoy Ballroom in Harlem in "Savoy dancers, Harlem" 1936* Aaron
Siskind (Bernard 206#)
middle-aged couples dancing in "[Dance pavilion at amusement park]"
Anders Petersen (Time-Life/12 133)
multiple exposure of man tap dancing in "Gregory Hines" 1981* Enrico
Ferorelli (Time-Life/14 219)
nude woman dancing with veil in "Doris Humphrey dancing naked" c.
1916* Arnold Genthe (Bernard 173#)

Russian workers in poster-filled room in "Cafeteria of the workers' build-
ing, the Hotel Metropol, Moscow" 1954 Henri Cartier-Bresson (Cartier-
Bresson 61)
three men in mid-air in "Centaurs--Charles Weidman, José Limón and Lee
Sherman" 1939 Gjon Mili (Time-Life/7 212)
DANDELIONS
its feathery seeds in "Dandelion" Ralph Weiss (Rugoff 135#)
DART BOARD
couple embracing under it in "[Embrace under a dart board]" Anders
Petersen (Time-Life/12 136)
DAUGHTERS OF THE AMERICAN REVOLUTION
women posing for portrait in "The Generals of the Daughters of the
American Revolution, Washington, D.C." 1963 Richard Avedon (Avedon
14•)
DEATH. See also ASSASSINATIONS; CAPITAL PUNISHMENT; CEMETERIES;
FUNERALS; MURDERS
Asanuma being killed by assassin in "Inejiro Asanuma and assassin" 1960
Yasushi Nagao (Time-Life/10 31)
blood-covered man lying on ground in "Dead Confederate soldier" 1865*
Timothy H. O'Sullivan (Bernard 81#)
body covered with towels on floor of barber shop in "Detectives inspect
the corpse of Albert Anastasia" 1957 George Silk (Time-Life/10 42)
chaplain holding soldier in "Chaplain and soldier" 1962 Hector Rondon
(Time-Life/10 37)
Confederate soldier lying in trench in "Dead Confederate soldier in
trenches of Fort Mahone at Petersburg, Virginia" 1865 Timothy H.
O'Sullivan (Gruber 420#)
Confederate soldiers by fence and road in "Confederate dead by fence on
the Hagerston Road, Antietam" 1862 Alexander Gardner (Photography
72a)
Indian Medicine Man lying on ground in "The Medicine Man--taken at the
Battle of Wounded Knee, South Dakota" 1891 George Trager (Sandweiss
50#)
man hanging from telephone wires after smashing car into telephone pole
in "Automobile accident" 1945 William W. Dyviniak (Time-Life/10 40)
man in uniform, on deathbed in "Dom Pedro II of Alcantara, Emperor of
Brazil" 1891 Paul Nadar (Tournachon 286b)
man with white beard in "Victor Hugo on his deathbed" 1885 Nadar (Gern-
sheim 231#; Tournachon 109)
men in open wooden coffins in "Bodies of unidentified Communards" 1871
Photographer Unknown (Gernsheim/2 152#)
men on battlefield in "The Harvest of Death. The battlefield of Gettys-
burg" 1863 Timothy H. O'Sullivan (Gernsheim/2 146#; Gruber 42#)
people viewing bodies of soldiers on beach in "D-Day plus one: the
Dead on Normandy Beach" 1944 Robert Capa (Gruber 421#)
Robert F. Kennedy after being shot in "Robert F. Kennedy shot" 1968
Bill Eppridge (Time-Life/10 30)
Russian soldiers looking at dead Japanese soldiers in "Russian soldiers
viewing bodies of Japanese war dead in a trench, Port Arthur" Bert
Underwood (Loke 84)
shoes of children standing around dead rabbit in "First death" 1965
George W. Gardner (Time-Life/9 80)
soldier lying in trench in "Dead Confederate soldier, Petersburg, Virginia"
1865 Mathew Brady or assistant (Time-Life/14 105)
soldier with gun at moment of death in "Falling Spanish soldier" 1936
Robert Capa (Gruber 419#)
soldiers in fort in "Capture of Fort Taku, North China" 1858 Photographer

Unknown (Gernsheim 168#; Gernsheim/2 143#)
 soldiers in row on ground in "Gathered for burial at Antietam after the
 Battle of September 17, 1862" Alexander Gardner (Photography 72b)
 woman falling from hotel window in "Suicide" 1942 I. Russell Sorgi (Time-
 Life/10 41)
 woman on her deathbed holding cross in "Marceline Desbordes-Valmore on
 her deathbed" 1859 Nadar (Tournachon 12)
 women around dead man in "His wife, daughter, granddaughter and
 friends have their last earthly visit with a villager" or "Spanish wake"
 1951 W. Eugene Smith (Time-Life/7 219; Time-Life/10 81)
 young child lying in bed with man by her side in "Post-mortem picture"
 c. 1850* A. Le Blondel (Bernard 16#)
 young woman in bed, attended by others in "Fading away" 1858 Henry
 Peach Robinson (Gernsheim 126#; Gernsheim/2 108#; Gruber 37#; Time-
 Life/7 188c)
DEATH VALLEY
 inner walls of Ubehebe Crater in "Inner walls of Ubehebe Crater, Death
 Valley National Monument, California"* David Muench (Rugoff 64#)
 mounds of brown-toned alkali in "Caked alkali in bottomland near Mesquite
 Flat Dunes, Death Valley"* David Muench (Rugoff 68#)
 ridge of a barren sand dune in "Death Valley" 1970* Charles Moore (Time-
 Life/16 27)
 sharp salt floor in "Salt floor of the Devil's Golf course in Death Valley"*
 David Muench (Rugoff 67#)
 sunrise highlighting golden sand dune in "Sunrise on Mesquite Flat
 Dunes"* David Muench (Rugoff 69#)
 surface of land like fish scales in "Artist's Palette, a volcanic area of
 Death Valley"* David Muench (Rugoff 65#)
 volcanic patterns and edge of crater in "Volcanic patterns on the edge of
 Ubehebe Crater, Death Valley"* David Muench (Rugoff 66#)
DEER
 buck with fore-legs in pond in winter in "A white-tailed buck crosses a
 Louisiana pond in winter"* Thase Daniel (Rugoff 93#)
 doe and fawns in stream at night in "Doe white-tailed deer with twin
 fawns" 1896 George Shiras (Guggisberg 39)
 fawn crossing trout-filled stream in "Fawn and trout, Montana" 1961*
 George Silk (Time-Life/14 227)
 in forest of birch trees in "White-tailed deer in woods"* Larry West (Rug-
 off 112#)
 red deer feeding in "[Red deer feeding]" 1884 Ottomar Anschutz (Guggis-
 berg 18)
 still life with dead deer, wild fowl and guns in "Still life with deer and
 wild fowl" c. 1865* Adolphe Braun (Bernard 85#)
DEMONSTRATIONS
 shirtless young men marching with signs in "Chicago suburb" 1966 Bene-
 dict J. Fernandez (Time-Life/7 21c)
DEPRESSION--U.S.
 children on bare ground by tents in "Okie homes in California" 1936
 Dorothea Lange (Time-Life/10 129)
 farm workers picking lettuce in "Lettuce pickers, Salinas Valley" 1938*
 Dorothea Lange (Bernard 209#)
 father and sons walking to cabin in dust storm in "Dust storm in Okla-
 homa" or "Farmer and sons walking in the face of a dust storm" 1936
 Arthur Rothstein (Sandweiss 110#; Time-Life/10 125)
 girl dragging empty sack along dirt road in "Kern County, California"
 1936 Dorothea Lange (Time-Life/9 74)
 girl sitting on cot in torn tent in "Migrant girl" 1936 Dorothea Lange

(Time-Life/10 131)
men sitting by tree in "Old men, California" 1937 Dorothea Lange (Time-Life/10 130)
a mother with children leaning on her shoulder in "Migrant mother" 1936 Dorothea Lange (Photography 262, 264, 265)
old man with hat over eyes in "Old man, California" 1936 Dorothea Lange (Time-Life/10 121c)
poor children with dirty faces in "Farm child in Tennessee" 1936 Carl Mydans (Time-Life/10 120)
poor family pushing wheelbarrow and carriage along empty road in "Headed west, Texas" 1937 Dorothea Lange (Time-Life/10 126)
sad woman standing with arms crossed in "Destitute" 1935 Ben Shahn (Gruber 89#; Time-Life/10 121a)
towel hanging on hook by washbasin, in shack in "Cabin in Alabama" 1935 Walker Evans (Time-Life/10 124)
trucks on muddy road in "Cars going west" 1936 Dorothea Lange (Time-Life/10 127)
DESERTS
and mule-drawn wagon in "The photographer's wagon and mules in the Nevada Desert" 1868 Timothy H. O'Sullivan (Time-Life/14 89)
panoramic view of valley and cliffs from the air in "Monument Valley from the air" 1967* Ernst Haas (Time-Life/8 149)
ridge of barren sand dunes in "Death Valley" 1970* Charles Moore (Time-Life/16 27)
sand dunes in parallel lines in "Sand dunes near Yuma, Arizona"* Steve Crouch (Rugoff 75#)
truck stopped on road in "Truck in the desert near Yuma, Arizona" 1962 Danny Lyon (Sandweiss 126#)
with dead tree trunks in "Desert on Big Cumberland Island"* James P. Valentine (Rugoff 157#)
with some trees and bushes in "Desert on Big Cumberland Island"* James P. Valentine (Rugoff 156#)
DINNERS AND DINING
casseroles on wooden table in "One-dish meals" 1970* Rudy Muller (Time-Life/13 63)
Chinese man eating from bowl and wooden table in "The last days of the Kuomintang, Peking" 1949 Henri Cartier-Bresson (Cartier-Bresson 63)
family eating at table in room lined with newspapers in "Miner's family, Scott's Run, West Virginia" 1936-37 Lewis Hine (Hine 38)
homeless people sitting outdoors at long wooden tables in "Emergency feeding of homeless people after the San Francisco earthquake" 1906 Arnold Genthe (Gernsheim/2 261#)
men and women seated at long tables outdoors in "Coronation dinner for London's poor" 1902? Underwood and Underwood (Loke 80)
men at table in Japanese robes in "Russian officers, prisoners of war, at lunch in a garden in Matsuyama, Japan" H.C. White (Loke 85c)
old woman at table, holding tea cup in "The Whisperers, England" 1966 Irwin Dermer (Time-Life/14 29)
ornate dining car with waiter in "Dining car of the Pennsylvania Limited" c. 1889 Photographer Unknown (Loke 33)
people eating on grassy slope on riverbank in "Lunch by the Marne" or "By the Marne River" 1938 Henri Cartier-Bresson (Cartier-Bresson 27; Gruber 96#)
young girls eating while standing outside in "Lunchtime" 1915 Lewis Hine (Hine 79)
DIRIGIBLE BALLOONS see AIRSHIPS
DISASTERS. See also types of disasters, e.g. Fire; Shipwrecks; also names

of particular disaster, e.g. San Francisco--Earthquake and Fire, 1906
dirigible bursting into flames after hitting tower in "Explosion of the
Hindenburg, Lakehurst, New Jersey" 1937 Sam Shere (Time-Life/7 28)
scene of crushed houses and furniture after a flood in "Aftermath of the
Johnstown (Pennsylvania) flood of 1889 which took 2,300 lives" Under-
wood and Underwood (Loke 16c)
DISEASES
face of man with a skin disease in "Sycosis, a skin disease" 1872* Dr.
A. Hardy and Dr. A. de Montmeja (Bernard 100#)
white patch on boy's scalp in "Study of ringworm of the scalp" Pub.
1878* Léon Vidal (Bernard 110#)
DIVERS AND DIVING
boy jumping into water in "Kingston, Jamaica" 1968* Bernard Wolf (Time-
Life/9 193)
boy jumping off wooden diving board into lake in "Boy on diving board"
1964 Bill Binzen (Time-Life/9 154)
man diving into lake in "The diver" c. 1887 John L. Stettinus (Photogra-
phy 151)
movement of women diving off board in "Off the springboard" 1963 Tony
Triolo (Time-Life/16 73c)
DOCKS
and waiting crowds in "Waiting for the boat, Greenwich" 1857 George
Washington Wilson (Gernsheim 155#; Gernsheim/2 130#)
lake steamers tied up in winter in "Lake steamers at winter moorings,
Switzerland" c. 1865* Adolphe Braun (Bernard 83#)
steamboats by the edge of the city in "Cincinnati waterfront" 1848 South-
gate & Hawes (Time-Life/14 69d)
DOCTORS see PHYSICIANS
DOG RACING
greyhounds running with muzzles in "Greyhound races" 1962* John Zim-
merman (Time-Life/16 145)
DOGE'S PALACE
a courtyard in "Courtyard of the Doge's Palace, Venice" 1862 Carlo Ponti
(Gernsheim 200#; Gernsheim/2 163#)
DOGS. See also DALMATIANS; GERMAN SHEPHERDS; GREYHOUNDS; SHEEP
DOGS; WHIPPETS
black dog resting on pavement in "[Black dog resting]" Wolf Von dem
Bussche (Time-Life/11 69)
lying by feet of child in "Paul Nader" c. 1862 Paul Nadar (Tournachon
289d)
fashionably dressed women walking dogs in "Woman with dog" Brassaï
(Gruber 413#)
greyhound racing in "Greyhound" 1884-5 Eadweard Muybridge (Gernsheim
298#; Gernsheim/2 243#)
on barge near man, woman and child in "Seine bargeman" 1957 Henri
Cartier-Bresson (Gruber 416#)
portrait of an Afghan in "Afghan 'Shah'" 1970 Norman Wightman (Time-
Life/13 33)
posing with young boy in "Bertrand de Lesseps" Nadar (Tournachon
285c)
small dog tied to nail in wall in "[Small dog tied to nail in wall]" Shin
Sugino (Time-Life/12 129)
small one walking near child in front of stores in "Ramsgate, England"
1967 Tony Ray-Jones (Time-Life/12 151)
small one by woman's feet in "New York" 1953 Elliot Erwitt (Gruber 443#)
standing on hind legs, while in costume in "M. Pierson's performing dog"
Nadar (Tournachon 255d)

two standing by man's feet in "William Faulkner, Oxford, Mississippi"
1947 Henri Cartier-Bresson (Cartier-Bresson 73)
DOLLS
antiques on hobbyhorse in "Antique dolls on a hobbyhorse" 1967 Paul
Caponigro (Time-Life/13 220)
cardboard Victorian doll and driftwood in "Haveth childers everywhere"
1952 Clarence John Laughlin (Time-Life/12 53)
displayed on table in front of window in "Autochrome color transparency
of Yvonne Lumière and her dolls" 1913* Louis Lumière (Time-Life/8
53)
girl lying on grass with dolls in "Nancy" 1965 Emmet Gowin (Time-Life/9
147)
miniature doll in dollhouse kitchen in "Kitchen in a Swiss dollhouse" 1970
Thomas Cugini (Time-Life/13 220)
seated boy holding undressed doll and flag in "Christopher and the re-
building of America" 1961 Ralph Eugene Meatyard (Time-Life/9 162)
surrealistic, segmented doll in "Doll" Late 1930's* Hans Bellmer (Bernard
208#)
DONKEYS
carrying a load of peat in straw baskets in "Boy with donkey carrying
peat, Connemara, Ireland" 1913* Mespoulet and Mignon (Bernard 169#)
DOORS
flag reflected in brass door handle in "The Flag" 1966* Reid Miles (Time-
Life/8 46)
man and woman going through revolving doors from opposite directions in
"Revolving doors" 1963 Lee Friedlander (Time-Life/11 136)
of the Baptistry, Florence in "The Baptistry, Florence, one of Ghiberti's
doors" c. 1855 Leopoldo and Giuseppe Alinari (Gernsheim/2 160#)
open to see staircase in house in "Open door" 1945 Paul Strand (Photog-
raphy 296)
open wooden interior door in "The open door" c. 1932 Charles Sheeler
(Sandweiss 119#)
painted doorknob in "Doorknob" 1970 Sebastian Milito (Time-Life/11 53)
series of wooden doors in "Untitled" Ralph Meatyard (Gruber 117#)
weathered wood door in "Church door, Hornitos, California" 1940 Edward
Weston (Time-Life/14 36)
with peeling white paint in "White door, Eureka, Nevada" 1973 Oliver
Gagliani (Sandweiss 81#)
DRIFTWOOD
mass of roots in "Driftwood, Dark roots, Maine" 1928* Paul Strand (Ber-
nard 187#)
root of tree in surf in "Driftwood" 1951 Wynn Bullock (Bullock 71)
DRIVEWAYS
and closed garage door in "Tract house no. 23" 1970 Lewis Baltz (Time-
Life/11 123)
DUCKS
flying in "Man jumping and duck flying" c. 1882 E.J. Marey (Gernsheim
302#; Gernsheim/2 248#)
mallard swimming with ducklings in "Mallard hen and family" Jack Dermid
(Rugoff 142#)
stages of flight in "Flight of a duck" c. 1890 E.J. Marey (Time-Life/7
157)
swimming alone in "Goldeneye near Bartlett Cove, Glacier Bay"* Dean
Brown (Rugoff 14#)
two walking on lawn near tree in "Untitled" 1972 Terry Reed (Time-Life/
12 40)
DUST STORMS

father and sons walking to cabin in dust storm in "Dust storm in Okla-
homa" or "Farmer and sons walking in the face of a dust storm" 1936
Arthur Rothstein (Sandweiss 110#; Time-Life/10 125)
DUTCH
family on dock with boats in "A fisherman and his family, Island of Mark-
ham, the Netherlands" Underwood and Underwood (Loke 108c)

E

EAGLES
golden eagle watching eaglet in nest in "Golden eagle watching the eaglet
in a Scottish eyrie" Seton Gordon (Guggisberg 68)
EARS
and three fingers in "Hand and ear" 1928 Brett Weston (Photography
232a)
EARTH--PHOTOGRAPHS FROM SPACE
Earthrise from space in "Earthrise as seen from Apollo 8" 1968* Frank
Borman (Time-Life/7 58)
EARTHQUAKES--SAN FRANCISCO
bank vaults gutted by fire in "Bank vaults cracked during the earth-
quake, their contents gutted by fire" 1906 Underwood and Underwood
(Loke 170a)
demolished cable cars and rubble in "Cable cars demolished by the dis-
aster, stored east of Hyde Street on California" 1906 Underwood and
Underwood (Loke 170b)
fire after quake in "San Francisco fire" 1906 Arnold Genthe (Time-Life/
10 38)
street of rubble in "San Francisco, April 18th, 1906" Arnold Genthe
(Sandweiss 60#)
a woman cooking over a crack in road in "A woman camping by the road-
side" 1906 H.C. White (Loke 170c)
EAST INDIANS
men carrying large bundles of hay on their backs in "Men with bundles
of hay, Simla, India" 1903 Underwood and Underwood (Loke 137b)
men inflating bullock-skin boats in river in "Boatmen inflating bullock-
skin boats, Sutlej River, India" 1903 Underwood and Underwood (Loke
133c)
seated Bhutanese woman with medicinal plants spread out before her in
"Medicines offered by a Bhutanese woman, Darjeeling, India" 1903
Underwood and Underwood (Loke 128d)
squatting man selling fruit from baskets in "A fruit seller, Jaipur, India"
1902 Keystone View Company (Loke 129a)
various photographs of people and life in the monsoon season in "[Mon-
soon in India]"* Brian Brake (Time-Life/10 87-92)
woman working at spinning wheel in "A woman at the spinning wheel,
India" B.W. Kilburn (Loke 135b)
women pulling large roller on gravel highway in "A twenty-woman team
working in a highway, Darjeeling, India" 1903 Underwood and Under-
wood (Loke 143b)
women standing in surf in "Madras" 1971 Edouard Boubat (Gruber 392#)
EDINBURGH, SCOTLAND
row of houses in "Old houses in Edinburgh" c. 1855 Thomas Keith (Gern-
sheim 94#)
street scene in "Princes Street, Edinburgh, Scotland" Underwood and
Underwood (Loke 160)
street scene in "Princess Street, Edinburgh" 1859 George Washington Wil-

son (Gernsheim 154#; Gernsheim/2 126#)

EGGS

as round, white shapes in "Geometric patterns" 1969 Greg McQuade (Time-Life/16 165a)

child with intertwined arms holding eggs in "See what I can do with eggs" 1969 Emmet Gowin (Time-Life/9 130)

fried on plate and glass of milk on checkered tablecloth in "Egg and milk" 1968* Henry Sandbank (Time-Life/13 227)

in cardboard cartons in "Eggs and cartons" 1968* Martin Schweitzer (Time-Life/11 56d)

in silhouette against a reflector in "Silhouettes" 1969 Jonathan Haskell (Time-Life/16 165d)

on table with painting and fern in "Still life" 1970* Nob Fukuda (Time-Life/13 37)

one spot of light reveals texture of shell in "Texture" 1970 Karen Keller-house (Time-Life/16 164a)

silhouette of three eggs in "Illusion" 1969 John McQuade (Time-Life/16 164c)

spotted in "Inner glow" 1970 Keith Hunt (Time-Life/16 165c)

two near a cónical shape in "Consciousness" 1931 Paul Outerbridge, Jr. (Gruber 75#)

with streaks of light across them in "Lightstruck" 1969 Jonathan Haskell (Time-Life/16 165b)

EGRETS

and spoonbills wading in "Egrets and spoonbills"* Patricia Caulfield (Rug-off 166#)

bird walking in tall grass in "American egret in sawgrass marsh, Ever-glades National Park"* James H. Carmichael, Jr. (Rugoff 161#)

family of cattle egrets in nest in "Male and female cattle egrets at nest with young on Avery Island, Louisiana"* Thase Daniel (Rugoff 95#)

snowy egret at shore by breaking waves in "Snowy egret on Captiva Is-land, Florida" William G. Damroth (Rugoff 150#)

young cattle egret holding onto vine above swamp in "Young cattle egret climbing back to nest"* Leonard Lee Rue III (Rugoff 158#)

EGYPT--ANTIQUITIES

Colossus at Temple in "Colossus at Temple of Abu Simbel" 1857 Francis Frith (Gernsheim 192#; Gernsheim/2 169#)

large stone statues and columns in "Osiride Pillars and Great Fallen Colos-sus" 1858 Francis Frith (Gruber 29#)

EGYPTIANS

dancers and musicians in "Egyptian dancer and musicians" c. 1890* Photographer Unknown (Bernard 132#)

man selling lemonade from bottle around his neck in "A lemonade vendor and his customer, Cairo, Egypt" B.W. Kilburn (Loke 129d)

EIFFEL TOWER

amidst Exposition buildings in "The Eiffel Tower and exposition grounds, Paris Exposition" 1900 H.C. White (Loke 37)

looking through base to exhibition in "Paris International Exhibition: at the Eiffel Tower" 1889 Photographer Unknown (Gernsheim 292#)

ELDERLY PEOPLE

bearded man, and woman in shawl in "East Side, New York City" 1910 Lewis Hine (Hine 77)

bearded old man carrying sandwich board in "The sandwich man" Paul Strand (Green 320)

bearded old man near carved busts from Cyprus in "Untitled" 1970 Sieg-fried Halus (Time-Life/12 43)

granddaughter showing embroidery to grandmother in "Mme. Antoine

Lumière and granddaughter" c. 1915* Louis Lumière (Time-Life/8 72)
man with long white beard seated on wood pile in "My Father" 1936 Imo-
gen Cunningham (Time-Life/12 125)
man with white beard leaning on railing of staircase in "New York City
subway" 1965 Gary Renaud (Time-Life/14 193)
men and women seated outdoors on benches in "St. Petersburg, Florida"
1958 Robert Frank (Gruber 116#)
old man and young child in "The Jersey Patriarch (Aged 102) and his
Great-Great-Granddaughter" c. 1848* William Collie (Bernard 14#)
old man in ill-fitting clothes and his wife in paisley shawl in "An elderly
veteran and his wife" c. 1860* Photographer Unknown (Bernard 65#)
old man reading book at table covered with newspaper in "Old man"
1936-37 Lewis Hine (Hine 52)
old woman in scarf and hat in "Portrait, Washington Square" Paul Strand
(Green 318)
old woman in white cap in "Unidentified old woman" 1850's* Southworth &
Hawes (Bernard 18#)
old woman on steps in "An old woman of Seattle, Washington" B.W. Kil-
burn (Loke 182d)
old woman sitting with pipe in "Old woman with a pipe" 1920's* Doris Ul-
mann (Bernard 188#)
old woman with sign saying 'Blind' in "Blind woman" Paul Strand (Green
322)
portrait of woman in cap and shawl in "A domestic servant" 1850's*
Photographer Unknown (Bernard 27#)
profile of man seated on wooden bench in "On the Staten Island Ferry"
1967 Neal Slavin (Time-Life/14 181)
seated man with untied boots in "John Herdman" 1969 John Wood (Time-
Life/11 163)
woman at table with tea cup in "The Whisperers, England" 1966 Irwin
Dermer (Time-Life/14 29)
woman in shawl and white cap in "Unknown old woman" c. 1860 Nadar
(Tournachon 155)
woman on step, holding infant in "Old woman with baby" 1876-7 John
Thomson (Gernsheim 309#; Gernsheim/2 255#)
woman with American flag tied around her neck in "Cape Cod, Massachu-
setts" or "New England, U.S.A." 1947 Henri Cartier-Bresson (Carti-
er-Bresson Frontispiece; Time-Life/7 214)
woman, with bent shoulders, casting shadow on wall in "The Shadow,
Seville, Spain" 1963 George Krause (Time-Life/14 43)
women and man speaking on street in "The Coronation Procession, Lon-
don" 1937 Henri Cartier-Bresson (Photography 285a)
ELECTRIC LIGHT BULBS
produced by posterization in "Light bulb" 1967* Fred Burrell (Time-Life/
8 226)
ELECTROCUTIONS see CAPITAL PUNISHMENT
ELEPHANTS
crossing a river in "Elephants crossing the Nile" Walter Mittelholzer (Gug-
gisberg 106)
drinking at a waterhole in "Elephants drinking at a waterhole near Na-
manga, Kenya" Marcuswell Maxwell (Guggisberg 102)
front view of a bull elephant in "Bull elephant photographed at a distance
of approximately eight yards" Marius Maxwell (Guggisberg 96)
in forest, with trunk raised in "West African forest elephant trying to get
the photographer's scent" E. Gromier (Guggisberg 99)
model feeding elephant in "[Elephant charming]" 1936 Herman Landshoff
(Hall-Duncan 82)

tuskless bull squiring water on itself in "A wild Indian elephant--a big, tuskless bull--squirting water over its body" F.W. Champion (Guggisberg 85)

tusks carried in street by Africans in "Elephant tusks ready for shipment to New York, Membas, Kenya" 1909 Underwood and Underwood (Loke 132b)

with foot on fallen tree in "Wild Malayan elephant on a fallen tree polished by the feet of many elephants playing the same game" T.R. Hubback (Guggisberg 90d)

woman posing between elephants in "Dovima in an evening gown by Dior with the elephants of the Cirque d'Hiver" 1955 Richard Avedon (Hall-Duncan 137)

ELEVATORS

couple kissing in elevator in "[Couple embracing in elevator]" 1971 Leonard Freed (Time-Life/11 105)

EMBRACE

couple embracing under dart board in "[Embrace under a dart board]" Anders Petersen (Time-Life/12 136)

couple kissing in elevator in "[Couple embracing in elevator]" 1971 Leonard Freed (Time-Life/11 105)

couple on round bed in "[Honeymooners]" 1971 Tony Ray-Jones (Time-Life/11 106)

man with arm around girl in "Dr. Benjamin Spock, pediatrician, Jane Cheney Spock" 1969 Richard Avedon (Avedon 35●)

man's arm around back of woman in slip in "Couple" 1972* Tassilo Trost (Time-Life/12 19)

EROSION

arches of rock in "Double Arch in Arches National Monument, Utah" Ed Cooper (Rugoff 58#)

deep furrows in dirt cliff in "Erosion" 1956 Wynn Bullock (Bullock 21)

rock with sand-filled crevices in "Eroded rock on the shore near Pescadero, California" Don Worth (Rugoff 32#)

sandstone and pebbles in "Eroded sandstone and tide-washed pebbles at Pebbly Beach"* Dennis Brokaw (Rugoff 36#)

EXECUTIONS see CAPITAL PUNISHMENT

EXERCISE

girls doing exercises in gymnasium in "Gym class, Tuskegee Institute, Alabama" 1905 Underwood and Underwood (Loke 147b)

EXHIBITIONS

of photographs in "Photographic Society's exhibition" 1884 Photographer Unknown (Gernsheim 108#)

EXPLOSIONS

atomic bomb in water in "Automatic camera recording of the atomic test at Bikini" 1946 Photographer Unknown (Time-Life/10 21)

fire of dirigible hitting tower in "Explosion of the Hindenburg, Lakehurst, New Jersey" 1937 Sam Shere (Time-Life/7 28)

EYEGLASSES

in man's hand in "Truman Capote" 1965 Irving Penn (Gruber 128#)

EYES

and nose of man in "Eddie Cantor" Philippe Halsman (Halsman 132)

make-up made of butterfly wings and feathers in "Butterfly eyes" 1964* Bert Stern (Hall-Duncan 163)

a woman's right eye in "The right eye of my daughter Sigrid" 1926 August Sander (Photography 232b)

F

FACES
 painted red and yellow in "New Guinea faces" 1967* Peter Turner (Time-Life/8 27)
FACTORIES
 coins being pressed at the mint in "Coinage presses, the U.S. Mint"
 Underwood and Underwood (Loke 218a)
 exterior of a foundry in "Production foundry, Ford Plant, Detroit" 1927
 Charles Sheeler (Sandweiss 114#)
 gowned women in lines by troughs of peaches in "Peach-canning factory,
 Visalia, California" Phil Brigandi (Loke 218b)
 men at tire-manufacturing machinery in "Workers of a tire-manufacturing
 plant, Akron, Ohio" Phil Brigandi (Loke 218b)
 men at work in "Factory interior, Baldwin Locomotive Works, Eddystone,
 Pennsylvania" 1936-37 Lewis Hine (Hine 57)
 men working at hot furnace in "Handling hot metal in a Pennsylvania
 shop" Lewis Hine (Hine 135)
 a mill complex at base of hillside in "The Gould and Curry Mill, Virginia
 City, Nevada" 1867 Timothy H. O'Sullivan (Photography 120)
 spools of yarn in knitting plant in "Health-tex knitting plant" 1973* Jay
 Maisel (Time-Life/12 68)
 stacks of an automobile plant in "Bleeder stacks, Ford Plant, Detroit"
 1927 Charles Sheeler (Sandweiss 112#)
 ventilator stacks in "Ventilators" c. 1930 Willard Van Dyke (Sandweiss
 117#)
FAIRS
 Eiffel Tower amidst Exposition buildings in "The Eiffel Tower and exposi-
 tion grounds, Paris Exposition" 1900 H.C. White (Loke 37)
 ferris wheels behind girl in rowboat on lake filled with lily pads in "Ex-
 position Park, Louisiana Purchase Exposition, St. Louis, Missouri"
 1904? Underwood and Underwood (Loke 155)
 fountains in front of ornate building in "Fountains in front of the Palace
 of Electricity, Paris Exposition" 1900 H.C. White (Loke 36)
 seen from the base of the Eiffel Tower in "Paris International Exhibition:
 at the Eiffel Tower" 1889 Photographer Unknown (Gernsheim 292#;
 Gernsheim/2 237#)
FAMILIES
 Algerians by their home in "An Algerian home" Underwood and Underwood
 (Loke 109b)
 an American couple on a sofa in "An American couple" Underwood and
 Underwood (Loke 102)
 an American family portrait in "William Howard Taft, the 27th President
 of the United States, with his wife, Helen, and their children, Robert,
 Charles and Helen" 1908 Brown Bros. (Loke 83)
 a Chinese family's portrait in "An Admiral of the River Fleet with his
 wife and daughter, China" c. 1901 James Ricalton (Loke 103)
 Chinese parents posing with their children in "A Chinese family" Key-
 stone View Company (Loke 213)
 Chinese woman and children in ornamental robes seated on wooden steps
 in "A Chinese woman and her children outside their cabin in Olympia,
 Washington" B.W. Kilburn (Loke 60)
 a Dutch family on dock with boats in "A fisherman and his family, Island
 of Markham, the Netherlands" Underwood and Underwood (Loke 108c)
 eating at table in room lined with newspapers in "Miner's family, Scott's
 Run, West Virginia" 1936-37 Lewis Hine (Hine 38)
 formal portrait in "The de Lesseps family" Nadar (Tournachon 284a)

formal portrait in "Family portrait" c. 1850 Photographer Unknown (Time-Life/14 67)

group portrait in "Portrait of Mrs. Klah Sewall and family" c. 1840 Photographer Unknown (Time-Life/7 183c)

group seated amongst trees in "Lunch on the grass, Rome" 1956 William Klein (Gruber 119#)

immigrant family standing with their suitcases in "Looking for lost baggage, Ellis Island" 1905 Lewis Hine (Gernsheim/2 260#; Hine 30; Sandweiss 115#)

an Irish family portrait in "Mr. and Mrs. James Ward and family, Creggs, Ireland" 1905 Underwood and Underwood (Loke 99)

a Jamaican couple by coconut palms in "A Jamaican couple" Photographer Unknown (Loke 108d)

Japanese bride and groom on way to wedding in "A bride and groom with their attendants halting by the wayside en route to the wedding, Japan" 1906 Keystone View Company (Loke 106)

a Japanese family by their straw hut in "The Ainus of Japan" 1906 H.C. White (Loke 107c)

Japanese family outside their ornate home in "A wealthy Japanese family outside their home, Japan" James Ricalton (Loke 210b)

a Korean couple by their home in "A Korean couple, Seoul" 1904 Underwood and Underwood (Loke 107d)

man and woman seated with their daughter, grandchildren and Black servant in "Jefferson Davis, U.S. soldier, statesman and only President of the Confederate States of America, with his wife, Varina, daughter Maggie Hayes and her three children" c. 1885 Photographer Unknown (Loke 51)

man, woman and child on barge with dogs in "Seine bargeman" 1957 Henri Cartier-Bresson (Gruber 416#)

mother and children on blanket in "Picnic on Garrett Mountain" 1968* George A. Tice (Time-Life/15 85a)

mother and children posing in living room in "Family in tenement, New York City" 1910 Lewis Hine (Hine 97)

a mother and daughters by horse and colt in "A woman and her daughters, Bretton Woods, New Hampshire" Underwood and Underwood (Loke 109a)

mother and nine children in line outside house in "Doffer family, Tifton, Georgia" 1909 Lewis Hine (Hine 39)

Navaho family in a covered wagon in "The covered wagon" 1934 Laura Gilpin (Sandweiss 120#)

Norwegians near their hand-made wooden house in "A Norwegian family" T.W. Ingersoll (Loke 108b)

Ozark family standing outside their cabin in "Ozark Mountain family" 1940 John Vachon (Time-Life/10 122)

pioneer woman and children at Grand Canyon in "A frontier woman and her children at the Grand Canyon, Arizona" Photographer Unknown (Loke 53)

poor Black family cooking in shack in "A peasant's home in Santiago de Cuba" Underwood and Underwood (Loke 55)

poor couple and infant under awning in "Okie family" 1936 Dorothea Lange (Time-Life/10 123)

portrait of a Filipino family in "A Visayan family, Cebu, Philippines" Photographer Unknown (Loke 98)

portrait of three South Africans in "Three generations, Pretoria, South Africa" B.W. Kilburn (Loke 101)

portrait on front lawn in "Thomas Alva Edison with his wife, Mina, daughter Madeline, and sons Theodore and Charles at their home in Llewellyn

Park, New Jersey" Underwood and Underwood (Loke 35)
a Salish family in "A Salish family of western Montana" 1907 Underwood
and Underwood (Loke 110)
seated man and woman with young boy in "Ulysses S. Grant, U.S. soldier
and 18th President of the United States, with his wife, Julia, and
youngest son, Jesse" c. 1872 G.W. Pach (Loke 50)
sewing and ironing clothing in small room in "Finishing clothing, tenement
homework, New York City" 1906 Lewis Hine (Hine 32)
wealthy family seated in lush garden in "A wealthy Cuban family" Under-
wood and Underwood (Loke 54)
woman and children in small tenement room in "Tenement, New York
City" 1910 Lewis Hine (Hine 70)
women holding children while shelling nuts at table in "Tenement home-
work, Lower West Side, New York City" 1911 Lewis Hine (Hine 95)
FANS
large ornate one outside window of fan shop in "Miyawaki Fan Shop"
1960* Ken Domon (Gruber 162#)
FARMS AND FARMING
aerial view of plowed field in "Plowed field, Arvin, California" 1951 Wil-
liam A. Garnett (Sandweiss 140#)
Black family working field with hoes in "Sharecroppers in Alabama" 1936
Dorothea Lange (Photography 266b; Time-Life/10 133)
boy squatting by berry bush in "Boy picking berries, Baltimore" 1909
Lewis Hine (Hine 88)
corn stalks in piles in "A cornfield" 1856 Henry White (Gernsheim 187#;
Gernsheim/2 153#)
farmhouse and wooden fence in "[Farmhouse and fence]" Wolf von dem
Bussche (Time-Life/11 74)
in cornfield showing harvest of vegetables in "Easy harvest from Wiscon-
sin earth" 1895 H.J. Perkins (Time-Life/19 95)
man plowing with donkeys in "Seeding time" W. Eugene Smith (Time-Life/
10 77a)
men of the Depression in "Once a Missouri farmer, now a migratory farm
worker in California" 1936 Dorothea Lange (Gruber 317#)
migrant workers in field in "Near Waxahachie, Texas" 1913 Lewis W. Hine
(Sandweiss 108#)
plowing with a pair of horses in "A stiff pull" c. 1888 Peter Henry Emer-
son (Gruber 43#; Photography 161)
plowing with a team of oxen in "Lombardy ploughing team" 1894 J. Craig
Annan (Photography 191b)
sharecropper family working in field in "Sharecroppers, Eutaw, Alabama"
c. 1936 Dorothea Lange (Photography 266b)
women separating the wheat from the chaff in "Winnowing grain" 1951
W. Eugene Smith (Time-Life/10 77b)
workers cutting lettuce in "Lettuce pickers, Salinas Valley" 1938* Dorothea
Lange (Bernard 209#)
FASHION PHOTOGRAPHY, 19TH CENTURY
back of a woman in a black lace shawl, considered to be the first fashion
photograph in "Lady Mary Ruthven" c. 1845 Hill and Adamson (Gern-
sheim 78#; Gernsheim/2 73#; Green 170; Hall-Duncan 16b)
front and back views of man in coat and top hat in "Gentleman's coat and
top hat" c. 1860's Adolphe Reau (Hall-Duncan 17)
photograph of woman reproduced in magazine in "Reproduced in an un-
identified French pattern book" 1881 Lermercier et Cie, Paris (Hall-
Duncan 21c)
women and children in fashion photograph in "Revue de la Famille" 1894?
Reutlinger Studio (Hall-Duncan 21a)

FASHION PHOTOGRAPHY, 1900-1909
 Bechoff-David coat modeled in "Chinchilla coat by Bechoff-David" 1906*
 Reutlinger Studio (Hall-Duncan 22a)
 hat from Maison Toré being modeled in "Maison Toré hat" c. 1905 Paul
 Nadar (Tournachon 283b)
 heavily retouched photograph of fashionable woman in "Fashion figure--
 fashion study" 1903-04 F.W. Brookman (Hall-Duncan 19)
 Maison Reveillon dress with long train in "Maison Reveillon dress" c. 1900
 Paul Nadar (Tournachon 283c)
 models seated on bench in "Devant Le Boudoir" 1901 Boyer (Hall-Duncan
 27)
 photograph reproduced in magazine in "Reproduced in 'La Mode Pratique'"
 1901* Reutlinger Studio (Hall-Duncan 22c)
 society women with parasols in "Photographs of society women wearing
 their own designer clothes at the races" 1909-10 Seeberger Frères
 (Hall-Duncan 29-30)
 woman in beaded dress in "Untitled" c. 1900's Talbot Studio (Hall-Duncan
 24)
 woman modeling fur coat in "Untitled" c. 1900's Talbot Studio (Hall-
 Duncan 25)
 Worth ballgown on dress form in "Page from a documentation album of
 Worth ballgowns" 1903-4 Photographer Unknown (Hall-Duncan 31)
 Worth dresses on dress forms in "Pink peau de soie with embroidery by
 House of Worth" Photographer Unknown (Hall-Duncan 30)
FASHION PHOTOGRAPHY, 1910-1919
 bride gazing into crystal ball in "['Eager-eyed under the bridal veil...']"
 1919 Baron Adolf de Meyer (Hall-Duncan 35)
 gowns for "Art et Décoration" 1911 Edward Steichen (Hall-Duncan 46-47)
 Lucille, Ltd. gown modeled by Dinarzade in "Dinarzade in gown by Lu-
 cille, Ltd." c. 1916 Joel Feder (Hall-Duncan 42)
 model wearing Russian style blouse in "[A Russian blouse of cafe au lait
 net]" 1918 Baron Adolf de Meyer (Hall-Duncan 38)
 Thurn hat being modeled in "Dolores the beautiful ... wears this sweep-
 ing hat from Thurn" 1918 Baron Adolf de Meyer (Hall-Duncan 37)
 woman in gold lamé costume, holding cup in "Woman with cup" c. 1910
 Gayne de Meyer (Time-Life/13 108)
 woman modeling fur coats in "Mlle. Mistinguett modeling costumes by vari-
 ous designers" 1911 Felix Studio, Paris (Hall-Duncan 20)
 women fixing model's dress designed by Poiret in "An early fashion pho-
 tograph of a dress by designer Paul Poiret, Paris" 1911 Edward
 Steichen (Time-Life/13 105)
FASHION PHOTOGRAPHY, 1920-1929
 Art Deco gown modeled by Tamaris in "Art Deco gown photographed in
 the apartment of Nina Price, New York" 1925 Edward Steichen (Hall-
 Duncan 45)
 Augustabernard ensemble of white fox and crepe in "White evening wrap"
 1929 Edward Steichen (Hall-Duncan 50)
 Fortuny gown being modeled in "Natasha Rambov in Fortuny gown" c.
 1924 James Abbe (Hall-Duncan 41)
 Marion Morehouse modeling two piece dress in "Summer fashions and some
 Benda masks" 1926 Edward Steichen (Hall-Duncan 48)
 model in crepe dress by railing in "The bride at her second marriage"
 1926 Edward Steichen (Hall-Duncan 54)
 model in plumed veil in "Helen Lee Worthing" 1920 Baron Adolf de Meyer
 (Hall-Duncan 34)
 Patou evening gown with sequins in "Dinarzade" 1924 Baron Adolf de
 Meyer (Hall-Duncan 33)

portrait of girl with toy dog in "Fashion illustration" 1920 Gayne de Meyer (Time-Life/9 54)

woman in evening gown in "Jeanne Eagels" 1921 Gayne de Meyer (Time-Life/13 109a)

woman wearing sequined dress in "Marion Morehouse" 1927 Edward Steichen (Time-Life/13 110)

women in hats and coats at railing in "Country clothes and town clothes" 1926 Edward Steichen (Hall-Duncan 55)

FASHION PHOTOGRAPHY, 1930-1939

back of woman in corset in "From Paris--the new Detolle corset with back lacing" 1939 Horst P. Horst (Hall-Duncan 65)

Bruyere's white summer dress and hat on model in garden in "Midsummer audacities" 1934 André Kertész (Hall-Duncan 79)

Chanel dress being modeled in "Dress by Chanel" 1935 Cecil Beaton (Hall-Duncan 116)

chiffon dress being modeled in "['We may wander into gay light chiffon...']" 1938 Baron Adolf de Meyer (Hall-Duncan 39a)

Heim beach coat on model lying below picture of lips in "[Against his surrealist painting[" 1936 Man Ray (Hall-Duncan 86)

Lelong black lace gown on woman in empty, paperlined room in "For the Lace Ball" 1936 Cecil Beaton (Hall-Duncan 118)

Lucien Lelong crepe gown on woman, by shadows of men in "[Shadow her]" 1935 Cecil Beaton (Hall-Duncan 114)

Lucien Lelong gown on woman seated in wheelbarrow in "[Model in a wheelbarrow]" 1937 Man Ray (Hall-Duncan 85)

Maggy Rouff crocheted black gown on woman by shadows of men in "[Shadow her]" 1935 Cecil Beaton (Hall-Duncan 115)

Maggy Rouff ensemble worn by model reading newspaper in "Ensemble by Maggy Rouff" 1936 Cecil Beaton (Hall-Duncan 119a)

male model wearing clothes of the future in "Gilbert Rhodes banishes buttons, pockets, collars, ties" 1939 Anton Bruehl (Hall-Duncan 120)

man and woman in formal attire, on pillows in "Untitled" c. 1930 George Hoyningen-Huene (Hall-Duncan 60)

man and woman in swim suits, on beach in "Two-piece swimming-suit" 1930 George Hoyningen-Huene (Hall-Duncan 61)

men and women lying on sand, pushing large ball in "Push ball" 1930 George Hoyningen-Huene (Hall-Duncan 62)

model feeding elephant in "[Elephant charming]" 1936 Herman Landshoff (Hall-Duncan 82)

model in cape by obelisk in "[Woman by obelisk]" 1935 André Durst (Hall-Duncan 105)

model in Pacquin gown in "Pacquin gown" 1933 Edward Steichen (Hall-Duncan 51)

model in satin-lamé robe in "Housecoat by Chanel" 1931 George Hoyningen-Huene (Time-Life/13 112)

model on lounge chair in "Two on a terrace" 1932 The 3 (Hall-Duncan 59)

model on parapet of futuristic building in "For the Winter season" 1939 Martin Munkacsi (Time-Life/13 119)

model on steel girders in "[Model on steel girders]" 1939 Erwin Blumenfeld (Hall-Duncan 93)

Molyneux's floral gowns in "[Molyneux's newest trick]" 1936 André Durst (Hall-Duncan 104)

Pacquin mannequin before classic female heads in "Pacquin dress modeled by Pacquin house-mannequin" 1934 George Hoyningen-Huene (Hall-Duncan 64)

portrait of woman's face through hat in "[Woman in large hat]" 1930's Erwin Blumenfeld (Hall-Duncan 90c)

Schiaparelli cape being modeled in "Schiaparelli cape from Bergdorf Good-
man" 1933 Baron Adolf de Meyer (Hall-Duncan 39c)
two models and piano in silhouette in "Black" 1935 Edward Steichen (Hall-
Duncan 52)
Vionnet gown, back view in "Vionnet gown" c. 1930's Reutlinger Studio
(Hall-Duncan 57)
woman in bathing suit running on beach in "Untitled" 1934 Martin Munk-
acsi (Hall-Duncan 70c)
woman in billowing coat on sand dune in "Beach fashion" 1936 Martin
Munkacsi (Time-Life/13 118)
woman in evening gown on stairs, near nude torso in "Evening gown"
1934 George Hoyningen-Huene (Time-Life/13 113)
woman in fur coat holding dalmatian on leash in "Boom for brown beavers"
1939 Toni Frissell (Hall-Duncan 74)
woman in gown by tableau of silhouettes in "Evening gown" 1934 Cecil
Beaton (Time-Life/13 114)
woman in hat and fur stole in "Ensemble by Hattie Carnegie" 1937 Horst
P. Horst (Time-Life/13 125)
woman in Henri Bendel gown with bouquet of roses in "The florist's box"
1937 Cecil Beaton (Time-Life/13 115c)
woman in high crowned felt hat in "Untitled" 1938 Horst P. Horst (Hall-
Duncan 66)
woman in Hindu-inspired dress in "Gown by Schiaparelli" 1935 Man Ray
(Time-Life/13 116)
woman in jersey hat holding a copy of her photograph in "In the news
today" 1939 Horst P. Horst (Hall-Duncan 67)
woman in sheer gown in "[Woman in sheer gown]" 1939* Anton Bruehl
(Hall-Duncan 99)
woman in shirtwaist dress sitting on tree limb in "Shirtwaist" 1938*
Toni Frissell (Time-Life/13 121)
woman in taffeta dress in "[A Victorian ruche]" 1935 Cecil Beaton (Hall-
Duncan 117)
woman running on beach in cape and shorts in "[Mercury cape in green
jersey]" 1933 Martin Munkacsi (Hall-Duncan 71)
woman wearing free-flowing gown in "Vionnet gown 'Sonia'" 1931 George
Hoyningen-Huene (Hall-Duncan 63)
woman with racket playing tennis in "Untitled" 1935 Martin Munkacsi
(Hall-Duncan 69)
women in white near white white horse in "White fashions" 1935 Edward Steichen
(Time-Life/13 111)
Yvonne Carette polka dot suit against polka dot background in "Polka
dots" 1930 Cecil Beaton (Hall-Duncan 112)
FASHION PHOTOGRAPHY, 1940-1949
back of woman in coat in "All year coat" 1944* John Rawlings (Hall-Dun-
can 133)
Christian Dior suit on woman standing in front of floral carpet in "The
season in town" 1949* Louise Dahl-Wolfe (Hall-Duncan 129)
double portrait of woman in dark coat in "Coming ... Parma Blue" 1944*
John Rawlings (Hall-Duncan 134)
group portrait of top models in "Twelve most photographed models" 1947
Irving Penn (Hall-Duncan 148; Time-Life/13 126)
multiple image of woman's face in "What looks new" 1947* Erwin Blumen-
feld (Hall-Duncan 94)
negative and positive print of model in "Untitled," c. 1940 Erwin Blumen-
feld (Hall-Duncan 96)
partially solarized portrait of woman in fur hat in "Fashion is how you
wear it" 1945 Erwin Blumenfeld (Hall-Duncan 97)

silhouetted woman by leg in stocking in "Untitled" c. 1940's* Erwin
Blumenfeld (Hall-Duncan 95)
triple portrait of woman in multi-colored jacket in "[Woman in multi-
colored jacket]" 1944* John Rawlings (Hall-Duncan 132)
two women in tennis dresses dropping tennis balls from basket in "[Two
tennis dresses]" 1942 Herman Landshoff (Hall-Duncan 83)
woman in bikini lying on pavement in "[Taking the sun in a bikini]" 1947
Toni Frissell (Hall-Duncan 75)
woman in evening dress, photographed underwater in "[Model in evening
dress underwater]" 1941 Toni Frissell (Hall-Duncan 76)
woman in hooded robe by harp in "[The hooded robe]" 1945 George Platt
Lynes (Hall-Duncan 110)
woman in lace nightgown by windows with lace curtains in "My bedroom"
1942* Louise Dahl-Wolfe (Time-Life/12 122)
woman in nightgown by window with sheer curtains in "The miracle of
Spring" 1941* Louise Dahl-Wolfe (Hall-Duncan 127)
woman in organdy dress seated at table in "In the Daguerreotype manner"
1941* John Rawlings (Hall-Duncan 131)
woman model photographed with man's arms in "Untitled" c. 1940 George
Platt Lynes (Hall-Duncan 106a)
woman sunbathing in bikini in "Bikini" 1946 Toni Frissell (Time-Life/13
120)
woman wearing Handmacher suit leans on globe and book of maps in "The
covert look" 1949* Louise Dahl-Wolfe (Hall-Duncan 128)
woman with veil over face in "Untitled" c. 1940 George Platt Lynes (Hall-
Duncan 106b)
FASHION PHOTOGRAPHY, 1950-1959
Christian Dior gown on model posing between two elephants in "Dovima
in an evening gown by Dior with the elephants of the Cirque d'Hiver"
1955 Richard Avedon (Hall-Duncan 137)
model in striped shirt and straw hat in Mayan ruins in "Sun fashion"
1952 Louise Dahl-Wolfe (Time-Life/13 123)
model wearing Rochas gown in "Mermaid dress" 1950 Irving Penn (Hall-
Duncan 145)
overhead view of woman in bold print silk in "The power of the print"
·1957* Hiro (Hall-Duncan 166)
Patou dress on woman with escort in "Suzy Parker in an evening dress
by Patou with Gardner McKay entering Scheherazade, Paris" 1956
Richard Avedon (Hall-Duncan 138)
seated woman wearing a burnoose in "Woman in Moroccan palace" 1952
Irving Penn (Hall-Duncan 146)
woman in cuffed shorts and blouse, between two filigreed bird cages
in "Sportswear in Tunisia" 1950 Louise Dahl-Wolfe (Time-Life/13 93)
woman in dress with large black and white squares in "Harlequin dress"
1950 Irving Penn (Hall-Duncan 153)
woman in Jacques Heim dress in "Dorian Leigh in a Jacques Heim dress"
1955 Henry Clarke (Hall-Duncan 156)
women in large brimmed hat and dark veil in "Girl in black and white"
1950 Irving Penn (Time-Life/13 127)
woman in large hat holding cigarette in "Girl with tobacco on the tongue"
1950 Irving Penn (Hall-Duncan 152)
woman seated on couch in "[Woman on couch]" 1950* Louise Dahl-Wolfe
(Hall-Duncan 126)
FASHION PHOTOGRAPHY, 1960-1969
brightly colored paper shoes in "Disposable paper shoes" 1967* Hiro
(Time-Life/7 226)
handbags of rust and green, on ledge in "Handbag" 1967* Silano (Time-

Life/13 134)

mannequins in metal bikinis and Dynel wigs in "Metal dresses" 1969* Bert Stern (Time-Life/13 137)

miniskirted woman seated on window sill near card-playing men in "Winter day" 1969* Alen MacWeeney (Time-Life/13 140)

model, Donyale Luna in dress of aluminum-hinged squares in "Dress by Paco Rabanne" 1967 Richard Avedon (Time-Life/13 128)

model in African-inspired mask of silver bands in "Mask by Emanuel Ungaro" 1968 Richard Avedon (Time-Life/13 129)

model in dress by Ben Reig in "Jean Shrimpton in a dress by Ben Reig" 1966 Richard Avedon (Hall-Duncan 139c)

model in dress by Gustave Tassell in "Jean Shrimpton in a dress by Gustave Tassell" 1966 Richard Avedon (Hall-Duncan 139d)

model suspended in bubble over small French street in "Suspended model" 1962 Melvin Sokolsky (Time-Life/13 30)

model wearing dress by Cardin in "Penelope Tree in a dress by Cardin" 1968 Richard Avedon (Hall-Duncan 143)

model wearing dress by Paco Rabanne in "Donyale Luna in a dress by Paco Rabanne" 1966 Richard Avedon (Hall-Duncan 142)

model showing vivid patterns of dress material in "High-fashion fabrics" 1967* HIro (Time-Life/13 132)

overhead view of model in black gown in "[Bold venture into night]" 1963* Hiro (Hall-Duncan 167)

seated woman in heavy, textured blue stockings in "Girl in blue stockings" 1963* Art Kane (Time-Life/13 138)

two women in Mollie Parnis dresses in "Giggling" 1965 Bob Richardson (Hall-Duncan 172)

two young boys seated on man's lap in "Beach babies" 1969 Diane Arbus (Hall-Duncan 181)

woman in dark coat and hat standing in field in "Portrait d'une Dame en Noir" 1964 Jeanloup Sieff (Hall-Duncan 182)

woman in St. Laurent dress posing in wax museum in "St. Laurent's modern French history" 1963 William Klein (Hall-Duncan 178)

woman in sunglasses with scarf over face in "[The sky is an accessory]" 1963* Hiro (Hall-Duncan 168)

woman wearing long, beaded earrings in "Luxury earrings" 1969* HIro (Time-Life/7 227)

FASHION PHOTOGRAPHY, 1970-1979

dog grabbing wrist of model in "Fetching is your Dior" 1976* Chris von Wangenheim (Hall-Duncan 198)

model in clinging gown with billowing sleeves in "Classic gown" 1970 Guy Bourdin (Time-Life/13 31)

model in evening gown seated on floor of bare apartment, next to boa constrictor in "New York woman" 1970* Art Kane (Time-Life/13 133)

nude woman lying on red bedspread in "Charles Jourdan shoe advertisement"* Guy Bourdin (Hall-Duncan 185)

seated women in red outfits in "Le Soir, Des Robes Fendues Sur la Jambe ou Sur un Pantalon" 1976* Guy Bourdin (Hall-Duncan 186)

shoes at accident scene in "Charles Jourdan shoe advertisement" 1975* Guy Bourdin (Hall-Duncan 190)

snakeskin belts on models in leotoards in "Belts" 1970* Alberto Rizzo (Time-Life/13 136)

woman embracing mannequin in "[Women in bikinis]" 1975 Helmut Newton (Hall-Duncan 203)

woman greeted at door by maid in "[A long two-part dress of crepe]" 1976 Helmut Newton (Hall-Duncan 204)

woman in black gown standing in plowed field in "L'Horizon de Soir le Noir" 1976* Guy Bourdin (Hall-Duncan 197)

woman in dress by Ann-Mari, in man's arms in "[A long sheath in patterned black jersey]" 1976 Helmut Newton (Hall-Duncan 205)

women in gowns by Madame Grès in "Les Robes Drapees de Madame Grès" 1976* Guy Bourdin (Hall-Duncan 189)

woman in knee-high boots seated on man's lap on "Medico's boutique fashions" 1970* H.P. Mühlemann (Time-Life/13 139)

woman in man's suit, and naked woman in alley in "[Of an insurpassable cut]" 1975 Helmut Newton (Hall-Duncan 207)

woman in striped Christian Dior gown in "Christian Dior gown" 1974 Guy Bourdin (Hall-Duncan 196)

woman lying on artificial turf near fish pond in shoe advertisement in "Ronsard" 1975* Guy Bourdin (Hall-Duncan 194)

woman model with bare breast in "Paloma Picasso in Karl Lagerfeld dress" 1973 Helmut Newton (Hall-Duncan 202)

woman on couch, and woman in pool in "[Woman on zebra-striped couch]" 1973* Helmut Newton (Hall-Duncan 200)

women running from dilapidated house in "[At Cinecitta]" 1976* Guy Bourdin (Hall-Duncan 192)

woman running in suit by Antony Arland in "Verushka in a suit by Antony Arland" 1972 Richard Avedon (Hall-Duncan 141)

woman with raised fist, wearing mink coat in "Fur power" 1974 Helmut Newton (Hall-Duncan 206)

woman with purple face and grey cap in "Girl with purple face" 1970* Richard Beck (Time-Life/11 55)

FASHION PHOTOGRAPHY, UNDATED

backs of women in bathing suits, on sand in "[Women on sand]"* Clifford Coffin (Hall-Duncan 102)

dress modeled by woman holding large white fur muff in "A dress from Maison Lanvin" Paul Nadar (Tournachon 290c)

hat by Hausard, on woman in fur stole in "Madame Dréau" Paul Nadar (Tournachon 292b)

male model showing off morning coat in "Male fashion" Gayne De Meyer (Time-Life/13 109c)

model wearing hat from Maison Lanvin in "A hat from Maison Lanvin" Paul Nadar (Tournachon 291c)

models in dark dresses posing as "Three graces" in "Untitled" George Platt Lynes (Hall-Duncan 109)

Panem dress in retouched photograph in "Dinner dress by Panem" Reutlinger Studio, Paris (Hall-Duncan 23)

Piguet and Heim gowns being modeled in "Outfits by Robert Piguet and Jacques Heim" Clifford Coffin (Hall-Duncan 100)

woman holding scarf overhead in "Untitled" George Platt Lynes (Hall-Duncan 107)

woman modeling a dress from Maison Lanvin in "A dress from Maison Lanvin" Paul Nadar (Tournachon 293a)

woman with gloved hand over her face in "Ruth Ford modeling" George Platt Lynes (Hall-Duncan 111)

young women riding bicycles in "[Riding bicycles]" Herman Landshoff (Hall-Duncan 81)

young women roller skating in "[Roller skating]" Herman Landshoff (Hall-Duncan 80)

FATHER AND CHILD see PARENT AND CHILD

FAUCETS

upright one by large bird in "New York" 1946 Elliot Erwitt (Gruber 441#)

FEATHERS
cyanotype of peacock feathers in "Cyanotype of peacock feathers" 1845
Photographer Unknown (Gernsheim 81#; Gernsheim/2 75#)
a single one in "The white quill" 1939 Emmanuel Sougez (Gruber 207#)
single one on rocks in "Feather" 1950 Rolf Winquist (Gruber 204#)
FEET
at right angles to each other in "Feet" 1957 Aaron Siskind (Time-Life/11
40)
silhouette of feet as they hang over fishing pier in "Barefoot boy fishing"
1967 Harald Sund (Time-Life/16 175)
with bent toes and colored stocking in "Stocking" 1967* Art Kane (Time-
Life/8 48)
woman's, near small dog in "New York" 1953 Elliot Erwitt (Gruber 443#)
FEMALE IMPERSONATORS see TRANSVESTITES
FENCES
boy by fence of hollow tubes in "Child in a strange world" 1971 Ron
Benvenisti (Time-Life/9 178)
boys standing in front of wooden plank fence in "Keep Me Close" c. 1938
Ben Shahn (Sandweiss 122#)
jagged, barbed wire fence and young man running naked in "Untitled"
1972 Crawford Barton (Time-Life/12 27)
of square wooden poles in "House with fence" 1948 Ansel Adams (Gruber
247#)
of wooden slats, on beach in "Beach patterns" 1969 Mel Ingber (Time-
Life/14 153)
small picket fence rolled up in garden in "Untitled" Mark Cohen (Gruber
269#)
weathered wooden farm fence in "Trois Rivières, Quebec" 1936* Paul
Strand (Bernard 207#)
white picket fence and farm buildings in "The white fence" 1916* Paul
Strand (Green 319; Time-Life/12 50)
with torn patches in "[Fence with torn patches]" Wolf von dem Bussche
(Time-Life/11 73)
wooden one and farmhouse in "[Farmhouse and fence]" Wolf von dem
Bussche (Time-Life/11 74)
FENCING
women fencing in Japanese style, with long poles in "Women fencers,
Japan" Photographer Unknown (Loke 116c)
FERNS
and one red lily in "Wood lily and hayscented ferns"* Les Line (Rugoff
108#)
some fronds by rocks in "Southern lady fern"* Larry West (Rugoff 140#)
FERRIES
filled with passengers in "The ferry boat" Alfred Stieglitz (Green 314)
from dock in "New York Ferry" 1910 Alvin Langdon Coburn (Gruber
362#)
FESTIVALS
men in suits wearing ornate hats in "Carnival" 1978 André Gelpke (Gruber
133#)
FETUS
eleven week old fetus in womb in "Eleven-week-old human fetus" 1963*
Lennart Nilsson (Time-Life/7 52)
FILIPINOS
woman and children standing on board to iron clothes in "A woman and
her children ironing clothes, Island of Luzon, Philippines" Photograph-
er Unknown (Loke 124a)
FIRE ESCAPES

child on fire escape overlooking alley in "View from a Harlem fire escape"
1968 Bruce Davidson (Time-Life/9 218)

on row of apartment buildings in "Tenth Street" 1967* Bill Binzen (Time-
Life/8 85)

FIRE FIGHTERS

group portrait of fire company in "The Franklin Hose Co., Utica, N.Y."
1858* Photographer Unknown (Bernard 56#)

FIRE HYDRANTS

and boys playing leapfrog in "Leapfrog, New York City" 1911 Lewis Hine
(Hine 2)

near stop sign and boy on bicycle in "Stop sign" 1972* Tomas Sennett
(Time-Life/12 21)

two from side of building in "Hose connection" 1965* Norman Rothschild
(Time-Life/8 214)

FIREARMS

armed American soldier guarding prisoner in cell in "An American soldier
guarding prisoner, Spanish-American War, Cuba" Photographer Un-
known (Loke 41)

armed Bedouins near tent in "Bedouin robbers, wilderness of Judea,
Palestine" 1896 Bert Underwood (Loke 46d)

armed Italian soldiers guarding Chinese prisoners in "Boxers guarded by
Italian soldiers" B.W. Kilburn (Loke 45d)

armed men and boys near train in "Boer farmers and boys on their way
to the front, South Africa" B.W. Kilburn (Loke 44a)

Chinese soldiers seated with rifles in "China" 1958 Henri Cartier-Bresson
(Gruber 418#)

Greeks with guns and ammunition belts in mountains in "A band of in-
surgents, Greco-Turkish war" 1897 Bert Underwood (Loke 46a)

guard standing with Gatling gun in "Guard at Polson Prison, Montana,
with Gatling gun" c. 1892* Skylar (Bernard 133#)

two Persian men practicing their marksmanship in "The Governor's body-
guards" c. 1880 Ernst Holtzer (Time-Life/14 120)

FIRES

after San Francisco earthquake in "San Francisco fire" 1906 Arnold Genthe
(Time-Life/10 38)

and explosion of dirigible hitting tower in "Explosion of the Hindenburg,
Lakehurst, New Jersey" 1937 Sam Shere (Time-Life/7 28)

people on hillside watching San Francisco burning after the earthquake
in "Watching the approach of the fire" 1906 Arnold Genthe (Sandweiss
72#)

smoke filled sky from forest fire in "Forest fire, Nevada" 1962* Ernst
Haas (Time-Life/8 154)

FISHERMEN

mending nets at building doorway in "Fishermen mending nets, Hastings,
England" Underwood and Underwood (Loke 143a)

FISHES

in beak of anhinga in "Anhinga seizing a fish"* Caulion Singletary (Rug-
off 162#)

in talons of flying osprey in "Osprey in the Everglades"* Kojo Tanaka
(Rugoff 163#)

school of young, feeding in "Juvenile bluehead wrasses feeding, Molasses
Reef, Upper Key Largo"* Douglas Faulkner (Rugoff 129#)

speckle-backed pike with lemon and parsley on newspaper in "Still life
with fish" 1965 B. Trutmann (Time-Life/13 225)

FISHING

children seated on stone steps in "A minnow pool, the Finlay children"
1843-1848 Hill & Adamson (Gruber 246#)

men standing in small boat, as they pull up net in "Taking up the eel
net" 1885 P.H. Emerson (Gernsheim 325#; Gernsheim/2 278#)
silhouette of boy's feet and fishing pole as they hang over pier in "Bare-
foot boy fishing" 1967 Harald Sund (Time-Life/16 175)
two boys on fallen limb of birch tree in "Two boys fishing" 1970* Stephen
Green-Armytage (Time-Life/16 202)

FLAGS
American flag held by boy in straw hat in "Patriotic boy with straw hat,
button and flag, waiting to march in a pro-war-parade, New York
City" 1967 Diane Arbus (Gruber 316#)
American flag reflected in brass door handle in "The Flag" 1966* Reid
Miles (Time-Life/8 46)
American flag spread out in store window in "New York City" 1965 Lee
Friedlander (Time-Life/7 220b)
American flag tied around old woman's neck in "New England, U.S.A."
or "Cape Cod, Massachusetts" 1947 Henri Cartier-Bresson (Cartier-
Bresson Frontispiece; Time-Life/7 214)
American flags on clothesline in "Robert Fichter" 1967 Alice Wells (Time-
Life/11 167a)
men carrying casket draped with American flag in "Funeral of Robert F.
Kennedy" 1968 Robert Lebeck (Gruber 381#; Time-Life/14 149)
seated boy holding flag and undressed doll in "Christopher and the re-
building of America" 1961 Ralph Eugene Meatyard (Time-Life/9 162)
small American flag on porch post in "Martha's Vineyard" 1963* Farrell
Grehan (Time-Life/8 94)

FLAMINGOS
sitting on nests in "Breeding flamingos, Andros Island, Bahamas" Frank
M. Chapman (Guggisberg 34b)

THE FLATIRON BUILDING, NEW YORK CITY
in the evening in "The Flatiron-Evening" Edward Steichen (Green 77)
men gathered by wagon and team of oxen near Flatiron building in "Ezra
Meeker with the wagon and ox team he drove across the continent..."
1907 Underwood and Underwood (Loke 165)

FLEABANE
pink flower in granite crack in "Fleabane in a granite crack near Italy
Lake in the central Sierra Nevada"* David Cavagnaro (Rugoff 44#)

FLIES
magnification of eye of a fruit fly in "The eye of a fruit fly, magnified"
1968 Lloyd Beidler (Time-Life/7 50)

FLIGHT (AERONAUTICS)
an early airplane in the air in "Aeroplane" Alfred Stieglitz (Green 311)
an early flying machine in "Santos Dumont in an experimental flying-
machine" c. 1906 Paul Nadar (Gruber 296#; Tournachon 33a)
Wilbur Wright flying over New York in "Wilbur Wright flying over Gov-
ernors Island, New York at 45 miles per hour" 1909 H.C. White (Loke
172)
Wright Brothers flying the first airplane in "The first airplane flies"
1903 John D. Daniels (Time-Life/10 22)

FLIGHT (BIRDS)
a flock of cranes migrating in "Cranes migrating along the White Nile"
Bengt Berg (Guggisberg 87)
gulls in flight in "Exxon USA magazine" 1973* George Watson (Time-Life/
12 70)
in flight over mountain in "Clark's nutcracker in Rocky Mountain National
Park"* Kojo Tanaka (Rugoff 50#)
stages of duck in flight in "Flight of a duck" c. 1890 E.J. Marey (Time-
Life/7 157)

FLOODS
aftermath, trees uprooted in "Floods at Sheffield" 1864 James Mudd (Gern-
sheim 186#)
organ standing on land destroyed by flood in "Aftermath of flood, Mount
Vernon, Indiana" 1937 Russell Lee (Photography 269)
scene of crushed houses and furniture in "Aftermath of the Johnstown
(Pennsylvania) flood of 1889 which took 2,300 lives" Underwood and
Underwood (Loke 16c)
street in Lyons in "Flood at Lyons" 1856* Froissart (Bernard 36#)
water rushing through town in "Photographers covering Ohio River flood"
1937 Photographer Unknown (Time-Life/10 11)
FLOWERPOTS
stacked on wheelbarrow in "Wheelbarrow with flowerpots" 1920 Edward
Steichen (Time-Life/11 49)
FLOWERS. See also Cacti; Callas; Daisies; Dandelions; Heather; Hibiscus;
Horsetails; Hydrangeas; Kale; Lichens; Lilies; Lotus; Magnolias; Nar-
cissus; Orchids; Poppies; Rhododendrons; Roses; Sunflowers; Texas
Bluebonnets; Tulips; Water Lilies
around head of woman, to be used as a Vogue cover in "Spring fashion"
1949 Cecil Beaton (Time-Life/12 115a)
arrangement of lilies and other flowers in "Still life" c. 1855* Adolphe
Braun (Bernard 52#)
field of red poppies and creosote bush in "Spring poppies and creosote
bush in Antelope Valley, Mojave Desert, southern California"* David
Muench (Rugoff 77#)
field of yellow flowers and tree-like cacti in "Spring flowers with the vol-
canic crest of the Ajo Mountains in the distance, Organ Pipe Cactus
National Monument, Arizona"* David Muench (Rugoff 76#)
girl sitting amongst flowers with hands folded in lap in "Mountain girl
and flowers" 1970 Arthur Tress (Time-Life/9 171)
growing in swamp in "Swampflowers" 1897* Theodor and Oskar Hofmeister
(Gruber 142#)
held by young child in party dress in "Maria, Mexico" 1966* Marie Cosin-
das (Time-Life/9 62)
in a vase in "Still life" c. 1900* Frederic E. Ives (Time-Life/8 57)
in still life with grapes and other fruit in "Still life (Fruit and flowers)
c. 1860 Roger Fenton (Gruber 200#)
of ribbon, in box with stuffed bird in "Bird of the death dream" 1953
Clarence John Laughlin (Time-Life/12 54)
on cactus, with bee in "Cactus for a bee" 1968* Farrell Grehan (Time-
Life/8 125)
on saguaro cactus in "Saguaro cactus in April in southern Arizona"*
Thase Daniel (Rugoff 83#)
pregnant woman in field of jonquils in "Indications of motherhood" 1969*
Sam Zarember (Time-Life/8 111)
red flowers with thorns in "Hedgehog cactus in Arizona's Painted Desert"*
Bill Ratcliffe (Rugoff 84#)
red ones held by woman in "Flower vendor" 1968* Sam Zarember (Time-
Life/8 110)
taken without a camera in "Cameraless shadow picture of field flowers"
1839 William Henry Fox Talbot (Time-Life/12 189)
two daisy-like flowers in "Wildflower in Iowa"* Patricia Caulfield (Rugoff
100#)
workman with flowers passing through graveyard in "Workman on his way
home, Scotland" 1960 Bruce Davidson (Time-Life/11 132)
yellow flowers and prairie grass in "Prairie grass in South Dakota"*
Patricia Caulfield (Rugoff 101#)

FOG
coming across coastline in "Fog bank" c. 1947 Minor White (Sandweiss
133#)
covering forest of sequoia in "The fog-shrouded boles of Sequoia in Red-
wood National Park"* David Muench (Rugoff 28#)
over lake with dead trees in "Periyar National Park" 1966* Jean-Max Fon-
taine (Time-Life/8 83)
over landscape of cactus and oaks in "Foggy dawn over the Edwards
Plateau of central Texas, with prickly-pear cactus in the foreground
and live oaks and cedar elms in the background"* Jim Bones (Rugoff
86#)
over rows of houses in "Fog over city" 1951 Minor White (Time-Life/11
204)
two men in a rowboat in "Fog--Nova Scotia" 1968 George Krause (Time-
Life/12 143)
FOODS. See also ARTICHOKES; CABBAGES; PEPPERS; PIES; TOMATOES
casseroles on wooden table in "One-dish meals" 1970* Rudy Muller (Time-
Life/13 63)
FOOTBALL
at instant of contact in "Wesley Fesler kicks a football" c. 1937* Harold
E. Edgerton (Bernard 211#)
boy with helmet on clothes-strewn table in locker room in "Defensive
Back, George Washington High Eagles" 1970 Kenneth Graves (Time-
Life/12 24)
defense tackling player with ball in "Giants' defense" 1963 Walter Iooss,
Jr. (Time-Life/16 135)
John Stallworth catching football in "John Stallworth's winning catch at
the Super Bowl" 1980* Walter Iooss, Jr. (Time-Life/14 148)
player kneeling on ground in "Y.A. Tittle" 1964 Morris Berman (Time-
Life/10 47)
FORESTS
aerial view of tree tops in "Forest landscape, Catskill Mountains, New
York" Ralph Weiss (Rugoff 133#)
child standing under Shinto ritual gateway in "Tarii light, Tokyo" 1975*
Harald Sund (Time-Life/14 30)
deer in woods of birch trees in "White-tailed deer in woods"* Larry West
(Rugoff 112#)
girl with green dress in black and white photograph of woods in "Prime-
val dress" 1968* Harold H. Jones III (Time-Life/12 228)
in autumn colors at base of mountains in "Willows in autumn colors at
about 8700 feet up in the Minarets Wilderness, California"* David
Cavagnaro (Rugoff 43#)
in autumn colors in "Vermont autumn"* Sonja Bullaty and Angelo Lomeo
(Rugoff 114#, 115#)
moss covered trees, and ferns in "Rain forest in the Hoh River area of
Olympic National Park, Washington"* Betty Randall (Rugoff 21#)
nude child on ground in "Child in forest" c. 1951-54 Wynn Bullock
(Bullock 49; Gruber 222#)
nude woman lying on blanket in "Woman and dog in forest" 1953 Wynn
Bullock (Bullock Cover)
nude woman lying on forest floor in "Nude in dead forest" 1954 Wynn
Bullock (Bullock 43)
of pine tree trunks in "Forest of lodgepole pines"* Charles Steinhacker
(Rugoff 54#)
of pine trees and morning mist in "Before dawn near the entrance to
Mt. McKinley National Park" Ed Cooper (Rugoff 8#)
silhouette of trees reflected in water in "Black ash and white cedar in a

swamp in spring"* Les Blacklock (Rugoff 106#)
small child on dirt road in "Child on forest road" 1958 Wynn Bullock
(Bullock 13)
snow-covered pine trees in "Vermont winter" Sonja Bullaty and Angelo
Lomeo (Rugoff 116#)
trees covered with mosses, lichens and ferns in "Trees covered with
mosses, lichens and ferns in rain forest, Olympic National Park"*
Betty Randall (Rugoff 22#)
trees in autumn colors on hillside in "The central Texas hills in the
Devil's Backbone country in autumn"* Jim Bones (Rugoff 89#)
trees with rough bark, and ferns in "The Forest" 1956 Wynn Bullock
(Bullock 45)

FORKS
leaning against side of plate in "The fork" 1928 André Kertész (Gruber
76#)
pronged end in "Rollmops" Max Burchartz (Gruber 195#)

FORTIFICATIONS
cannons and cannonballs in fort overlooking water in "The fortress of
Malta" c. 1860 James Robertson? (Gernsheim/2 149#)
dead soldiers in fort in "Capture of Fort Taku, North China" 1858 Pho-
tographer Unknown (Gernsheim 168#; Gernsheim/2 143#)
of stone in "Temple Fort, Southern India" before 1858* Linnaeus Tripe
(Bernard 60#)
stone wall and canal in "Ramparts at Avignon" c. 1851 E. Baldus (Gern-
sheim 98#; Gernsheim/2 91#)

FORTUNE TELLING
bride gazing into crystal ball in "['Eager-eyed under the bridal veil...']"
1919 Baron Adolf de Meyer (Hall-Duncan 35)

FOSSILS
lined up on shelf in "Shells and fossils" 1839 Louis Jacques Mande Da-
guerre (Photography 19)

FOUNTAINS
in front of ornate building in "Fountains in front of the Palace of Elec-
tricity, Paris Exposition" 1900 H.C. White (Loke 36)

FOXES
Red fox in brush in "Red fox pup lurking in the tundra near Mt. Mc-
Kinley National Park"* Dean Brown (Rugoff 10#)

FRIENDSHIP
Black boy with arm around white boy in "New York" 1953 Henri Leighton
(Time-Life/7 30c)

FRIGATE BIRD
in flight in "Frigate bird on Hemp Key, Florida" William G. Demroth
(Rugoff 151#)

FRONTIER AND PIONEER LIFE
mother and children at rim of Grand Canyon in "A frontier woman and
her children at the Grand Canyon, Arizona" Photographer Unknown
(Loke 53)

FROST
on window in "Frost window no. 2" 1961 Paul Caponigro (Time-Life/11
50)

FRUIT. See also Still life; Apples; Berries; Grapes; Lemons; Melons;
Oranges; Pears; Persimmons; Pineapples; Watermelons
and decanter of wine in still life in "Still life" c. 1858 Roger Fenton
(Gernsheim 130#)
apples and orange in a bowl in "Fruit in a Majolica dish" 1921 (Gruber
191#)
arranged as still life in "Still life" 1899 or 1900* Auguste and Louis

Lumière (Bernard 144#)
cut-up in a bowl in "Still life" 1967* Peter Worth (Time-Life/8 45)
grapes and other fruit in still life with flowers in "Still life (Fruit and flowers)" c. 1860 Roger Fenton (Gruber 200#)
still life of bowl of fruit in "Still life" c. 1850 Henri Le Secq (Time-Life/ 7 185)

FUNERAL RITES AND CEREMONIES
backs of group kneeling in forest in "The burial of Leo Tolstoy" 1910* Photographer Unknown (Bernard 165#)
Black man weeping while playing accordion in "Weeping for F.D.R." 1945 Edward Clark (Time-Life/10 32)
group gathered at large open grave in "Karl Liebknecht speaking at the mass grave of fallen Spartacists, Berlin" 1919* Photographer Unknown (Bernard 176#)
men carrying flag-draped casket in "Funeral of Robert F. Kennedy" or "Kennedy's burial" 1968 Robert Lebeck (Gruber 381#; Time-Life/ 14 149)
women in black dresses and veils in "Bereaved Queens" 1952 Photographer Unknown (Time-Life/10 33)

FUNGI
growing on tree in "Oyster mushrooms" 1969 Ralph Weiss (Time-Life/11 11)

FUR
white muff held by woman in "A dress from Maison Lanvin" Paul Nadar (Tournachon 290c)

FURNESS ABBEY
ivy-covered ruins in "Furness Abbey, the transepts from the Northwest" c. 1856 Roger Fenton (Gruber 352#)

G

GALLINULES
bird with orange-yellow beak hunting in water for insects in "A purple gallinule hunts for insects on Grassy Lake, Arkansas"* Thase Daniel (Rugoff 94#)

GAMES
boys playing leapfrog on city sidewalk in "Leapfrog, New York City" 1911 Lewis Hine (Hine 2)
children playing Blindman's Buff in "Children playing Blindman's Buff" Photographer Unknown (Loke 120)
girls playing ring toss indoors in "Ring toss" 1899* Clarence H. White (Green 69; Gruber 277#; Time-Life/12 29)
Korean men seated on floor playing Go in "Yun Wong-Niel, Korean Minister of War in a game of Go with a friend in his home in Seoul, Korea" 1904 Underwood and Underwood (Loke 115c)
Turkish men playing backgammon with onlookers in "A game of Turkish backgammon in Palestine" 1900 Keystone View Company (Loke 66b)
women in large hats playing dominoes in "Women playing dominoes, Palm Beach, Florida" Underwood and Underwood (Loke 115d)

GANGS
men and women posed with their motorcycles in "A group of Hell's Angels" 1967 Irving Penn (Time-Life/7 217)
young men in leather jackets in "Sparky and Cowboy" 1965 Danny Lyon (Time-Life/7 23)

GARAGES

closed door and driveway in "Tract house no. 23" 1970 Lewis Baltz (Time-Life/11 123)

family sitting in front of open door in "Our house is built with the living room in the back..." 1972 Bill Owens (Gruber 131#)

GARROTES

man with head locked into garrote in "Execution chamber and garrote, Manila" 1899 C.H. Graves (Loke 43d)

GAS MASKS

man with rifle over shoulder in "[A Tommy in a gas mask]" 1915 Photographer Unknown (Time-Life/10 56)

person pushing baby carriage while wearing gas mask in "Journey into the past" c. 1945 Wolf Strace (Gruber 379#)

soldiers in formation wearing gas masks in "American soldiers training with gas masks, Fort Dix, New Jersey" Underwood and Underwood (Loke 205)

GATES

double gate in disrepair in "Cemetery gates" 1965 George A. Tice (Gruber 248#)

GAZELLE

drinking in a river in "Soemmering's gazelle drinking in the bed of the Dinder River" H.A. Bernatzik (Guggisberg 100b)

GEARING

large gears of a lathe in "Lathe in the Oerlikon Engineering Works" 1935 Jakob Tuggener (Gruber 179#)

GEESE

girl sitting on grass with lap full of goslings in "Goose girl" 1918 André Kertész (Time-Life/9 72)

swimming in lake in "PepsiCo World Headquarters, Purchase, New York"* Jay Maisel (Time-Life/12 57)

GERMAN SHEPHERDS

young girl covering eyes of dog with her hands in "Untitled" 1973 (Time-Life/12 31)

GERMANS

circle of girls in traditional dress in "Hessian schoolgirls in their holiday costume, Mengsburg, near Treysa, Germany" 1908 Underwood and Underwood (Loke 148)

woman carrying grapes in bucket on head in "A woman carrying a bucket of grapes on her head, Rüdesheim, Germany" 1905 Keystone View Company (Loke 130a)

GIANTS

two men standing by average height man in "Underwood photographer James Ricalton with two giants of Kashmir at the Great Durbar of 1903, Delhi, India" Photographer Unknown (Loke 14)

GIBBON FALLS

view of Falls from base in "Gibbon Falls, 84 feet, Yellowstone National Park" c. 1884 Frank Jay Haynes (Sandweiss 20#)

GIBRALTAR

and fortified bridge in "[Gibraltar]" c. 1865 Photographer Unknown (Time-Life/12 77b)

GIRAFFES

one grazing near a zebra in "Reticulated giraffe and Grévy's zebra posing side by side" Oskar Olson (Guggisberg 97)

running in "A snapshot taken from a car in order to illustrate the various phases of the giraffe's gait" Marius Maxwell (Guggisberg 95)

GLACIER BAY

chunk of ice on pebbled beach near water in "Beach iceberg in an inlet of Glacier Bay"* Dean Brown (Rugoff 4#)

GLACIERS
 cul de sac in mountain range in "Kichatna spire in the Alaska Range" Ed
 Cooper (Rugoff 6#)
 parallel paths flowing through mountains in "The Barnard Glacier flowing
 through the Natazhat and Bear Mountains" Bradford Washburn (Rugoff
 5#)
 spreading from mountain over tundra in "The south face of 12,540-foot
 Mt. Deborah in the Alaska Range with a glacier spreading out over the
 tundra plains" Ed Cooper (Rugoff 7#)
GLASS MANUFACTURE
 children working at glass blowing in "Children in New Jersey glass fac-
 tory" 1909 Lewis Hine (Hine 33)
 young boy working in glassworks in "Factory boy, glassworks" 1909
 Lewis Hine (Hine 55)
GLASSWARE
 rose in glass of water in "Yellow rose and skyscraper" 1950* Irving Penn
 (Gruber 166#)
 roses in glass of water near wet window in "Roses" 1956 Josef Sudek
 (Gruber 199#)
 water with hydrangia in "Still life" Baron A. De Meyer (Green 241)
 wineglass and apple on table in "Wineglass and apple" 1896* Josef Watzek
 (Gruber 165#)
 wineglass turned upside down in "Glass" 1923 Jaroslav Rössler (Gruber
 189#)
GLOBES
 model leaning on globe and book of maps in "The covert look" 1949*
 Louise Dahl-Wolfe (Hall-Duncan 128)
 teacher explaining globe to girls in "The geography lesson" 1851 Antoine
 Claudet (Gernsheim 140#; Gernsheim/2 116#; Time-Life/9 45)
GLOUCESTER CATHEDRAL
 tomb of Edward II, with his likeness in "Gloucester Cathedral: Tomb of
 Edward II, at dusk" 1890* Frederick H. Evans (Time-Life/15 91)
GLOVES
 one on weathered wood in "Gloucester I" 1944 Aaron Siskind (Gruber
 185#)
GOATS
 and goatherd on dirt road in "Long-haired goats on a Swiss highway"
 Photographer Unknown (Loke 56)
 and group of children by cottage in "Children in Warsaw, Poland" B.W.
 Kilburn (Loke 149)
GOLF
 silhouette of woman with golf club and ball in "Active sports silhouette"
 1930 Barré (Hall-Duncan 53)
 woman having hit golf ball in "Untitled" 1935 Martin Munkacsi (Hall-Dun-
 can 70a)
GONDOLAS
 in silhouette in "Gondolas at San Marco" 1955* Ernst Haas (Time-Life/8
 140)
GRAF ZEPPELIN
 flying over pyramid in "The Graf Zeppelin flying over the pyramids of
 Gizeh" George Lewis (Loke 220)
GRAFFITI
 on brick wall in "Boys with graffiti" 1955 Henri Cartier-Bresson (Time-
 Life/9 129)
GRAND CANYON NATIONAL MONUMENT
 at sunset in "Sunset over the Grand Canyon as seen from Bright Angel
 point looking toward South Rim and San Francisco Peaks"* David

Muench (Rugoff 62#)
Colorado River passing through deep canyons in "Colorado River below
Toroweap View, Grand Canyon National Monument, Arizona"* David
Muench (Rugoff 61#)
in muted tones in "Westward view from Hopi Point, Grand Canyon"*
David Muench (Rugoff 63#)
GRAND TETONS
man's arm holding ruler up to mountains in "Wyoming" 1971 Kenneth
Josephson (Gruber 449#)
GRAPES
black ones on slice of melon in "Melon slice with grapes" 1968* Richard
Jeffrey (Time-Life/14 157)
bunches as still life in "Still life" c. 1860* Roger Fenton (Bernard 70#)
a single bunch in "Grapes" Kiyoshi Nishayama (Gruber 193#)
GRASSES
blade of grass with drop of water in "Water drops on grass blades in
Point Reyes National Seashore, California"* David Cavagnaro (Rugoff
70#)
close-up of prairie grass in "Prairie grass in South Dakota"* Patricia
Caulfield (Rugoff 97#)
detail of prairie grass in "Detail of prairie grass"* Patricia Caulfield
(Rugoff 2#)
in water in "[Grasses in water]" 1960 Brett Weston (Sandweiss 131#)
photogram of marsh grass in "[Marsh grass]" Yale Joel (Time-Life/12
166)
prairie grass and yellow flowers in "Prairie grass in South Dakota"*
Patricia Caulfield (Rugoff 101#)
thick field of green with red-orange flowers in "Day lilies on a hill in
North Dakota"* Patricia Caulfield (Rugoff 98#)
GRASSHOPPERS
with army ant on its back in "Death of a grasshopper" 1967 Carlo Bavag-
noli (Time-Life/16 86)
GRAVES see CEMETERIES; FUNERAL RITES AND CEREMONIES
GREBES
black-necked grebe on nest in "Black-necked grebe on nest" Oliver G.
Pike (Guggisberg 27)
sitting on mound of sticks in water in "Red-necked grebe in Banff Na-
tional Park"* Kojo Tanaka (Rugoff 52#)
GRECO-TURKISH WAR
armed Greeks in mountains in "A band of insurgents, Greco-Turkish war"
1897 Bert Underwood (Loke 46a)
GREEKS
armed men in mountains in "A band of insurgents, Greco-Turkish war"
1897 Bert Underwood (Loke 46a)
GREYHOUNDS
views of dog racing in "Greyhound" 1884-5 Eadweard Muybridge (Gern-
sheim 298#)
GUANAJUATO, MEXICO
view from mountain overlooking town in "A glimpse of Guanajuato, Mexi-
co" c. 1883-1884 William Henry Jackson (Sandweiss 35#)
GUARDS
armed Italian soldiers guarding Chinese prisoners in "Boxers guarded by
Italian soldiers" B.W. Kilburn (Loke 45d)
man with Gatling gun in "Guard at Polson Prison, Montana, with Gatling
gun" c. 1892* Skylar (Bernard 133#)
GUGGENHEIM MUSEUM
its spiral above moving bus in "Guggenheim Museum" 1965* Ernst Haas

(Time-Life/8 135)

GUITARS

man playing guitar on bench in "Serenading gondoliers" 1955* Ernst Haas
(Time-Life/8 141)

young couple playing in "[Couple playing guitars]" Robert Walch (Time-Life/10 106-7)

GULLS

in flight in "Exxon USA magazine" 1973* George Watson (Time-Life/12 70)

on misty beach in "Cape Johnson in Olympic National Park on the Washington coast"* Steven C. Wilson (Rugoff 31#)

two birds piggy-back in "Herring gulls at play" W. Schack (Guggisberg 110)

GYPSIES

young woman standing on chained lion in "Gypsy girl with lion" 1901*
Lala Deen Dayal (Bernard 149#)

GYROSCOPES

and magnifying glass in "Imitation of the gyroscope by the magnifying glass" 1922 Man Ray (Photography 229c)

H

HAIR

curlers on man with long fingernails in "A young man in curlers at home in West 20th Street, New York" 1956 Diane Arbus (Gruber 123#)

girl in front of mirror on vending machine in "Teenagers at Coney Island" 1959 Bruce Davidson (Time-Life/7 30d)

girl standing on stool to fix her hair in "Girl fixing her hair" c. 1895
Giuseppe Primoli (Time-Life/14 97c)

mother combing girl's hair, on bed in "Morning repose" 1957 Wayne Miller (Time-Life/9 189)

HALF-DOME

view of Yosemite with Half-Dome in "The Half-Dome from Glacier Point, Yosemite" c. 1866 Carleton E. Watkins (Sandweiss 26#)

HAMBURG, GERMANY

attached houses on a canal in "Houses on a canal, Hamburg, Germany" 1884 G. Koppman & Co. (Time-Life/14 113)

ruins after the fire in "Ruins of Hamburg after the great fire" 1842 C.F.
Stelzner (Gernsheim/2 63#; Time-Life/14 85)

HAMBURGERS

shirtless boy with hamburger in mouth in "Hamburger grin" 1968 John
P. Aikins (Time-Life/9 131)

HANDICAPPED

boy on crutches playing with others in rubble in "Children in Seville, Spain" or "Seville, Spain" 1933 Henri Cartier-Bresson (Cartier-Bresson 17; Time-Life/9 75)

man with one foot, on crutches on sidewalk in "Man on crutches" c.
1910 Lewis Hine (Hine 34)

portrait of man with both legs amputated in "Private Charles N. Lapham, Civil War amputee" 1863* Photographer Unknown (Bernard 79#)

HANDS

adjusting corset in "Plate 31 from 'Practical poses for the practical artist'" 1912* Photographer Unknown (Bernard 164#)

and feet of an infant in "[An infant's hands and feet]" Wolf von dem
Bussche (Time-Life/9 108)

in prayer in "Praying hands" c. 1927* Albert Renger-Patzsch (Bernard 189#)

leathery and gnarled hands of farmwoman in "Iowa homesteader's wife"
1936 Russell Lee (Time-Life/10 119)

making fists in "Joe Louis" 1964* Art Kane (Time-Life/7 127)

of a man in "Hand of M.D. ... Banker" c. 1860* Nadar (Bernard 75#)

of man holding cigarette in "David Alfaro Siqueiros" 1966 Farrell Grehan
(Time-Life/7 86)

of woman at her chest in "[Georgia O'Keefe's hands]" 1917 Alfred Stieg-
litz (Sandweiss 83#)

of woman holding vase in "Hands and vase" c. 1860 Oscar Rejlander
(Gernsheim 123#; Gernsheim/2 103#)

of woman sewing in "Hands and thimble--Georgia O'Keeffe" 1920 Alfred
Steiglitz (Photography 216)

three fingers and an ear in "Hand and ear" 1928 Brett Weston (Photog-
raphy 232a)

HAPPINESS

mother holding newborn infant in "A child is born" 1964 John Minshall
(Time-Life/9 11)

of woman's face in "Young New Yorker" 1964* Jay Maisel (Time-Life/8
106)

smiling boy with men in "Meeting father's friends, Hungary" 1963 Paul
Schutzer (Time-Life/9 20)

HARPS

by woman in hooded robe in "[The hooded robe]" 1945 George Platt
Lynes (Hall-Duncan 110)

woman playing harp in "Lady at the harp" c. 1843 William Henry Fox
Talbot (Photography 35)

HATS

men in store filled with sombreros in "A sombrero store, Mexico City,
Mexico" 1903 Underwood and Underwood (Loke 124c)

HAWKS

Harris' Hawk with mouth open on yucca branch in "Harris' Hawk on yuc-
ca, Baja California"* Willis Peterson (Rugoff 80#)

sparrow hawk and young at nest in "Sparrow hawk and young" C.W.R.
Knight (Guggisberg 63)

HAY

men carrying large bundles of hay on their backs in "Men with bundles
of hay, Simla, India" 1903 Underwood and Underwood (Loke 137b)

stack tied with spiraling hay rope in "[Haystack in field]" Dennis Hearne
(Time-Life/12 150)

HEATHER

white flowers on red stems in "White heather covers a hillside"* David
Cavagnaro (Rugoff 45#)

HELICOPTERS

descent of helicopter traced by lights in "Navy rescue helicopter" 1949
Andreas Feininger (Time-Life/7 89)

HERONS

adult heron at nest with young in "Purple heron at nest" R.B. Lodge
(Guggisberg 19a)

head and beak of little blue heron in "Little blue heron" William G. Dam-
roth (Rugoff 153#)

yellow-crowned night heron on beach in "Yellow-crowned night heron on
Sanibel Island" William G. Damroth (Rugoff 152#)

HIBISCUS

superimposed over beach in winter in "Seasons" 1968* Bill Binzen (Time-
Life/8 219)

HIDING

child hiding in bush in "My secret place in Central Park, New York" 1969

Charles Harbutt (Time-Life/9 31)
child with paper over face in "I can see you, but you can't see me" 1966
Alen MacWeeney (Time-Life/9 133)
HIEROGLYPHICS
on entrance in "Egypt" 1858 Francis Frith (Gruber 370#)
on large columns in "Thebes, Medînet-Habou" c. 1851 Félix Teynard
(Gruber 28#)
on rows of large columns in "Hypostyle Hall at Edfu" after 1862* Felice
A. Beato (Bernard 72#)
on ruins of wall in "Karnak" c. 1850 Félix Teynard (Gruber 369#)
on side of throne of Colossus in "Colossus, decoration on northeast side
of throne" c. 1851-52* Félix Teynard (Bernard 25#)
on wall in "Relief on temple at Thebes" 1851 John Shaw Smith (Gernsheim
90#; Gernsheim/2 83#)
HIGHWAYS see ROADS
HINDENBURG
bursting into flames in "Explosion of the Hindenburg, Lakehurst, New
Jersey" 1937 Sam Shere (Time-Life/7 28)
HIPPOPOTAMI
asleep near zoo cage bars in "The hippopotamus at the Zoological Gardens,
Regent's Park" 1855* Count de Montizon (Bernard 45#)
a group of three resting in "A troop of hippopotami on the banks of the
Uaso Nyiro" Marius Maxwell (Guggisberg 94)
HOME ECONOMICS
girls in aprons in cooking class in "High school domestic-science room,
Rockford, Illinois" Underwood and Underwood (Loke 216)
HORNS
ancient Roman horn in "Ancient Roman horn" 1870's* Giorgio Sommer
(Bernard 117#)
HORSE RACING
jockeys and horses at starting gate in "Starting gate at Aqueduct" 1964*
Walter D. Osborne (Time-Life/16 154)
looking at horse race over heads of people in grandstand in "Going to the
start" Alfred Stieglitz (Green 94)
HORSES
and tents in encampment in valley in "Encampment of Horse Artillery, the
Crimea" 1855 Roger Fenton (Time-Life/14 87)
braided mane in "[Braided horse's mane]" Dennis Hearne (Time-Life/12
151)
child on pony in park in "Equestrienne" 1912 Jacques-Henri Lartigue
(Time-Life/9 73)
cowboys riding on open range in "Western homecoming" 1958* Ernst Haas
(Time-Life/8 151)
farm horse facing cart in "Farm study" c. 1855* Photographer Unknown
(Bernard 39#)
girl standing on back of horse in circus ring in "In the circus" or "Cir-
cus rider" 1905* Harry C. Rubincam (Gernsheim/2 205#; Green 90;
Time-Life/12 31)
grazing beneath redwoods in "Coastal redwoods in Santa Cruz County,
California" Don Worth (Rugoff 30#)
horse in motion in "Racehorse" 1884-5 Eadweard Muybridge (Gernsheim
297#; Gernsheim/2 242#)
man by horse looking out from stable in "At the Curragh race course
near Dublin" 1955 Henri Cartier-Bresson (Cartier-Bresson 55)
man plowing with a pair of horses in "A stiff pull" 1888 Peter Henry
Emerson (Gruber 43#; Photography 161)
a mare and her colt, by woman and her daughters in "A woman and her

daughters, Bretton Woods, New Hampshire" Underwood and Underwood
(Loke 109a)

mounted warriors with metal breastplates in "Mounted warriors with chain
armor and metal breastplates, Delhi, India" Photographer Unknown
(Loke 90)

of bronze in "Greek bronze horses, Basilica di San Marco, Venice" c.
1860 Carlo Ponti (Gernsheim/2 161#)

performer on white circus horse in "Circus" 1967* Marcia Keegan (Time-
Life/16 191)

photographing a boy on a horse, before a screen in "The Prince Imperial,
Paris" c. 1859 Mayer & Pierson (Time-Life/9 65)

pulling carriages on city street in winter in "The Street, design for a
poster" c. 1900* Alfred Stieglitz (Time-Life/12 30)

pulling man in buckboard on sand dunes in "[Great sand dunes along
the Columbia River, Oregon]" H.C. White (Loke 152)

pulling wagon near bicycles on cobblestone intersection in "Touraine,
France" 1930 André Kertész (Time-Life/11 128)

small magenta horse against red background in "Magenta horse" 1969*
Pete Turner (Time-Life/8 216)

teams walking with their drivers in "Berkshire teams and teamsters"
George Davison (Green 86)

three men standing on bare backs of horses, near tent in "Three bare-
back riders"* Nathan Lazarnick (Bernard 180#)

turning around a horse-drawn streetcar in "The Terminal" 1893 Alfred
Stieglitz (Gernsheim 340#; Gernsheim/2 307#; Green 312; Gruber 407#;
Photography 169; Time-Life/7 19)

walking and running in "The horse in motion" 1878 Eadweard Muybridge
(Photography 140, 143)

white horse standing by wooden gate in "White horse" 1932 Paul Strand
(Gruber 268#; Photography 221a)

white horse standing with models in white gowns in "White fashions" 1935
Edward Steichen (Time-Life/13 111)

with braided mane in "[Braided horse's mane]" Dennis Hearne (Time-Life/
12 151)

woman riding in pony cart in "[Mme. Beaurepaire in her pony cart]" 1944
Lee Miller (Hall-Duncan 123)

HORSETAILS

feathery plants and logs in "Horsetails and log" 1957 Wynn Bullock (Bul-
lock 17)

HOTELS, MOTELS, ETC.

entrance to fancy hotel in "Entrance to Miami Beach Hotel" 1939 Mario
Post Wolcott (Time-Life/10 134)

HOUSEHOLD EMPLOYEES

attendants of king by his carriage in "Attendants at the wedding of Vit-
torio Emanuele III" 1896 Giuseppe Primoli (Time-Life/14 95)

carrying man in traditional dress, on one-wheeled cart in "One-wheeled
cart of a Korean general, Seoul, Korea" 1904 Underwood and Underwood
(Loke 162d)

a Chinese woman and her servants in "A Chinese woman with her maid-
servants, Hong Kong" c. 1901 James Ricalton (Loke 100)

litter-bearers carrying man in palanquin in "A palanquin in Calcutta, In-
dia" Underwood and Underwood (Loke 163c)

maid with feather duster leaning over balcony in "Montmartre" c. 1900 C.
Puyo (Gernsheim 337#; Gernsheim/2 295#)

men carrying woman in hammock-like litter in "A hammock carriage,
Funchal, Madeira" Underwood and Underwood (Loke 162a)

servants carrying a woman in a palanquin in "A woman carried in a palan-

quin, Botanical Gardens, Darjeeling, India" Underwood and Underwood
(Loke 163a)
woman greeted at door by maid in "[A long two-part dress of crepe]"
1976 Helmut Newton (Hall-Duncan 204)
HOUSEHOLD EQUIPMENT AND SUPPLIES
spoon and earthenware coffeepot and jug in "Earthenware utensils with
a spoon" 1967* Henry Sandbank (Time-Life/13 212)
HUNGER
child with tears on cheeks in "Child in distress" or "Hunger" 1947 Wern-
er Bischof (Gruber 279#; Time-Life/9 175)
men and women holding plates on soup line in "Flood refugees, Forrest
City, Arkansas, February 1937" Walker Evans (Photography 266a)
mother with outstretched hands, holding infant in "Famine in India" 1951
Werner Bischof (Time-Life/7 26)
people in food line underneath billboard in "Kentucky" 1937 Margaret
Bourke-White (Time-Life/7 20d)
skeleton-like bodies of children watching man screen in "Hyderabad fam-
ine" 1890's* Lala Deen Dayal (Bernard 135#)
starving men being helped by others in "Famine victims receiving aid,
India" c. 1901 Keystone View Company (Loke 185c)
young boy suffering from malnutrition, seated on ground in "Famine in
Russia" 1910 Nahum Luboshez (Gernsheim/2 262#)
HUNTERS AND HUNTING
Africans and hunter with dead zebras in "Zebra hunting in Tanganyika
Territory, Africa" Underwood and Underwood (Loke 132a)
crocodile by group of Africans in "Africans beside a crocodile that was
shot by white hunter, Uganda" 1909 Underwood and Underwood (Loke
133d)
dead bird hanging upside down in "Dead game" c. 1855 William Lake
Price (Gernsheim 131#)
dead game hanging on poles in "After a day's hunt in the Yangtze River
Valley, China" Photographer Unknown (Loke 132c)
elephant tusks carried in street by Africans in "Elephant tusks ready
for shipment to New York, Membas, Kenya" 1909 Underwood and Un-
derwood (Loke 132b)
lying in rowboat in marsh in "Gunner working up to fowl" 1885 Peter H.
Emerson (Gernsheim 324#; Gernsheim/2 279#)
standing in studio with rabbit and gun in "Rabbit-shooting in the studio"
c. 1865 James Ross (Gernsheim 212#)
still life with dead deer, wild fowl and guns in "Still life with deer and
wild fowl" c. 1865* Adolphe Braun (Bernard 85#)
HYDRANGEAS
two flowers in glass of water in "Still life" 1908 Baron Adolf de Meyer
(Green 241; Sandweiss 59#)
HYRAXES
a family of rock hyraxes on a log in "Rock hyraxes 'like a family party
at a circus'" Cherry Kearton (Guggisberg 75)

I

IBIS
flock of birds in various stages of flight in "Sacred ibis on a South Afri-
can bird island" C.W.R. Knight (Guggisberg 67)
ICE
chunk of ice on pebble beach in "Beached iceberg in an inlet of Glacier
Bay"* Dean Brown (Rugoff 4#)

encasing pine needles in "Pine needles in ice" 1967* Ernst Haas (Time-
Life/8 157c)
melted and refrozen snow in "Ice in light and shadow" 1960 Minor White
(Time-Life/11 38)
ICE SKATING
on lake in "Skating" c. 1887 Oscar van Zel (Gernsheim 291#; Gernsheim/2
236#)
ICEBERG
in bay in "Iceberg in the northern end of Glacier Bay"* Dean Brown
(Rugoff 20#)
IMMIGRANTS
crowded aboard a ship in "The Steerage" 1907 Alfred Stieglitz (Gernsheim
341#; Gernsheim/2 306#; Green 307; Gruber 61#; Hine 119; Sandweiss
74#; Time-Life/12 37)
crowded on deck of ship in "Immigrants arriving at Ellis Island" Photog-
rapher Unknown (Hine 124)
family standing with their suitcases in "Looking for lost baggage, Ellis
Island" 1905 Lewis Hine (Hine 30; Gernsheim/2 260#; Sandweiss 115#)
men and women wearing numbers, waiting with their baggage in "Slovak
group, Ellis Island" 1906 Lewis Hine (Hine 98)
Russian woman with children in "A Russian family at Ellis Island" 1905
Lewis Hine (Sandweiss 105#)
seated men in "Jews at Ellis Island" 1904 Lewis Hine (Hine 69)
undergoing eye examination by Ellis Island officials in "Immigrants at Ellis
Island undergoing examinations by Public Health officers" Underwood
and Underwood (Loke 61)
viewing Statue of Liberty from deck of ship in "View of Statue of Liberty
from ship bearing immigrants" Photographer Unknown (Hine 124)
with suitcases, climbing steps in "Climbing into America" 1908 Lewis Hine
(Hine 29)
INDIANS (OF INDIA) see EAST INDIANS
INDIANS OF NORTH AMERICA
adobe houses on several levels in "Pueblo de Taos, New Mexico" c. 1883
William Henry Jackson (Sandweiss 36#)
Blackfoot chief in native dress in "Two Guns White Calf, the Blackfoot
chief, one of the three models for the profile composite on the buffalo
nickel" Photographer Unknown (Loke 59d)
clustered walls of adobe in "Adobe walls, Taos, New Mexico" c. 1920
Clara Sipprell (Sandweiss 75#)
dead Medicine Man on ground in "The Medicine Man--taken at the Battle
of Wounded Knee, South Dakota" 1891 George Trager (Sandweiss 50#)
family with woman in rocking chair in "A Navaho family" 1953 Laura Gil-
pin (Sandweiss 87#)
Geronimo in suit and hat in "Geronimo, the Apache chief" William H. Rau
(Loke 58)
group of Albino Indians sitting by wall in "Albino Zuñi Indians" c. 1879*
John K. Hillers (Bernard 109#)
man in Indian and clerical garb in "Reverend Peter Jones" c. 1844-1846
Hill & Adamson (Sandweiss 2#)
Mohave children waist-deep in water in "Mohave Indian children" c.
1890's Frederick Imman Monsen (Sandweiss 68#)
Navaho family in a covered wagon in "The covered wagon" 1934 Laura
Gilpin (Sandweiss 120#)
Navaho woman holding child and lambs in "Navaho woman, child and lambs"
1931 Laura Gilpin (Sandweiss 84#)
portrait of a brave in "Portrait of an Indian" c. 1860 Photographer Un-
known (Time-Life/14 80)

portrait of a brave with bow and arrows in hand in "Mahe, a Brave" c.
1850* Photographer Unknown (Time-Life/15 39)

portrait of a Dakota Chief in "Has-No-Horses" 1898 Gertrude Käsebier
(Sandweiss 71#)

portrait of a Navaho youth in "A Navajo youth" 1907* Karl Moon (Bernard
155#)

portrait of a Salish family in "A Salish family of western Montana" 1907
Underwood and Underwood (Loke 110)

portrait of Ogalalla Dakota in "Little Big Man, Ogalalla Dakota" 1877
Charles M. Bell (Sandweiss 45#)

portrait of Sitting Bull in "Sitting Bull" c. 1884 David F. Barry (Sand-
weiss 46#)

seated daughter of a Kwakiutl chief in "A Nakoaktok Chief's daughter"
1914 Edward S. Curtis (Sandweiss 70#)

Shoshone women and child in tepee in "Shoshone tepee" c. 1870 William
Henry Jackson (Time-Life/14 93)

unmarried women of the Walpi Pueblo on rooftop in "Watching the dancers"
1906 Edward S. Curtis (Sandweiss 69#)

woman with infant in "Navaho Madonna" 1932 Laura Gilpin (Sandweiss
99#)

young woman with elaborate hairstyle in "Chaiwa-Tewa-Profile" 1921 Ed-
ward S. Curtis (Gruber 59#)

Zuñi Indian standing by mud and wood cage with eagle in "Zuñi eagle
cage" 1879 John K. Hillers (Sandweiss 43#)

INFANTS

arching back on pool table in "Baby on pool table" 1970 Ronald Mesaros
(Time-Life/9 85)

at play with straw, hat, piano, dog and flowers in "[Baby at play]" Bill
Binzen (Time-Life/9 118-119)

at television screen in "Football fan" 1960 Bill Binzen (Time-Life/9 116)

back of crawling baby in "Baby crawling" 1966 George Krause (Time-Life/
9 114)

being bathed in "[Infant being bathed]" Wolf von dem Bussche (Time-
Life/9 102-3)

Black woman holding up white child in "Mrs. Wilson's Nurse" c. 1890's
Photographer Unknown (Sandweiss 54#)

boys walking in step past baby in carriage, in "Children walking in step"
1966 Raimondo Borea (Time-Life/9 139)

chewing on seashell in "New taste sensation" 1965 Dena (Time-Life/9
113c)

chewing on toes in "Chewing toes" 1965 Dena (Time-Life/9 113d)

crawling on wood floor with kitten in "Confrontation" 1968 Jay Maisel
(Time-Life/9 117)

drinking bottle of milk in "Nicolas feeding" 1971 Wolf von dem Bussche
(Time-Life/9 91, 101)

face of the "Sunkist Baby" in "Sunkist Baby" 1933 Will Connell (Time-
Life/9 58)

father holding newborn baby wrapped in blankets in "Bringing home the
first born" 1952 Dorothea Lange (Time-Life/9 14)

girl sitting on floor in "Amanda" 1968 Bradley Hindson (Time-Life/9 111)

hands and feet of an infant in "[An infant's hands and feet]" Wolf von
dem Bussche (Time-Life/9 108)

in basket near young girl in "Young girl with basket and baby" early
1850's* Charles Nègre (Bernard 23#)

infant sleeping in bassinet in "[Infant sleeping in bassinet above English
Bull Dog]" Wolf von dem Bussche (Time-Life/9 105)

infant sleeping in fetal position on wooden board in "Bangkok, Thailand"

1969* Bernard Wolf (Time-Life/9 196)
legs curled, drinking from bottle in "Comfortable snack" 1957 Charles
 Pratt (Time-Life/9 121)
lying on bed with mother in "[Infant lying on bed with mother]" Wolf von
 dem Bussche (Time-Life/9 109)
lying on grass, over shadow of man in "Season's Greetings" 1963 Ken
 Josephson (Time-Life/16 183)
lying on table by doctor with stethoscope in "[Doctor with stethoscope
 examining baby]" Wolf von dem Bussche (Time-Life/9 107)
making faces in "[Baby banter]" 1940-1950 Constance Bannister (Time-
 Life/9 60-61)
mother holding newborn baby in "A child is born" 1964 John Minshall
 (Time-Life/9 11)
naked child holding artist's palette in "Infant art" 1856 Oscar Rejlander
 (Time-Life/7 168)
· naked child lying on corner of bed in "Elijah Gowin" 1969 Emmit Gowin
 (Time-Life/11 201)
newborn infant in hospital bassinet in "[Newborn infant in hospital bas-
 sinet]" Sebastian Milito (Time-Life/9 95-97)
nursing at mother's breast in "Helpless and beloved" 1965 Anthony Wolff
 (Time-Life/9 15)
person in gas mask pushing baby carriage in "Journey into the past" c.
 1945 Wolf Strache (Gruber 379#)
portrait in "Portrait of a baby" Alfred Stieglitz (Photography 171)
posed naked on sheepskin rug in "Baby on a rug" c. 1900 Photographer
 Unknown (Time-Life/9 52)
shirtless man holding naked infant in "Man and baby" Jan Saudek (Gruber
 215#)
sitting naked on vinyl chair in "Asian's moment" 1973 John Loori (Time-
 Life/12 42)
sleeping, with hand across cheek in "[Sleeping infant]" Wolf von dem
 Bussche (Time-Life/9 106)
standing on braided rug in "Amanda" 1969 Bradley Hindson (Time-Life/9
 115)
sucking thumb while sleeping in "Baby sucking thumb" 1960 Bill Binzen
 (Time-Life/9 112)
taking bath in kitchen sink in "Baby in the sink" 1970 Ron Mesaros
 (Time-Life/9 120)
women wheeling two children in carriage in "London" 1970 Donald Scheller
 (Time-Life/16 168)
yawning infant being held by man with camera in "[Photographer with
 camera holding yawning infant]" Wolf von dem Bussche (Time-Life/9
 99)
INJURIES
 child with head bandaged in hospital bed, holding doll in "Eileen Dunne"
 1940 Cecil Beaton (Time-Life/9 76)
 doctor operating on soldier in field alongside wagon in "A British doctor
 operating on a wounded soldier, Boer War" B.W. Kilburn (Loke 44d)
 old woman with leg wrapped in bandages in "An old woman who was shot
 through the leg while carrying ammunition to the insurgents, Manila
 hospital" R.Y. Young (Loke 42)
INSECTS see ANTS; GRASSHOPPERS; SPIDERS AND SPIDERWEBS; WALK-
 ING STICKS
INTERLAKEN
 a panoramic view in "Panorama of Interlaken" c. 1868 Adolphe Braun
 (Gernsheim 191#; Gernsheim/2 176#; Time-Life/14 111)
IRISH

women carrying peat in baskets on their backs in "Irish peasant women
carrying peat, Ireland" 1903 William H. Rau (Loke 137a)
ISLANDS
small island of rocks and trees in bay in "Island, Limon Bay" 1871 John
Moran (Sandweiss 16#)
ITALIANS
homeless families in city street in "Homeless beggars of Naples, Italy"
H.C. White (Loke 57c)
women in black coats and hats in "Scanno" 1962 Mario Giacomelli (Time-
Life/12 159)

J

JAI ALAI
men playing in "Jai Alai rebound" 1965 Lynn Pelham (Time-Life/16 142)
JAMAICANS
children standing with books in classroom in "Jamaica schoolchildren and
their teacher, Jamaica" 1904 H.C. White (Loke 150b)
a couple by coconut palms in "A Jamaican couple" Photographer Unknown
(Loke 108d)
women selling trays of candy by brick wall in "Candy vendors in King-
ston, Jamaica" 1899 C.H. Graves (Loke 57a)
JAPANESE
actor with bow and arrow in "Japanese actor" Nadar (Tournachon 254c)
actress in traditional dress in "Japanese actress" Nadar (Tournachon
255a)
bride and groom with attendants on way to wedding in "A bride and
groom with their attendants halting by the wayside en route to the
wedding, Japan" 1906 Keystone View Company (Loke 106)
class of student artists in "Tokyo fine-arts class" Underwood and Under-
wood (Loke 116a)
family by their straw hut in "The Ainus of Japan" 1906 H.C. White (Loke
107c)
family posing outside of their ornate home in "A wealthy Japanese family
outside their home, Japan" James Ricalton (Loke 210b)
man pulling cart with baskets in "A bamboo-basket seller sharing a joke
with his customer, Japan" 1904 Keystone View Company (Loke 126c)
men posing for their portraits, in traditional dress in "Japanese visitors
to Paris" c. 1865 Paul Nadar (Tournachon 290b)
sumo wrestler and child standing in garden in "A sumo wrestler and a
child, Japan" James Ricalton (Loke 180b)
woman in rain with open parasol in "Studio study" c. 1890* Baron R. von
Stillfried (Bernard 123#)
women viewing stereo cards through stereoscope in "Stereoscopic view of
a group of Japanese women taking turns viewing stereo cards through
a stereoscope" Keystone View Company (Loke 18)
JERUSALEM
outside view of North Wall in "North Wall, Jerusalem" 1854* Auguste Salz-
mann (Bernard 29#)
view of convent of Mar-Saba in "Convent of Mar-Saba, near Jerusalem"
c. 1862 Francis Frith (Photography 114a)
JEWELRY
amethysts and jade brooch on artichoke half in "Brooch of amethysts with
jade pendants" 1968* Fred Burrell (Time-Life/13 217c)
diamond and ruby necklace around bull's hoof in "[Bull's hoof and dia-
mond necklace]" 1963* Hiro (Hall-Duncan 165)

on negative print of woman in "The Princess of pearls" 1939 Erwin Blu-
menfeld (Hall-Duncan 89)

onyx and ivory brooch on tomato slice in "Brooch of onyx and carved
ivory" 1968* Fred Burrell (Time-Life/13 217a)

opal jewelry on nutmeg grater in "Arrangement with opals" 1969*
Charles R. Collum (Time-Life/13 216)

red diamond in coconut half in "Red diamond" 1969* Charles R. Collum
(Time-Life/13 217b)

JEWS
Hasidic Jew teaching boys to read Hebrew in "Scholars of tradition,
Brooklyn" 1955 Cornell Capa (Time-Life/9 26)

Hasidic Jews on street in "Jerusalem" 1967 Henri Cartier-Bresson (Time-
Life/7 124)

Hasidic men in line at wedding in "Jewish wedding party, New York"
1960 Leonard Freed (Time-Life/14 35)

JOCKEYS
man in courtyard in "Jockey" 1932 August Sander (Gruber 342#)

JUKE BOXES
garish lighting from juke box in drab cafe in "Bar--New York City" 1955
Robert Frank (Time-Life/11 140)

JUMPING
boy caught in mid-air after jumping in "Boy jumping" 1968 Frederic Weiss
(Time-Life/7 90)

girl jumping off jetty into water in "[Girl jumping off jetty into water]"
Shin Sugino (Time-Life/12 131)

man jumping over hurdle in "Man jumping and duck flying" c. 1882 E.J.
Marey (Gernsheim 302#; Gernsheim/2 248#)

man jumping over puddle in "Place de l'Europe, Paris" 1932 Henri Cartier-
Bresson (Time-Life/11 125)

man jumping over wire in "Man jumping" c. 1885 Count Esterhazy (Gern-
sheim 305#; Gernsheim/2 253#)

man leaping from ladder in puddle in "Behind the Saint-Lazare station,
Paris" 1932 Henri Cartier-Bresson (Cartier-Bresson 39)

multiple images of boy broad jumping in "Boy jumping" 1884-5 Thomas
Eakins (Gernsheim/2 251#)

K

KALE
plant in "Kale" 1968 Ann Warrington (Time-Life/11 39)

KICKING
of football, at instant of contact in "Wesley Fesler kicking a football" c.
1937* Harold E. Edgerton (Bernard 211#)

KISSING
man kissing woman on cheek in "Eddie and his wife" 1973 Michael Kauf-
man (Time-Life/12 38)

two people in darkened hallway in "The kiss" 1904 Clarence H. White
(Gruber 52#)

two women in mink stoles in "Wedding of Mr. and Mrs. H.E. Kennedy"
1961 Richard Avedon (Avedon 13•)

woman kissing soldier near train in "Farewell at the train station" Pho-
tographer Unknown (Loke 206a)

KITCHENS
barefooted girls standing and talking in "All the time in the world" 1964
William Gedney (Time-Life/9 33)

doctor in surgical gown drinking coffee in "Country doctor" 1948 W.

Eugene Smith (Photography 294)
man making pies at mess wagon in "The mess wagon" c. 1890's Laton Al-
ton Huffman (Sandweiss 47#)
miniature doll in dollhouse kitchen in "Kitchen in a Swiss dollhouse" 1970
Thomas Cugini (Time-Life/13 220)
sink of porcelain and chrome in "Kitchen sink" 1967* Lynn St. John (Time-
Life/13 230)
tablecloth on table with two jars in "Kitchen" 1968 Thomas Brown (Time-
Life/11 122)
with wood burning stove in "Christmas, Sandy's (black cat on stove)"
1956 Wynn Bullock (Bullock 79)
KITTIWAKES
on rocks in "Kittiwakes at Ailsa Craig" Charles Kirk (Guggisberg 30)
KOREANS
a couple by their home in "A Korean couple, Seoul" 1904 Underwood and
Underwood (Loke 107d)
formal portrait of officials and staff in "Government officials and staff,
Seoul, Korea" Underwood and Underwood (Loke 92c)
man in traditional dress being carried in one-wheeled cart in "One-wheeled
cart of a Korean general, Seoul, Korea" 1904 Underwood and Underwood
(Loke 162d)
men seated on floor playing Go in "Yun Wong-Hiel, Korean Minister of War
in a game of Go with a friend in his home in Seoul, Korea" 1904 Un-
derwood and Underwood (Loke 115c)

L

LABOR AND LABORING CLASSES. See also Agricultural Laborers; Child
Labor; Farms and Farming; Fishermen; Miners; Women--Employment
family sewing and ironing clothing in small room in "Finishing clothing,
tenement homework, New York City" 1906 Lewis Hine (Hine 32)
lines of men waiting to be paid in steel mill in "Homestead workers wait-
ing to be paid" H.C. White (Loke 28c)
man drilling through rock in "Rock driller, New York City" 1930 Lewis
Hine (Hine 105)
man with hard hat, arms crossed in front of chest in "[Man in hard hat]"
Sebastian Milito (Time-Life/10 98-99)
men and boy by pile of wood in "Workers outside Pittman Handle Factory,
Denison, Texas" 1913 Lewis Hine (Hine 71)
men and women sewing in small room in "New York City sweatshop" 1908
Lewis Hine (Hine 28)
men at sewing machines making clothing in "Old-time sweatshop, New
York City" 1912 Lewis Hine (Hine 66)
men carrying large bundles of hay on their backs in "Men with bundles
of hay, Simla, India" 1903 Underwood and Underwood (Loke 137b)
men carrying large bundles of pots on their backs in "Laborers transport-
ing pots to the interior, Chosan, Korea" B.W. Kilburn (Loke 136a)
men ironing and women sewing jackets and vests at long table in "New
York City sweatshop" 1908 Lewis Hine (Hine 53)
men playing cards around a bed in "Inside workers' quarters, New York
State Barge Canal Construction Camp" 1909 Lewis Hine (Hine 65)
men working at salt mines in "Working at the salt mines, San Fernando,
Spain" Underwood and Underwood (Loke 131)
men working on top of Empire State Building before its completion in
"Empire State Building, New York City" 1930-31 Lewis Hine (Hine 107)
road gang with picks and shovels, posed by eroded escarpment in "Road

builders" 1968 Neal Slavin (Time-Life/11 119)
sacks of potatoes being unloaded in "Unloading potatoes on the street" c.
1912 Lewis Hine (Hine 31)
seated women sorting coffee beans in "Women sorting coffee beans, Nica-
ragua" 1902 Photographer Unknown (Loke 130b)
steamfitter with wrench, by piece of equipment in "[Steamfitter]" 1921
Lewis Hine (Sandweiss 113#)
two tiers of beds in immigrants' sleeping quarters in "Sleeping quarters
of immigrant workers, construction camp, New York State Barge
Canal" 1909 Lewis Hine (Hine 61)
woman and child making lace in apartment in "Making pillow lace, New
York City" 1911 Lewis Hine (Hine 72)
woman carrying bucket of grapes on her head in "A woman carrying a
bucket of grapes on her head, Rüdesheim, Germany" 1905 Keystone
View Company (Loke 130a)
women carrying baskets of peat on their backs in "Irish peasant women
carrying peat, Ireland" 1903 William H. Rau (Loke 137a)
women pulling large roller on gravel highway in "A twenty-woman team
working on a highway, Darjeeling, India" 1903 Underwood and Under-
wood (Loke 143b)
women unloading wood from box car in "[Unloading wood from box car]"
Photographer Unknown (Loke 138)
LABOR SUPPLY
men standing outside employment office in "Labor Agency, New York
City" 1910 Lewis Hine (Hine 81)
LABOR UNIONS
crowd of people at rally in "Rally, New York City" Photographer Unknown
(Hine 123)
LACOCK ABBEY
courtyard in "The courtyard at Lacock Abbey" 1841-2 William Henry Fox
Talbot (Gernsheim 88#)
man under arch in "The cloisters at Lacock Abbey, with the Rev. Clavert
Jones" 1843 William Henry Fox Talbot (Gernsheim 86#; Gernsheim/2
80#; Gruber 13#)
the North Court in "Lacock Abbey, North Court" c. 1845* William Henry
Fox Talbot (Time-Life/15 31)
LADDERS
ballet dancers posed on and near ladders in "American Ballet Theatre"
1947 Irving Penn (Gruber 299#)
leaning against filled bookshelves in ornate library in "Main library of the
University of Prague, Czechoslovakia" Photographer Unknown (Loke
176)
leaning against the building in "The ladder" 1844 William Henry Fox Tal-
bot (Gernsheim 87#; Gernsheim/2 79#; Gruber 393#)
man leaping from ladder lying in puddle in "Behind the Saint-Lazare
station, Paris" 1932 Henri Cartier-Bresson (Cartier-Bresson 39)
near two men sawing a plank in "Carpenters on the Lacock Estate" 1842*
William Henry Fox Talbot (Bernard 1#)
LAKES
and pine trees in "Early morning light in Lake Superior Provincial Park"*
Tome Algire (Rugoff 104#)
at foot of mountains, with bird sitting on mound of sticks in "Red-necked
grebe in Banff National Park"* Kojo Tanaka (Rugoff 52#)
cloud over lake in "The big white cloud, Lake George" 1903 Edward
Steichen (Time-Life/7 36)
from hotel porch in "Lake Louise and the glacier of Mount Victoria, Al-
berta, Canada" Photographer Unknown (Loke 158)

looking across lake, through trees in "Loch Katrine" c. 1845 William
 Henry Fox Talbot (Gruber 263#)
panoramic view of town, mountains and lake in "Interlaken" c. 1868
 Adolphe Braun (Gernsheim 191#; Gernsheim/2 176#; Time-Life/14 111)
small boats on mountain lake in "Lake Orta" c. 1864 William England
 (Gernsheim 185#; Gernsheim/2 175#)
trees reflected in tree-lined lake in "Minnies Lake, Okefenokee National
 Wildlife Refuge, Georgia"* Yvona and Momo Momatiuk (Rugoff 159#)
vast expanse with small alkali lake in "Alkali Lake, Albany County, Wyo-
 ming" 1979 Robert Adams (Sandweiss 128#)
with dead trees, covered by mist in "Periyar National Park" 1966*
 Jean-Max Fontaine (Time-Life/8 83)
with large protruding rocks in "Pyramid Lake" 1867 Timothy H. O'Sullivan
 (Photography 123)
LAMBS
 Navaho woman holding lambs and child in "Navaho woman, child and
 lambs" 1931 Laura Gilpin (Sandweiss 84#)
LAMPS
 round plastic lamp suspended over plastic table in "Molded plastic furni-
 ture" 1969* Aldo Ballo (Time-Life/13 213)
 seated men holding lanterns in "Switching crew, freight yard, Pennsyl-
 vania" 1907-08 Lewis Hine (Hine 103)
LASERS
 beam aimed at rabbit's eye in "Laser surgery" 1961* Fritz Goro (Time-Life/
 14 229)
LASSEN'S BUTTE
 panoramic view in "The summit of Lassen's Butte" 1807 Carleton E. Wat-
 kins (Sandweiss 30#)
LATHES
 boy working at school lathes in "High school workshop, Rockford, Illinois"
 Underwood and Underwood (Loke 217)
LAUNDRY
 children playing in alley below clothesline in "Playground in tenement al-
 ley, Boston" 1909 Lewis Hine (Hine 75)
 clothesline stretched above men at campsite in "T.E.R.A. Camp at Green
 Haven, New York State" 1936-37 Lewis Hine (Hine 93)
 Filipino woman and children standing on board to iron clothes in "A wom-
 an and her children ironing clothes, Island of Luzon, Philippines"
 Photographer Unknown (Loke 124a)
 hanging on line in tenement alley in "Tenement house and yard, Pitts-
 burgh" 1907-08 Lewis Hine (Hine 56)
 on clothesline between houses in "Genoa, Italy" H.C. White (Loke 169)
LEAVES
 and ferns with dew in "Leaves, Glacier National Park, Montana" 1942
 Ansel Adams (Photography 256)
 a calotype negative in "Calotype negative of leaves and grasses" c. 1841
 William Henry Fox Talbot (Time-Life/15 25)
 a golden autumn leaf in "Golden translucent leaf" 1963* Ernst Haas (Time-
 Life/8 156)
 in a large cluster in "Leaves" 1970 Josef Sudek (Gruber 197#)
 in cobwebs in "Leaves in cobwebs" 1968 Wynn Bullock (Bullock 73)
 leaf of the sea-grape in "Leaf" 1965* Lilo Raymond (Time-Life/11 56c)
 maple leaves in distorted shades in "Autumn leaves" 1970* Henry A.
 Shull (Time-Life/16 201)
 a negative and positive picture in "Photogenic drawing of a leaf" c. 1836-
 1839 William Henry Fox Talbot (Gruber 9#, 10#)
 a negative print in "Negative print" 1963 Paul Caponigro (Time-Life/12

213)
of the Dutchman's pipe in "Two leaves" 1963 Paul Caponigro (Time-Life/
11 32)
of the iris in "Iris, Georgetown Island, Maine" 1928 Paul Strand (Gruber
196#)
on maple tree branch silhouetted against limestone cliff in "Untitled" 1973
Carl Leavitt (Time-Life/12 36)
photogenic drawing in "Photogenic drawing" 1840's* Robert Hunt (Ber-
nard 2#)
stem and section of a leaf in "Tropical leaf" 1970* Nick Foster (Time-Life/
11 56a)
stems and veins of leaf in "Ecuadorian leaves" 1964* Ernst Haas (Time-
Life/8 159)
symmetrical in "Tree no. 19, California" 1965 George Tice (Time-Life/11
35)
a triptych of leaves and pebbles in "Patterns in nature" 1966 Werner
Köhler (Time-Life/14 155)
two maple leaves in "Two leaves" 1970 Ralph Weiss (Time-Life/11 52)
LEGS
and man's arm sticking out through cell bars in "Cell in a modern prison
in the U.S.A." 1975 Henri Cartier-Bresson (Cartier-Bresson 81)
giant pair at entrance to circus tent, an advertisement in "[Giant pair
of legs with sunburst for body]"* Luigi Ghirri (Time-Life/12 139)
LEMONS
between cruets of colored liquids in "Cruets with a lemon" 1968* Pete
Turner (Time-Life/13 228)
LEOPARDS
after killing its prey in "[A leopard]" John Dominis (Time-Life/7 209)
eating its kill at night in "Flashlight photograph of a leopard with its
kill" F.W. Champion (Guggisberg 84)
in silhouette in tree in "Leopard at sunset" 1965* John Dominis (Time-
Life/7 128)
male approaching water at night in "Flashlight photograph of a big male
leopard" C.G. Schillings (Guggisberg 48a)
LEPERS
begging by stone wall in "Lepers begging outside the walls of Jerusalem"
H.C. White (Loke 191a)
person wraped in blanket in "Leprosy in Ethiopia" 1964 Thomas Höpker
(Gruber 402#)
LETTER WRITING
young woman seated at table with pen and paper in "Study (The letter)"
Robert Demachy (Gruber 53#)
LIBRARIES
filled bookshelves in ornate library in "Main library of the University of
Prague, Czechoslovakia" Photographer Unknown (Loke 176)
LICHENS
and mosses in "Moss and lichens"* Les Blacklock (Rugoff 105#)
LIGHT
spectrum of colors of light in "Prism and spectrum" 1970* Sebastian Milito
(Time-Life/8 11)
LIGHT DRAWING
Picasso making a drawing with a flashlight in "Centaur by Picasso, Val-
lauris, France" 1949 Gjon Mili (Time-Life/14 230)
LIGHTHOUSES
and ships in small harbor in "Mystic seaport in fog" 1969* Alfred Eisen-
staedt (Time-Life/8 93)
the Montauk Point Lighthouse in "The Montauk Point, Long Island Light-

house" Jules Zalon (Time-Life/12 111)
LILIES
 arrangement with other flowers in "Still life" c. 1855* Adolphe Braun
 (Bernard 52#)
 red-orange day lilies in green field in "Day lilies on a hill in North Dako-
 ta"* Patricia Caulfield (Rugoff 98#)
 two calla lilies in "Two callas" 1929 Imogen Cunningham (Time-Life/11 43)
 wood lily amidst ferns in "Wood lily and hayscented ferns"* Les Line
 (Rugoff 108#)
LILY PADS
 girl in rowboat on lake filled with lily pads; ferris wheel in background
 in "Exposition park, Louisiana Purchase Exposition, St. Louis, Mis-
 souri" 1904? Underwood and Underwood (Loke 155)
LINCOLN CATHEDRAL
 seen over the rooftops in "Lincoln Cathedral: from the Castle" 1898*
 Frederick H. Evans (Time-Life/15 93)
LIONS
 chained and lying with girl standing on back in "Gypsy girl with lion"
 1901* Lala Deen Dayal (Bernard 149#)
 in blue, eating piece of meat in "Blue lion" 1969* Tom McCarthy (Time-
 Life/8 213)
 lioness rushing at a bullock in "Lioness rushing at a bullock" C.G.
 Schillings (Guggisberg 48b)
 male approaching a waterhole in "Male lion approaching a waterhole" C.G.
 Schillings (Guggisberg 49)
 male lion standing over zebra bait in "Flashlight photograph of a male
 lion standing over a zebra bait" 1909 A.R. Dugmore (Guggisberg 56)
 resting under a tree in "Serengeti lions settling down to their digestive
 siesta" Marcuswell Maxwell (Guggisberg 101)
LIQUIDS
 splash caused by a falling ball in "A milk splash caused by a falling ball"
 c. 1900 A.M. Worthington (Gernsheim 307#)
 splash made by drop of milk in "Splash of a milk drop" c. 1936 Harold
 Edgerton (Time-Life/7 48)
 water droplet on white fabric in "Water drop on a curtain" 1970* Manfred
 Kage (Time-Life/13 218)
LITTERS
 man in traditional dress being carried on one-wheeled cart in "One-
 wheeled cart of a Korean general, Seoul, Korea" 1904 Underwood and
 Underwood (Loke 162d)
 woman being carried in a palanquin in "A woman carried in a palanquin,
 Botanical Gardens, Darjeeling, India" Underwood and Underwood
 (Loke 163a)
 woman being carried on hammock-like litter in "A hammock carriage,
 Funchal, Madeira" Underwood and Underwood (Loke 162a)
 young men carrying another in a palanquin in "Palanquin in Calcutta,
 India" Underwood and Underwood (Loke 163c)
LIZARDS
 a giant monitor lizard in "Portrait of a dragon: the giant monitor lizard
 of Komondo Island" A. Hoogerwerf (Guggisberg 92a)
LOBSTERS
 at ocean bottom in "Lobster in a cover near Gloucester, Massachusetts"*
 Douglas Faulkner (Rugoff 131#)
LOCKER ROOMS
 boy with football helmet on clothes-strewn table in "Defensive Back,
 George Washington High Eagles" 1970 Kenneth Graves (Time-Life/12
 24)

LOCOMOTIVES
 in roundhouse in "Roundhouse on the Bourbonnais Railway" 1862-67* Collard (Bernard 76#)
 a steam locomotive in "Eight Feet Driver Locomotive" 1850* William and Frederick Langenheim (Time-Life/15 33)
LOG CABINS
 soldiers standing by their cabins in "Camp of the Oneida Cavalry, at the Headquarters of the Army of the Potomac" 1865 Photographer Unknown (Time-Life/14 103)
LOGGERS AND LOGGING
 boy pushing logs down river in "River boy, Beaumont, Texas" 1913 Lewis Hine (Hine 47)
LONDON BRIDGE
 carriages, horses and people crossing bridge in "London Bridge" 1905 Alvin Langdon Coburn (Photography 200c)
LOONS
 Arctic loon on nest in "Arctic loon brooding in the Yukon-Kuskokwim Delta"* Michael Wotton (Rugoff 13#)
LOTUS
 blossom photographed as if roots of tree in "Untitled" 1968 Jerry N. Uelsmann (Time-Life/12 215)
THE LOUISIANA PURCHASE EXPOSITION, ST. LOUIS, MISSOURI
 aerial view of exposition halls, statuary and grounds in "The Louisiana Purchase Exposition, St. Louis, Missouri" 1904 H.C. White (Loke 154)
LOUVRE, PARIS
 facade in "Paris, Le Louvre" 1860 Edouard-Denis Baldus (Gruber 346#)
LOVE
 couple holding hands in snowy landscape "[Couple in snowy landscape]" 1971* Bill Binzen (Time-Life/11 107)
LUBECK, GERMANY
 large turreted gateway by bridge in "Medieval gateway to the town of Lübeck, Germany" Underwood and Underwood (Loke 161)
LUGGAGE
 family standing with their suitcases in "Looking for lost baggage, Ellis Island" or "Italian immigrant family, Ellis Island" 1905 Lewis Hine (Hine 30; Gernsheim/2 260#; Sandweiss 115#)
 man and woman emerging from taxicab in "Taxicab, London" 1969 Garry Winogrand (Time-Life/11 138)
LUMBER
 snow-covered pile of logs in "Louisiana-Pacific timber" 1973* Harald Sund (Time-Life/12 65)
LUXOR, EGYPT
 entrance to the Great Temple in "Entrance to the Great Temple, Luxor" 1857 Francis Frith (Photography 114b)
LYNX
 on edge of lake at night in "Lynx at Loon Lake, a flashlight photograph" 1909 George Shiras (Guggisberg 40)

M

MACHINERY
 large gears of a lathe in "Lathe in the Oerlikon Engineering Works" 1935 Jakob Tuggener (Gruber 179#)
MAGNOLIAS
 close-up of a blossom in "Magnolia blossom" Imogen Cunningham (Time-Life/12 37)

fresh blossom at base of worn headstone in "Unmarked graves" 1969
Wynn Bullock (Time-Life/11 195)
MAILBOXES
of metal on red background in "Found color" 1959-1969* Gene Laurents
(Time-Life/8 47)
MAKEUP (COSMETICS) see COSMETICS
MANNEQUINS
a clothing store window in "Avenue des Gobelins" 1925 Eugène Atget
(Gruber 82#; Photography 237a)
headless, dressed in suit, seated on couch in "[Headless mannequin]"
1971 Duane Michals (Time-Life/11 97)
in various positions in "[Moveable mannequin]" 1971 Neal Slavin (Time-
Life/11 95)
wooden, adjustable on toilet seat in "[Mannequin on toilet seat]" 1971
John Senzer (Time-Life/11 93)
MAORIS
pipe-smoking mothers carrying babies on their backs in "Maori mothers
with their babies, New Zealand" Photographer Unknown (Loke 104)
MARINE ANIMALS. See also CRABS; FISHES; LOBSTERS; MORAY EELS;
PORTUGUESE-MAN-OF-WAR; SNAILS; STARFISH
starfish and other marine animals in "Life on piling near Gloucester"*
Douglas Faulkner (Rugoff 132#)
MARIPOSAS
fallen tree and stagecoach in "Yosemite Stage by the Fallen Monarch,
Mariposa Grove" 1894 I.W. Taber, Publisher (Sandweiss 21#)
log cabin by giant Sequoia in "Mariposa Grove of mammoth trees, William
H. Seward, 85 feet in circumference, 268 feet high" 1872 Eadweard
Muybridge (Sandweiss 25#)
MARKETS
horse-drawn vegetable and fruit wagons in "Street market, Homestead,
Pennsylvania" 1907-08 Lewis Hine (Hine 73)
MARRIAGE CUSTOMS AND RITES
bride gazing into crystal ball in "['Eager-eyed under the bridal veil...']"
1919 Baron Adolf de Meyer (Hall-Duncan 35)
bride holding bouquet, by stone wall in "Daughter Jennie as a bride"
1969* Bob Garrett (Time-Life/13 196)
father and bride near group of children in "Wedding day" 1965 Mary Ellen
Mark (Time-Life/11 130)
Japanese bride and groom with their attendants in "A bride and groom
with their attendants halting on the wayside en route to the wedding,
Japan" 1906 Keystone View Company (Loke 106)
newlyweds and coalman drinking at bar in "Coalman and newlyweds" 1948
Robert Doisneau (Gruber 103#)
newlyweds seated on round bed in "[Honeymooners]" 1971 Tony Ray-
Jones (Time-Life/11 106)
portrait of bride and groom in "Mr. and Mrs. John Locicero" 1926* Mach
(Bernard 185#)
wedding party and guests in "The Gadea wedding, Cuzco" 1930* Martin
Chambi (Bernard 196#)
MARSHES
and aquatic plants in "Aquatic plants in a fresh-water swamp on Big
Cumberland Island, Georgia"* James P. Valentine (Rugoff 155#)
and gnarled pterocarpus trees in "Swamp in Dominica" 1965* John Dominis
(Time-Life/16 31)
egret in tall grass in "American egret in sawgrass marsh, Everglades Na-
tional Park"* James H. Carmichael, Jr. (Rugoff 161#)
marshland and river in "Salt marsh estuary of the Herring River" Gordon

Smith (Rugoff 124#)
near farm house in "A rushy shore" 1886 Peter Henry Emerson (Photography 158)
of cypress trees in "Florida cypress trees in Big Cypress Swamp"* Ed Cooper (Rugoff 165#)
with palm trees in "Swamp on Ossabaw Island, Georgia"* James P. Valentine (Rugoff 154#)
young egret holding onto vine above swamp on "Young cattle egret climbing back to nest"* Leonard Lee Rue III (Rugoff 158#)
MASKS (FACIAL)
man in white face paint in "Actor on the deck of the ferryboat Veneto"* Branko Lenart Jr. (Time-Life/12 11)
model wearing African-inspired mask of silver bands in "Mask by Emanuel Ungaro" 1968 Richard Avedon (Time-Life/13 129)
mud masks on men with wooden spears in "Asaro mudmen, New Guinea" 1970* Irving Penn (Time-Life/13 102)
paper masks hanging from hook in "Masks" Emmanuel Sougez (Gruber 186#)
MEASURING INSTRUMENTS
man holding ruler up to view of Grand Tetons in "Wyoming" 1971 Kenneth Josephson (Gruber 449#)
MEDICAL CARE
mothers and children in poor clinic in "Volunteers in Bolivia" 1975 Hilmar Pabel (Gruber 383#)
MEDICINAL PLANTS
laid out before a Bhutanese woman in "Medicines offered by a Bhutanese woman, Darjeeling, India" 1903 Underwood and Underwood (Loke 128d)
MELONS
a slice of honeydew melon and black grapes in "Melon slice with grapes" 1968* Richard Jeffrey (Time-Life/14 157)
MERCHANTS
an Egyptian man selling lemonade from bottle in "A lemonade vendor and his customer, Cairo, Egypt" B.W. Kilburn (Loke 129d)
seated woman with medicinal plants spread out before her in "Medicines offered by a Bhutanese woman, Darjeeling, India" 1903 Underwood and Underwood (Loke 128d)
squatting man selling fruits from baskets in "A fruit seller, Jaipur, India" 1902 Keystone View Company (Loke 129a)
women selling trays of candy by brick wall in "Candy vendors in Kingston, Jamaica" 1899 C.H. Graves (Loke 57a)
MERCURY (AUTOMOBILE)
near seashore in "Mercury at Big Sur" 1970* Hiro (Time-Life/13 41)
MEXICANS
boy in straw hat and serape in "Boy. Hidalgo" 1933 Paul Strand (Sandweiss 98#)
formal family portrait in "Mexican family" c. 1847 Photographer Unknown (Sandweiss 8#)
Indian women carrying pots and baskets on their heads in "Women of Tehuantepec, Oaxaca, Mexico" Underwood and Underwood (Loke 189)
men in store filled with sombreros in "A sombrero store, Mexico City, Mexico" 1903 Underwood and Underwood (Loke 124c)
peasants sitting on stone wall in "Hog traders" 1951 Paul Senn (Gruber 391#)
MICE
harvest mouse on grass stalk in "A harvest mouse photographed in captivity" Douglas English (Guggisberg 62)
MIDGETS

four men and one man of normal size in "[Circus performers]" Alfred
Eisenstaedt (Time-Life/12 113a)

MIGRANT LABOR

girl dragging empty sack along dirt road in "Kern County, California"
1936 Dorothea Lange (Time-Life/9 74)

in field in "Near Waxahachie, Texas" 1913 Lewis Hine (Sandweiss
108#)

MILAN, ITALY

overhead view of people walking in "The Galeria, Milan" 1930 Bruno
Stefani (Gruber 366#)

MILK

baby drinking bottle of milk in "Nicolas feeding" 1971 Wolf von dem
Bussche (Time-Life/9 91, 101)

baby drinking bottle of milk in "Comfortable snack" 1957 Charles Pratt
(Time-Life/9 121)

glass and bottle of milk and fried egg on plate on checkered tablecloth
in "Egg and milk" 1968* Henry Sandbank (Time-Life/13 227)

MILLS AND MILLWORK

workers in a Japanese silk-weaving plant in "Silk-weaving plant, Kiryu,
Japan" Photographer Unknown (Loke 122)

young girls at stocking knitting machines in "Young girls knitting stock-
ings in Southern hosiery mill" 1910 Lewis Hine (Hine 48)

young girls posing in mill in "Young workers at cotton mill, Scotland
Neck, North Carolina" 1914 Lewis Hine (Hine 99)

MINERS

man wearing safety helmet outside mine in "Miner in safety helmet" 1933
Lewis Hine (Hine 102)

men with nets over heads, using shovel and pan in "Placer mining near
the Yukon River, Alaska" Photographer Unknown (Loke 142c)

perspiring Black men with miners' helmets in "A mile underground" 1950
Margaret Bourke-White (Gruber 401#)

with blackened face in "Miner" c. 1908 Lewis Hine (Hine 127)

with blackened faces in "Welsh miners" 1960 W. Eugene Smith (Time-Life/
11 221)

working small stream for gold in "Gold miners, California" c. 1850* Pho-
tographer Unknown (Bernard 57#)

MINES AND MINING

group of boys in coal mine in "Breaker boys inside coal breaker" 1909
Lewis Hine (Time-Life/9 70)

interior of a coal mine in "West Virginia coal mine" 1908 Lewis Hine (Hine
60)

men at conveyor belt laden with large rocks in "Men working at a quartz-
sorting table, Robinson Mine, Johannesburg, South Africa" Photograph-
er Unknown (Loke 140a)

men panning and digging for gold in "[Gold mining scene]" c. 1850's
Photographer Unknown (Sandweiss 9#)

men working at mounds of salt in "Working at the salt mines, San Fer-
nando, Spain" Underwood and Underwood (Loke 131)

miners with piece of mining equipment in "Excavating for gold ore, Village
Deep Gold Mines, South Africa" Underwood and Underwood (Loke 140b)

railroad tracks near mine in "Tracks at coal mine, Scott's Run, West Vir-
ginia" 1936-37 Lewis Hine (Hine 104)

rows of boys seated in coal mine in "Boys picking slate in a breaker in
an anthracite coal mine in Pittsburgh, Pennsylvania" Underwood and
Underwood (Loke 28b)

young boys bending over bins of coal in "Coal breakers, Pennsylvania"
1910 Lewis Hine (Hine 101)

young boys posing in coal mine in "Breaker boys in coal chute, South
 Pittston, Pennsylvania" 1911 Lewis Hine (Hine 59)
MINTS
 coins being pressed in "Coinage presses, the U.S. Mint" Underwood and
 Underwood (Loke 218a)
MIRRORS
 boy holding mirror in front of face in "Faceless boy" 1970 Garry Thall
 (Time-Life/16 169a)
 boy making faces in mirror in "Boy looking in mirror" 1967 Larry Fink
 (Time-Life/9 145)
 child's face reflected in motorcycle mirror in "Wet motorcycle" 1970* Don
 Hinkle (Time-Life/8 96)
 on vending machine, with girl combing hair in "Teenagers at Coney Is-
 land" 1959 Bruce Davidson (Time-Life/7 30d)
 television turned on in front of dresser mirror in "Hotel room, Portland,
 Maine" 1962 Lee Friedlander (Time-Life/7 25)
 woman standing at full-length mirror in "The toilet" c. 1864 Lady Hawar-
 den (Gernsheim 132#; Gernsheim/2 113#)
MISSISSIPPI RIVER
 aerial view of the delta with marshes in "Aerial view of bayous in a marsh
 of the Mississippi delta"* Robert Perron (Rugoff 96#)
 sunset on tidal flat in "Aerial view of sunset on tidal flat in the Mississip-
 pi delta"* Robert Perron (Rugoff 1#)
MOBS see CROWDS
MODELS, FASHION see FASHION PHOTOGRAPHY
MOJAVE DESERT
 field of red poppies and creosote bush in "Spring poppies and creosote
 bush in Antelope Valley, Mojave Desert, southern California"* David
 Muench (Rugoff 77#)
MONKEYS
 and zookeeper seated near child on steps in "A zoo keeper and his laugh-
 ing monkey" 1902 H.C. White (Loke 118)
 at foot of woman's bed in "Mae West" Philippe Halsman (Halsman 64)
 in painted cage in "Fortunetelling monkey" 1967* Douglas Faulkner (Time-
 Life/15 96)
 woman with macaque in baby clothes in "[Woman with baby macaque]"
 Diane Arbus (Time-Life/11 110)
MONKS
 standing two abreast in long hallway in "A monastery, Portugal" Under-
 wood and Underwood (Loke 177)
MONT ST. MICHEL
 narrow stone street in "Sunlight and shadow, Mont St. Michel" 1906
 Frederick H. Evans (Photography 183)
MONUMENT VALLEY, ARIZONA
 a panorama view from the air in "Monument Valley from the air" 1967*
 Ernst Haas (Time-Life/8 149)
MOON
 half in shadow, half in light in "The Moon" 1851 John Adams Whipple
 (Photography 75)
 over calm water in "Let There Be Light" 1954 Wynn Bullock (Bullock 33)
 over eroded rock formation in "Moon over Fisher Towers group, Utah"
 Ed Cooper (Rugoff 57#)
 view of a half moon in "The moon" 1894 Loewy and Puiseux (Time-Life/7
 47)
MOON--EXPLORATION
 astronaut on the surface of the moon in "Buzz Aldrin on the moon" 1969
 Neil Armstrong (Time-Life/10 23)

MOOSE
 bull moose on the bank of a river in "Bull moose on the bank of Loon
 River, a flashlight photograph" 1909 George Shiras (Guggisberg 41)
MORAY EELS
 with mouth open in "Moray eel"* Ron Church (Rugoff 38#)
MOROCCANS
 two fully draped women in "Two Guedras, Morocco" 1971 Irving Penn
 (Hall-Duncan 155)
MORRO CASTLE
 washed up on beach while on fire in "Morro Castle aground" 1934 Carl
 Nesensohn (Time-Life/10 39)
MOSCOW, SOVIET UNION
 domes of a cathedral in "Domes of the Cathedral of the Resurrection, the
 Kremlin" 1852 Roger Fenton (Gernsheim 93#; Gernsheim/2 82#; Time-
 Life/14 109)
 horse-drawn sleighs at water station in winter in "Water station in Mos-
 cow, Russia" c. 1896 B.W. Kilburn (Loke 72)
 ornate home of wealthy merchant in "Home of a wealthy merchant in Mos-
 cow, Russia" H.C. White (Loke 70c)
MOSQUES
 detail of Mosque in Cairo in "Mosque of Kalaun, Cairo--detail" 1842 J.P.
 Girault de Prangey (Gernsheim 33#; Gernsheim/2 44#)
MOSSES
 and lichens in "Moss and lichens"* Les Blacklock (Rugoff 105#)
 covering trees in "Trees covered with mosses, lichens and ferns in rain
 forest, Olympic National Park"* Betty Randall (Rugoff 22#)
MOTHER AND CHILD see PARENT AND CHILD
MOTHS
 luna moth on oak bark in "Luna moth on oak tree"* Larry West (Rugoff
 109#)
MOTION PICTURE SCREENS
 in a living room in "New Jersey home" 1966 Joel Meyerowitz (Gruber 438#)
MOTORCYCLES
 Black man and woman sitting on motorcycle in "Indianapolis" 1955 Robert
 Frank (Gruber 398#)
 by round metal cage in "The All-British Globe of Death" 1930's* Photog-
 rapher Unknown (Bernard 197#)
 front end of motorcycle in rain in "Wet motorcycle" 1970* Don Hinkle
 (Time-Life/8 96)
 men and women posed with their cycles in "A group of Hell's Angels"
 1967 Irving Penn (Time-Life/7 217)
 rider seeming to be traveling quickly in "Illusion of speed" 1965 Yale
 Joel (Time-Life/16 75)
MOUNTAIN CLIMBING see MOUNTAINEERING
MT. DEBORAH
 and glacier spreading over tundra in "The south face of 12,540-foot Mt.
 Deborah in the Alaska Range with a glacier spreading out over the
 tundra plains" Ed Cooper (Rugoff 7#)
MOUNT McKINLEY
 covered with snow on "Sunrise, Mount McKinley National Park, Alaska"
 1948 Ansel Adams (Sandweiss 139#)
MT. OLYMPUS
 and view of surrounding area in "Mt. Olympus" 1967* Farrell Grehan
 (Time-Life/8 40)
MOUNT SHASTA
 seen in distance across rocky field in "Mount Shasta from Sheep Rocks"
 1870 Carleton E. Watkins (Sandweiss 22#)

MOUNT WILLIAMSON
field of rocks at base of mountain in "Mount Williamson, California" 1943
Ansel Adams (Time-Life/7 102)
MOUNTAINEERING
men in line on icy pass to camp in valley in "The Scales, Chikoot Pass,
Alaska" 1897 Eric A. Hegg (Time-Life/15 57)
men on glacier with ladders in "Grindelwald glacier" c. 1862 Adolphe
Braun (Gernsheim 190#; Gernsheim/2 173#)
people at mountain crevice in "Savoy 44, the Crevice" c. 1860 Bisson
Freres (Gruber 33#)
small figures on top ridge of snow-covered mountain in "Climbers in the
snow at 11,500 feet, the Doldenhorn, Switzerland" 1960 Bradford
Washburn (Time-Life/16 11)
MOUNTAINS
and a rainbow in "Rainbow in the Ecuadorian Andes" 1965* Ernst Haas
(Time-Life/14 40)
covered with ice and snow in "Mont Blanc and the Mer de Glace" 1861
Auguste Bisson (Gernsheim 184#; Gernsheim/2 174#)
cul de sac glacier and snow-covered mountains in "Kichatna spire in the
Alaska Range" Ed Cooper (Rugoff 6#)
field of rocks at base of mountain in "Mount Williamson, California" 1943
Ansel Adams (Time-Life/7 102)
in gold of sunrise in "Sunrise above Lake Ediza in the Minaret Wilder-
ness"* David Cavagnaro (Rugoff 48#)
parallel paths of glacier flowing through mountains in "The Barnard
Glacier flowing through the Natazhat and Bear Mountains" Bradford
Washburn (Rugoff 5#)
snow-covered above lake with bird on mound of sticks in "Red-necked
grebe in Banff National Park"* Kojo Tanaka (Rugoff 52#)
with trees in autumn colors in valley in "Willows in autumn colors at about
8700 feet up in the Minaret Wilderness, California"* David Cavagnaro
(Rugoff 43#)
MOUTHS
bright red lips in "Hot lips" 1966* Pete Turner (Time-Life/11 56a)
close-up of woman's mouth and finger in "[Untitled]" 1972* Hiro (Hall-
Duncan 164)
MULES
one standing in field in "[A mule in the field]" Dennis Hearne (Time-
Life/12 154)
MUSEUMS
women sculpting in museum in "Sculptor at work, Acropolis Museum,
Athens, Greece" Underwood and Underwood (Loke 117c)
MUSHROOMS
in the grass in "Toadstool and grasses, Georgetown, Maine" 1928 Paul
Strand (Photography 300)
slices in silhouette in "I am a mushroom" 1968 Naomi Savage (Time-Life/
12 220)
MUSICAL INSTRUMENTS see ACCORDIONS; CLARINETS; GUITARS;
PIANOS; SITARS; VIOLINS
MUSICIANS
Egyptian dancer and musicians in "Egyptian dancer and musicians" c.
1890* Photographer Unknown (Bernard 132#)
shadows of men and the amplifiers for their electronic instruments in
"Musicians' shadows" 1968 Gerald Jacobson (Time-Life/16 85)
trio of women playing piano, cello and violin in "The Prelude" 1917 Laura
Gilpin (Sandweiss 57#)
young boys with musical instruments by iron fence in "Street musicians

in Porchester Terrace, London" c. 1860* Camille Silvy (Bernard 69#)
MUSK OXEN
faces in "Musk oxen"* Kojo Tanaka (Rugoff 3#)
MYTHOLOGY
sculpture of a faun in "Faun sculpture, Versailles"* Eugène Atget (Bernard 159#)
young man made to look like faun in "Youth as faun"* Baron Wilhelm von Gloeden (Bernard 150#)

N

NAGASAKI, JAPAN
aerial photograph of destruction after the atomic bomb in "Nagasaki" 1945 George Silk (Time-Life/10 35)
NARCISSUS
arranged in glass bowl in "Narcissus" 1928 Laura Gilpin (Sandweiss 62#)
NARCOTIC ADDICTS
photo essay of heroin addicts in "[Heroin addicts]" 1965 Bill Eppridge (Time-Life/10 82-85)
NAZIS
Hitler and other men examining a new car in "Hitler's birthday present" 1939* Hugo Jaeger (Time-Life/15 65)
marching with shovels past viewing stand with large swastikas in "Nazis on parade" 1937 Photographer Unknown (Time-Life/10 27)
rows of helmeted soldiers in town square in "The Wehrmacht at the Felderrnhall, Munich" 1935* Photographer Unknown (Bernard 199#)
NEW GUINEANS
men with wooden spears and mud masks in "Asaro mudmen, New Guinea" 1970* Irving Penn (Time-Life/13 102)
warrior with bone pierced nose in "A warrior of New Guinea" Photographer Unknown (Loke 186c)
NEW YORK CITY
aerial photograph of Manhattan Island in "Manhattan Island from an altitude of 8,000 feet" 1956 Edwin Hawbecker (Time-Life/7 53)
buildings with lights at night in "New York at night" 1933 Berenice Abbott (Sandweiss 90#)
Flatiron Building in "The Flatiron-Evening" Edward Steichen (Green 77)
from a balcony in "N.Y.C., changing New York" 1937 Berenice Abbott (Gruber 350#)
horse and carriages on street in winter in "The Street, Fifth Avenue" 1896 Edward Steichen (Photography 198)
New York Herald Building and pedestrians in "New York Herald Building at Broadway and Thirty-fourth Street, New York City" H.C. White (Loke 71c)
scene of streets in rain in "Broadway, New York, on a rainy day" 1859 Edward Anthony (Gernsheim 158#)
skyline at sunset from north of Central Park in "Temple of Dendur, the Metropolitan Museum of Art, New York" 1978* Henry Groskinsky (Time-Life/14 163)
skyline behind Brooklyn Bridge in "Brooklyn Bridge" 1952* Ernst Haas (Time-Life/8 131)
NEWSBOYS
young boy holding newspapers on city street in "Dannie Mercurio, Washington, D.C." 1912 Lewis Hine (Hine 76)
NEWSPAPERS
boy wrapped up in comic pages in "Matthew" 1965 Ken Josephson (Time-

Life/9 143)
boys reading papers at newstand in "Citizen in Downtown Havana" 1932
　　Walker Evans (Gruber 409#)
Truman holding newspaper with headline "Dewey defeats Truman" in
　　"Truman defeats Dewey" 1948 Al Muto (Time-Life/10 24)
NIAGARA FALLS
and large rocks at base in "Niagara Falls" 1888* George Barker (Bernard
　　122#; Sandweiss 18#)
couple sitting on bench having portrait taken in "Portrait-taking at Nia-
　　gara Falls" c. 1875 Photographer Unknown (Gernsheim 211#)
frozen in winter in "Niagara Falls, New York" Underwood and Underwood
　　(Loke 159)
group of people standing at edge of Falls in "Group at Niagara Falls" c.
　　1855 Platt D. Babbitt (Gernsheim/2 51#; Gruber 3#; Time-Life/14 69a)
people skating at base of frozen falls in "Niagara Falls frozen" 1880's*
　　H.F. Nielson, Attrib. (Bernard 111#)
with people in raincoats at base of tower in "Niagara Falls with group
　　and tower" c. 1860* Photographer Unknown (Bernard 66#)
NICARAGUANS
seated women sorting coffee beans in "Women sorting coffee beans, Nica-
　　ragua" 1902 Photographer Unknown (Loke 130b)
NIGHT
bridge with lights over Thames in "Thames embankment by night" c.
　　1905-10 Alvin Langdon Coburn (Gruber 58#)
buildings with lights at night in "New York at night" 1933 Berenice Ab-
　　bott (Sandweiss 90#)
car parked on street by darkened houses in "Street at night, San Fran-
　　cisco" 1967 William Gedney (Time-Life/11 117)
fog in forest in "Night scene" 1959 Wynn Bullock (Bullock 51)
Italian coastal town at twilight in "Amalfi twilight" 1963* Maitland A. Edey
　　(Time-Life/8 90)
moon over calm water in "Let There Be Light" 1954 Wynn Bullock (Bul-
　　lock 33)
moonrise over cemetery in "Moonrise, Hernandez, New Mexico" 1941
　　Ansel Adams (Gruber 101#; Sandweiss 125#; Time-Life/7 210)
young man standing under street light in "Peter under the lamppost" 1973
　　William Messer (Time-Life/12 32)
NOBILITY
royal families at.the coronation of Tsar Nicholas II in "Members of the
　　royal families of Russia and Europe at the coronation of Tsar Nicholas
　　II" 1896 B.W. Kilburn (Loke 48)
NORMANDY, ATTACK ON, 1944
people viewing bodies of dead soldier on beach in "D-Day plus one:　the
　　Dead on Normandy Beach" 1944 Robert Capa (Gruber 421#)
soldier swimming ashore in "D-Day" 1944 Robert Capa (Gruber 102#)
NORWEGIANS
family near their hand-made wooden house in "A Norwegian family" T.W.
　　Ingersoll (Loke 108b)
NOTRE DAME DE PARIS
negative print of facade in "Notre Dame, Paris" 1850 John Shaw Smith
　　(Gernsheim 91#; Gernsheim/2 81#)
out of focus in background in "Notre Dame" Alvin Langdon Coburn
　　(Green 155)
shadowy view of cathedral in "Notre Dame" c. 1908* Alvin Langdon Co-
　　burn (Time-Life/12 38)
NUDES
back of kneeling nude in "Back of a nude" c. 1890-95* Edgar Degas, at-

trib. (Bernard 140#)
back of kneeling woman in "Dolor" c. 1922 Edward Steichen (Gruber
228#)
back of person lying in fetal position in "Nude" 1934 Brassaï (Gruber
227#)
back of seated fat woman in "Fat woman" c. 1875* Photographer Unknown
(Bernard 105#)
back of seated figure in "Nude" 1927 Edward Weston (Gruber 231#)
back of woman in turban in "Violon d'Ingres" 1924 Man Ray (Time-Life/
12 198)
back of woman lying on couch in "Daphne" 1915 Francis Bruguière
(Gruber 213#)
back of woman next to photo of Black man in "From 'Song of the Shirt'"
1967* Gary Metz and John Moore (Time-Life/12 226)
back of woman on grass, seen through window of woodshed in "Barbara"
1956 Wynn Bullock (Bullock 83)
backs of two people curled in fetal position in "Nude" Kishin Shinoyama
(Gruber 226#)
bare branches of bush superimposed over young woman in "Dream walk-
ing" 1967 Imogen Cunningham (Time-Life/12 217)
buttocks, legs and torsos of two sunbathers in "Bibi Lartigue and Denise
Grey on deck" c. 1926* Jacques-Henri Lartigue (Bernard 186#)
a couple walking away in "The Imaginary Photograph" 1930 Frantisek
Dritol (Gruber 220#)
female torso in "Torso" Clarence White and Alfred Stieglitz (Green 151)
female torso in "Torso" 1919 Alfred Stieglitz (Photography 213)
female torso in "Torso" 1923 Paul Outerbridge, Jr. (Gruber 218#)
female torso in "Torso" c. 1936* Paul Outerbridge (Bernard 210#)
female torso draped in wet cloth in "Female torso" Jan Saudek (Gruber
217#)
female torso, horizontal in "Torso" Martin Munkacsi (Gruber 237#)
male chest and upper arms in "Nude" 1928 Imogen Cunningham (Gruber
225#)
male kneeling with outstretched fist in front of face in "Male nude" 1969
Christian Vogt (Gruber 242#)
male standing in "Male nude" c. 1856* Charles Simart, Attrib. (Bernard
38#)
male supporting raised legs with arms in "Male nude, legs lifted" George
Platt Lynes (Gruber 241#)
male youth in "Nude youth" F. Day Holland (Gruber 240#)
man and woman, standing in "Adam and Eve" c. 1910* Frank Eugene
(Time-Life/12 42)
man seated on leopard skin, facing wall in "Figure study" c. 1853 Eugène
Durieu (Time-Life/7 197)
man standing in group portrait in "Andy Warhol and members of The
Factory" Richard Avedon (Avedon 33•)
mother and child on bed in "Mother and child" 1968 Bruce Davidson (Time-
Life/11 121)
muscular male, back view in "Male nude" Noriaki Yokosuka (Gruber 239#)
naked stomach and breasts of pregnant woman in "Pregnant" 1940 Bar-
bara Morgan (Time-Life/11 41)
painted body covered with flowers in "A lass of Spring" 1969 Hisae Imai
(Time-Life/12 139)
pregnant woman in chair by open window in "Pregnant girl" Philippe Hals-
man (Halsman 129)
reclining Black woman in "Nude" 1850's* Photographer Unknown (Bernard
43#)

reclining veiled woman near suit of armor in "Veiled nude with suit of armor" 1854* Braquehais (Bernard 26#)

reclining woman with long hair in "Nude" c. 1850* Photographer Unknown (Bernard 42#)

seated woman in "In memoriam" Edward Steichen (Green 73)

seated woman in "Nude" 1933 Edward Weston (Sandweiss 116#)

seated woman holding nude child on her lap in "Woman and child (Nudes)" 1971 Jean-François Bauret (Gruber 216#)

sections of female form in light and shadows in "Nude, Lausanne, Switzerland" 1963 Pierre Jousson (Time-Life/14 37)

side of seated woman in "Perplexity" 1906 Robert Demachy (Gruber 229#)

standing woman in "Untitled" c. 1900 Robert Demachy (Gruber 214#)

sun reflecting on torso of woman in "Reflected sunlight on torso" 1922 Edward Weston (Photography 224)

television above back of reclining woman in "From 'Plastic love-dream'" 1968 Roger Mertin (Time-Life/12 137)

torso of a young boy in "Neil, nude" 1924 Edward Weston (Time-Life/11 183)

two figures on lounge chairs in "Two nudes" 1927-1929 László Moholy-Nagy (Gruber 244#)

two reclining women in "Two reclining nudes with mirror" c. 1850* Photographer Unknown (Bernard 15#)

two women standing with their arms on each other's shoulders in "Two standing nudes" c. 1850* Photographer Unknown (Bernard 58#)

woman asleep by large window in "Nude in Sandy's window" 1956 Wynn Bullock (Bullock 39)

woman before three others in long cloaks in "Motion study" 1926 Rudolf Koppitz (Gruber 219#)

woman in between rocks in "The cleft of the rock" Annie W. Brigman (Green 157)

woman in crouched position in "Nude" 1934 Imogen Cunningham (Time-Life/7 38)

woman in man's suit in alley in "[Of an insurpassable cut]" 1975 Helmut Newton (Hall-Duncan 207)

woman kneeling in "Dawn flowers" Edward Steichen (Green 71)

woman kneeling on one knee in "Nude" 1921 Erna Lendvai-Dircksen (Gruber 212#)

woman lying face down in sand in "Nude on sand" 1936 Edward Weston (Gruber 100#)

woman lying in box in "In the Box--Horizontal" 1962 Ruth Bernhard (Sandweiss 91#)

woman lying in dead forest in "Nude in dead forest" 1954 Wynn Bullock (Bullock 43)

woman lying in water in bathtub in "Nude in bathtub" 1962 Alen Mac-Weeney (Time-Life/11 182)

woman lying on blanket in forest in "Woman and dog in forest" 1953 Wynn Bullock (Bullock Cover)

woman lying on bluish ground in "Veruschka" 1965* Franco Rubartelli (Time-Life/8 212)

woman lying on couch in "Reclining nude" c. 1880 Thomas Eakins (Time-Life/7 195)

woman lying on couch in "Self-portrait" 1976* Paul de Nooijer (Gruber 172#)

woman lying on her back, and her reflection in "Nude" 1978* Roel Jacobs (Gruber 175#)

woman lying on red bedspread in "Charles shoe advertisement"* Guy Bourdin (Hall-Duncan 185)

woman lying on rug in "A good reputation" 1938 Manuel Alvarez Bravo
(Gruber 233#)
woman lying on steps in "Nude in a room" George Lynes Platt (Gruber
238#)
woman lying on wicker couch in "Nude" c. 1912 E.J. Bellocq (Gruber
232#)
woman, middle-aged, pasted with snapshots in "[Mother love]" 1971
Leslie Krims (Time-Life/11 109)
woman on bed in "Nude on bed" 1929* Martin Munkacsi (Bernard 191#)
woman on couch in "Nude" 1965* Jay Maisel (Time-Life/8 30)
woman seated in window of wooden shack in "Woman and thistle" 1953
Wynn Bullock (Bullock 87)
woman seated on rock by side of dirt road in "Book cover for Wayward
Wife" Philippe Halsman (Halsman 37)
woman seated with hand behind her head in "Figure study" c. 1853
Eugène Durieu (Time-Life/7 196a)
woman squeezing her breasts in "'Study for artists'" c. 1900* Photograph-
er Unknown (Bernard 142#)
woman standing, holding white drape, by vase of flowers in "Nude"
Clarence H. White (Gruber 210#)
woman standing in window covered by cobwebs in "Nude in cobweb win-
dow" 1955 Wynn Bullock (Bullock 37)
woman standing with arm across face in "Nude" Franz Grainer (Gruber
211#)
woman standing with arm over her face in "Musette" c. 1855 Nadar (Gern-
sheim 228#; Gernsheim/2 203#; Tournachon 69)
woman standing with clasped hands in "Homage to Seurat" 1965 Jean-Loup
Sieff (Gruber 208#)
woman standing with clasped hands in "New York" 1972 Eva Rubinstein
(Gruber 209#)
woman standing with legs spread apart in "Nude" 1929 Frantisek Drtikol
(Gruber 236#)
woman struggling in "Struggle" Robert Demachy (Green 88)
woman with face on body in "Nude with face" Philippe Halsman (Halsman
169)
woman's back in "Nude back" Sanne Sannes (Gruber 230#)
woman's breast and bent arm in "Nude in a room" 1961 Bill Brandt (Gru-
ber 224#)
woman's lower body in "Female nude" c. 1856* Charles Simart, Attrib.
(Bernard 37#)

O

OAK TREES
with roots entwined in "Twin oaks" 1956 Wynn Bullock (Bullock 41)
with split trunk in "An old oak" John Percy (Photography 98)
OATS
a photogenic drawing in "Oats" 1839 William Henry Fox Talbot (Photogra-
phy 22)
OBESITY
back of seated, nude, woman in "Fat woman" c. 1875* Photographer Un-
known (Bernard 105#)
two obese women in "'The fattest women in the world'" c. 1930* Photog-
rapher Unknown (Bernard 193#)
OCEAN WAVES
boy running in surf towards abandoned pier in "Boy at seat gate" 1968

Arthur Tress (Time-Life/9 207)
breaking waves and snowy egret in "Snowy egret on Captiva Island,
Florida" William G. Damroth (Rugoff 150#)
men surfing on large wave in "Hawaiian surf" 1968* Neil Leifer (Time-
Life/16 150)
pounding at the rocks in a storm in "Storm surf at Cape Ann" 1963*
Leonard McCombe (Time-Life/16 34)
stormy waves breaking at sea wall in "Stormy sea at Bognor" c. 1900
W.P. Marsh (Gernsheim 287#; Gernsheim/2 234#)
waves breaking at sea in "The dark blue sea" Henry Pollock (Photogra-
phy 101)
OCEANS
calm water in "Seascape" c. 1857 Gustave Le Gray (Gruber 264#)
sunset over the water in "Big Sur sunset" 1957 Wynn Bullock (Bullock
23)
OCELOTS
in the jungle at night in "Ocelots photographed on their nightly prowls
along jungle tracks" Frank M. Chapman (Guggisberg 113)
OIL see PETROLEUM
OLYMPIC NATIONAL PARK, WASHINGTON
Cape Johnson gulls on misty beach in "Cape Johnson in Olympic National
Park on the Washington coast"* Steven C. Wilson (Rugoff 31#)
forest of moss-covered trees in "Rain forest in the Hoh River area of
Olympic National Park, Washington"* Betty Randall (Rugoff 21#)
trees covered with mosses, ferns and lichens in "Trees covered with
mosses, lichens and ferns in rain forest, Olympic National Park"*
Betty Randall (Rugoff 22#)
OPERA HOUSES
with many automobiles in street in "The Opera House, Paris" c. 1901
Underwood and Underwood (Loke 164a)
OPOSSUMS
by water's edge in "Opossum" Jack Dermid (Rugoff 144#)
ORANGES
in crate in "Found color" 1959-1969* Gene Laurents (Time-Life/8 47)
ORCHARDS
women picking fruit from trees and ground in "The orchard" c. 1900
Clarence White (Green 80; Gruber 49#; Hine 119; Sandweiss 61#)
ORCHIDS
in "Orchid" 1970 Nick Foster (Time-Life/11 57c)
ORGAN GRINDERS
man turning organ handle in arcade in "Ash Wednesday, Munich, Ger-
many" 1967 Werner Thieme (Time-Life/14 45)
ORGAN PIPE CACTUS NATIONAL MONUMENT
field of yellow flowers and tree-like cacti in "Spring flowers with the vol-
canic crest of the Ajo Mountains in the distance, Organ Pipe Cactus
National Monument, Arizona"* David Muench (Rugoff 76#)
ORYX
a herd on the run in "Oryx in Kenya" 1969* John Dominis (Time-Life/16
32)
OSPREY
flying with fish in talons in "Osprey in the Everglades"* Kojo Tanaka
(Rugoff 163#)
landing on nest in "Osprey settling on nest on Gardiner Island, New
York" Frank M. Chapman (Guggisberg 34c)
OUTDOOR COOKING see COOKERY, OUTDOOR
OUTER SPACE
Earth seen from the Moon in "Earthrise as seen from Apollo 8" 1968* Frank

Borman (Time-Life/7 58)
OUTHOUSES
with door ajar in "Threatening outhouse" 1970 John Graham Lamb (Time-
Life/16 189)
OWLS
elf owl peering through hole in cactus in "Elf owl in nest in saguaro cac-
tus, Sonoran Desert, southern Arizona"* Jerry Gentry (Rugoff 79#)
saw-whet in flight with wings spread in "Saw-whet owl"* Ron Austing
(Rugoff 110#)
OXEN
and covered wagon by crowd near the Flatiron Building in "Ezra Meeker
with the wagon and ox team he drove across the continent..." 1907
Underwood and Underwood (Loke 165)

P

PAINT
peeling in "Peeled paint" 1959 Minor White (Gruber 127#)
PAINTERS
class of student artists in "Tokyo fine-arts class" Underwood and Under-
wood (Loke 116a)
girl painting on wall easel in "Girl painting" 1971 Suzanne Szasz (Time-
Life/9 82)
portrait of man with brush and palette in "Self-portrait with brush and
palette" 1901 Edward Steichen (Photography 172)
woman with brush and palette in "The painter" 1907 George H. Seeley
(Photography 196)
PAINTING, INDUSTRIAL
man on scaffold painting side of building in "Poster painter, Times
Square" 1952* Ernst Haas (Time-Life/8 137)
PALACE DEL INFANTADO
facade in "Palace del Infantado at Guadalajara" 1855 Charles Clifford
(Gernsheim 195#)
PALACES
man squatting in Amber Palace in "Amber Palace, India" B.W. Kilburn
(Loke 175c)
a richly decorated hall with crystal chandeliers in "The great durbar
hall in the palace of the Maharaja of Gwalior, India" Underwood and
Underwood (Loke 174)
PALESTINIANS
girls' sewing class in "At a mission school for girls, Lydda, Palestine"
Underwood and Underwood (Loke 150d)
PALM TREES
in swamp in "Swamp on Ossabaw Island, Georgia"* James P. Valentine
(Rugoff 154#)
on either side of car under a cover in "Long Beach, California" 1955
Robert Frank (Gruber 182#)
PANAMA CANAL
construction of the Gatun Locks in "Work in progress at Gatun Locks"
Photographer Unknown (Loke 97)
the Culebra Cut under excavation in "Culebra Cut, Panama, looking north-
west toward the Atlantic" Underwood and Underwood (Loke 96a)
PANTOMIMES
mime in clown costume, holding basket of fruit in "Charles Debureau,
celebrated mime" c. 1858 Adrien Tournachon (Tournachon 38)
mime with camera on tripod in "Charles Debureau" c. 1854 Adrien Tour-

nachon (Tournachon 46)
PARADES
Black women in costume in "[Toronto street parade]"* Michael Semack
(Time-Life/10 104-5)
man standing in car in motorcade, with police on motorcycles in "Wendell
Willkie motorcade" 1940 John D. Collins (Time-Life/10 25)
men lining street to view parade of suffragists in "'Joan of Arc' among
the suffragists, coronation procession, London" 1911 Underwood and
Underwood (Loke 164b)
the Rough Riders, on horseback, stopping at reviewing stand in "Rough
Riders saluting President McKinley in a reception in Los Angeles"
1901 Underwood and Underwood (Loke 40b)
PARASOLS see UMBRELLAS AND PARASOLS
PARENT AND CHILD
Congolese fathers with their small children in "Fathers and sons, the
Congo" Underwood and Underwood (Loke 105)
father holding newborn infant wrapped in blankets in "Bringing home the
first born" 1952 Dorothea Lange (Time-Life/9 14)
Filipino woman and children standing on board to iron clothes in "A wom-
an and her children ironing clothes, Island of Luzon, Philippines"
Photographer Unknown (Loke 124a)
girl sitting on mother's lap in "Mother and children in the Aran Islands"
1966* Humphrey Sutton (Time-Life/8 104)
grandmother holding baby in dress and blanket in "Maggie and Donna
Jo" 1966 Emmet Gowin (Time-Life/11 120)
in numerous positions in "[Woman and child]" 1887 Eadweard Muybridge
(Gruber 7#)
mother and child in "Mary and her mother" 1905 Edward Steichen (Time-
Life/9 46-47)
mother and child nude on bed in "Mother and child" 1968 Bruce Davidson
(Time-Life/11 121)
mother and child pleading for food, with outstretched hands in "Famine,
India" 1951 Werner Bischof (Time-Life/7 26)
mother and daughter in doorway in "Blessed Art Thou Among Women"
1899 Gertrude Käsebier (Green 68; Gruber 48#; Time-Life/12 28)
mother and daughter in subway in "[Untitled, Subway series]" 1938
Walker Evans (Sandweiss 124#)
mother and son sitting in chair in "Mother and son" 1913 Ludwig Silber-
stein (Time-Life/9 44)
mother combing girl's hair on bed in "Morning repose" 1957 Wayne Miller
(Time-Life/9 189)
mother feeding child under makeshift tent in "Okie family" 1936 Dorothea
Lange (Time-Life/10 123)
mother holding hand of child roller skating in "Untitled" 1958 David Heath
(Time-Life/9 215)
mother holding newborn infant in "A child is born" 1964 John Minshall
(Time-Life/9 11)
mother nursing infant in "Helpless and beloved" 1965 Anthony Wolff
(Time-Life/9 15)
Navaho woman holding child and lambs in "Navaho woman, child and
lambs" 1931 Laura Gilpin (Sandweiss 84#)
nude woman holding nude child on lap in "Woman and child (Nudes)"
1971 Jean-François Bauret (Gruber 216#)
Persian sultan posing with son in "The Governor of Isfahan Province and
his son" c. 1880 Ernst Höltzer (Time-Life/14 118)
pioneer woman with children at the rim of Grand Canyon in "A frontier
woman and her children at the Grand Canyon, Arizona" Photographer

poor Black family cooking in shack in "A peasant's home in Santiago de
 Cuba" Underwood and Underwood (Loke 55)
Russian families outside wooden houses by dirt road in "Russian peasant
 families" c. 1896 B.W. Kilburn (Loke 49)
woman carrying large sack on head, near man on burro in "Portuguese
 peasants standing below Pena Castle in Sintra, Portugal" Underwood
 and Underwood (Loke 142b)
women carrying load of peat in baskets on their backs in "Irish peasant
 women carrying peat, Ireland" 1903 William H. Rau (Loke 137a)
PEDDLERS AND PEDDLING
children around ice seller's cart in "Ha'penny ices" 1876-7 John Thomson
 (Gernsheim 308#)
Japanese man pulling cart filled with baskets in "A bamboo-basket seller
 sharing a joke with his customer, Japan" 1904 Keystone View Company
 (Loke 126c)
man selling toys on sticks in "A toy seller's stock, Tokyo, Japan" 1906
 H.C. White (Loke 125c)
sitting behind pushcart filled with cotton candy in "Cotton candy vendor
 in twilight colors, Mexico" 1969* Douglas Faulkner (Time-Life/8 79)
woman selling magazines on street in "Street vendor, London" 1892-4
 Paul Martin (Gernsheim/2 263#)
PEDESTRIANS
crossing street in dark shadows in "Chicago" 1961 Kenneth Josephson
 (Time-Life/14 44)
on tree-lined street in "A snapshot, Paris" Alfred Stieglitz (Green 315)
walking across bridge in "Pont Neuf, Paris" c. 1860 Adolphe Braun
 (Gernsheim 151#)
walking past large dark recesses in building in "Wall Street, New York"
 1915 Paul Strand (Green 316; Time-Life/7 37)
woman with bent shoulders, casting shadow on wall in "The Shadow,
 Seville, Spain" 1963 George Krause (Time-Life/14 43)
PELICANS
adults and young birds in "Home life of the White Pelican, Lake Malik,
 Albania" H.A. Bernatzik (Guggisberg 112)
one in flight in "Brown pelican on Sanibel Island, Florida" William G.
 Damroth (Rugoff 149#)
PENGUINS
group of penguins nesting in "The photographer among Adélie penguins"
 H.G. Ponting (Guggisberg 80)
group of rockhoppers on rocky island in "Challenger expedition: Photo-
 graph of rockhopper penguins on Inaccessible Island" c. 1874 C. New-
 bold (Guggisberg 15)
PENNSYLVANIA STATION, NEW YORK CITY
interior view in "Pennsylvania Station" 1936 Berenice Abbott (Sandweiss
 94#)
PEPPERS
green pepper in "Pepper No. 30" 1930 Edward Weston (Time-Life/7 39)
two green peppers in "Peppers" c. 1923 Paul Outerbridge (Sandweiss
 58#)
PERCH
swimming in kelp bed in "Pacific white perch in kelp bed"* Ron Church
 (Rugoff 39#)
PERSIANS
barber shaving a man in "A Persian barber and customers" c. 1880 Ernst
 Holtzer (Time-Life/14 121)
linked together by heavy chains around their necks in "State prisoners
 in chains" c. 1880 Ernst Höltzer (Time-Life/14 117)

a sultan with his son in "The Governor of Isfahan Province and his son" c. 1880 Ernst Höltzer (Time-Life/14 118)

two men lifting weights in "Persian gymnasts" c. 1880 Ernst Höltzer (Time-Life/14 122)

two men practicing their marksmanship in "The Governor's bodyguards" c. 1880 Ernst Höltzer (Time-Life/14 120)

women and young girl in "Nun, woman and child" c. 1880 Ernst Höltzer (Time-Life/14 119)

PERSIMMONS

in "Persimmons" 1959* Martin Schweitzer (Time-Life/11 56b)

PETRIFIED FOREST NATIONAL PARK

clay slopes in "The clay slopes of Blue Mesa, Petrified Forest National Park, Arizona"* David Muench (Rugoff 78#)

PETROLEUM

spot on asphalt in "Oil spot" 1952* Ernst Haas (Time-Life/8 136)

PETROLEUM INDUSTRY AND TRADE

fuel tanks in "Fuel tanks, Wisconsin" Charles Sheeler (Gruber 180#)

fuel tanks and pipes in "Gulf Oil, Port Arthur" 1941 Edward Weston (Sandweiss 95#, 96#)

PHONOGRAPHS

Japanese men crowded around American phonograph in "A crowd gathered around an American phonograph in Tokyo park" 1906 H.C. White (Loke 114)

with "morning glory" horn, on lace-covered table, by glass jar in "Milwaukee nostalgic still life" 1964 Clarence John Laughlin (Time-Life/12 52)

woman listening to sound from phonograph in "Sarah Bernhardt listening to her voice on phonograph" 1891 Photographer Unknown (Gernsheim 318#)

PHOTOGRAMS, 1926

László Moholy-Nagy (Photography 240a)

PHOTOGRAPHERS

camera on tall tripod to view nest in "The Kearton brothers at work with Cherry standing on Richard's shoulders to photograph a nest high up in a hedge" Richard and Cherry Kearton (Guggisberg 22)

holding 16 lb. reflex-camera, and a rifle in "The photographer carrying the reflex-camera with which he took all daylight photographs on his first African expedition" A.R. Dugmore (Guggisberg 54)

man holding camera in front of face in "Photojournalist" c. 1955 Andreas Feininger (Time-Life/7 61)

man in an early hide in the form of a tree trunk in "An early hide in the form of an artificial tree trunk designed and used by the brothers in 1898" Richard and Cherry Kearton (Guggisberg 23)

man standing on ladder of elevated tripod camera in "An Underwood stereographer preparing to take a view of the crater of Asosan, central Kyushu, Japan" 1904 Photographer Unknown (Loke 15)

sitting with camera atop a steel girder in "An H.C. White stereographer perched with his camera on a steel column of a new skyscraper, New York City" Photographer Unknown (Loke 13)

with camera near river in "The photographer with his Eyemo Camera" Eugen Schuhmacher (Guggisberg 117)

PHOTOGRAPHIC HISTORY

earliest extant daguerreotype in "[Earliest extant daguerreotype]" 1837 Louis Jacques Mande Daguerre (Gernsheim 27#; Gernsheim/2 27#; Time-Life/7 170)

first photography in "[The world's first photograph]" Nicephore Niepce (Gernsheim 18#; Gernsheim/2 21#)

photograph on glass in "[The earliest extant photography on glass]"
1839 J.F.W. Herschel (Gernsheim 50#; Gernsheim/2 39#)
PHOTOGRAPHY, AERIAL
Boston, from a balloon in "Boston, from the balloon 'Queen of the Air'"
1860 James Wallace Black (Photography 73)
Manhattan Island from 8,000 feet in "Manhattan Island from an altitude of
8,000 feet" 1956 Edwin Hawbecker (Time-Life/7 53)
of Labruguière in "Kite photograph of Labruguière" 1889 Arthur Batut
(Gernsheim/2 310#)
PHOTOGRAPHY--EQUIPMENT AND SUPPLIES
camera and climbing equipment in "Cameras and climbing equipment used
by the Keartons during the nineties" Richard and Cherry Kearton
(Guggisberg 25)
different types of lighting in "Floodlights, spotlight and reflectors" 1968
Howard Harrison (Time-Life/14 189)
a dummy bullock used as a hide by the Keartons in "The famous dummy
bullock which the Keartons used as a hide" Richard and Cherry Kear-
ton (Guggisberg 24)
an early telephoto-camera in "One of his telephoto-cameras" C.G. Schil-
lings (Guggisberg 46)
1400 pound camera and team of men in "The Mammoth" c. 1900 Photogra-
pher Unknown (Time-Life/7 144)
image of apple formed through lens of camera in "Image of apple formed
through lens of sectioned camera" 1969* Ken Kay (Time-Life/14 11)
man with large camera a distance from Zuñi Pueblo in "William Henry
Jackson, with his 20 x 24 inch view camera, photographing Zuñi
Pueblo near Laguna, New Mexico" c. 1877 Photographer Unknown
(Time-Life/14 83)
men setting up camera in jungle in "The UFA expedition of 1926 at work
in the Amazon jungle" August Brückner (Guggisberg 115)
photographers posing with cameras and African men in "The photograph-
ers with an old-time cine-camera and ... an Akeley Panoramic camera"
Martin and Osa Johnson (Guggisberg 104)
shadows of studio camera on backdrop in "Self-portrait with photographic
paraphernalia" 1929 Edward Steichen (Time-Life/13 11)
still life seen upside down on screen of view camera in "Still life as seen
on the ground-glass screen of a view camera" 1970* Ken Kay (Time-
Life/13 143)
an uncamouflaged tent as a hide in a swamp in "First use of an uncamou-
flaged tent as a photographer's hide" Francis H. Herrick (Guggisberg
35)
William Henry Fox Talbot and assistant displaying equipment in "[Talbot's
photographic studio]" Photographer Unknown (Gernsheim 82#; Gern-
sheim/2 78#; Time-Life/7 142)
PHOTOGRAPHY--EXHIBITIONS
couple viewing the "Family of Man" in "The Family of Man" 1955 Andreas
Feininger (Time-Life/15 161)
PHOTOGRAPHY--STUDIOS
boy on horse in front of screen in "The Prince Imperial, Paris" c. 1859
Mayer & Pierson (Time-Life/9 65)
Japanese women viewing stereo cards through a stereoscope in "Stereo-
scopic view of a group of Japanese women taking turns viewing stereo
cards through a stereoscope" Keystone View Company (Loke 18)
man standing with cameras, etc. in "At Peter Britt's studio" c. 1860
Photographer Unknown (Time-Life/7 133)
Mathew Brady's photographic van in "Mathew Brady's photographic van
at Petersburg, Virginia" c. 1864 Brady staff (Gernsheim 169#; Gern-

sheim/2 145#)
opulent Victorian portrait studio in "[T.C. Marceau's posh Fifth Avenue
photo gallery]"* Theodore C. Marceau (Time-Life/12 52-53)
photographic van with driver in "Roger Fenton's photographic van" 1855
Photographer Unknown (Gernsheim 165#; Gernsheim/2 137#)
a restoration of a 19th century portrait studio in "[A 19th century por-
trait parlor]"* Evelyn Hofer (Time-Life/12 48-49)
tintype studio reconstructed in "[Tintype studio]"* Evelyn Hofer (Time-
Life/12 50-51)
with photographs and equipment in "Studio of the photographer Bour-
geois, Paris" c. 1870 Photographer Unknown (Time-Life/14 49)
wooden building by boardwalk in "Photo studio in Stillwater, Oklahoma"
c. 1895 Henry Wantland (Time-Life/13 173)

PHYSICIANS
around patient on table in "Operation by Sir Alexander Ogstone" c.
1883 G.W. Wilson (Gernsheim 316#; Gernsheim/2 275#)
drinking coffee in kitchen while in surgical gown in "Country doctor"
1948 W. Eugene Smith (Photography 294)
with stethoscope examining baby in "[Doctor with stethoscope examining
baby]" Wolf von dem Bussche (Time-Life/9 107)
woman examining a baby in "Helen Taussig" 1975 Yousuf Karsh (Karsh
199)

PIANOS
boy standing on broken piano ready to hurl rock at it in "Bashing a
piano" 1962 Philip Jones Griffiths (Time-Life/9 153)
in rooms with book-filled table in "Paris interior"* Eugéne Atget (Time-
Life/15 51)
in silhouette with two models in "Black" 1935 Edward Steichen (Hall-
Duncan 52)
keyboard and sheet music of upright piano in "Piano" 1924 Paul Outer-
bridge, Jr. (Gruber 205#)
man in shirt sleeves, sitting at piano in "Richard Nixon" 1967 Philippe
Halsman (Halsman 30)
man resting arm on open grand piano in "Igor Stravinsky" 1946 Arnold
Newman (Gruber 110#)
man seated by piano in "Igor Stravinsky" 1956 Yousuf Karsh (Karsh 195)
man with cigarette in mouth, playing the piano in "Duke Ellington"
Philippe Halsman (Halsman 53)
teacher watching two girls at piano in "The music lesson" c. 1857 Pho-
tographer Unknown (Gernsheim 146#; Gernsheim/2 125#)
trio of women playing piano, cello and violin in "The Prelude" 1917 Laura
Gilpin (Sandweiss 57#)
views of keyboard and strings in "Piano" Änne Biermann (Gruber 78a-c)

PICNICS
group of people with baskets on blanket in "A picnic" c. 1882 J. Bridson
(Gernsheim 288#; Gernsheim/2 233#)
mother and children on blanket in "Picnic on Garrett Mountain" 1968*
George A. Tice (Time-Life/15 85a)
people eating on grassy slope of riverbank in "By the Marne River" or
"Lunch by the Marne" 1938 Henri Cartier-Bresson (Cartier-Bresson
27; Gruber 96#)

PIES
woman holding pie on tray in "Northern California" 1944 Dorothea Lange
(Sandweiss 121#)

PIGEONS
gathering on park walkway in "[Pigeons]" George Krause (Time-Life/7
83)

on fountain near library in "[Pigeons by the New York Public Library]" 1971 Inge Morath (Time-Life/11 103)

on sidewalk in "Pigeons in Piazza San Marco" 1955* Ernst Haas (Time-Life/8 143)

PIGS

old man petting a large sow in "[Petting a white sow]" Dennis Hearne (Time-Life/12 147)

PILLARS OF HERCULES

pillars of rocks on either side of railroad tracks in "Flooded meadow" c. 1902 Willard Worden (Sandweiss 33#)

pillars of rocks on either side of railroad tracks in "Hercules' Pillars-- Columbia River, Oregon" William Henry Jackson (Sandweiss 31#)

PINE TREES

forest of bare tree trunks in "Forest of lodgepole pines"* Charles Steinhacker (Rugoff 54#)

PINEAPPLES

and other fruit in two baskets in "A fruit piece" c. 1844 William Henry Fox Talbot (Gruber 202#)

PIPES, TOBACCO see TOBACCO PIPES

PISA, ITALY

leaning belltower in "Belltower, Pisa" c. 1860 Bisson Freres (Gruber 357#)

PLANTATIONS

overgrown columns of destroyed plantation house in "The enigma" 1941 Clarence John Laughlin (Time-Life/12 48)

PLAY. See also PLAYGROUNDS; SWINGS AND SWINGING

boy in cowboy hat playing croquet in "Boy playing croquet" 1962 Bill Binzen (Time-Life/9 152)

boy standing on broken piano ready to hurl rock at it in "Bashing a piano" 1962 Philip Jones Griffiths (Time-Life/9 153)

boy swinging on swing in "Inertia" 1968 Egons Spuris (Time-Life/11 197)

boys and girls together in "Gypsy children" 1964 Josef Koudelka (Gruber 382#)

boys playing leapfrog on city sidewalk in "Leapfrog, New York City" 1911 Lewis Hine (Hine 2)

children holding hands and spinning in circle in "Child's game" 1965* Steven C. Wilson (Time-Life/7 93)

children in make-believe army costumes in "Children at play" 1968 Lilo Raymond (Time-Life/9 182)

children jumping rope by front stoop of apartment house in "[A street scene on New York's Lower East Side]"* Marcia Keegan (Time-Life/10 102-3)

children parading with homemade flag on "Children playing" 1968 Lilo Raymond (Time-Life/16 177)

children playing among rubble of building in "Children in Seville, Spain" 1933 Henri Cartier-Bresson (Time-Life/9 75)

children playing baseball in alley with laundry hanging between tenements in "Playground in tenement alley, Boston" 1909 Lewis Hine (Hine 75)

children playing Blindman's Buff in "Children playing Blindman's Buff" Photographer Unknown (Loke 120)

children playing follow-the-leader on train tracks in "Follow the leader" 1961 Dick Swanson (Time-Life/9 190)

children swinging each other in "Peking Mission School children at play, China" 1902 C.H. Graves (Loke 121)

children with sleds on small hill on outskirts of city in "Winter in Prague" 1961 Zdeněk Vozenilek (Time-Life/11 222)

girl watching two boys at puppet show in "Children's theater" 1965 Max Dellacher (Time-Life/9 141)

girls playing in dirt of vacant lot in "Vacant lot playground, New York City" c. 1910 Lewis Hine (Hine 92)

men and women lying on sand pushing large ball in "Push ball" 1930 George Hoyningen-Huene (Hall-Duncan 62)

two boys in capes in "Batman and Robin" 1970 Terry Bisbee (Time-Life/ 9 140)

PLAYGROUNDS

child coming down slide in "Sliding board" 1970 Charles Traub (Time-Life/ 9 150)

child on suspended rings in "Muscle Beach" 1968 Ron Mesaros (Time-Life/9 9 155)

children on swings in "Playground, Boston" c. 1909 Lewis Hine (Hine 40)

small boy wearing large hockey gloves in "Boy with ice hockey gloves" 1970 Arthur Tress (Time-Life/9 204)

POINT LOBOS

eroded sandstone and pebbles in "Eroded sandstone and tide-washed pebbles at Pebbly Beach"* Dennis Brokaw (Rugoff 36#)

looking down at tide pools in "Point Lobos, Tide pools" 1972 Wynn Bullock (Bullock 27)

tide pool with algae in "Tide pool (upper middle zone) containing chiefly algae and periwinkles, Point Lobos, California"* Dennis Brokaw (Rugoff 34#)

tide pool with anemones in "Tide pool (middle to lower zone) showing anemones, sea urchins, chitons, algae, encrusting sponge, and tiny red 'spiders'"* Dennis Brokaw (Rugoff 37#)

tide pool with limpets and closed anemones in "Limpets and closed anemones in a tidal area at Pebbly Beach, Point Lobos"* Dennis Brokaw (Rugoff 35#)

wave splashing against rocks in "Point Lobos, wave" 1958 Wynn Bullock (Bullock 25)

weathered tree trunk in "Point Lobos tree, California" 1960* Ernst Haas (Time-Life/8 155)

POISON IVY

and sumac leaves in "Groundcover" 1968* Dorothea Kehaya (Time-Life/8 202)

POLES

children and goats by cottage in "Children in Warsaw, Poland" B.W. Kilburn (Loke 149)

peasants in marketplace in "Market scene in Warsaw, Poland" c. 1896 B.W. Kilburn (Loke 57b)

POLICE

arresting a man in "Arrest of Gavrillo Princip, assassin of the Archduke Franz Ferdinand, Sarajevo" 1914 Philipp Rubel (Gernsheim/2 274#)

in white helmets, fighting off demonstrators with shields in "Tokyo riot" 1971* Bruno Barbey (Time-Life/12 14)

investigating scene of crime at stone house in "Police at the scene of a crime" c. 1910* Photographer Unknown (Bernard 162#)

men of the Spanish national guard in "Guardia Civil" 1951 W. Eugene Smith (Time-Life/10 78a)

on motorcycles in motorcade in "Wendell Willkie motorcade" 1940 John D. Collins (Time-Life/10 25)

of Rome posing with their Commisioner in "Rome Commissioner of Public Safety and Carabinieri" c. 1884 Guiseppe Primoli (Time-Life/14 97a)

walking with 'hobo' as children follow in "Arrest of a hobo, New York" 1897 Photographer Unknown (Gernsheim 313#; Gernsheim/2 259#)

woman being carried by police in "The arrest of Mrs. Pankhurst" 1914 Photographer Unknown (Time-Life/10 44)

PONDS
 sunrise over mountain pool in "Sunrise over Highland Pool, Mount Evans,
 Colorado" 1969* Harald Sun (Time-Life/14 21)
 water lilies and overhanging trees in "Water lilies, Giverny, France"
 1979* Dmitri Kessel (Time-Life/14 39)
PONIES
 child posed on pony in "Mary McGee, Jersey City" 1926 Photographer Un-
 known (Time-Life/9 53)
POOL
 baby arching back on pool table in "Baby on pool table" 1970 Ronald
 Mesaros (Time-Life/9 85)
 group of boys playing pool in "Pool hall interior, St. Louis" 1910 Lewis
 Hine (Hine 96)
POPES
 mass to thousands in baseball stadium in "Papal Mass at Yankee Stadium,
 New York City" 1965* Ralph Morse (Time-Life/14 225)
 procession to altar of Cathedral in "Pope Paul VI entering St. Patrick's
 Cathedral, New York City" 1965* Yale Joel (Time-Life/14 224)
POPPIES
 field of red poppies and creosote bush in "Spring poppies and creosote
 bush in Antelope Valley, Mojave Desert, southern California"* David
 Muench (Rugoff 77#)
PORCELAIN
 articles on shelves in "Articles of china" William Henry Fox Talbot (Gru-
 ber 11#)
PORCHES
 children leaning over porch railing in "On a porch" 1967 Danny Lyon
 (Time-Life/9 186)
 small boy at end of porch in "Morning, New Hampshire" 1965* Bill Bin-
 zen (Time-Life/8 38)
 small flag on post in "Martha's Vineyard" 1963* Farrell Grehan (Time-
 Life/8 94)
 with bouquet of flowers on table in "The bouquet" 1967* Robert D. Routh
 (Time-Life/8 224)
PORTUGUESE MAN-OF-WAR
 on beach in "Portuguese man-of-war stranded on a beach" Jack Dermid
 (Rugoff 148#)
POSTCARDS
 view compared with original castle in "Postcard visit, Stockholm, Sweden"
 1967 Ken Josephson (Time-Life/11 162)
POSTERS
 campaign posters on abandoned, boarded-up building in "For rent" 1973*
 Tomas Sennett (Time-Life/12 20)
POTTERY
 clay pots and pitchers beneath window in "Pots and pans at Nice" 1855*
 Arthur Backhouse (Bernard 53#)
POVERTY
 boy posing in burnt-out store in "Boy in a fire-bombed store" 1969
 Arthur Tress (Time-Life/9 205)
 children dressed in rags, holding kittens and broken doll in "The Mulhall
 children, Ozark Mountain family" 1935* Ben Shahn (Bernard 201#)
 children in alley between buildings in "Baxter Street Alley in Mulberry
 Bend, New York" 1888 Jacob A. Riis (Hine 128; Photography 154)
 children on bare ground by tents in "Okie homes in California" 1936
 Dorothea Lange (Time-Life/10 129)
 couple in ill-fitting clothes in "Monsieur and Madame Garafino, Clochards"
 1952 Robert Doisneau (Gruber 405#)

woman in field of jonquils in "Indications of motherhood" 1969* Sam
Zarember (Time-Life/8 111)
PRESIDENTS--U.S.--INAUGURATION
Theodore Roosevelt giving speech in "Pres. Theodore Roosevelt's Inaug-
ural Address outside the Capitol, Washington" 1905 Photographer Un-
known (Gernsheim 321#)
PRIESTS
Buddhist priest carrying portable altar on his back in "A schoolboy giv-
ing a contribution to an itinerant Buddhist priest who carries on his
back a portable altar equipped with his religious paraphernalia, Japan"
Photographer Unknown (Loke 126a)
group of seminarians dancing in "Seminarians dancing" 1965 Mario Gia-
comelli (Time-Life/11 129)
seated Hindu priest with attendants in "Hindu Priest from southern India
with attendants" 1870's* Photographer Unknown (Bernard 101#)
PRISMS
of glass showing spectrum of light in "Prism and spectrum" 1970* Sebastian
Milito (Time-Life/8 11)
PRISONERS
American soldier with rifle guarding man in cell in "An American soldier
guarding a prisoner, Spanish-American War, Cuba" Photographer Un-
known (Loke 41)
armed Italian soldiers guarding Chinese prisoners in "Boxers guarded by
Italian soldiers" B.W. Kilburn (Loke 45d)
chain gang of Black men in striped uniforms in "Convicts and their
guards, Atlanta, Georgia" B.W. Kilburn (Loke 59a)
linked together by heavy chains around their necks in "State prisoners
in chains" c. 1880 Ernst Höltzer (Time-Life/14 117)
PRISONS
guard with Gatling gun in "Guard at Polson Prison, Montana, with Gatling
gun" c. 1892* Skylar (Bernard 133#)
man's arm and leg sticking out through cell bars in "Cell in a modern
prison in the U.S.A." 1975 Henri Cartier-Bresson (Cartier-Bresson 81)
PROSTITUTES
heavily made-up women sitting at openings in wooden doors in "Calle
Cuauhtemocztin, Mexico" 1934 Henri Cartier-Bresson (Cartier-Bresson
Front cover)
stretched out on ironing board, playing with a puppy in "Storyville por-
trait" 1912* E.J. Bellocq (Time-Life/15 52)
woman in slip and stockings kneeling on chair in "Storyville portrait"
1912* E.J. Bellocq (Time-Life/15 53)
PUFFINS
with food in beak in "Puffin bringing home a good catch on Skomer"
Francis Pitt (Guggisberg 66)
PULITZER PRIZE PHOTOGRAPHS, 1969
execution of a Vietnamese man in "Execution of a suspected Viet Cong
terrorist" 1968 Edward T. Adams (Time-Life/7 33)
PUNISHMENT. See also CAPITAL PUNISHMENT; PRISONERS; PRISONS
whipping of African man in "A German on a rubber plantation counting
to the strokes at a beating of a native, East Africa" Underwood and
Underwood (Loke 95)
PUPPETS AND PUPPET PLAYS
two boys behind puppet stage in "Children's theater" 1965 Max Dellacher
(Time-Life/9 141)
PYRAMIDS
and Sphinx in "The Sphinx and Pyramid of Cheops in distance" Francis
Beato (Gruber 27#)

Graf Zeppelin flying over the Gizeh in "The Graf Zeppelin flying over the pyramids of Gizeh" George Lewis (Loke 220)
of Dahshoor, Egypt in "The Pyramids of Dahshoor from the Southwest" 1857-1858 Francis Frith (Gruber 245#)

Q

QUAGGA
the last living quagga, photographed in zoo in "London Zoo's last quagga" c. 1870 Photographer Unknown (Guggisberg 14)

R

RABBITS
dead rabbit in still life in "Still life" c. 1855 Hugh W. Diamond (Photography 97; Time-Life/7 183)
laser beam aimed at eye in "Laser surgery" 1961* Fritz Goro (Time-Life/14 229)
shoes of children standing around dead rabbit in "First death" 1965 George W. Gardner (Time-Life/9 80)
RACING see AUTOMOBILE RACING; DOG RACING; HORSE RACING
RAILROADS. See also LOCOMOTIVES
depot of freight train in small town in "Phillipsburg, New Jersey" 1936 Walker Evans (Photography 315; Time-Life/7 24)
interior view of Pennsylvania Station, New York City in "Pennsylvania Station" 1936 Berenice Abbott (Sandweiss 94#)
locomotive and two cars on tracks through canyon in "Chipeta Falls, Black Cañon of the Gunnison" 1883 William Henry Jackson (Sandweiss 17#)
locomotives in roundhouse in "Roundhouse on the Bourbonnais Railway" 1862-67* Collard (Bernard 76#)
man with hat and work gloves holding onto corner of train in "Freight brakeman, New York Central Lines" 1921 Lewis Hine (Hine 63)
men leaning over wall, looking at train tracks in "Quai Saint-Bernard, Paris" 1932 Henri Cartier-Bresson (Cartier-Bresson 31)
on bridge over river in "Train crossing Niagara River" 1859 William England (Gernsheim 143#; Gernsheim/2 123#)
ornate dining car with waiter in "Dining car of the Pennsylvania Limited" c. 1889 Photographer Unknown (Loke 33)
tracks between pillars of rock in "Hercules Pillars--Columbia River, Oregon" William Henry Jackson (Sandweiss 31#)
tracks going through small town in "East Rush, L.V.R.R." c. 1900 William Herman Rau (Sandweiss 34#)
tracks paralleling river in rocky land in "Embudo, New Mexico" c. 1880's William Henry Jackson (Sandweiss 28#)
train blowing smoke on one of many railroad tracks in "The Hand of Man" 1902 Alfred Stieglitz (Green 82; Hine 135; Sandweiss 77#)
train crossing trestle in "Train passing over a trestle" 1891 B.W. Kilburn (Loke 32)
train hanging over edge of wrecked bridge in "Wrecked German troop train near Mezières, Franco-Prussian War" 1870 Photographer Unknown (Gernsheim 174#; Gernsheim/2 150#)
train on edge of cliff overlooking a canyon in "Cañon of the Rio Las Animas" c. 1884 William Henry Jackson (Sandweiss 23#)
RAIN AND RAINFALL

children in raincoats and hats standing in rain with open mouths in "Singing and drinking rain" 1950 Barbara Morgan (Time-Life/9 79)
front end of motorcycle in rain in "Wet motorcycle" 1970* Don Hinkle (Time-Life/8 96)
girl with hat looking through window with raindrops in "Little girl in the rain" 1959 Bill Ray (Time-Life/9 166)
man jumping over puddle in "Place de l'Europe, Paris" 1932 Henri Cartier-Bresson (Time-Life/11 125)
man walking through rain filled park in "Washington Square Park" 1967* Leif-Erik Nygards (Time-Life/8 97)
people on street with open umbrellas in "Italy" 1961 Michael Semak (Time-Life/11 126)
people walking with umbrellas on tree-lined street in "A wet day on the boulevard, Paris" 1894 Alfred Stieglitz (Photography 170)
people walking with umbrellas near cafe in "Effet de Pluie" c. 1899 M. Bucquet (Gernsheim 338#; Gernsheim/2 291#)
reflecting lights on wet street in "Rainy night, Times Square" 1952* Ernst Haas (Time-Life/8 138)
water buffaloes grazing in monsoon in "Java monsoon" 1970* Co Rentmeester (Time-Life/16 33)
RAIN FORESTS
moss covered trees in "Rain forest in the Hoh River area of Olympic National Park, Washington"* Betty Randall (Rugoff 21#)
trees covered with mosses, ferns and lichens in "Trees covered with mosses, lichens and ferns in rain forest, Olympic National Park"* Betty Randall (Rugoff 22#)
RAINBOWS
across a mountain in "Rainbow in the Ecuadorian Andes" 1965* Ernst Haas (Time-Life/14 40)
RAYOGRAPH
circle with many lines in "Rayograph" Man Ray (Gruber 425#)
silhouette of model on honeycomb background in "Fashion rayograph" 1934 Man Ray (Time-Life/13 117)
READING
boy reading with teacher from book in "A schoolmaster and his pupil, Monaghan County, Ireland" Underwood and Underwood (Loke 151)
Hasidic Jew teaching young boys to read Hebrew in "Scholars of tradition, Brooklyn" 1955 Cornell Capa (Time-Life/9 26)
man with paper sitting on bench with others in "Waiting for the train" 1923* J.B. Pardoe (Bernard 177#)
old man at table covered with newspapers in "Old man" 1936-37 Lewis Hine (Hine 52)
seated woman reading newspaper by ladder in "Ensemble by Maggy Rouff" 1936 Cecil Beaton (Hall-Duncan 119a)
young child reading book, sitting under tree with mother in "The picture book" 1905 Gertrude Käsebier (Gruber 282#)
REDWOODS
and grazing horses in "Coastal redwoods in Santa Cruz County, California" Don Worth (Rugoff 30#)
REFUGEES
group of people in ragged clothes by pot on open fire in "Serbian refugees returning home" 1918* Lewis Hine (Bernard 174#)
group on flat-bed horse-drawn wagon in "French refugees fleeing from the Somme to Amiens" Photographer Unknown (Loke 201d)
with arms upraised in "Gymnastics in a refugee camp at Kurukshetra, Punjab, India" 1948 Henri Cartier-Bresson (Cartier-Bresson 69)
REFUSE

boy standing on broken piano ready to hurl rock at it in "Bashing a piano" 1962 Philip Jones Griffiths (Time-Life/9 153)

men surrounded by empty tin cans, under pier in "The Short Tail Gang, under pier at foot of Jackson Street, later Corlears Hook Park" 1888 Jacob A. Riis (Photography 157c)

veiled woman in room with garbage in "The repulsive bed" 1941 Clarence John Laughlin (Time-Life/12 47)

RELIGIOUS CEREMONIES see RITES AND CEREMONIES

RESEARCH

man at table filled with test tubes and bottles in "George Washington Carver in his research laboratory at Tuskegee Institute, Alabama" Phil Brigandi (Loke 34d)

RESTAURANTS, BARS, ETC.

backs of people seated on stools in "The Stooped" 1934 Manuel Alvarez Bravo (Gruber 95#)

couple at table with wine glasses in "Dance hall" 1932 Brassaï (Photography 281)

empty cafe tables, with plaid tablecloths in "Cafe in Venice, Italy" 1978* Harry Callahan (Time-Life/14 42)

empty table and chairs, and television set turned on in "U.S. 1, South Carolina" 1955 Robert Frank (Gruber 377#)

men on bench with mugs in "Outside the pub, London" 1876 John Thomson (Gernsheim/2 257#)

men playing cards and drinking wine at cafe tables in "Buvette, Keritz, France" 1975* Michel Thersiquel (Time-Life/14 32)

newlyweds drinking at bar with coalman in "Coalman and newlyweds" 1948 Robert Doisneau (Gruber 103#)

people with umbrellas walking near awning-covered tables in "Effet de Pluie" c. 1899 M. Bucquet (Gernsheim 338#)

woman and men with tankards standing by bar in "London pub interior" 1898* Harry Ellis (Bernard 136#)

RHINOCEROS

head-on view of charging black rhinoceros in "Charging black rhinoceros photographed at a distance of fifteen yards" A.R. Dugmore (Guggisberg 55)

in jungle in "Sumatran rhinoceros visiting a salt lick in Pahang, Malaya" T.R. Hubback (Guggisberg 90c)

in muddy water in "Javanese rhinos" A. Hoogerwef (Guggisberg 91a)

profile of rhino through the grass in "A white rhino of the northern sub-species..." Kermit Roosevelt (Guggisberg 71)

standing in the marsh in "Indian rhinoceros among the elephant grass marshes of the Jaldapara Reserve" Bengt Berg (Guggisberg 89)

RHODODENDRONS

bush in bloom in forest in "Rhododendron beneath Sequoia in the Bald Hills, Redwood Creek area of Redwood National Park, California"* David Muench (Rugoff 27#)

RICHMOND, VIRGINIA

in ruins in "Ruins of Richmond" 1865 Mathew Brady (Gernsheim 170#; Gernsheim/2 148#; Gruber 41#)

RIOTS. See also CROWDS; DEMONSTRATIONS

police in white helmets, fighting off shielded protestors in "Tokyo riot" 1971* Bruno Barbey (Time-Life/12 14)

RITES AND CEREMONIES. See also FUNERAL RITES AND CEREMONIES; MARRIAGE CUSTOMS AND RITES

Cardinals offering Communion in "St. Peter's Cathedral, Rome" 1978* Enrico Ferorelli (Time-Life/14 192)

a procession of royalty in "A reception at the Quirinal Palace" 1893

Giuseppe Primoli (Time-Life/14 94)
two girls in First Communion dresses in "[Parody of a First Communion]"*
Luigi Ghirri (Time-Life/12 142)
young child being christened in "A christening" 1951 W. Eugene Smith
(Time-Life/10 79c)

RITUALS see RITES AND CEREMONIES

RIVERS
and high cliffs in "View near the mouth of Santa Elena Canyon on the
Rio Grande, Big Bend National Park, Texas"* Jim Bones (Rugoff 85#)
boats docked at Aswan in "Aswan, Egypt" 1856 Francis Frith (Time-Life/
14 115)
brown bears in white water of river in "Brown bears in the McNeil River"*
Kojo Tanaka (Rugoff 16#)
calm water reflecting small village in "River scene" c. 1806 Camille Silvy
(Time-Life/7 187)
couple on river bank with rowboat in "In the twilight" 1888 Lyddell Saw-
yer (Gernsheim 327#; Gernsheim/2 280#; Time-Life/7 189)
estuary and marshland in "Salt marsh estuary of the Herring River" Gor-
don Smith (Rugoff 124#)
flowing over rocks in "Roaring Fork River" 1969* George A. Tice (Time-
Life/15 85d)
icebound and snow-covered in "Androscoggin River, Maine, icebound"
1967* William Garnett (Time-Life/7 225)
panoramic view of Paris in "Panorama of Paris" 1846 Friedrich von Martens
(Gernsheim/2 46#; Time-Life/7 150)
panoramic view of town and barges in "Siebengebirge" c. 1936 August
Sander (Gruber 261#)
passing through deep canyons in "Colorado River below Toroweap View,
Grand Canyon National Monument, Arizona"* David Muench (Rugoff
61#)
small boat on river bank in "African monsoon" 1978* Anni-Siranne Coplan
(Time-Life/14 41)
through mountains in "The Scinde River" c. 1864 Samuel Bourne (Gern-
sheim 188#; Gernsheim/2 170#)
trees overhanging river, running through hills in "The river at Bettws-
y-Coed, North Wales" c. 1856* Henry White (Bernard 50#)
white water of river, and barren trees in "High shoals in the Appalachee
River"* William A. Bake, Jr. (Rugoff 141#)
wide river (The Thames) with small dam across it in "New Lock, Hurley"
c. 1862* Victor Albert Prout (Bernard 71#)

ROADS
and a Volkswagen Beetle in "Country road, Lancaster, Pennsylvania"
1961 George Tice (Time-Life/12 153)
highways overlapping each other in "Chicago landscape" 1964 Art Sinsa-
baugh (Time-Life/12 127)
nude figure lying at base of skyline in "Untitled" 1946 Arthur Siegel
(Time-Life/12 214)
of bricks in "Halifax" 1937 Bill Brandt (Time-Life/11 186)
team of women pulling large roller on gravel highway in "A twenty-woman
team working on a highway, Darjeeling, India" 1903 Underwood and
Underwood (Loke 143b)

ROBBERS AND OUTLAWS
portraits of two men in "Two burglars" 1860* Photographer Unknown
(Bernard 64#)

ROCKS
covered with barnacles on beach in "Beach and barnacled rock" Gordon
Smith (Rugoff 126#)

eroded sandstone and pebbles in "Eroded sandstone and tide-washed
pebbles at Pebbly Beach"* Dennis Brokaw (Rugoff 36#)
fractured basalt with yellow lichens in "Fractured basalt and lichens"*
Eliot Porter (Rugoff 117#)
a triptych of leaves and pebbles in "Pattern in nature" 1966 Werner Köhler (Time-Life/14 155)

RODEOS

cowboy on horse, roping calf in "Calf roper, Madison Square Garden"
1958* Ernst Haas (Time-Life/8 144)

ROLLER COASTERS

with screaming people in "Pacific Ocean Park, Santa Monica" 1960 C.
Robert Lee (Time-Life/7 27)

ROLLER SKATING

mother holding hand of child trying to roller skate in "Untitled" 1958
David Heath (Time-Life/9 215)
young women on skates in "[Roller skating]" Herman Landshoff (Hall-Duncan 80)

ROOFS

Lincoln Cathedral seen over the rooftops in "Lincoln Cathedral: from
the Castle" 1898* Frederick H. Evans (Time-Life/15 93)
of small city in "Rooftops, Paterson, New Jersey" 1969* George A. Tice
(Time-Life/15 83)

ROPE

man by wheel, spinning rope in "Rope spinning" 1887* Peter Henry Emerson (Bernard 119#)

ROSES

bouquet of plastic flowers on coffin slab in "Rings and roses" 1973 Minor
White (Time-Life/12 44)
in glass of water by wet window in "Roses" 1956 Josef Sudek (Gruber
199#)
large wilting flowers in "Heavy roses, Voulangis, France" 1914 Edward
Steichen (Gruber 56#)
petals and shells and rocks in "Rose petals and shells on beach"* Eliot
Porter (Rugoff 119#)
single rose in glass of water in "Yellow rose and skyscraper" 1950* Irving
Penn (Gruber 166#)

ROWBOATS see BOATS AND BOATING

RUGS

laid out to dry in "Ahmedabad, India" 1965 Henri Cartier-Bresson (Cartier-Bresson 71)
men on floor restoring a Persian rug in "Artisans restoring an old Persian rug, Constantinople, Turkey" 1912 Underwood and Underwood
(Loke 134)

RUNNING

blurred movement of runners in "Malibu Beach runners" 1958* Ernst Haas
(Time-Life/8 146)
girls holding hats as they run through street in "School's out, Antigua"
1968 John Yang (Time-Life/9 27)
motion of man with briefcase in "Man in motion" 1961 Phillip Leonian
(Time-Life/16 127)
multiple images of man in motion in "Man running" 1884-5 Thomas Eakins
(Gernsheim/2 250#)
start and finish of 60-yard dash in "Sixty-yard dash, Madison Square
Garden, New York City" 1956 Ralph Morse (Time-Life/14 217)
woman in bathing suit running along beach in "Untitled" 1934 Martin
Munkacsi (Hall-Duncan 70c)
young, naked man near jagged barbed wire fence in "Untitled" 1972

Crawford Barton (Time-Life/12 27)
RUSSIANS
 Cossack men dancing in "Cossacks dancing, Russia" c. 1896 B.W. Kilburn
 (Loke 67a)
 immigrant woman with children in "A Russian family at Ellis Island" 1905
 Lewis Hines (Sandweiss 105#)
 in traditional dress by a garden in "A Russian couple at a hospice, Jeru-
 salem, Palestine" Underwood and Underwood (Loke 190)
 peasant families outside wooden houses by dirt road in "Russian peasant
 families" c. 1896 B.W. Kilburn (Loke 49)
 workers dancing in poster-filled room "Cafeteria of the workers' building,
 the Hotel Metropol, Moscow" 1954 Henri Cartier-Bresson (Cartier-
 Bresson 61)
RUSSO-JAPANESE WAR
 men in Japanese robes at table in "Russian officers, prisoners of war, at
 lunch in a garden in Matsuyama, Japan" H.C. White (Loke 85c)
 Russian soldiers looking at dead Japanese soldiers in "Russian soldiers
 viewing the bodies of Japanese war dead in a trench, Port Arthur"
 Bert Underwood (Loke 84)
 Russian soldiers milling around battlefield, having been taken prisoner in
 "Russians taken prisoner after the siege at Port Arthur" 1904? Ameri-
 can Stereoscopic Company (Loke 87)
RUSSO-TURKISH WAR, 1853-1856 see CRIMEAN WAR, 1853-1856

S

SAFETY APPLIANCES
 man wearing safety helmet outside mine in "Miner in safety helmet" 1933
 Lewis Hine (Hine 102)
SAILBOATS see BOATS AND BOATING
SAILORS
 Chinese Admiral with his family in "An Admiral of the River Fleet with
 his wife and daughter, China" c. 1901 James Ricalton (Loke 103)
 lying shirtless on floor in "Sailors, Key West" c. 1966* Marie Cosindas
 (Gruber 170#; Time-Life/8 28)
ST. CLOUD
 statue and tree in "St. Cloud" 1926 Eugène Atget (Gruber 83#)
ST. PATRICK'S CATHEDRAL, NEW YORK CITY
 papal procession to altar in "Pope Paul VI entering St. Patrick's Cathe-
 dral, New York City" 1965* Yale Joel (Time-Life/14 224)
ST. TROPHIME, ARLES
 portal in "Portal of St. Trophime, Arles" 1866 William Henry Fox Talbot
 (Gernsheim 354#; Gernsheim/2 317#)
SALMON
 close-swimming school of fish in "Sockeye salmon in Adams River, British
 Columbia"* Steven C. Wilson (Rugoff 23#)
 eggs with alevins in "Salmon eggs with alevins"* Steven C. Wilson (Rug-
 off 26#)
 eggs with newly hatched alevins in "Salmon eggs with newly hatched ale-
 vins still attached to the yolk mass"* Steven C. Wilson (Rugoff 25#)
 female with mouth open, by other salmon near river bottom in "Female
 salmon holding in the current over a redd, or nest, in the river bot-
 tom"* Steven C. Wilson (Rugoff 24#)
SAMARITANS
 men and children posing in "The Samaritans, Palestine" B.W. Kilburn
 (Loke 191c)

SAN FRANCISCO--EARTHQUAKE AND FIRE, 1906
bank vaults gutted by fire in "Bank vaults cracked during the earth-
quake, their contents gutted by fire" 1906 Underwood and Underwood
(Loke 171a)
fire after the quake in "San Francisco fire" 1906 Arnold Genthe (Time-
Life/10 38)
people on hillside watching the city burn after the earthquake in "Watch-
ing the approach of the fire" 1906 Arnold Genthe (Sandweiss 72#)
people sitting outdoors at long wooden tables in "Emergency feeding of
homeless people after the San Francisco earthquake" 1906 Arnold
Genthe (Gernsheim/2 261#)
rubble and demolished cable cars in "Cable cars demolished by the dis-
aster, stored east of Hyde Street on California" 1906 Underwood and
Underwood (Loke 170b)
view down street of rubble in "San Francisco, April 18th, 1906" Arnold
Genthe (Sandweiss 60#)
weeping angel monument destroyed by earthquake in "A monument de-
stroyed by the earthquake" 1906 Underwood and Underwood (Loke
171b)
woman cooking over crack in road in "A woman camping by the roadside"
1906 H.C. White (Loke 170c)
SAN MARCO, ITALY
a section of the piazza in "Piazza San Marco, Venice" c. 1862 Carlo Ponti
(Gernsheim 199#; Gernsheim/2 164#)
SAND DUNES. See also DESERTS
and grasses in "Sand dunes" 1890 B. Gay Wilkinson (Gernsheim 326#;
Gernsheim/2 282#)
and horse-drawn wagon in "Shifting sand dunes" 1867 Timothy H. O'Sul-
livan (Photography 125)
dune with bare branches in "Provincetown dune" Gordon Smith (Rugoff
122#)
eroded by the wind in "Wind erosion, dunes--Oceano" 1936 Edward Weston
(Sandweiss 134#)
in gold from sunrise in "Sunrise on Mesquite Flat Dunes"* David Muench
(Rugoff 69#)
in parallel lines in "Sand dunes near Yuma, Arizona"* Steve Crouch
(Rugoff 75#)
SCHADOGRAPH, 1918
Christian Schad (Gruber 66#; Time-Life/12 196)
SCHOOL BUILDINGS
children posing outside wood-frame schoolhouse in "School, Ash Grove,
Oklahoma" 1916 Lewis Hine (Hine 41)
SCHOOL SHOPS
boys working at lathes in "High school workshop, Rockford, Illinois"
Underwood and Underwood (Loke 217)
SCULPTURE
bas-relief on the Arch of Titus--'Spoils from the Temple in Jerusalem'
in "Bas-relief on the interior of the Arch of Titus, Rome" c. 1865*
Robert Macpherson (Bernard 88#)
bust of Patroclus in "Bust of Patroclus" 1843 William Henry Fox Talbot
(Gruber 15#)
detail on Chartres Cathedral in "Detail of Chartres Cathedral" 1852*
Henri Le Secq (Bernard 20#)
photograph of 'The Rape of the Sabines' in "Florence, 'The Rape of the
Sabines'" 1845-46* Rev. Calvert Jones (Bernard 4#)
statuary on museum pedestals in "Statuary in a museum" 1880's* Photog-
rapher Unknown (Bernard 113#)

SEA LIONS see SEALS (ANIMALS)
SEA URCHINS
 and starfish along rocks in "Sea urchins and starfish"* Eliot Porter (Rug-
 off 118#)
SEALS
 bull elephants fighting on beach in "Bull elephant seals fighting, Living-
 ston Island, South Shetlands" A. Saunders (Guggisberg 83a)
 sea lions on rock in sea spray in "Northern sea lion amidst spray"* Fred
 Bruemmer (Rugoff 19#)
 sea lions playing underwater in "California sea lions"* Ron Church (Rug-
 off 40#)
 Weddell seal and pup on ice in "Weddell seal and pup" H.G. Ponting
 (Guggisberg 79)
SEASHORE
 Indian women standing in surf in "Madras" 1971 Edouard Boubat (Gruber
 392#)
 sandy beach and blue sea in "[Beach scene]"* Franco Fontana (Time-Life/
 12 121)
 waves breaking gently in "[Sea breaking gently on beach]"* Franco Fon-
 tana (Time-Life/12 125)
SEAWEED
 beach filled with sea wrack in "Sea wrack on Harding Beach, Chatham"
 Gordon Smith (Rugoff 123#)
SECRETS
 boys with hot chocolate whispering a secret in "Paul and Eric" 1968
 Arthur Freed (Time-Life/9 144)
SEEDS AND SEA PODS
 plumage of a thistle seed in "Thistle seed and its plume in a California
 valley"* David Cavagnaro (Rugoff 74#)
SEQUOIAS
 Eadweard Muybridge sitting at the base of the U.S. Grant in "U.S.
 Grant, 80 ft. circ., Mariposa Grove" 1872 George Leander Weed,
 Attrib. (Sandweiss 53#)
 fallen tree by stagecoach in "Yosemite Stage by the Fallen Monarch,
 Mariposa Grove" 1894 I.W. Taber (Sandweiss 21#)
 large trunks by pine trees in fog in "The fog-shrouded boles of Sequoia
 in Redwood National Park"* David Muench (Rugoff 28#)
 log cabin by giant Sequoia in "Mariposa Grove of mammoth trees, William
 H. Seward, 85 feet in circumference, 268 feet high" 1872 Eadweard
 Muybridge (Sandweiss 25#)
SEWERAGE
 views of the interior of sewers in "Modern-looking studies of the Paris
 sewers" 1861 Nadar (Tournachon 32)
SEWING
 family sewing and ironing in small room in "Finishing clothing, tenement
 homework, New York City" 1906 Lewis Hine (Hine 32)
 men and women around small table in small room in "New York City sweat-
 shop" 1908 Lewis Hine (Hine 28)
 men at sewing machines in sweatshop in "Old-time sweatshop, New York
 City" 1912 Lewis Hine (Hine 66)
 men ironing and women sewing jackets and vests at long table in "New
 York sweatshop" 1908 Lewis Hine (Hine 53)
 zippers, seam binding and thimble on slate in "Notions on slate" 1968*
 Peter Scolamiero (Time-Life/13 39)
SHADOWS
 of man, and baby on grass in "Season's Greetings" 1963 Ken Josephson
 (Time-Life/16 183)

of tree extending from foreground to fort in background in "Shadow of a
tree" 1963 René Burri (Time-Life/16 182)
SHAVING
poor man shaving by canvas-covered truck in "Shaving on the road,
California" 1937 Dorothea Lange (Time-Life/10 128)
SHEEP
being herded by shepherd in "Shepherd, Switzerland" c. 1960 Robert
Gnant (Time-Life/14 28)
Bighorn sheep on rocks in "Bighorn sheep in Jasper National Park"*
Kojo Tanaka (Rugoff 49#)
flock at dusk in "Pastoral moonlight" Edward Steichen (Green 83)
SHEEPDOGS
standing on wood pile in "Sheepdog" 1964* Nina Leen (Time-Life/8 120)
SHELLS
and rose petals and rocks in "Rose petals and shells on beach"* Eliot
Porter (Rugoff 119#)
close view of a shell in "Shell" 1927 Edward Weston (Gruber 81#)
lined up on shelf in "Shells and fossils" 1839 Louis Jacques Mande Da-
guerre (Photography 19)
SHIPS
crowded with immigrants in "The steerage" 1907 Alfred Stieglitz (Gern-
sheim 341#; Gernsheim/2 306#; Green 307; Gruber 61#; Hine 119; Sand-
weiss 74#; Time-Life/12 37)
deck of an ocean liner in "The Queen Mary" c. 1940 Walker Evans (Sand-
weiss 118#)
a restored sailing ship at port in "[Mystic Seaport, Connecticut]" Evelyn
Hofer (Time-Life/10 146)
sailing ship at water's edge, with anchor up in "The Jane Tudor" David
Johnson (Photography 100)
sailing ship in dry dock in "A vessel Boston dry dock" c. 1850 South-
worth & Hawes (Gernsheim/2 48#)
sailing ship in harbor in "Harbour scene" c. 1852 Henri Le Secq (Gern-
sheim/2 90#)
sailing ship in icy water in "The Terra Nova in the Antarctic" 1912 Her-
bert Ponting (Gernsheim/2 268#)
SHIPWRECKS
sinking ship after collision in "H.M.S. Victoria sinking after collision with
H.M.S. Camperdown off Tripoli" 1893 Staff-Surgeon Collot (Gernsheim
319#; Gernsheim/2 270#)
wrecked ship that had run aground on beach in "The wreck of the Vis-
cata" 1868 Carleton E. Watkins (Sandweiss 1#)
SHOES
cobbler's shop advertisement photographed as hanging from street lamp
in "Untitled" 1965 Ray K. Metzker (Time-Life/12 216)
hanging across store window in "Balcon, 17 rue du Petit Pont" 1912-13
Eugène Atget (Photography 234)
man shining other man's shoe in posed picture in "Shoeshine and pick-
pocket" 1870's* Giorgio Sommer (Bernard 116#)
of bright colored paper in "Disposable paper shoes" 1967* Hiro (Time-
Life/7 226)
of children standing around dead rabbit in "First death" 1965 George
W. Gardner (Time-Life/9 80)
ski boot photographed against sky in "Ski boot" 1967 Silano (Time-Life/
13 135)
SHOP WINDOWS see SHOW WINDOWS
SHORTHORN SCULPIN
at ocean bottom in "Shorthorn sculpin in a cove at Gloucester, Massachu-

setts"* Douglas Faulkner (Rugoff 127#)
SHOVELS
 men with nets over heads using shovel and pan in "Placer mining near
 the Yukon River, Alaska" Photographer Unknown (Loke 142c)
SHOW WINDOWS
 corsets on display in "Corset shop, Paris" c. 1908 Eugène Atget (Gern-
 sheim/2 266#)
 female mannequins in clothing store window in "Avenue des Gobelins"
 1925 Eugène Atget (Gruber 82#)
 luggage piled up outside pawnbroker's shop in "Pawnbroker's shop in a
 disreputable district, Nashville" 1910 Lewis Hine (Hine 83)
 man and woman looking at paintings in window in "The Windowshopper"
 Robert Doisneau (Gruber 397#)
THE SICK
 man lying in bed in "Man with tuberculosis, Chicago" 1910 Lewis Hine
 (Hine 89)
SICKLE GRINDER
 man in apron holding a sickle in "Samuel Renshaw, sickle grinder" 1854
 or 1857* Photographer Unknown (Bernard 46#)
SIERRA NEVADA
 mountains golden from sunrise in "Sunrise above Lake Ediza in the Minaret
 Wilderness"* David Cavagnaro (Rugoff 48#)
 trees in autumn colors at base of mountains in "Willows in autumn colors
 at about 8700 feet up in the Minaret Wilderness, California"* David
 Cavagnaro (Rugoff 43#)
SIGNS AND SIGNBOARDS
 billboards on brick wall in "Billboard--Minstrel show" 1936 Walker Evans
 (Sandweiss 106#)
 hand-painted signs on storefront in "Storefront and signs, Beaufort,
 South Carolina" 1936 Walker Evans (Photography 319)
 Nehi advertisement on side of wood frame house in "Nehi sign on A. Es-
 posito's Grocery" 1929 Ralph Steiner (Sandweiss 97#)
 on abandoned, boarded-up building in "For rent" 1973* Tomas Sennett
 (Time-Life/12 20)
 sandwich board carried by a bearded old man in "The sandwich man"
 Paul Strand (Green 320)
 sign painter painting building in "Poster painter, Times Square" 1952*
 Ernst Haas (Time-Life/8 137)
SILVERWARE. See also FORKS
 on colored blocks in "Silverware" 1968* Peter Turner (Time-Life/8 43)
SINKS
 baby taking bath in kitchen sink in "Baby in the sink" 1970 Ron Mesaros
 (Time-Life/9 120)
SITAR
 seated man playing sitar in "Ravi Shankar" Yousuf Karsh (Karsh 175)
 young boy playing sitar in "Siamese boy musician" c. 1875* Photographer
 Unknown (Bernard 102#)
SKIERS AND SKIING
 on chair lifts in "PepsiCo ski meet" 1973* Burt Glinn (Time-Life/12 64)
 racer in motion, squatting over skiis in "Billy Kidd at Val Gardena"
 1970* Neil Leifer (Time-Life/16 146)
 racing down slope in "[A snow-level view of a skier flashing down a
 slope]" George Silk (Time-Life/7 202)
SKUAS
 adult bird feeding chick in "Antarctic skua feeding its chick" H.G.
 Ponting (Guggisberg 81)
SKULLS

color-enhanced interior of the skull in "Color-enhanced x-ray of a human
skull" 1968* Don Ross (Time-Life/7 57)
human skull near crucifix and hourglass in "Memento Mori" after 1854*
Duboscq-Soleil (Bernard 35#)
SKYSCRAPERS
and a crane in "[Buildings and crane]" Yale Joel (Time-Life/12 177)
and elevated railroad tracks in "Corner of 38th Street, New York" 1952*
Ernst Haas (Gruber 154#)
at night in "Skyscrapers at night" 1925* Edward Steichen (Bernard 181#)
being constructed above small houses in "Old & new New York" Alfred
Stieglitz (Green 313)
by building with circular terraces in "Murray Hill Hotel Spiral" 1935
Berenice Abbott (Gruber 98#)
from a balcony in "N.Y.C., Changing New York" 1937 Berenice Abbott
(Gruber 350#)
half in shadows in "Skyscrapers" 1920 Francis Bruguière (Gruber 351#)
men on roof finishing construction in "Time & Life Building" 1961 Yale
Joel (Time-Life/16 71)
men working on top of Empire State Building before its completion in
"Empire State Building, New York City" 1930-31 Lewis Hine (Hine 107)
reflected in windows in "Window reflections" 1954* Ernst Haas (Time-Life/
8 134)
reflecting images of other skyscrapers in "Reflections" 1965* Ernst Haas
(Time-Life/8 133)
superimposed with man's face in "[Young man and skyscrapers]" Yale
Joel (Time-Life/12 183)
SLAVERY IN THE U.S.
men standing by brick cabins in "The slave quarters of the Hermitage
Plantation near Savannah, Georgia" Underwood and Underwood (Loke
73)
SLEEP
couple on sand below woman looking through binoculars in "Untitled"
1969 Ray K. Metzker (Time-Life/11 166)
couple with arms around each other, in train in "Rumania" 1975 Henri
Cartier-Bresson (Cartier-Bresson 83)
infant sleeping on wooden board in "Bangkok, Thailand" 1969* Bernard
Wolf (Time-Life/9 196)
man asleep in newspapers, below a crowd in "Trafalgar Square on the
day George VI was crowned, London" 1938 Henri Cartier-Bresson
(Cartier-Bresson 53)
man asleep on bench on Brooklyn Bridge in "Man sleeping on Brooklyn
Bridge" c. 1929* Walker Evans (Bernard 192#)
man asleep on grass in "Marseilles" 1932 Henri Cartier-Bresson (Cartier-
Bresson 13)
man by doorway of store in "Man asleep in doorway" c. 1910 Lewis Hine
(Hine 82)
man resting head on arm in "Barrio Chino, Barcelona, Spain" 1938 Henri
Cartier-Bresson (Cartier-Bresson 29)
man sleeping in chair with newspaper in "Commerson with his paper 'Le
Tintamarre'" Nadar (Tournachon 4)
men lying on wooden steps in "Dock workers enjoying siesta, New York
City" c. 1922 Lewis Hine (Hine 51)
nude woman by large window in "Nude in Sandy's window" 1956 Wynn
Bullock (Bullock 39)
nude woman lying on rug in "A good reputation" 1938 Manuel Alvarez
Bravo (Gruber 233#)
nude woman lying on rumpled sheets in "Untitled" 1855 Franz Hanfstaengl

(Gruber 234#)
person lying on grass near series of doors in "Trieste, Italy" 1933 Henri
Cartier-Bresson (Cartier-Bresson 41)
poor men on porch in "Street Arabs in sleeping quarters at night" 1888
Jacob A. Riis (Photography 157a)
woman on couch and woman in pool in "[Woman on zebra-striped couch]"
1973* Helmut Newton (Hall-Duncan 200)
SLEIGHS
horse-drawn sleighs at water station in winter in "Water station in Mos-
cow, Russia" c. 1896 B.W. Kilburn (Loke 72)
SLIDES
blur of child coming down slide in "Sliding board" 1970 Charles Traub
(Time-Life/9 150)
SLOTHS
close-up of face in "Portrait of a sloth" August Brückner (Guggisberg
114)
SMOKING. See also TOBACCO PIPES
bearded man with cigar in "Edward Steichen" 1967 Yousuf Karsh (Karsh
187)
cigarette protruding from under brim of hat in "Magazine illustration"
1970* Hans Feurer (Time-Life/12 17)
hands of man holding cigarette in "David Alfaro Siqueiros" 1966 Farrell
Grehan (Time-Life/7 86)
lit cigarette and matches in "Cigarette" 1929 Jaroslav Rössler (Gruber
431#)
man with a cigar in "Che Guevara" 1963 René Burri (Gruber 313#)
man with cigarette in "Jean-Paul Sartre" Philippe Halsman (Halsman 90)
man with cigarette in "John Steinbeck" 1954 Yousuf Karsh (Karsh 191)
man with cigarette by typewriter in "Tennessee Williams" 1956 Yousuf
Karsh (Karsh 203)
man with long fingernails and hair in curlers in "A young man in curlers
at home in West 20th Street, New York" 1956 Diane Arbus (Gruber
123#)
men with pipes, holding mugs in "Three men in a pub" or "Outside the
pub, London" c. 1876 John Thomson (Gernsheim/2 257#; Time-Life/14
99a)
model in large hat holding cigarette in "Girl with tobacco on the tongue"
1950 Irving Penn (Hall-Duncan 152)
three women in bathing suits lighting cigarettes on the beach in "Three
women, Atlantic City, New Jersey" Phil Brigandi (Loke 214)
woman holding cigarette in front of face, with her gloved hand in "Unti-
tled" 1974 Ralph Gibson (Gruber 304#)
woman in checkered dress, smoking in "Harlequin dress" 1950 Irving
Penn (Hall-Duncan 153)
woman in floral hat smoking in "[Woman smoking]" 1956 William Klein
(Hall-Duncan 176)
SNAILS
smooth shell of snail in "Smooth brown turban kelp snail"* Ron Church
(Rugoff 41#)
SNAKES
cottonmouth on rotted log in "Cottonmouth" Jack Dermid (Rugoff 143#)
wrapped around shoulders of young woman snake charmer in "Mlle Paula"
Nadar (Tournachon 257d)
SNOW
bison walking through snow in storm in "Bison in a storm"* Charles
Steinhacker (Rugoff 56#)
children covered by straw mats, walking in "Snowcountries children" 1956

Hiroshi Hamaya (Gruber 386#)
a few weeds above the snow in "Weeds in snow" 1943 Harry Callahan
(Time-Life/12 154)
looking down on snow-covered street in "New York snowstorm" 1968*
Norman Rothschild (Time-Life/8 98)
men in line on icy pass to camp in valley in "The Scales, Chikoot Pass,
Alaska" 1897 Eric A. Hegg (Time-Life/15 57)
small figures of mountain climbers on mountain ridge in "Climbers in the
snow at 11,500 feet, the Doldenhorn, Switzerland" 1960 Bradford
Washburn (Time-Life/16 11)
SNOWMOBILES
man and woman by snowmobile in "Snowmobile" 1970* Pohlman Studios
(Time-Life/13 69)
SOCCER
goalkeeper on ground with ball in air in "Goalkeeper" 1926* Martin Munk-
acsi (Bernard 184#)
player walking by goal cage in "Soccer player" 1966* Jay Maisel (Time-
Life/8 32)
SOLDIERS
African men marching in line in "Soldiers" 1968 Romano Cagnoni (Time-Life/
11 191)
African Rifles inspection in "Princess Margaret inspecting King's African
Rifles, Mauritius" 1956 Mark Kauffman (Time-Life/7 87)
American men in overcoats on board ship in "American soldiers going
home in a transport vessel" Underwood and Underwood (Loke 207)
American troops marching off to Mexican War in "Exeter, New Hampshire,
Volunteers" c. 1846 Photographer Unknown (Sandweiss 4#)
Americans in formation, wearing gas masks in "American soldiers training
with gas masks, Fort Dix, New Jersey" Underwood and Underwood
(Loke 205)
Americans marching from the Arch of Triumph in "The U.S. 28th Division
marching down the Champs-Elysées" 1944 Bob Landry (Time-Life/7
21a)
Belgian infantrymen in uniform in field in "Belgian infantrymen" 1914
Underwood and Underwood (Loke 199)
British men crossing river in "British infantry fording the Vet River in
its advance on Pretoria" 1900 Underwood and Underwood (Loke 44c)
Chinese officer and his bodyguards in "A Chinese military officer and
his bodyguards, China" Photographer Unknown (Loke 93)
Crimean War soldiers with rifles in "Crimean Braves" Pub. 1856* Joseph
Cundall and Robert Howlett (Bernard 34#)
Englishman's face peering over edge of armored car in "British soldier in
Northern Ireland" 1972* Michael Abramson (Time-Life/12 18)
Frenchmen in rows on bicycles in "A company of French military cyclists"
Keystone View Company (Loke 201a)
Frenchmen seated on ground in "French troops resting before an attack,
Verdun, France" 1916 Underwood and Underwood (Loke 202a)
Frenchmen washing in stream in "French soldiers in the field" c. 1915*
Jean Tournassou (Time-Life/8 74)
German men sitting with guitar in night club in "The German prisoners'
club room, Brest, France" Photographer Unknown (Loke 200)
German Nazis in rows in town square in "The Wehrmacht at the Feld-
herrnhall, Munich" 1935* Photographer Unknown (Bernard 199#)
Germans sitting on rubble of building in "German soldiers along the ruins
of Messines, near Ypres, Belgium" Photographer Unknown (Loke
203d)

Indians in dress uniforms by tents in "Indian troops encamped on the grounds of Hampton Court Palace for the coronation" 1902? Underwood and Underwood (Loke 81d)
Mounted Indian warriors with metal breastplates in "Mounted warriors with chain armor and metal breastplates, Delhi, India" Photographer Unknown (Loke 90)
Russian soldiers looking at bodies of dead Japanese soldiers in "Russian soldiers viewing the bodies of Japanese war dead in a trench, Port Arthur" Bert Underwood (Loke 84)
Russian woman with rifle behind sandbags in "The only woman soldier in the Russian army, killed here a few hours after the stereograph was taken" Photographer Unknown (Loke 88a)
Russians milling around battlefield, having been taken prisoner in "Russians taken prisoner after the siege at Port Arthur" 1904? American Stereoscopic Company (Loke 87)
Spanish soldiers with rifles in "Spanish village" 1951 W. Eugene Smith (Photography 292)
Turkish military officers in uniform in "Turkish military officers, Jerusalem" 1899 B.W. Kilburn (Loke 47)
Vietnamese barefooted men near boat landing in "Vietnamese soldiers near a boat landing in Saigon, Cochin, China" James Ricalton (Loke 92d)
woman kissing soldier by train in "Farewell at the train station" Photographer Unknown (Loke 206a)
SOUTH AFRICAN WAR, 1899-1902
armed farmers and boys beside train in "Boer farmers and boys on their way to the front, South Africa" B.W. Kilburn (Loke 44a)
calvary at rest in "Lord Robert's army, 84th Battery and Balloon Corps, Boer War" 1901 Photographer Unknown (Gernsheim 320#)
doctor operating on soldier in field, alongside wagon in "A British doctor operating on a wounded soldier, Boer War" B.W. Kilburn (Loke 44d)
infantry crossing river in "British infantry fording the Vet River in its advance on Pretoria" 1900 Underwood and Underwood (Loke 44c)
SPANISH-AMERICAN WAR, 1898 see U.S.--HISTORY--WAR OF 1898
SPANISH CIVIL WAR, 1936-1939
soldiers fighting in "This is War!" Robert Capa (Time-Life/10 66-67)
SPANISH MOSS
hanging from trees in "Buen-Ventura, Savannah, Georgia" 1865 George N. Barnard (Gruber 262#)
hanging over green bayou in "Duckweed covers the water and Spanish moss hangs from the trees in a Louisiana bayou near the Mississippi River"* Thase Daniel (Rugoff 91#)
SPEECHES, ADDRESSES, ETC.
at presidential inauguration in "Pres. Theodore Roosevelt's Inaugural Address outside the Capitol, Washington" 1905 Photographer Unknown (Gernsheim 321#; Gernsheim/2 276#)
woman on platform making a speech in "Miss Christabel Pankhurst addressing a Suffragette meeting" 1909 Mrs. Albert Broom (Gernsheim 323#)
SPHINX
and pyramid in distance in "The Sphinx and Pyramid of Cheops in distance" 1865 Francis Beato (Gruber 27#)
SPIDERS AND SPIDERWEBS
on surface of pond near leaf in "Wolf spiders riding the surface film of a pond" Jack Dermid (Rugoff 145#)
on web, feeding on prey in "Female banded garden spider feeding on prey"* David Cavagnaro (Rugoff 72#)
web of an orb weaver in "Web of an orb weaver spider in a California

valley"* David Cavagnaro (Rugoff 71#)
SPINNING
 Indian woman working at spinning wheel in "A woman at the spinning
 wheel, India" B.W. Kilburn (Loke 135b)
 Japanese woman spinning silk in "A woman spinning silk from cocoons,
 Japan" Photographer Unknown (Loke 123)
 man reading near spinning wheel in "Gandhi" 1946 Margaret Bourke-White
 (Time-Life/10 29c)
 man seated on floor near spinning wheel in "Mahatma Gandhi, spinning"
 1946 Margaret Bourke-White (Gruber 297#)
 woman spinning thread in "The thread maker" 1951 W. Eugene Smith
 (Time-Life/10 79d)
SPINY BOXFISH
 puffed up in "Spiny boxfish in White Rock Bank, Upper Key Largo"*
 Douglas Faulkner (Rugoff 130#)
SPOONBILLS
 and egrets wading in "Egrets and spoonbills"* Patricia Caulfield (Rugoff
 166#)
SQUIRRELS
 on hind legs in "Belding ground squirrel, near Lake Ediza, over 9000
 feet up in the Minaret Wilderness"* David Cavagnaro (Rugoff 46#)
 on hind legs, eating with cheeks puffed in "Golden-mantled squirrel in
 Jasper National Park"* Kojo Tanaka (Rugoff 51#)
STAIRWAYS
 boys running down stairs in "Staircase at the French Pavillion, Expo '67,
 Montreal" 1967 Jack Schrier (Time-Life/11 133)
 circular metal stairs on metal structure in "Detail of the Eiffel Tower"
 1889* N.D. (Bernard 125#)
 a circular stairway of stone in "Lincoln Cathedral: a turret stairway"
 1895 Frederick H. Evans (Photography 178)
 from quiet lake near palace in "Steps to the lake at Capricho Palace near
 Guadalajara" 1855 Charles Clifford (Gernsheim 196#)
 girl climbing worn, stone staircase between houses in "Little Greek girl
 mounting a staircase" c. 1963 Henri Cartier-Bresson (Time-Life/7 213)
 heart-shaped, with boy in sailor suit in "Jerome Buttrick" 1965* Toni
 Frissell (Time-Life/9 63)
 intersecting stone steps in "A sea of steps, Wells Cathedral" 1903 Fred-
 erick H. Evans (Gernsheim 333#; Gernsheim/2 288#; Gruber 380#;
 Time-Life/11 198)
 man standing under wooden staircase of old house in "Rooming house in
 Los Angeles" 1955 Robert Frank (Time-Life/11 208)
 of house, beyond open front door in "Open door" 1945 Paul Strand (Pho-
 tography 296)
 of stone, by stone columns in "Ancient crypt cellars in Provins, France"
 1910 Frederick H. Evans (Gruber 57#)
 old man walking up cement steps in "Old man on steps" 1973 Eva Rubin-
 stein (Gruber 359#)
 spiral staircase seemingly in midair in "Spiral staircase, Marseille" c.
 1928 Herbert Bayer (Photography 247)
 wooden steps of house in alley in "Baxter Street Alley in Mulberry Bend,
 New York" 1888 Jacob A. Riis (Photography 154)
STARFISH
 and sea urchins among rocks in "Sea urchins and starfish"* Eliot Porter
 (Rugoff 118#)
STEAMBOATS. See also BOATS AND BOATING; SHIPS
 at the docks, with view of city in "Cincinnati waterfront" 1848 Southgate
 & Hawes (Time-Life/14 69d)

lake steamers at dock in winter in "Lake steamers at winter moorings, Switzerland" c. 1865* Adolphe Braun (Bernard 83#)

STEEL INDUSTRY AND TRADE

Andrew Carnegie's Homestead Steel Plant seen from a hill in "View of Homestead Steel Works, Pennsylvania" H.C. White (Loke 27)

clapboard homes near steel mill in "Homestead workers' homes overlooking the steel plant" H.C. White (Loke 30)

rows of men waiting to be paid in "Homestead workers waiting to be paid" H.C. White (Loke 28c)

smokestacks of steel mill beyond small cemetery in "Graveyard, houses, and steel mill, Bethlehem, Pennsylvania, November 1935" Walker Evans (Photography 268)

tall towers of the plant in "Armco Steel, Ohio" 1922 Edward Weston (Photography 226)

STILL LIFE

basket and other objects in "Still life" c. 1921 Ira Martin (Sandweiss 64#)

baskets of fruit including a pineapple in "A fruit piece" c. 1844 William Henry Fox Talbot (Gruber 202#)

cosmetics, lipsticks, and other containers in "Cosmetics containers" 1968* Henry Sandbank (Time-Life/13 38)

bowl of fruit in "Still life" c. 1850 Henri Le Secq (Time-Life/7 185)

bowl of fruit in "Still life" 1908 Heinrich Kuehn (Photography 195)

bunches of grapes in "Still life" c. 1860* Roger Fenton (Bernard 70#)

dead deer, wild fowl and guns in "Still life with deer and wild fowl" c. 1865* Adolphe Braun (Bernard 85#)

eggs, grapes, napkin and other objects in "New York still life with food" 1947 Irving Penn (Time-Life/13 199)

fruit on plate, and glassware in "Still life with oranges" 1903 Heinrich Kühn (Gruber 203#)

fruit on plates in "Still life" 1899 or 1900* Auguste and Louis Lumière (Bernard 144#)

fruits and decanter of wine in "Still life" c. 1858 Roger Fenton (Gernsheim 130#; Gernsheim/2 112#)

grapes, other fruit and flowers in "Still life (Fruit and flowers)" c. 1860 Roger Fenton (Gruber 200#)

hydrangea in glass of water in "Still life" Baron Adolphe de Meyer (Green 241; Sandweiss 59#)

loaf of bread and bottle of wine in "Bread and wine" 1953 Bert Stern (Time-Life/13 226)

objects with wine bottle in "Still life with wine bottle" 1945 Marta Hoepffner (Gruber 190#)

piles of peeled and unpeeled fruit in "Still life" Victor Guidalevitch (Gruber 201#)

plaster casts of cherubs in earliest daguerreotype known to exist in "Still life in the artist's studio" 1837 Louis Jacques Mande Daguerre (Time-Life/7 170)

round plastic lamp suspended over plastic table in "Molded plastic furniture" 1969* Aldo Ballo (Time-Life/13 213)

sculptor's tools and fish in "Still life with fish" 1958 Otto Steinert (Gruber 188#)

several apples in "Still life" 1850's* Henri Le Secq (Bernard 40#)

speckle-backed pike with lemon and parsley on newspaper in "Still life with fish" 1965 B. Trutmann (Time-Life/13 225)

spoon and earthenware coffeepot and jug in "Earthenware utensils with a spoon" 1967 Henry Sandbank (Time-Life/13 212)

table with eggs, fern and painting in "Still life" 1970* Nob Fukuda (Time-Life/13 37)

tomato halves near bell jar filled with whole ones in "Still life with toma-
toes" 1962* Milton Halberstadt (Time-Life/13 36)
vase of flowers in "Still life" c. 1850 Henri Le Secq (Time-Life/7 184)
vase of flowers in "Still life" c. 1900* Frederic E. Ives (Time-Life/8 57)
wineglass and apple on table in "Wineglass and apple" 1896* Josef Watzek
(Gruber 165#)
with dead rabbit and other objects in "Still life" c. 1855 Hugh W. Diamond
(Photography 97; Time-Life/7 183)
zipper, seam binding and thimble on slate in "Notions on slate" 1968*
Peter Scolamiero (Time-Life/13 39)
STONECUTTING
man at work on stone sculpture in "Stonemasons at work on the Paris
Opera" Pub. 1876* Durandelle (Bernard 107#)
STONEHENGE
close view of stones, with flat rock in foreground in "Stonehenge" 1967
Paul Caponigro (Gruber 272#)
distant view of stones and clouds in "Stonehenge" 1947 Bill Brandt (Gru-
ber 270#)
distant view of stones, with dead tree in foreground in "Untitled" 1971
Jerry Uelsmann (Gruber 271#)
STORES
man in apron by sacks of beans in "[Aproned man in delicatessen]"*
Evelyn Hofer (Time-Life/8 114)
men in store filled with sombreros in "A sombrero store, Mexico City,
Mexico" 1903 Underwood and Underwood (Loke 124c)
STORKS
adult feeding its young in "[Adult stork feeding its young]" 1884 Otto-
mar Anschütz (Guggisberg 17b)
adult near young in nest in "Black stork at nest" Horst Siewert (Guggis-
berg 111)
leaving nest in "Stork leaving nest" 1884 Ottomar Anschütz (Gernsheim
306#; Gernsheim/2 252#)
a whale-headed stork in grasses in "Abu Markub, 'father of the shoe'--
a whale-headed stork" Bengt Berg (Guggisberg 88)
STORMS. See also DUST STORMS; RAIN AND RAINFALL; SNOW
dark clouds over lake in "The approaching storm" 1887 Alfred Stieglitz
(Photography 168a)
dark clouds over windmill in "Storm near Santa Fe, New Mexico" 1965
Liliane De Cock (Sandweiss 137#)
grasses and sandhills in "Storm over the sandhills of central Nebraska"*
Patricia Caulfield (Rugoff 102#)
heavy, dark clouds over landscape in "Storm from La Bajada Hill, New
Mexico" 1946 Laura Gilpin (Sandweiss 135#)
STOVES
kitchen with wood burning stove in "Christmas, Sandy's (black cat on
stove)" 1956 Wynn Bullock (Bullock 79)
STREAMS
clear water with grass in "Woodland stream, Pittsburgh, New Hampshire"
1965* Eliot Porter (Gruber 144#)
fawn crossing trout-filled stream in "Fawn and trout, Montana" 1961*
George Silk (Time-Life/14 227)
grainy dry bed in "Dry stream bed" 1967 Minor White (Time-Life/11
46)
STREETCARS
along cobblestone street in "Wenzel Square, Prague" 1969 Gerd Sander
(Time-Life/11 167b)
horses pulling streetcar in "The Terminal" c. 1892 Alfred Stieglitz (Gern-

sheim 340#; Gernsheim/2 307#; Green 312; Gruber 407#; Photography
169; Time-Life/7 19)
STREETS
children playing on cobblestone street in "Children on street, Lower East
Side, New York City" Lewis Hine (Hine 94)
deserted streets and buildings in "[Deserted city street]" Wolf von dem
Bussche (Time-Life/11 75)
in rain in "A wet day, Paris" 1897 Alfred Stieglitz (Gruber 47#)
rear door of parked hearse in "London street" 1951 Robert Frank (Time-
Life/11 213)
small town in "Wind Street in Swansea, Wales" 1845 William Henry Fox
Talbot (Time-Life/14 75)
street corner of city in "El Paso Street, El Paso, Texas" 1975* Stephen
Shore (Gruber 159#)
view of tree-lined street from upper window in "Avenue des Capucines"
c. 1843 William Henry Fox Talbot (Gruber 16#)
woman riding in pony cart in "[Mme. Beaurepaire in her pony cart]" 1944
Lee Miller (Hall-Duncan 123)
young Black children on street corner in "Pride Street" W. Eugene Smith
(Gruber 387#)
STUDENTS
class of student artists in "Tokyo fine-arts class" Underwood and Under-
wood (Loke 116a)
young boy reading from book with teacher in "A schoolmaster and his
pupil, Monaghan County, Ireland" Underwood and Underwood (Loke
151)
SUBWAYS
mother and daughter in subway car in "[Untitled, Subway series]" 1938
Walker Evans (Sandweiss 124#)
old man with white beard leaning on railing of station staircase in "New
York City subway" 1965 Gary Renaud (Time-Life/14 193)
SUMMER. See also BEACHES; OCEAN WAVES
Black boy covered by water from fountain in "Fountainhead" 1969 George
Krause (Time-Life/11 224)
boy jumping off wooden diving board into lake in "Boy on diving board"
1964 Bill Binzen (Time-Life/9 154)
child in puddle on sidewalk in "Child lying in water" 1968 Raimondo Borea
(Time-Life/9 156)
couple on beach blanket in "Coney Island, New York" 1946 Henri Cartier-
Bresson (Photography 287)
group of people in swim suits photographed on beach in "Cherry Beach,
Toronto" 1912 William James (Time-Life/7 11)
man and woman in swimming suits, on beach in "Two-piece swimming suit"
1930 George Hoyningen-Huene (Hall-Duncan 61)
men and women lying on beach near low wall in "The sun bathers, Cali-
fornia" 1964 Bruce Davidson (Time-Life/11 137)
naked boys leaning on beached boat in "Natives of these isles" 1885
Frank M. Sutcliffe (Time-Life/9 69)
people on the beach in "Atlantic City beach, New Jersey" 1891 B.W.
Kilburn (Loke 67d)
woman in bathing suit running along beach in "Untitled" 1934 Martin
Munkacsi (Hall-Duncan 70c)
woman in bikini lying on pavement in "[Taking the sun in a bikini]" 1947
Toni Frissell (Hall-Duncan 75)
woman sunbathing in bikini in "Bikini" 1946 Toni Frissell (Time-Life/13
120)
women in bathing suits, lighting cigarettes on beach in "Three women,

Atlantic City, New Jersey" Phil Brigandi (Loke 214)
women in bathing suits playing and exercising on beach in "One page
from the album" 1921* Jacques Henri Lartigue (Gruber 174#)
SUMO WRESTLERS
large man standing in garden with small child in "A sumo wrestler and
a child, Japan" James Ricalton (Loke 180b)
SUN
illuminating skyscrapers in "New York" 1969* Jay Maisel (Time-Life/8 39)
SUNFLOWERS
rear view of a sunflower and stem in "Sunflower" 1965 Paul Caponigro
(Time-Life/13 223)
SUNI
woman in hat holding a small animal in "A woman of Zanzibar holding a
suni" Underwood and Underwood (Loke 182c)
SUNRISE
highlighting golden sand dune in "Sunrise on Mesquite Flat Dunes"*
David Muench (Rugoff 69#)
making mountains golden in "Sunrise above Lake Ediza in the Minaret
Wilderness"* David Cavagnaro (Rugoff 48#)
over mountain pool in "Sunrise over Highland Pool, Mount Evans, Colo-
rado" 1969* Harald Sund (Time-Life/14 21)
over valley in "View up from Barton Creek Valley in the Edwards Pla-
teau"* Jim Bones (Rugoff 90#)
trees at daybreak in "Landscape" 1969* Terence Naysmith (Time-Life/11
58)
SUNSETS
and flock of birds in "New York (Sunset silhouette)" 1952* Ernst Haas
(Gruber 155#)
and the New York City skyline from north of Central Park in "Temple
of Dendur, the Metropolitan Museum of Art, New York" 1978* Henry
Groskinsky (Time-Life/14 163)
leopard in tree, in silhouette in "Leopard at sunset" 1965* John Dominis
(Time-Life/7 128)
over mountains in "Sunset, Rocky Mountain National Park, Colorado"
1969* Harald Sund (Time-Life/14 19)
over water in "Big Sur sunset" 1957 Wynn Bullock (Bullock 23)
purple sky above houses in "Evening" 1969* Harald Sund (Time-Life/8
37)
reflected off the Grand Canyon in "Sunset over the Grand Canyon as
seen from Bright Angel Point looking toward South Rim and San Fran-
cisco Peaks"* David Muench (Rugoff 62#)
silhouette of girl in redness of twilight in "End of the day--Trinidad"
1967* Bill Binzen (Time-Life/16 198)
SURF see OCEAN WAVES
SURFING
men on surfboards in "Surfers" 1963* George Silk (Time-Life/16 151)
men surfing across large waves in "Hawaiian surf" 1968* Neil Leifer
(Time-Life/16 150)
SURGERY. See also PHYSICIANS
doctor operating on soldier in field, alongside wagon in "A British doctor
operating on a wounded soldier, Boer War" B.W. Kilburn (Loke 44d)
group of doctors around patient on table in "Operation by Sir Alexander
Ogstone" c. 1883 George Washington Wilson (Gernsheim 316#; Gern-
sheim/2 275#)
incision being made in woman's eye in "Linear incision of the eye" Pub.
1871* Dr. A. de Montmeja (Bernard 95#)
a soldier's leg being amputated in a Japanese hospital in "The shattered

leg of a soldier about to be amputated in the operating room of the
Military Reserve Hospital in Hiroshima, Japan" c. 1904? H.C. White
(Loke 88c)

SWAMPS see MARSHES

SWEATSHOPS
 men and girls sewing garments in "Tailor's workshop employing sweated
 labour, New York" 1888 Jacob Riis (Gernsheim/2 258#)
 men and women sewing around small table in small room in "New York
 City sweatshop" 1908 Lewis Hine (Hine 28)
 men at sewing machines in "Old-time sweatshop, New York City" 1912
 Lewis Hine (Hine 66)
 men ironing and women sewing jackets and vests in "New York City
 sweatshop" 1908 Lewis Hine (Hine 53)

SWIMMERS AND SWIMMING
 girl jumping off jetty into water in "[Girl jumping off jetty into water]"
 Shin Sugino (Time-Life/12 131)

SWINGS AND SWINGING
 boy on porch railing near swing in "Long summer afternoon" 1967 Danny
 Lyon (Time-Life/9 32)
 boy swinging on swing in "Inertia" 1968 Egons Spuris (Time-Life/11 197)
 small child swinging on door knobs in "A door is for swinging" 1965 Ken
 Josephson (Time-Life/9 17)
 young children on swings and tricycles in "[A day care center]" Leonard
 McCombe (Time-Life/10 174)
 young girl on swing in "The swing" 1966 Suzanne Szasz (Time-Life/9 151)

T

TABLES
 empty white tables on carpet in "Untitled" 1972 Gary Stewart (Time-Life/
 12 29)
 man with elbow on stained white tablecloth in "Man at table" 1977* Jo Ann
 Callis (Gruber 168#)
 photogenic drawing of a table set with dishes in "The breakfast table"
 1840 William Henry Fox Talbot (Photography 26)
 small table with cloth, and three chairs in "[Three garden chairs around
 small covered table]" Shin Sugino (Time-Life/12 127)

TAILORING
 man with scissors, sitting on table in "The village tailor" early 1850's*
 Edouard Duseigneur (Bernard 41#)
 men and girls sewing garments in sweatshop in "Tailor's workshop em-
 ploying sweated labour, New York" 1888 Jacob Riis (Gernsheim/2 258#)
 young men in tailor's workshop in "Tailors' workshop, Germany" c. 1924*
 August Sander (Bernard 178#)

TAXICABS
 two drivers in overcoats and caps in "Taxi drivers, Berlin" 1932 Henri
 Cartier-Bresson (Cartier-Bresson 11)
 woman riding in taxi in "[Taxicab]" 1971 Larry Fink (Time-Life/11 102)

TEACHERS
 man standing with two girls at piano in "The music lesson" c. 1857
 (Gernsheim 146#; Gernsheim/2 125#)
 same woman in many areas of the classroom in "A teacher's tasks" 1954
 Ralph Morse (Time-Life/16 89)
 showing globe to young girls in "The geography lesson" 1851 Antoine
 Claudet (Gernsheim 140#; Gernsheim/2 116#; Time-Life/9 45)

TELEPHONE POLES

from foreground to horizon in "Highway to Las Vegas" 1960* Ernst Haas
(Time-Life/8 153)

in field in "Powerlines and telephone poles" 1939 Edward Weston (Gruber
253#)

looking up at pole from street in "[Cityscape with telephone pole]" Wolf
von dem Bussche (Time-Life/11 67)

TELEVISIONS

in room with decorated Christmas tree in "Christmas tree" 1962 Diane Ar-
bus (Gruber 376#)

picture above back of reclining nude in "From 'Plastic love-dream'" 1968
Roger Mertin (Time-Life/12 137)

set turned on in "Child on TV" 1962 Lee Friedlander (Gruber 378#)

set turned on by empty restaurant table and chairs in "U.S. 1, South
Carolina" 1955 Robert Frank (Gruber 377#)

turned on in front of dresser mirror in "Hotel room, Portland, Maine"
1962 Lee Friedlander (Time-Life/7 25)

women in swim suits on television set in "Beauty contest" 1973 Sarah
Moon (Hall-Duncan 212)

TEMPLE OF ANTONINUS PIUS

in ruins in "Temple of Antoninus Pius and Faustina, Rome" c. 1857
Robert Macpherson (Gernsheim 197#; Gernsheim/2 159#)

TENNIS

woman with racket playing tennis in "Untitled" 1935 Martin Munkacsi
(Hall-Duncan 69)

women in tennis dresses dropping tennis balls from basket in "[Two ten-
nis dresses]" 1942 Herman Landshoff (Hall-Duncan 83)

women watching other women playing tennis in "Tennis match at Smith
College, Northampton, Mass." 1901* Photographer Unknown (Bernard
143#)

TENTS

encampment of horses and tents in valley in "Encampment of Horse Artil-
lery, the Crimea" 1855 Roger Fenton (Time-Life/14 87)

three men standing on bare backs of horses near circus tent in "Three
bareback riders"* Nathan Lazarnick (Bernard 180#)

TEXAS BLUEBONNETS

a field of the state flower in "Texas bluebonnets, the Texas state flower,
on the Edwards Plateau"* Jim Bones (Rugoff 87#)

TEXTILE INDUSTRY

balls of thread in "Warp waste in a spinning factory" 1969* John Ellard
(Time-Life/13 215)

photomacrograph of woven swatch of orlon in "Orlon magnified 20X" 1969*
Manfred Kage (Time-Life/13 214)

spools of yarn in knitting plant in "Health-tex knitting plant" 1973* Jay
Maisel (Time-Life/12 68)

THIMBLES

and seam binding and zipper on slate in "Notions on slate" 1968* Peter
Scolamiero (Time-Life/13 39)

THISTLES

naked child standing among them in "Child among thistles" 1956 Wynn
Bullock (Bullock 15)

silhouette on a curtain in "Scottish thistle" 1958 Paul Caponigro (Time-
Life/13 222)

THREE PATRIARCHS

view of three rock formations in "Three Patriarchs, Zion Canyon, Rio
Virgen, Utah" 1872 John K. Hillers (Sandweiss 37#)

TIDE POOLS

in "Tide pool" 1957 Wynn Bullock (Bullock 19)

of limpets and closed anemones in "Limpets and closed anemones in a tidal area at Pebbly Beach, Point Lobos"* Dennis Brokaw (Rugoff 35#)

overhead view in "Point Lobos, Tide pools" 1972 Wynn Bullock (Bullock 27)

thickly matted eelgrass in "Tidepool" 1966 Paul Caponigro (Time-Life/11 36)

with algae and periwinkles in "Tide pool (upper middle zone) containing chiefly algae and periwinkles, Point Lobos, California"* Dennis Brokaw (Rugoff 34#)

with anemones in "Tide pool (middle to lower zone) showing anemones, sea urchins, chitons, algae, encrusting sponge, and tiny red 'spiders'"* Dennis Brokaw (Rugoff 37#)

TIGERS

on the prowl at night in jungle in "Tiger prowling along a jungle path" F.W. Champion (Guggisberg 83b)

studies of tigers in motion in "Tiger studies" c. 1877 Eadweard Muybridge (Guggisberg 17a)

TOADS

female with long string of newly laid eggs in "Desert toad and string of eggs she has just laid in one of the Dead End Canyons, Lake Powell, Utah"* Steven C. Wilson (Rugoff 82#)

TOBACCO PIPES

man holding pipe in mouth in "J. Robert Oppenheimer" Philippe Halsman (Halsman 78)

rims of stacked pipes in "Pipes" 1970 Sebastian Milito (Time-Life/11 31)

white-haired man with pipe in his mouth in "Bertrand Russell" Philippe Halsman (Halsman 111)

TOMATOES

halves of tomatoes near bell jar filled with whole ones in "Still life with tomatoes" 1962* Milton Halberstadt (Time-Life/13 36)

onyx and ivory brooch on tomato slice in "Brooch of onyx and carved ivory" 1968* Fred Burrell (Time-Life/13 217a)

TOMBS

above-ground in cemetery in "Graveyard in Chiapas, Mexico" 1969* Douglas Faulkner (Time-Life/8 89)

in the Sanctuary of Westminster Abbey in "Westminster Abbey: The Sanctuary" 1911* Frederick H. Evans (Time-Life/15 71)

of Edward II, with his likeness on coffin in "Gloucester Cathedral: Tomb of Edward II, at dusk" 1890* Frederick H. Evans (Time-Life/15 91)

TORII

child standing under Shinto ritual gateway in forest in "Tarii light, Tokyo" 1975* Harald Sund (Time-Life/14 30)

TOWER OF BABEL

large rock formation in "Tower of Babel, Garden of the gods" c. 1880's William Henry Jackson (Sandweiss 13#)

TOYS

man selling toys on sticks in "A toy seller's stock, Tokyo, Japan" 1906 H.C. White (Loke 125c)

one boy on rocking horse, one with ukelele in "Two little boys" 1961 Frank Horvat (Gruber 274#)

three girls playing ring toss on wooden floor in "Ring toss" 1899 Clarence H. White (Gruber 277#)

TRACK ATHLETICS

man about to land after broad jump in "Broad jumper" 1969* Eric Schweikardt (Time-Life/16 143)

men doing the hurdles in "Hurdlers" 1959 George Silk (Time-Life/16 141)

TRAFFIC ACCIDENTS

man hanging from wires after smashing car into telephone pole in "Automobile accident" 1945 William W. Dyviniak (Time-Life/10 40)

TRAFFIC SIGNS

stop sign and fire hydrant near boy on bicycle in "Stop sign" 1972* Tomas Sennett (Time-Life/12 21)

TRAINS see RAILROADS

TRAJAN'S COLUMN

view of the base in "Base of Trajan's Column, Rome" c. 1858 James Anderson (Gernsheim 198#; Gernsheim/2 162#)

TRANSVESTITES

man in wig and dress in "John Martin, dancer, New York City" 1975 Richard Avedon (Avedon 20●)

TREE BARK

of cherry tree in "Tree bark" 1970 Joseph Dankowski (Time-Life/11 37)

of oak tree with luna moth in "Luna moth on oak tree"* Larry West (Rugoff 109#)

of tree with walking stick insect in "Walking stick insect on bark"* Jim Bones (Rugoff 88#)

peeling bark of paper birch in "Paper birch"* Larry West (Rugoff 111#)

peeling birch bark behind flying wren in "Winter wren"* Eliot Porter (Rugoff 120#)

TREES. See also Beech; Birch; Cypress; Mariposas; Oak; Palm; Pine; Redwoods; Sequoias

a bare elm in "Elm tree at Lacock" William Henry Fox Talbot (Gruber 14#)

at daybreak in "Landscape" 1969* Terence Naysmith (Time-Life/11 58)

autumn yellows and golds in "November rain on Bear Mountain" 1968* Dorothea Kehaya (Time-Life/8 203)

bare branches with lotus blossom photographed as roots in "Untitled" 1968 Jerry N. Uelsmann (Time-Life/12 215)

bare trunks lining a canal in "Trees along French canal" 1951* Irving Penn (Gruber 152#)

dead, barkless tree among thistles in "Child among thistles" 1956 Wynn Bullock (Bullock 15)

dead tree trunks in desert in "Desert on Big Cumberland Island"* James P. Valentine (Rugoff 157#)

dead trees in sand in "Florence, trees and sand dunes" 1959 Wynn Bullock (Bullock 69)

dirt road at edge of tree line in "Untitled" 1969 David Vestal (Time-Life/12 131)

a forest-like setting in "Study of trees" Gustave Le Gray (Gruber 32#)

gnarled pterocarpus in a swamp in "Swamp in Dominica" 1965* John Dominis (Time-Life/16 31)

grove of aspens in "Aspen grove in California" 1969 George Tice (Time-Life/11 205)

intertwining roots in "Tree roots at St. Cloud" c. 1900 Eugène Atget (Gernsheim 314#; Gernsheim/2 267#)

large trunk with roots lifting up ground in "Tree at La Verrerie" c. 1850* Louis Robert (Bernard 19#)

lining dirt road, flanked by open field in "In Brie, France" 1968 Henri Cartier-Bresson (Cartier-Bresson 87)

log among feathery plants in "Horsetails and log" 1957 Wynn Bullock (Bullock 17)

logs in water in "Floating logs" 1957 Wynn Bullock (Bullock 63)

one with bare branches in "Tree no. 4, New Jersey" 1964 George Tice (Time-Life/11 34)

stark, leafless trees, resulting from volcanic action in "Volcanic landscape, Mexico" 1951 Paul Senn (Gruber 265#)

trunk with knothole in "Knothole" 1967 Minor White (Time-Life/11 47)
two large ones in the woods in "Big Basin" 1968 William R. Current
(Time-Life/12 147)
with Spanish moss in "Buen-Ventura, Savannah, Georgia" 1865 George
N. Barnard (Gruber 262#)

TRIANGLE SHIRTWAIST COMPANY FIRE
police checking remains of victims in "Aftermath of Triangle Fire" 1911
Photographer Unknown (Hine 123)

TRUCKS
dump truck dropping load in "New Leyland tipper at Wavertree, Liver-
pool" 1914* Photographer Unknown (Bernard 166#)
on muddy road in "Cars going west" 1936 Dorothea Lange (Time-Life/10
127)
one on a road in the desert in "Truck in the desert near Yuma, Arizona"
1962 Danny Lyon (Sandweiss 126#)

TRUMPETS
man playing one in "Louis Armstrong" Philippe Halsman (Halsman 52)

TUILERIES
a view from Quai d'Orsay in "The Tuileries and the Seine from the Quai
d'Orsay" 1839 Louis Jacques Mande Daguerre (Photography 20)

TULIPS
blue and green flowers with red stems in "Flowers" 1964* Norman Roths-
child (Time-Life/8 215)
Chinese child in silk, holding flower in "Tang Yung-Mei" 1942 Louise
Dahl-Wolfe (Time-Life/9 167)
drooping over side of glass vase in "Melancholy tulip" 1939 André Kertész
(Time-Life/11 192)

TUNDRA
at base of glacier and mountains in "The south face of 12,540-foot Mt.
Deborah in the Alaska Range with a glacier spreading out over the
tundra plains" Ed Cooper (Rugoff 7#)
brush in summer in "Red fox pup lurking in the tundra near Mt. McKin-
ley National Park"* Dean Brown (Rugoff 10#)

TURKEYS
two boys, two buckets and two turkeys in "Barry, Dwayne and turkeys"
1969 Emmet Gowin (Time-Life/9 209)

TURTLES
diamondback terrapin crossing sand in "Diamondback terrapin crossing a
sandbar in a tidal creek" Jack Dermid (Rugoff 146#)

TYPEWRITERS
man with cigarette by typewriter in "Tennessee Williams" 1956 Yousuf
Karsh (Karsh 203)
a section of the keys in "Typewriter" 1921-2 Ralph Steiner (Photography
233)

U

UMBRELLAS AND PARASOLS
crowd standing with umbrellas, in front of platform in "Nomination of
election candidates" or "Election meeting at Dover" 1863-1865 Photog-
rapher Unknown (Gernsheim 173#; Gernsheim/2 129#)
held by people walking in rain near awning-covered tables in "Effet de
Pluie" c. 1899 M. Bucquet (Gernsheim 338#; Gernsheim/2 291#)
held by woman on shore, watching small boat with smokestack in "Woman
with sunshade by the waterside" c. 1896 Emile Joachim Constant Puyo
(Gruber 46#)

held by young woman posed for portrait in "A lady" c. 1878 Prümm
(Gernsheim 349#)
held open by people on street in "Italy" 1961 Michael Semak (Time-Life/
11 126)
man in coat holding unopened umbrella in "Parliamentarian" 1928 August
Sander (Gruber 88#)
next to young woman seated by roadside in "Young lady with am um-
brella" 1907* Louis Lumière (Time-Life/8 73)
one held by two small children in "Freddy Gould and Lizzie Koewen" 1865
Julia Margaret Cameron (Time-Life/12 83c)
society women standing with parasols in "Photographs of society women
wearing their own designer clothes at the races" 1909-10 Seeberger
Frères (Hall-Duncan 28-29)
young woman holding parasol in garden in "Woman" c. 1896 Emile Joachim
Constant Puyo (Gruber 284#)
UNDERGARMENTS
back view of woman in back-laced corset in "From Paris--the new Detolle
corset with back lacing" 1939 Horst P. Horst (Hall-Duncan 65)
brassiere on woman's torso in "Charnaux Caslis" c. 1927 Man Ray (Hall-
Duncan 88)
corset in store window in "Corset shop, Paris" c. 1908 Eugène Atget
(Gernsheim/2 266#)
woman beside corset poster in "Spain" or "Cordoba, Spain" 1933 Henri
Cartier-Bresson (Cartier-Bresson 9; Time-Life/11 127)
UNDERWATER EXPLORATION
men in diving suits on pier in "Divers at Pier No. 4, Kansas City
Bridge" 1869* Photographer Unknown (Bernard 94#)
UNEMPLOYED
men standing outside employment office in "Labor Agency, New York
City" 1910 Lewis Hine (Hine 81)
UNIFORMS, SCHOOL
backs of boys in school uniforms in "Schoolboys on tour" 1966 Charles
Pratt (Time-Life/9 184)
girls in school uniforms in "Schoolgirls in Trabzon, Turkey" 1965* Mary
Ellen Mark (Time-Life/9 200)
U.S.--HISTORY--WAR WITH MEXICO, 1845-1848
uniformed troops marching to war in "Exeter, New Hampshire, Volun-
teers" c. 1845 Photographer Unknown (Sandweiss 4#)
U.S.--HISTORY--WAR OF 1898
American soldier with rifle guarding prisoner in cell in "An American
soldier guarding a prisoner, Spanish-American War, Cuba" Photog-
rapher Unknown (Loke 41)
U.S.--HISTORY--CIVIL WAR, 1861-1865
dead soldier in trench in "Dead Confederate soldier in trenches of Fort
Mahone, at Petersburg, Virginia" 1865 Timothy H. O'Sullivan or Mathew
Brady (Gruber 420#; Time-Life/14 105)
dead soldiers in row in "Gathered for burial at Antietam after the Battle
of September 17, 1862" Alexander Gardner (Photography 72b)
dead soldiers near fence and road in "Confederate dead by a fence on
the Hagerston Road, Antietam" 1862 Alexander Gardner (Photography
72a)
dead soldiers on battlefield in "Battlefield of Gettysburg" 1863 Timothy
H. O'Sullivan (Gernsheim/2 146#; Gruber 42#)
First Pennsylvania Light Artillery, cannons ready for battle in "Battery
B, First Pennsylvania Light Artillery, Petersburg, Virginia" 1864
Alexander Gardner (Time-Life/14 104)
General and staff posing by trees in "Mathew Brady, photographed by an

assistant while posing with General Robert B. Potter and his staff"
1864 Brady Staff (Time-Life/14 101)
officers seated on wooden benches in "View of General Ulysses S.
Grant in a council of war with General George Meade, Virginia" 1864 Timothy
H. O'Sullivan (Loke 16d)
114th Pennsylvania Zouaves, men in formation by tents in "Headquarters
Guard (114th Pennsylvania Zouaves), Army of the Potomac, Culpeper,
Virginia" c. 1863 Timothy H. O'Sullivan (Time-Life/14 102)
Oneida Cavalry, men standing by log cabins in "Camp of the Oneida
Cavalry, at the Headquarters of the Army of the Potomac" 1865 Pho-
tographer Unknown (Time-Life/14 103)
portrait of young soldier in "Portrait of a soldier" c. 1863* Photographer
Unknown (Time-Life/8 55)
ruins of a city on a river in "Ruins of Richmond" 1865 Mathew Brady
(Gernsheim 170#; Gernsheim/2 148#; Gruber 41#)
ruins of a large flour mill in "Ruins of the Gallego Flour Mill, Richmond,
Virginia" 1865 Alexander Gardner (Time-Life/14 107)
ruins of a mansion in "Ruins of Pickney Mansion, Charleston, South
Carolina" 1865 George N. Barnard (Gruber 353#)
soldier by rows of cannons in "Union soldier at an arsenal near Washing-
ton, D.C." c. 1865* A.J. Russell (Bernard 80#)
UPPER CLASSES
fashionably dressed women with parasols in "Photographs of society wom-
en wearing their own designer clothing at the races" 1909-10 See-
berger Frères (Hall-Duncan 28-29)

V

VEGETABLES
farmers in cornfield showing harvest in "Easy harvest from Wisconsin
earth" 1895 H.J. Perkins (Time-Life/10 95)
VENDÔME COLUMN
men by fallen statue in "The fallen Vendôme Column" 1871 Photographer
Unknown (Gernsheim 175#; Gernsheim/2 151#)
VERNAL FALL
along river at base of Falls in "Vernal Fall, 350 feet" c. 1879-1881 George
Fiske (Sandweiss 29#)
VERSAILLES
palace seen from corner of pool in "Versailles" c. 1900 Eugène Atget
(Gernsheim 315#)
seen by moonlight in "Moonlight impression from the Orangerie, Versailles
Series" 1908 Edward Steichen (Photography 197)
VIETNAMESE CONFLICT, 1961-1975
execution, by pistol, of man in street in "Execution of a suspected Viet
Cong terrorist" 1968 Edward T. Adams (Time-Life/7 33)
men and tents at dawn in "[Army camp in Vietnam at dawn]" Co Rent-
meester (Time-Life/12 112)
VIOLINS
held by woman, in "Madame Godard" Nadar (Tournachon 242b)
man holding violin and bow in "Pablo Sarasate" Atelier Nadar (Tournachon
246b)
trio of women playing piano, cello and violin in "The Prelude" 1917 Laura
Gilpin (Sandweiss 57#)
young girl playing violin in "Alexandra (Xie) Kitchin" 1876 Lewis Carroll
(Gruber 275#)
VOLCANOES

crest of the Ajo Mountains and field of yellow flowers and cactus in
"Spring flowers with the volcanic crest of the Ajo Mountains in the
distance, Organ Pipe Cactus National Monument, Arizona"* David
Muench (Rugoff 76#)
eruption and lava flows in "Fountains of lava" 1959* Robert B. Goodman
(Time-Life/16 28)
inner walls of crater in "Inner walls of Ubehebe Crater, Death Valley
National Monument, California"* David Muench (Rugoff 64#)
man peering into crater of smoking volcano in "At the edge of the crater
of Asosan, central Kyushu, Japan" 1906 H.C. White (Loke 156a)
men near crater of erupting volcano in "The eruption of Mount Pelée,
Martinique" 1902 Photographer Unknown (Loke 156b)
patterns at edge of crater in "Volcanic patterns on the edge of Ubehebe
Crater, Death Valley"* David Muench (Rugoff 66#)
pool of hot, glowing lava in "Lava pool at night" 1959* Robert B. Good-
man (Time-Life/16 29)
surface of land-like fish scales in "Artist's Palette, a volcanic area of
Death Valley"* David Muench (Rugoff 65#)
VOLKSWAGENS
alone on road in "Country road, Lancaster, Pennsylvania" 1961 George
Tice (Time-Life/12 153)
multiple images above photographs of young girls in "Highway A1A" 1968
Bert Parker (Time-Life/12 219)
VORTOGRAPHS
in "Vortograph" 1917 Alvin Langdon Coburn (Photography 204)

W

WAITERS AND WAITRESSES
young woman with tray at restaurant counter in "Young waitress" c.
1915* Lewis Hine (Bernard 170#)
WALKING
man on horizontal facade of building with windows in "Winter climber"
1969* Bill Binzen (Time-Life/8 218)
men with suitcases on side of road in "Near Los Angeles, California"
1938 Dorothea Lange (Photography 270)
WALKING STICK (INSECT)
on tree bark in "Walking stick insect on bark"* Jim Bones (Rugoff 88#)
WALLS
boy with hands on eyes, by brick wall in "I am a camera" 1970 Ken Jo-
sephson (Time-Life/9 132)
boy standing by large blank wall in "Masked boy" 1968 Arthur Tress
(Time-Life/9 88)
of brick in "Untitled" 1971 Wolf von dem Bussche (Time-Life/11 61)
outside view of North Wall of Jerusalem in "North Wall, Jerusalem" 1854*
Auguste Salzmann (Bernard 29#)
WALRUSES
herd asleep on rocks in "Walrus herd on a beach on Round Island"* Fred
Bruemmer (Rugoff 18#)
on ice floe in "Walrus on an ice floe off Franz Josef Land" c. 1894
Fridtjof Nansen (Guggisberg 76)
WAPITI
young stag in snow in "Portrait of a young wapiti" A.G. Wallihan (Gug-
gisberg 37)
WARBLERS
Dartford warbler on nest with young in "Dartford warbler on nest" Rich-

ard and Cherry Kearton (Guggisberg 26)
Parula warbler with wings spread in "Parula warbler"* Eliot Porter (Rugoff 121#)
Sedge warbler feeding a cuckoo while on its back in "A young cuckoo brought up by robins is here seen being fed by a sedge warbler on its back" Oliver G. Pike (Guggisberg 28)
WARSHIPS
Battleship and tugs going under bridge in "The Battleship Hatsuse on the Tyne at Newcastle" 1900* Photographer Unknown (Bernard 141#)
WASHINGTON SQUARE, NEW YORK
the Arch in the snow in "Washington Square, New York" 1916 Laura Gilpin (Sandweiss 56#)
WATCHES see CLOCKS AND WATCHES
WATER
blue droplet on edge of white fabric in "Water drop on a curtain" 1970* Manfred Kage (Time-Life/13 218)
droplets on a leaf in "Droplets on an autumn leaf" 1964* Ernst Haas (Time-Life/8 157d)
drops on blade of grass in "Water drops on grass blades in Point Reyes National Seashore, California"* David Cavagnaro (Rugoff 70#)
WATER BUFFALOES
a herd in the rain of a monsoon in "Java monsoon" 1970* Co Rentmeester (Time-Life/16 33)
WATER LILIES
and grasses in bayou in "Waterlilies on a Louisiana bayou"* Andreas Feininger (Rugoff 92#)
and trees overhanging water in "Water lilies, Giverny, France" 1979* Dmitri Kessel (Time-Life/14 39)
WATER--POLLUTION
boy sitting by river, with colander on head and holding wooden duck in "Boy with duck and colander" 1970 Arthur Tress (Time-Life/9 87)
WATERFALLS
and large rocks at base in "Niagara Falls" 1888* George Barker (Bernard 122#)
people skating at base of ice-covered Niagara Falls in "Niagara Falls frozen" 1880's* H.F. Nielson, Attrib. (Bernard 111#)
several cascading over side of hill in "Cascades at Tivoli" 1857 Robert Macpherson (Gernsheim 201#; Gernsheim/2 157#)
Shoshone Falls from above the falls in "Shoshone Falls" 1867 Timothy H. O'Sullivan (Photography 126)
small falls, flat rocks and calm water in "Twilight"* Larry West (Rugoff 107#)
small falls from cliff and over rocks in "The Falls of Terni" before 1867* Robert Macpherson (Bernard 87#)
using the rocks as steps in "Waterfall" 1967* Ken Domon (Gruber 143#)
WATERMELON
being eaten outside house by young women in "Watermelon party" Photographer Unknown (Photography 153a)
WATERWAYS. See also CANALS; LAKES; RIVERS
small boat in fog in "Gilly" 1898 Léonard Misonne (Gruber 45#)
small boat with smokestack watched by woman with parasol, on shore in "Woman with sunshade by the waterside" c. 1896 Emile Joachim Constant Puyo (Gruber 46#)
WAVES
breaking at shore in "Coastal area of Olympic National Park"* Steven C. Wilson (Rugoff 33#)
breaking over wall in "Stormy sea at Bognor" c. 1900 W.P. Marsh (Gern-

sheim 287#)
splashing against rocks in "Point Lobos, wave" 1958 Wynn Bullock (Bullock
25)
WEALTH
poor woman looking at women in furs and jewelry in "The critic" 1943
Weegee (Time-Life/10 49)
WEAVING
a photomacrograph of a woven swatch of orlon in "Orlon magnified 20X"
1969* Manfred Kage (Time-Life/13 214)
WEDDINGS see MARRIAGE CUSTOMS AND RITES
THE WEST (U.S.)
man making pies at mess wagon in "The mess wagon" c. 1890's Laton
Alton Huffman (Sandweiss 47#)
WEST INDIANS
a woman by shuttered windows in "A woman of Guadeloupe, West Indies"
Photographer Unknown (Loke 183)
WESTMINSTER ABBEY
without chairs or people in "Westminster Abbey: The Sanctuary" 1911*
Frederick H. Evans (Time-Life/15 71)
WHEELBARROWS
Lucien Lelong gown on woman seated in wheelbarrow in "[Model in a
wheelbarrow]" 1937 Man Ray (Hall-Duncan 85)
WHIMBRELS
standing on grass in "Whimbrel in Mt. McKinley National Park"* Michael
Wotton (Rugoff 11#)
WHIPPETS
a dog sitting on floral rug in "Whippet" 1964* Nina Leen (Time-Life/8
121)
WHITETHROATS
lesser whitethroat on nest in "Lesser whitethroat on nest" Richard and
Cherry Kearton (Guggisberg 20)
WILDEBEEST
and zebras drinking at a waterhole in "Zebra and wildebeest drinking at
an East African waterhole" Martin and Osa Johnson (Guggisberg 105)
WILLOW PTARMIGANS
on branch in "Willow ptarmigan hen in May"* Charlie Ott (Rugoff 12#)
WINDMILLS
heavy storm clouds, overhead in "Storm near Santa Fe, New Mexico" 1965
Liliane De Cock (Sandweiss 137#)
in town scene in "Windmills at Montmartre" 1839 Hippolyte Bayard (Gern-
sheim 48#; Gernsheim/2 41#)
in vast landscape in "[Windmill]"/ Wolf von dem Bussche (Time-Life/11 70)
lower half of wooden windmill in "A windmill, Somme" before 1898* Eugène
Atget (Bernard 158#)
WINDOWS. See also SHOW WINDOWS
boy looking out window onto quiet street in "Andy in Europe" 1966 Burk
Uzzle (Time-Life/9 146)
broken glass and torn drapes, with view of ocean in "Zuma Series No. 3"
1977* John M. Divola (Gruber 164#)
child at half opened window in "Gypsy child in a van" 1968 André A.
López (Time-Life/9 168)
child at wood frame window of train in "Russian child in a train" 1957
Dan Weiner (Time-Life/9 169)
daylight and figures in darkened room in "Mother and daughter, Pleasant
Valley, Maryland" 1973* Robert W. Madden (Time-Life/14 34)
glass of roses by wet window in "Roses" 1956 Josef Sudek (Gruber 199#)
looking out to feathery plants in "The Window" 1957 Wynn Bullock (Bullock

Frontispiece)
looking through wood shed to back of nude woman on grass in "Barbara" 1956 Wynn Bullock (Bullock 83)
nude standing at window covered with cobwebs in "Nude in cobweb window" 1955 Wynn Bullock (Bullock 37)
nude woman asleep by window in "Nude in Sandy's window" 1956 Wynn Bullock (Bullock 39)
sun shining in dark room in "Eleanor" 1948 Harry Callahan (Gruber 235#)
surrounded by small blue lights in "Window dressing, New York City" 1979* Eric Staller (Time-Life/14 231)
wet with condensation in "Window" 1944 Josef Sudek (Gruber 450#)
windowsill and uneven curtains in "Windowsill and daydreaming, Rochester, New York" 1958 Minor White (Photography 308b)
with heavy drape attached to sconce in "Dr. Soter's drape in living room" 1976* Wayne Sorce (Gruber 163#)
WINE AND WINE MAKING
carried by smiling boy in "Sunday morning errand, Paris" 1958 Henri Cartier-Bresson (Time-Life/9 23)
two men seated at table drinking wine in "Wine drinkers" 1850's* A. Le Blondel (Bernard 31#)
WINTER
barren bush with yellow grass in "Bush and yellow grass, Adirondacks" 1965* Eliot Porter (Gruber 145#)
birch trees in snow in "Winter in northern Minnesota"* Les Blacklock (Rugoff 103#)
bison walking in snow through storm in "Bison in a storm"* Charles Stienhacker (Rugoff 56#)
bus on snow-covered city street at night in "A tribute to Steichen, New York City" 1978* Jan Staller (Time-Life/14 46)
couple holding hands in snowy landscape in "[Couple in snowy landscape]" 1971* Bill Binzen (Time-Life/11 107)
horse-drawn sleighs at water station in "Water station in Moscow, Russia" c. 1896 B.W. Kilburn (Loke 72)
horses and carriages on street in snow in "The Street, Fifth Avenue" 1896 Edward Steichen (Photography 198)
horses turning streetcar around in "The Terminal" 1893 Alfred Stieglitz (Gernsheim 340#; Gernsheim/2 307#; Green 312; Gruber 407#; Photography 169; Time-Life/7 19)
people skating at base of frozen Niagara Falls in "Niagara Falls frozen" 1880's* H.F. Nielson, Attrib. (Bernard 111#)
people with sleds on outskirts of city in "Winter in Prague" 1961 Zdeněk Voženílek (Time-Life/11 222)
snow and ice covering river in "Androscoggin River, Maine, icebound" 1967* William Garnett (Time-Life/7 225)
snow on the ground by the Arch at Washington Square in "Washington Square, New York" 1916 Laura Gilpin (Sandweiss 56#)
snow-covered pile of logs in "Louisiana-Pacific timber" 1973* Harald Sund (Time-Life/12 65)
snow-covered pine trees in "Vermont winter" Sonja Bullaty and Angelo Lomeo (Rugoff 116#)
solarization of trees in snow in "[Winter woodland]" Yale Joel (Time-Life/12 169)
tourists on frozen waterfalls in "Niagara Falls, New York" Underwood and Underwood (Loke 159)
trail of light as skiers descend mountain in "Torchlight procession of skiers, Australia" 1966* David Moore (Time-Life/16 194)
white birch in snow in "White birch at twilight"* Larry West (Rugoff 113#)

WOMEN--EMPLOYMENT
carrying bundle of clothes on her head in "First work in America" or
 "Italian immigrant, East Side, New York City" 1910 Lewis Hine (Gruber
 414#; Hine 27)
gowned women in line by troughs of peaches in "Peach-canning factory,
 Visalia, California" Phil Brigandi (Loke 218b)
woman and child making lace in apartment in "Making pillow lace, New
 York City" 1911 Lewis Hine (Hine 72)
women pulling large roller on gravel highway in "A twenty-woman team
 working on a highway, Darjeeling, India" 1903 Underwood and Under-
 wood (Loke 143b)
women sitting in wicker chairs in "Women's lounge at a paper factory,
 Bangor, Maine" Underwood and Underwood (Loke 219)
women unloading wood from box car in "[Unloading wood from box car]"
 Photographer Unknown (Loke 138)
WOMEN--SUFFRAGE
parading with 'Joan of Arc' in "'Joan of Arc' among the suffragists, cor-
 onation procession, London" 1911 Underwood and Underwood (Loke
 164b)
WOOD
clothespin camouflaged by wood grain in "Untitled in space" 1964 Martus
 Granirer (Time-Life/11 214)
WOOD PILES
elderly man with long white beard seated on pile in "My Father" 1936
 Imogen Cunningham (Time-Life/12 125)
with sheepdog standing on it in "Sheepdog" 1964* Nina Leen (Time-Life/8
 120)
WOODPECKERS
Gila feeding young in nest in cactus in "Gila woodpecker feeding young
 in saguaro cactus, Sonoran Desert"* Jerry Gentry (Rugoff 81#)
WORLD TRADE CENTER, NEW YORK CITY
under construction, in view of cold cobblestone street and deserted
 warehouses in "[Old cobblestone street being torn up]" 1971 Norman
 Snyder (Time-Life/11 99)
WORLD WAR I, 1914-1918
American soldiers in overcoats, on ship's deck in "American soldiers go-
 ing home in a transport vessel" Underwood and Underwood (Loke 207)
Belgian infantrymen in field in "Belgian infantrymen" 1914 Underwood and
 Underwood (Loke 199)
excitement of crowds on Armistice Day in "[Armistice Day]" 1918 Photog-
 rapher Unknown (Time-Life/10 57)
French cavalry with swords and rifles watching fighter plane in "French
 cavalry officers looking up at a scout fighter plane" Photographer Un-
 known (Loke 208)
French soldiers on bicycles in rows in "A company of French military cy-
 clists" Keystone View Company (Loke 201a)
French soldiers seated in row on ground in "French troops resting before
 an attack, Verdun, France" 1916 Underwood and Underwood (Loke
 202a)
German men with guitar in night club in "The German prisoners' club
 room, Brest, France" Photographer Unknown (Loke 200)
German soldiers sitting among ruins in "German soldiers among the ruins
 of Messines, near Ypres, Belgium" Photographer Unknown (Loke 202d)
group of refugees in flat-bed, horse-drawn wagon in "French refugees
 fleeing from the Somme to Amiens" Photographer Unknown (Loke 201d)
group of well-dressed people viewing battlefield in "King Albert of Bel-
 gium with Mrs. Woodrow Wilson touring a Belgian battlefield" 1919

Photographer Unknown (Loke 209)
Moroccan cavalryman with a saber in "A Moroccan cavalryman with the
 French troops at the front" Photographer Unknown (Loke 203d)
rows of American soldiers in gas masks in "American soldiers training
 with gas masks, Fort Dix, New Jersey" Underwood and Underwood
 (Loke 205)
soldier and woman kissing near train in "Farewell at the train station"
 Photographer Unknown (Loke 206a)
soldier posing with French woman and child in "An American soldier with
 a French woman and child, Brest, France" Photographer Unknown
 (Loke 206b)
WORLD WAR II, 1939-1945
aerial view of rubble of Nagasaki after the atomic bomb in "Nagasaki"
 1945 George Silk (Time-Life/10 35)
American soldiers marching from the Arch of Triumph in "The U.S. 28th
 Division marching down the Champs-Elysées" 1944 Bob Landry (Time-
 Life/7 21a)
London bus in hole after the Blitz in "London Blitz" 1940* William Van-
 divert (Time-Life/15 67)
WRENS
one in flight by peeling birch bark in "Winter wren"* Eliot Porter (Rugoff
 120#)
WRESTLERS AND WRESTLING
group of young men watching in "Greek Wrestling Club, Hull-House"
 Lewis Hine (Hine 122)

X

X RAYS
bones of the human hand in "Early English X-ray photograph" c. 1896-7
 Photographer Unknown (Gernsheim/2 315#)

Y

YANKEE STADIUM
back of Babe Ruth as he faces teammates and fans in "Babe Ruth bows
 out" 1948 Nat Fein (Time-Life/10 46)
crowd surrounding altar in center, for Papal Mass in "The Papal Mass at
 Yankee Stadium, New York City" 1965* Ralph Morse (Time-Life/14
 225)
YARN
skeins in pile in "HCA-Martin, Inc. annual report" 1973* Gary Gladstone
 (Time-Life/13 69)
spools of yarn in knitting plant in "Health-tex knitting plant" 1973* Jay
 Maisel (Time-Life/13 68)
YOSEMITE VALLEY
with storm clouds in "Clearing Winter storm, Yosemite Valley, California"
 c. 1936 Ansel Adams (Photography 258)
YOUTH
barefooted girls, standing and talking in kitchen in "All the time in the
 world" 1964 William Gedney (Time-Life/9 33)
boy on porch railing near swing in "Long summer afternoon" 1967 Danny
 Lyon (Time-Life/9 32)
boy with arm around girl in "Teenage couple, New York City" 1963 Diane
 Arbus (Time-Life/7 223)

conversation between boy and girl at wire fence in "Serious conversation, Romania" 1963 Paul Schutzer (Time-Life/9 34)

men and women in speeding hot rod in "Hot rodders" 1949 Ralph Crane (Time-Life/7 92)

Z

ZEBRAS

and wildebeest drinking at a waterhole in "Zebra and wildebeest at an East African waterhole" Martin Osa Johnson (Guggisberg 105)

dead zebras near white hunter and Africans in "Zebra hunting in Tanganyika Territory, Africa" Underwood and Underwood (Loke 132a)

grazing near a giraffe in "Reticulated giraffe and Grevy's zebra posing side by side" Oskar Olson (Guggisberg 97)

ZOOS

hippopotamus asleep by bars of zoo cage in "The Hippopotamus at the Zoological Gardens, Regent's Park" 1855* Count de Montizon (Bernard 45#)

Portraits of Children

Buttrick, Jerome
1965*--Toni Frissell (Time-Life/
9 63)

Cameron, Henry Herschel Hay
1865*--Julia Margaret Cameron
(Bernard 89#)

Chomeley-Jones children
1887, in "Whitman and the
Chomeley-Jones children"
--George C. Cox (Time-Life/
15 23)

Douglas, Angus
c. 1865--Lewis Carroll (Time-
Life/9 51)

Edison, Madeline, Theodore and
Charles in "Thomas Alva Edison
with his wife, Mina, daugh-
ter Madeline, and sons
Theodore and Charles at
their home in Llewellyn Park,
New Jersey"--Underwood
and Underwood (Loke 35)

Fisher, Florence
1872--Julia Margaret Cameron
(Time-Life/7 177b)

Gould, Freddy
1865--Julia Margaret Cameron
(Time-Life/12 83c)

Grant, Jesse
c. 1872, in "Ulysses S. Grant,
U.S. soldier and 18th
President of the United
States, with his wife, Julia,
and youngest son, Jesse"--
G.W. Pach (Loke 50)

Henley, Beatrice
1862--Lewis Carroll (Time-Life/9
50)

Kennedy, Jr., Robert F.
1968, in "Funeral of Robert F.
Kennedy"--Robert Lebeck
(Time-Life/14 149)

Kitchin, Alexandra (Xie)
1876, girl playing violin in "Alex-
andra (Xie) Kitchin"--Lewis
Carroll (Gruber 275#)

Koewen, Lizzie
1865--Julia Margaret Cameron
(Time-Life/12 83c)

Lesseps, Bertrand de
Paul Nadar (Tournachon 285c)

Lesseps, Solange de
Paul Nadar (Tournachon 285d)

Liddell, Alice
c. 1859--Lewis Carroll (Time-
Life/7 175)

Lumière, Yvonne
1913*--Louis Lumière (Time-Life/
8 53)

McCandish, Miss
c. 1843--Hill & Adamson (Gern-
sheim/2 70#)

Macdonald, Irene
1863, in "It won't come smooth"--
Lewis Carroll (Gernsheim 236#;
Gernsheim/2 206#)

Millais, Effie

1865--Lewis Carroll (Gernsheim
235#; Gernsheim/2 207#;
Time-Life/9 48)

Nadar, Paul
c. 1862--Paul Nadar (Tournachon
289d)
c. 1865*, in "Self-portrait with
Mme Nadar and Paul Nadar"
--Nadar (Bernard 82#)

Polaire children
Paul Nadar (Tournachon 284d)

Porel, Master
Paul Nadar (Tournachon 289a)

Réjane, G.
Paul Nadar (Tournachon 296)

Stieglitz, Kitty
1905, in "Platinum print of Al-
fred Stieglitz and his daugh-
ter, Kitty"--Edward Steichen
(Time-Life/12 11)

Taft, Charles, Helen and Robert
1908, in "William Howard Taft,
the 27th President of the
United States, with his wife,
Helen and their children,
Robert, Charles and Helen"
--Brown Bros. (Loke 83)

Talbot, Rosamund
1843-44*, in "The photograph-
er's daughter"--William Henry
Fox Talbot (Bernard 3#)

Temple, Shirley
1932--Photographer Unknown
(Time-Life/9 59)

Wilhelm II, Kaiser
1860, as a child in "Little Wil-
ly's first salute"--L. Haase
(Gernsheim/2 182#)

Portraits of Men

About, Edmund
Atelier Nadar (Tournachon 224b)

Abrams, General Creighton W.
1971, in "The Mission Council,

Saigon"--Richard Avedon
(Avedon 24●)

Adam, Auguste Villiers de L'Isle-
see Villiers de L'Isle-Adam

Adam-Salomon, Antoine Samuel
c. 1865--Nadar (Tournachon 187)

Adams, Ansel
1942, in "Beaumont Newhall and
Ansel Adams jumping"--Bar-
bara Morgan (Sandweiss 151)
1943--Edward Weston (Sandweiss
154d)
1958, shadow as a self portrait
in "Self-portrait, Monument
Valley, Utah"--Ansel Adams
(Sandweiss 149a)
1974--Brassaï (Photography 278a)

Adams, John Quincy
c. 1848--Southworth & Hawes
(Time-Life/14 63)

Adamson, Robert
c. 1843--David O. Hill (Gern-
sheim 73#; Gernsheim/2 68#)

Adenauer, Konrad
1956--Chargesheimer (Gruber
121#)

Adler, Felix
Photographer Unknown (Hine
121)

Akeley, Carl E.
Photographer Unknown (Guggis-
berg 98)

Albert, Duc de Broglie
Paul Nadar (Tournachon 279b)

Albert I, Prince of Monaco
Paul Nadar (Tournachon 291a)

Albert, Prince
1861, in "Queen Victoria and
Prince Albert"--J.E. Mayall
(Gernsheim 205#; Gernsheim/2
183#)

Albert, King of Belgium
1919, in "King Albert of Belgium
with Mrs. Woodrow Wilson tour-
ing a Belgian battlefield"--

Photographer Unknown (Loke 209)

Aldrin, Edwin "Buzz"
1969, in "Buzz Aldrin on the moon"--Neil Armstrong (Time-Life/10 23)
1969--Yousuf Karsh (Karsh 15)

Alexander III, Czar of Russia
Atelier Nadar (Tournachon 263b)

Alexander III with Olga, Xenia, the Tsarevitch, Marie Feodorovna, George and Michael
c. 1886--Paul Nadar (Tournachon 280b)

Alfonso XIII
Underwood and Underwood (Loke 82a)

Ali bin Hamed bin Mohammed, Sultan of Zanzibar and Pemba
Underwood and Underwood (Loke 181d)

Ali, Muhammad
Philippe Halsman (Halsman 16)
1970?--Yousuf Karsh (Karsh 19)

Allen, Fred
Philippe Halsman (Halsman 28)

Allen, Woody
Philippe Halsman (Halsman 12)

Allon
c. 1860--Nadar (Tournachon 267d)

Amin as-Sultan
1902?, in "Shah Muzaffar ad-Din of Persia ... at Edward VII's coronation"--Underwood and Underwood (Loke 82b)

Anastasia, Albert
1957, body covered with towels on floor of barber shop in "Detectives inspect the corpse of Albert Anastasia"--George Silk (Time-Life/10 42)

Aragon, Louis
c. 1924*--Man Ray (Bernard 179#)

Archer, Frederick Scott
1855--R. Cade (Gernsheim 101#; Gernsheim/2 95#)

Armstrong, Louis
Philippe Halsman (Halsman 52)

Armstrong, Neil A.
1969--Yousuf Karsh (Karsh 15)

Asanuma, Inejiro
1960, being killed in "Inejiro Asanuma and assassin"--Yasushi Nagao (Time-Life/10 31)

Askew, Laurin B.
1971, in "The Mission Council, Saigon"--Richard Avedon (Avedon 24•)

Asselineau, Charles
c. 1857--Nadar (Tournachon 224c)

Athey, Byron
in "[Prosecuting Attorney Byron Athey]"--William Kuykendall (Time-Life/10 110-11)

Auber, Daniel François
c. 1870--Nadar (Tournachon 245b)

Augier, Emile
Atelier Nadar (Tournachon 260c)

Avedon, Jacob Israel
1969-1973--Richard Avedon (Avedon 68•)

Babbington, Joe
1975--Richard Avedon (Avedon 43•)

Bakunin, Mikhail
c. 1863--Nadar (Tournachon 175)

Balzac, Honoré de
Nadar (Tournachon 2)

Barbès, Armand
1862--Nadar (Tournachon 169)

Barrès, Maurice
Atelier Nadar (Tournachon 236a)

Barrière, Théodore
c. 1854--Nadar (Tournachon 57)

Barry, Ray
1963--Duane Michals (Gruber
314#)
1977--Duane Michals (Gruber
315#)

Barsky, Dr. Edward
1969--Richard Avedon (Avedon
36•)

Barye, Antoine
c. 1860--Nadar (Tournachon
216a)

Baudelaire, Charles
c. 1855--Nadar (Photography
111; Tournachon 67)
c. 1860--Nadar (Tournachon
237a)
c. 1863--Etienne Carjat (Gern-
sheim 233#; Gernsheim/2
202#)

Bauer, Harold
Atelier Nadar (Tournachon
241c)

Bayard, Hippolyte
1840*, in "Portrait of the pho-
tographer as a drowned
man"--Hippolyte Bayard
(Bernard frontispiece)
1845-47--Hippolyte Bayard
(Gruber 4#)
c. 1855--Hippolyte Bayard
(Gernsheim 47#; Gernsheim/2
40#)

Bayer, Herbert
1932, in "Self-portrait"--Her-
bert Bayer (Gruber 318#)

Beardsley, Aubrey
1895--Frederick H. Evans
(Gernsheim/2 286#; Gruber
292#)
1896--Frederick Hollyer (Gern-
sheim 345#)

Becquerel, Alexandre
c. 1870--Nadar (Tournachon 201)

Berger, Samuel D.
1971, in "The Mission Council,
Saigon"--Richard Avedon
(Avedon 24•)

Berlioz, Hector
c. 1863--Nadar (Tournachon 177)

Bernard, Tristan (Paul)
Atelier Nadar (Tournachon 237d)

Berthelier, Jean-François
c. 1858--Nadar (Tournachon 137)

Bibesco, George
Paul Nadar (Tournachon 295a)

Blavier, Emile
c. 1853--Adrien Tournachon
(Tournachon 44)

Bogart, Humphrey
Philippe Halsman (Halsman 146)

Boissy, Marquis de
c. 1860--Nadar (Tournachon 157)

Bonaparte, Jérôme
c. 1868--Nadar (Tournachon 263a)

Bonaparte, Joseph
Paul Nadar (Tournachon 286c)

Bonaparte, Louis
Paul Nadar (Tournachon 286c)

Bonaparte, Victor
Paul Nadar (Tournachon 286c)

Bonnard, Pierre
1944--Henri Cartier-Bresson
(Cartier-Bresson 59)

Borges, Jorge Luis
1975--Richard Avedon (Avedon
48•)

Boulanger, Georges
Atelier Nadar (Tournachon 269d)

Boulanger, Louis
c. 1854--Nadar (Tournachon 219d)

Braden, Carl
1969, in "The staff of the South-
ern Conference Educational
Fund"--Richard Avedon (Ave-

don (Avedon 37●)

Brady, Mathew B.
 c. 1850, in "Mathew B. Brady
 with his wife and friend"--
 Brady Gallery (Photography
 44)
 c. 1863--Photographer Unknown
 (Gernsheim 238#; Gernsheim/2
 204#)

Brassaï
 1974--Ansel Adams (Photography
 276)

Brazza, Pierre Savargnan de
 Atelier Nadar (Tournachon
 274a)

Breton, André
 c. 1924*--Man Ray (Bernard
 179#)

Brewster, Sir David
 c. 1865--Edwin Musgrave (Gern-
 sheim 138#; Gernsheim/2
 117#)

Briand, Aristide
 1929--Erich Salomon (Gruber
 74#)

Brinkley, David
 in "Huntley-Brinkley"--Philippe
 Halsman (Halsman 73)

Brodkey, Harold
 1975--Richard Avedon (Avedon
 56●)

Brodovitch, Alexey
 1969--Richard Avedon (Avedon
 27●)

Brown, John, M.D.
 Hill and Adamson (Time-Life/
 12 84d)

Brown, Dr. Samuel
 1843-5, in "Rev. George Gil-
 fillan and Dr. Samuel Brown"
 --Hill & Adamson (Gernsheim
 76#)

Brunel, I.K.
 1857--Robert Howlett (Gern-
 sheim/2 134#)

Buchwald, Art
 Philippe Halsman (Halsman 170)

Buckley, Jr., William F.
 Philippe Halsman (Halsman 125)
 1975--Richard Avedon (Avedon
 45●)

Bullock, Wynn
 1960--Imogen Cunningham (Sand-
 weiss 149c)

Bunker, Ellsworth
 1971, in "The Mission Council,
 Saigon"--Richard Avedon
 (Avedon 24●)

Buonaparte, Gabrielle
 c. 1862--A.A.E. Disderi (Gern-
 sheim 217#)

Burroughs, William
 1975--Richard Avedon (Avedon
 57●)

Byerly, Jacob
 Photographer Unknown (Time-
 Life/7 183a)

Campbell, Sir John
 c. 1855--Roger Fenton (Gruber
 21#)

Capote, Truman
 1965--Irving Penn (Gruber 128#)
 1974--Richard Avedon (Avedon
 23●)

Caran d'ache (Emmanuel Poiré)
 Atelier Nadar (Tournachon 217d)

Don Carlos de Borbon
 Paul Nadar (Tournachon 293d)

Carnegie, Andrew
 Underwood and Underwood (Loke
 29d)

Carroll, Lewis
 1863--Oscar G. Rejlander (Gern-
 sheim/2 210#)

Cartier-Bresson, Henri
 1946--Beaumont Newhall (Photog-
 raphy 282)

Carver, George Washington

Phil Brigandi (Loke 34d)

Casals, Pablo
 Atelier Nadar (Tournachon 241c)
 Philippe Halsman (Halsman 53)
 1954, back of seated man play-
 ing cello--Yousuf Karsh
 (Karsh 31)

Castro, Fidel
 Yousuf Karsh (Karsh 35)

Chagall, Marc
 Philippe Halsman (Halsman 100)
 Yousuf Karsh (Karsh 39)

Cham (Amédeé Noé)
 c. 1870--Nadar (Tournachon
 217c)

Champfleury, Jules
 c. 1865--Nadar (Tournachon
 185)

Charles, Prince of Wales
 1974?--Yousuf Karsh (Karsh
 43)

Chasles, Philarète
 c. 1855--Nadar (Tournachon 85)

Chenavard, Paul-Marc-Joseph
 1857--Nadar (Tournachon 125)

Chesterton, Gilbert K.
 Alvin Langdon Coburn (Photog-
 raphy 200a)

Chevreul, Eugène
 Atelier Nadar (Tournachon
 273a)

Chevreul, Michel
 1886*--Paul Nadar (Bernard
 115#; Gernsheim 230#; Gern-
 sheim/2 269#)

The Chicago Seven
 1969, portrait of the group in
 "The Chicago Seven"--
 Richard Avedon (Avedon
 41●)

Churchill, Lord Randolph
 Paul Nadar (Tournachon 282c)

Churchill, Winston

Philippe Halsman (Halsman 38)
 in hat and coat, with back to
 camera in "Winston Churchill"
 --Philippe Halsman (Halsman
 41)
 1941--Yousuf Karsh (Karsh 47)
 1951--Alfred Eisenstaedt (Time-
 Life/10 116)
 1951, making "V" sign in "Church-
 ill"--Alfred Eisenstaedt (Time-
 Life/10 117)

Ciceri, Pierre
 c. 1860--Nadar (Tournachon 161)

Cladel, Leon
 Atelier Nadar (Tournachon 225d)

Clairville, Louis-François
 c. 1860--Nadar (Tournachon 252d)

Claudet
 in "Portrait of Claudet"--William
 Henry Fox Talbot (Gruber 8#)

Claudet, Antoine
 c. 1865--Henri Claudet (Gern-
 sheim 52#; Gernsheim/2 57#)

Clemenceau, Georges
 Atelier Nadar (Tournachon 265d)

Clésinger, Auguste
 c. 1860--Nadar (Tournachon 165)

Coburn, Alvin Langdon
 Clarence White (Green 242)
 George Bernard Shaw (Green 93)

Cocteau, Jean
 Philippe Halsman (Halsman 162,
 164-166)
 George Platt Lynes (Gruber 320#)

Colantonio, Ernest J.
 1971, in "The Mission Council,
 Saigon"--Richard Avedon
 (Avedon 24●)

Coleman, Leo
 Philippe Halsman (Halsman 164,
 166)

Collins, Michael
 1969--Yousuf Karsh (Karsh 15)

Colonne, Edouard

c. 1870--Nadar (Tournachon
 265b)
1882*--Etienne Carjat (Bernard
 112#)

Gandhi, Mahatma
 George Lewis (Loke 211d)
 1946--Margaret Bourke-White
 (Gruber 297#; Time-Life/
 10 29c)

Gapon, George
 Atelier Nadar (Tournachon
 266c)

García Márquez, Gabriel
 1976--Richard Avedon (Avedon
 32●)

Garibaldi, Giuseppe
 c. 1870--Nadar (Tournachon
 269b)

Garnier, Charles
 1865--Antoine Samuel Adam-
 Salomon (Gruber 289#)
 c. 1877--Nadar (Tournachon
 207)

Gautier, Théophile
 c. 1856--Nadar (Photogrphy
 110; Tournachon 113)

Genet, Jean
 Philippe Halsman (Halsman 94)
 1970--Richard Avedon (Avedon
 25●)

Genoux, Claude
 c. 1857--Nadar (Tournachon
 233c)

George V, King of Hanover
 Paul Nadar (Tournachon 279d)

Gérôme, Leon
 c. 1860--Nadar (Tournachon
 220d)

Geronimo
 William H. Rau (Loke 58)

Ghirri, Luigi
 Williams Scurani (Time-Life/
 12 117a)

Giacometti, Alberto

Yousuf Karsh (Karsh 67)
 1958--Richard Avedon (Avedon
 2●)

Gide, André
 Philippe Halsman (Halsman 18)

Gilfillan, Rev. George
 1843-5--Hill & Adamson (Gern-
 sheim 76#)

Gill (Gosset de Guines)
 Atelier Nadar (Tournachon 212)

Girardin, Emile de
 c. 1856--Nadar (Tournachon 234b)

Gladstone, W.E.
 1885--J. Birtles (Gernsheim 317#;
 Gernsheim/2 271#)

Godowsky, Jr., Leopold
 1922--Photographer Unknown
 (Time-Life/8 64)

Goebbels, Joseph
 1933--Alfred Eisenstaedt (Time-
 Life/7 204)

Goldwater, Barry
 Philippe Halsman (Halsman 33)

Goncourt, Edmund de
 c. 1855--Nadar (Tournachon 77)

Goncourt, Jules de
 c. 1855--Nadar (Tournachon 77)

Gorki, Maxim
 1932--Felix H. Man (Gruber 87#)

Gounod, Charles
 Atelier Nadar (Tournachon 240d)

Gozlan, Léon
 c. 1855--Nadar (Tournachon 87)

Grant, Ulysses S.
 Atelier Nadar (Tournachon 277c)
 c. 1865--Mathew Brady (Gern-
 sheim 239#)
 c. 1872--G.W. Pach (Loke 50)

Grévy, Jules
 Atelier Nadar (Tournachon 264c)

Gropius, Walter

Philippe Halsman (Halsman 59)

Guevara, Che
1963--René Burri (Gruber 313#)

Guitry, Lucien
Atelier Nadar (Tournachon 251d)

Guizot, François
c. 1857--Nadar (Tournachon
129)

Guys, Constantin
c. 1855--Nadar (Tournachon 97)

Hahn, Reynaldo
Atelier Nadar (Tournachon
242d)

Halévy, Jacques François
c. 1855--Nadar (Tournachon
246c)

Hamtramck, Colonel John Francis
c. 1847--Photographer Unknown
(Sandweiss 6#)

Hand, Judge Learned
Philippe Halsman (Halsman 69)

Harding, Warren G.
Harris & Ewing (Time-Life/13
22d)

Harpignies, Henri
Atelier Nadar (Tournachon
218a)

Hartmann, Sadakichi
Edward Steichen (Green 89)

Has-No-Horses
1898--Gertrude Käsebier (Sand-
weiss 71#)

Hayden, Tom
1969, in "The Chicago Seven"
--Richard Avedon (Avedon
41●)

Hearne, Dennis
Tom Eckstrom (Time-Life/12
117b)

Heath, Edward
Philippe Halsman (Halsman 42d)

Hemingway, Ernest
1957--Yousuf Karsh (Karsh 75)

Hempertz, Tom
1969, in "Andy Warhol and mem-
bers of The Factory"--Richard
Avedon (Avedon 33●)

Hengeler, Adolf
Frank Eugene (Green 247)

Herschel, Sir John F.W.
1867--Julia Margaret Cameron
(Gernsheim 49#; Gernsheim/2
42#; Gruber 310#; Photography
138a; Time-Life/7 177a)

Hickock, Dick
1960--Richard Avedon (Avedon
16●)

Hickock, Walter
1960--Richard Avedon (Avedon
15●)

Hicks, Walter
1939--Alfred Eisenstaedt (Eisen-
staedt/3 9d)

Hill, David Octavius
c. 1843, in "Self-portrait"--Hill
& Adamson (Gruber 17#)
c. 1843--Robert Adamson (Gern-
sheim 74#; Gernsheim/2 71#)
1845--Hill & Adamson (Time-Life/
7 172)

Hine, Lewis
c. 1927--Photographer Unknown
(Hine 8)
c. 1935--Berenice Abbott (Hine
137)

Hines, Gregory
1981*--Enrico Ferorelli (Time-Life/
14 219)

Hirohito
1946--Alfred Eisenstaedt (Eisen-
staedt/3 10b)

Hiss, Alger
1975--Richard Avedon (Avedon
21●)

Hitchcock, Alfred
Philippe Halsman (Gruber 312#;

Halsman 10)

Hoffman, Abbie
1969, in "The Chicago Seven"
--Richard Avedon (Avedon
41•)

Hoffman, Dustin
Philippe Halsman (Halsman 67)

Hoover, Herbert
Harris & Ewing (Time-Life/13
23a)
Philippe Halsman (Halsman 25)

Hope, Bob
Philippe Halsman (Halsman 133)

Horowitz, Vladimir
1975--Richard Avedon (Avedon
52•)

Houssaye, Arsène
c. 1860--Nadar (Tournachon
231b)

Huertas, Esteban
1903, in "Colonel Esteban Huer-
tas, commanding officer of
the Panama garrison in
November 1903"--Underwood
and Underwood (Loke 96d)

Hugo, Victor
Atelier Nadar (Tournachon 223)
1885--Nadar (Gernsheim 231#;
Gernsheim/2 199#; Tourna-
chon 209)

Hunt, Robert
1862--Ernest Edwards (Gern-
sheim 99#)

Huntley, Chet
Philippe Halsman (Halsman 73)

Huston, John
Philippe Halsman (Halsman 112)

Huxley, Aldous
Philippe Halsman (Halsman 84)
1935--Cecil Beaton (Time-Life/
11 209)

Huysmans, Joris-Karl
Atelier Nadar (Tournachon
233a)

Hyacinthe, Louis
c. 1854--Nadar (Tournachon
256d)

Ibsen, Henrik
Underwood and Underwood (Loke
62d)

Isabey, Eugène
c. 1860--Nadar (Tournachon 214b)

Jackson, Graham
1945, tearfully playing accordion
in "Weeping for F.D.R."--
Edward Clark (Time-Life/10
32)

Jackson, Red
1948--Gordon Parks (Gruber 331#)

Jackson, William Henry
c. 1939--Charles Tremear (Sand-
weiss 154c)

Jacobson, George D.
1971, in "The Mission Council,
Saigon"--Richard Avedon
(Avedon 24•)

James, Jesse
c. 1870--Photographer Unknown
(Sandweiss 48#)

Janin, Jules
c. 1855--Nadar (Tournachon 107)

Janssen, Jean
Atelier Nadar (Tournachon 236b)

Jeanron, Philippe Auguste
c. 1860--Nadar (Tournachon 214c)

Joel, Yale
1969, in "Self-portrait, some of
its tones reversed by solari-
zation..."--Yale Joel (Time-
Life/12 163)

Johansson, Ingemar
1961, in "Johansson-Patterson
bout"--George Silk (Time-Life/
16 137)

John XXIII
1959--Yousuf Karsh (Karsh 83)

John, Augustus

1954--Yousuf Karsh (Karsh 79)

Johns, Jasper
1976--Richard Avedon (Avedon
 28•)

Johnson, Jay
 1969, in "Andy Warhol and
 members of The Factory"--
 Richard Avedon (Avedon 33•)

Johnson, Lyndon B.
 1963--Philippe Halsman (Halsman
 27)

Johnson, Martin
 and wife Osa, posing with cam-
 eras and Africans in "The
 photographers with an old-
 time cine-camera and ... an
 Akeley Panoramic Camera"--
 Martin and Osa Johnson
 (Guggisberg 104)

Joliot-Curie, Frédéric
 1945, in "Irène and Frédéric
 Joliot-Curie, Paris"--Henri
 Cartier-Bresson (Cartier-
 Bresson 43)

Jones, Reverend Peter (Kahkewa-
 quonaby)
 c. 1844-1846--Hill & Adamson
 (Sandweiss 2#)

Josephson, Larry
 1969, in "The staff of radio
 station WBAI"--Richard Ave-
 don (Avedon 29•)

Journet, Jean
 c. 1857--Nadar (Tournachon
 127)

Jouvenel, Henri de
 Atelier Nadar (Tournachon
 267a)

Kahkewaquonaby (Reverend Peter
 Jones)
 c. 1844-1846, in "Reverend
 Peter Jones"--Hill & Adam-
 son (Sandweiss 2#)

Kahn, Louis
 1964*--Arnold Newman (Time-
 Life/14 223)

Kalinowsky, Dr. Lothar
 1970--Richard Avedon (Avedon
 38•)

Kam, Richard
 1969, in "Self-portrait"--Kami
 (Time-Life/16 184)

Karr, Alphonse
 c. 1858--Nadar (Tournachon 141)
 c. 1867--Adam Salomon (Gern-
 sheim 234#; Gernsheim/2 205#)

Kauffman, Mark
 Photographer Unknown (Time-
 Life/16 92)

Kawabata, Yasunari
 1968?--Yousuf Karsh (Karsh 87)

Kearton, Cherry
 with his pet chimpanzee in "The
 photographer with 'Toto,' his
 famous pet chimpanzee"--
 Cherry Kearton (Guggisberg
 74)

Kellogg, Paul
 Photographer Unknown (Hine
 125)

Kennedy, John Fitzgerald
 Harris & Ewing (Time-Life/13
 23d)
 Philippe Halsman (Halsman 45)
 1953, sitting down to dinner in
 "Kennedy wedding"--Lisa
 Larsen (Time-Life/10 50)
 1960--Yousuf Karsh (Karsh 95)
 1962--Alfred Eisenstaedt (Eisen-
 staedt/3 17b)

Kennedy, Robert F.
 Philippe Halsman (Halsman 48)
 1968, in "Robert F. Kennedy
 shot"--Bill Eppridge (Time-
 Life/10 30)

Kennett, Richard
 1887--John Werge (Gernsheim
 250#)

Kenyatta, Jomo
 1966--Alfred Eisenstaedt (Eisen-
 staedt/3 16b)

Khachaturian, Aram

Philippe Halsman (Halsman 54)

Khrushchev, Nikita
1960--Alfred Eisenstaedt
(Eisenstaedt/3 15d)
1963--Yousuf Karsh (Karsh 99)

King, Jr., Martin Luther
1962--Yousuf Karsh (Karsh 103)

Kita, Roppeita
c. 1965--Yousuf Karsh (Karsh
107)

Konrashin, Kyril
1959--Alfred Eisenstaedt
(Eisenstaedt/3 14b)

Konienkov, Sergei
Philippe Halsman (Halsman 155)

Kropotkin, Prince Peter
Atelier Nadar (Tournachon
268a)

Krupp, Alfred
1963*--Arnold Newman (Time-
Life/14 222)

Kung Pao-yun
Paul Nadar (Tournachon 288b)

Kunstler, William
1969--Richard Avedon (Avedon
40•)

Laboulaye, Edouard Lefèbre
c. 1859--Nadar (Tournachon
145)

Lacroix, Paul
c. 1854--Nadar (Tournachon
236c)

Laing, R.D.
1972--Richard Avedon (Avedon
64•)

Lambert, Albert
Atelier Nadar (Tournachon
256b)

Laréveillière-Lepeaux
c. 1865--Nadar (Tournachon
231d)

Legouvé, Ernest

c. 1861--Nadar (Tournachon 159)

Leitch, William Leighton
Hill & Adamson (Time-Life/12
84c)

Léon-Noel, A.
c. 1860--Nadar (Tournachon
229b)

Léopold I, King of Belgium
c. 1860--Nadar (Tournachon
263c)

Léopold II, King of Belgium
c. 1875--Nadar (Tournachon
263d)

Lerski, Helmar
1912--Helmar Lerski (Gruber 60#)

Lesseps, Ferdinand de
c. 1869--Nadar (Tournachon
271d)

Lesueur, François Louis
c. 1854--Nadar (Tournachon
260b)
c. 1855--Nadar (Tournachon 81)

Levant, Oscar
1972--Richard Avedon (Avedon
59•)

Lewis, John L.
1944--Yousuf Karsh (Time-Life/
13 20)

Lewis, Sinclair
Philippe Halsman (Halsman 144)

Li Hung-chang
1900--Photographer Unknown
(Loke 39)

Liebknecht, Karl
1919*, in "Karl Liebknect speak-
ing at the mass grave of fallen
Spartacists, Berlin"--Photog-
rapher Unknown (Bernard
176#)

Lincoln, Abraham
1860--Mathew Brady (Photography
48; Time-Life/10 14)
1862--Alexander Gardner (Time-
Life/7 20a)

1862, standing with army offi-
cers in "President Lincoln
visiting the Army of the
Potomac"--Alexander Gard-
ner (Gernsheim 171#; Gern-
sheim/2 144#)

Lipchitz, Jacques
c. 1961--Yousuf Karsh (Karsh
111)

Lissitzky, El
El Lissitzky (Photography 243)

Liszt, Franz
Atelier Nadar (Tournachon 242a)

Little Big Man, Ogalalla, Dakota
1877--Charles M. Bell (Sand-
weiss 45#)

Littré, Emile
c. 1860--Nadar (Tournachon
225b)

Livingstone, David
1864--Thomas Annan (Gernsheim
222#; Gernsheim/2 192#)

Lloyd, Robert
1966, in "Actor Robert Lloyd
in the role of the Violent
Inmate in MARAT/SADE"--
Max Waldman (Time-Life/14
150)

Long, Avon
1942, in "Avon Long as Sportin'
Life"--Gjon Mili (Time-Life/
7 213)

Longfellow, Henry Wadsworth
c. 1876--Photographer Unknown
(Loke 62c)

Lorant, Stefan
1971, in "Felix H. Man and
Stefan Lorant"--Edward
Hausner (Photography 272)

Louis, Joe
1964*--Art Kane (Time-Life/7
127)

Luce, Henry R.
1966--Alfred Eisenstaedt
(Eisenstaedt/3 8c)

Ludwig II, of Bavaria
1867--Josef Albert (Gruber 340#)

Lytton, Lord
Atelier Nadar (Tournachon 262)

McAvoy, Thomas
1960--Alfred Eisenstaedt (Eisen-
staedt/3 8a)

McCarthy, Joseph
1954--United Press International
(Time-Life/7 21b)

McClellan, George
1862--Alexander Gardner (Time-
Life/7 20a)

Macdowell, William H.
c. 1884--Thomas Eakins (Sand-
weiss 52#)

McGowan, John E.
1971, in "The Mission Council,
Saigon"--Richard Avedon
(Avedon 24•)

Mack, Connie
Philippe Halsman (Halsman 24)

McKay, Donald
J.J. Hawes (Gernsheim/2 50#)

McLain, Denny
1968*, pitching a baseball in
"Denny McLain at work"--
James Drake (Time-Life/16
152)

MacLane, Robert
Atelier Nadar (Tournachon 277b)

McLuhan, Marshall
Yousuf Karsh (Karsh 135)

Macmillan, Harold
Philippe Halsman (Halsman 43)

Maddox, Dr. Richard Leach
c. 1880--W.E. Debenham (Gern-
sheim 249#; Gernsheim/2 209#)

Mahe
c. 1850*, in "Mahe, a Brave"--
Photographer Unknown (Time-
Life/15 39)

Mailer, Norman
 Yousuf Karsh (Karsh 115)

Malanga, Gerard
 1969, in "Andy Warhol and mem-
 bers of The Factory"--
 Richard Avedon (Avedon
 33•)

Mallarmé, Stéphane
 Atelier Nadar (Tournachon
 226a)

Malloy, Joseph
 1969, in "The staff of the
 Southern Conference Edu-
 cational Fund"--Richard Ave-
 don (Avedon 37•)

Malraux, André
 1933--Philippe Halsman (Hals-
 man 20)
 1968--Philippe Halsman (Hals-
 man 21)

Man, Felix H.
 1971--Edward Hausner (Photog-
 raphy 272)

Manet, Edouard
 c. 1865--Nadar (Tournachon
 189)

Mannes, Leopold
 1922--Photographer Unknown
 (Time-Life/8 64)

Manny, Frank
 Photographer Unknown (Hine
 121)

Manzù, Giacomo
 Youfu Karsh (Karsh 119)

Marceau, Marcel
 1956--Yousuf Karsh (Karsh
 123)

Marconi, Guglielmo
 Photographer Unknown (Loke
 34b)

Marcuse, Herbert
 1970--Richard Avedon (Avedon
 22•)

Marey, E.J.

c. 1890--Photographer Unknown
 (Gernsheim 295#; Gernsheim/2
 245#)

Marin, John
 1920--Alfred Stieglitz (Photogra-
 phy 208)

Martin, John
 1975, man in woman's wig and
 dress in "John Martin, dancer,
 New York City"--Richard Ave-
 don (Avedon 20•)

Marx, Groucho
 1972--Richard Avedon (Avedon
 63•)

Massemet, Jules
 Atelier Nadar (Tournachon 243b)

Matisse, Henri
 Philippe Halsman (Halsman 93)
 1944--Henri Cartier-Bresson
 (Cartier-Bresson 57)

Maugham, W. Somerset
 1950--Yousuf Karsh (Karsh 127)

Maupassant, Guy de
 Atelier Nadar (Tournachon 232b)

Mauriac, François
 1949--Yousuf Karsh (Karsh 131)

Mead, Taylor
 1969, in "Andy Warhol and mem-
 bers of The Factory"--Richard
 Avedon (Avedon 33•)

Meany, George
 1976--Richard Avedon (Avedon
 46•)

Meeropol, Michael
 1975--Richard Avedon (Avedon
 30•)

Meeropol, Robert
 1975--Richard Avedon (Avedon
 30•)

Meissonier, Ernest
 Atelier Nadar (Tournachon 214d)

Mendès, Catulle
 Atelier Nadar (Tournachon 232a)

Philippe Halsman (Halsman 122)

Peary, Admiral Robert
Atelier Nadar (Tournachon 275c)

Pedro II, Dom, Emperor of Brazil
1891--Paul Nadar (Tournachon
286b)

Pelletan, Eugène
c. 1855--Nadar (Tournachon 71)

Petersen, Anders
Anders Birkeland (Time-Life/
12 117b)

Philipon, Charles
c. 1854--Nadar (Tournachon 59)

Philipps, Henry W.
c. 1862--David Wilkie Wynfield
(Gernsheim 224#; Gernsheim/2
194#)

Picasso, Pablo
in "Marc Chagall and Pablo
Picasso"--Philippe Halsman
(Halsman 100)
1932--Brassaï (Photography
278c)
1949, in "Centaur by Picasso,
Vallauris, France"--Gjon Mili
(Time-Life/14 230)
1954--Yousuf Karsh (Karsh 159)
1957--Irving Penn (Gruber
120#; Time-Life/7 40)

Pietri, Joseph
c. 1866--Nadar (Tournachon
267c)

Poincaré, Raymond
Atelier Nadar (Tournachon
264d)

Poitevin, Alphonse
c. 1861--Pierre Petit (Gern-
sheim 256#; Gernsheim/2
216#)

Polk, James Knox
c. 1849--Photographer Unknown
(Sandweiss 7#)

Ponson du Terrail, Pierre-Alexis
1858--Nadar (Tournachon 139)

Ponton, Mungo
c. 1879--Klic (Gernsheim 255#;
Gernsheim/2 215#)

Post, Steve
1969, in "The staff of radio sta-
tion WBAI"--Richard Avedon
(Avedon 29•)

Pound, Ezra
1917--Alvin Langdon Coburn
(Photography 206)
1958--Richard Avedon (Avedon
9•, 10•)

Préault, Auguste
c. 1854--Nadar (Tournachon 61)

Proudhon, Pierre Joseph
c. 1862--Nadar (Tournachon 171)

Proust, Adrien
Atelier Nadar (Tournachon 273c)

Puvis de Chavannes, Pierre
Atelier Nadar (Tournachon 220a)

Queensberry, Marquis of
c. 1860--Disderi (Gernsheim
214#)

Rauch, Christian
c. 1856, in "The German sculptor
Christian Rauch"--C. Schwartz
(Gernsheim 237#; Gernsheim/2
208#)

Reade, Rev. J.B.
c. 1856--Maull & Polybank (Gern-
sheim 46#; Gernsheim/2 38#)

Reclus, Elisee
c. 1870--Nadar (Tournachon 203)

Rejlander, Oscar G.
c. 1871, in "Rejlander the artist
introducing Rejlander the
volunteer"--Oscar G. Rejland-
er (Photography 106)
1872--O.G. Rejlander (Gernsheim
124#; Gernsheim/2 106#)

Renard, Jules
c. 1859--Nadar (Tournachon 147)

Renoir, Jean
1972--Richard Avedon (Avedon

62•)

Rentmeester, Co
Photographer Unknown (Time-
Life/16 20)

Reske, Jean de
Atelier Nadar (Tournachon
244b)

Ricalton, James
1903, in "Underwood photograph-
er James Ricalton shown with
two giants of Kashmir at
the Great Durbar of 1903,
Delhi, India"--Photographer
Unknown (Loke 14)

Riopelle, Jean-Paul
Yousuf Karsh (Karsh 163)

Robinson, Henry Peach
1897--Ralph W. Robinson (Gern-
sheim 125#; Gernsheim/2
107#)

Rochefort, Henri Victor
Atelier Nadar (Tournachon
230d)

Rodin, Auguste
Alvin Langdon Coburn (Green
159)
Atelier Nadar (Tournachon
213c)
1902, in "Auguste Rodin with
his sculpture of Victor Hugo
as 'The Thinker'"--Edward
Steichen (Gernsheim/2 304#;
Green 78)
1907*, in "Rodin with sculpture
of Eve"--Edward Steichen
(Bernard 156#)

Rohatyn, Felix
1976--Richard Avedon (Avedon
31•)

Roosevelt, Franklin D.
Harris & Ewing (Time-Life/13
23c)
1938--Tom McAvoy (Time-Life/
10 29d)

Roosevelt, Theodore
Harris & Ewing (Time-Life/13
22a)

in "President Roosevelt on the
stump"--Underwood and Un-
derwood (Loke 40c)
1905, in "Pres. Theodore Roose-
velt's inaugural address out-
side the Capitol, Washington"
--Underwood and Underwood
(Gernsheim 321#; Gernsheim/2
276#)

Rossini, Giacome
c. 1870--Etienne Carjat (Gruber
19#)

Rossini, Gioacchino
c. 1856--Nadar (Tournachon 111)
c. 1865--Etienne Carjat (Gern-
sheim 232#; Gernsheim/2 201#)

Rostand, Edmond
Atelier Nadar (Tournachon 233d)

Rouget, Georges
Atelier Nadar (Tournachon 215d)

Rousseau, Théodore
c. 1857--Nadar (Tournachon
215b)

Rubin, Jerry
1969, in "The Chicago Seven"--
Richard Avedon (Avedon 41•)

Rubinstein, Artur
Philippe Halsman (Halsman 115)

Russell, Bertrand
Philippe Halsman (Halsman 111)

Russell, Charles M.
c. 1924-1926--Dorothea Lange
(Sandweiss 79#)

Sadaat, Sheik el-
1910--Underwood and Underwood
(Loke 180d)

Sadi-Carnot, François
Atelier Nadar (Tournachon 265a)

Saint-Saëns, Camille
Atelier Nadar (Tournachon 243a)

Sainte-Beuve, Charles Augustin
Atelier Nadar (Tournachon 227c)

Salk, Dr. Jonas

Philippe Halsman (Halsman 120)

Salomon, Erich
Photographer Unknown (Time-
Life/7 164c)
in "Self-portrait"--Erich Salomon
(Gruber 337#)

Sander, August
1956--Chargesheimer (Gruber
295#)

Saphir, Maurice-Gottlieb (Moses)
c. 1857--Nadar (Tournachon
109)

Sarasate, Pablo
Atelier Nadar (Tournachon 246b)

Sardou, Victorien
c. 1856--Nadar (Tournachon
250c)

Sartre, Jean-Paul
Philippe Halsman (Halsman 90)

Schanne, Alexandre
Atelier Nadar (Tournachon 234d)

Schillings, C.G.
C.G. Schillings (Guggisberg
44)

Schine, G. David
1954, in "[Army Secretary
Stevens and Private G.
David Schine]"--Photographer
Unknown (Time-Life/10 114-
15)

Schlemmer, Oskar
László Moholy-Nagy (Photogra-
phy 245)

Schuh, Oscar Fritz
1955--Liselotte Strelow (Gruber
343#)

Schuhmacher, Eugen
with camera near river in "The
photographer with his
Eyemo Camera"--Eugen
Schuhmacher (Guggisberg
117)

Schumacher, Fritz
Hugo Erfurth (Gruber 290#)

Schweitzer, Albert
1949--W. Eugene Smith (Gruber
105#; Photography 288)
1954--Yousuf Karsh (Karsh 167)

Scribe, Eugène
c. 1858--Nadar (Tournachon
257b)

Selye, Hans
Yousuf Karsh (Karsh 171)

Severin, Isidore
c. 1858--Nadar (Tournachon 103)

Shackleton, Sir Ernest
Atelier Nadar (Tournachon 275a)

Shahn, Ben
1934--Walker Evans (Sandweiss
149d)

Shankar, Ravi
Yousuf Karsh (Karsh 175)

Shaw, George Bernard
1907*--Edward Steichen (Green
167; Gruber 293#; Time-Life/
12 41)
1934--Yousuf Karsh (Gruber
294#)
1943--Yousuf Karsh (Karsh 179)

Sheeler, Charles
1945--Barbara Morgan (Sandweiss
152a)

Sibelius, Jean
1949--Yousuf Karsh (Karsh 183)

Siqueiros, David Alfaro
1966--Farrell Grehan (Time-Life/
7 86)

Sitting Bull
c. 1884--David F. Barry (Sand-
weiss 46#)

Sivori, Ernesto Camillo
c. 1860--Nadar (Tournachon 153)

Southworth, Albert Sands
c. 1848--Albert Sands Southworth
(Photography 36)

Spock, Dr. Benjamin
Philippe Halsman (Halsman 62)

Taylor, Baron
 c. 1865--Nadar (Gernsheim
 229#; Gernsheim/2 197#)

Taylor, Sir Henry
 1867--Julia Margaret Cameron
 (Gernsheim 225#; Gernsheim/2
 196#; Gruber 25#)

Teilhard De Chardin, Pierre
 Philippe Halsman (Halsman 126)

Tennyson, Alfred
 c. 1867--Julia Margaret Cameron
 (Time-Life/12 83d)

Thalberg, Sigismund
 c. 1852--Nadar (Tournachon
 246d)

Thaulow, Frits
 c. 1901--Edward Steichen (Pho-
 tography 175)

Thiers, Adolphe
 c. 1870--Nadar (Tournachon
 264a)

Thomas, Ambroise
 Atelier Nadar (Tournachon 246a)

Thoré, Théophile
 c. 1865--Nadar (Tournachon
 221a)

Tittle, Y.A.
 1964--Morris Berman (Time-Life/
 10 47)

Tone, Franchot
 c. 1936*, in "Joan Crawford
 and Franchot Tone"--Hur-
 rell (Bernard 205#)

Toscanini, Arturo
 1932--Alfred Eisenstaedt
 (Gruber 90#)
 1954--Sy Friedman (Time-Life/
 10 48)

Toulouse-Lautrec, Henri
 c. 1896--P. Sescau? or Maurice
 Guibert? (Gernsheim 351#)

Troubetzkoy, Prince Paul
 Paul Nadar (Tournachon 281c)

Troyon, Constans
 c. 1856--Nadar (Tournachon 218d)

Truman, Harry
 Harris & Ewing (Time-Life/13
 23b)
 1948--Al Muto (Time-Life/10 24)

Turgenev, Ivan
 Atelier Nadar (Tournachon 231a)

Twain, Mark
 Underwood and Underwood (Loke
 63)

Two Guns White Calf
 Photographer Unknown (Loke 59d)

Vacquerie, Auguste
 Atelier Nadar (Tournachon 234b)

Venedey, Jakob
 1848--Hermann Biow (Gernsheim/2
 64#)

Verdi, Giuseppe
 c. 1866--Nadar (Tournachon 197)

Verne, Jules
 Atelier Nadar (Tournachon 230a)

Vernet, Horace
 c. 1858--Nadar (Tournachon 219c)

Veuillot, Louis François
 c. 1856--Nadar (Tournachon 105)

Viennet, Jean Guillaume
 c. 1859--Nadar (Tournachon 149)

Villiers de L'Isle-Adam, Auguste
 Atelier Nadar (Tournachon 236d)

Viollet-le-Duc, Eugène
 Atelier Nadar (Tournachon 219b)

Vladimir, Grand Duke
 Paul Nadar (Tournachon 280a)

Vogel, H.W.
 c. 1895--Loescher & Petsch
 (Gernsheim 253#; Gernsheim/2
 214#)

Vogüé, Vicomte de, Eugène Melchior
 c. 1888--Paul Nadar (Tournachon
 292d)

Portraits of Women

Abbott, Berenice
 c. 1930--Consuelo Kanaga
 (Sandweiss 150a)

Adam, Juliette
 c. 1858--Nadar (Tournachon
 135)

Addams, Jane
 Photographer Unknown (Hine
 122)

Adler, Renata
 1969--Richard Avedon (Avedon
 18•)

Alexandra
 1902, in "Edward VII and Queen
 Alexandra in their coronation
 robes"--Underwood and Un-
 derwood (Loke 81c)

Alexandra, Princess of Wales
 1867--W. & D. Downey (Gern-
 sheim 206#)
 c. 1889--Alice Hughes (Gern-
 sheim 348#)

Alexandra Feodorovna
 c. 1896, in "Tsar Nicholas II,
 with the Tsarita Alexandra
 Feodorovna and members of
 the Imperial Family, St.
 Petersburg"--B.W. Kilburn
 (Loke 38c)

Alexandra Iosifovna
 1896, in "Members of the royal
 families of Russia and Eu-
 rope at the coronation of
 Tsar Nicholas II"--B.W. Kil-
 burn (Loke 48)

Ambrose, Marilyn
 1947, in "Twelve most photo-
 graphed models"--Irving
 Penn (Hall-Duncan 148;
 Time-Life/13 126)

Anderson, Marian
 Philippe Halsman (Halsman 58)
 1945--Yousuf Karsh (Karsh 23)

Anderson, Mary

Atelier Nadar (Tournachon 260d)

Astin, Patty Duke
 1959--Philippe Halsman (Halsman
 96)

Avedon, Evelyn
 1975--Richard Avedon (Avedon
 51•)

Baez, Joan
 Philippe Halsman (Halsman 152)
 1970--Yousuf Karsh (Karsh 27)

Baker, Carroll
 Philippe Halsman (Halsman 89)

Bankhead, Tallulah
 Philippe Halsman (Halsman 135)

Bardot, Brigitte
 Philippe Halsman (Halsman 92)
 1959--Richard Avedon (Gruber
 339#)

Beaton, Baba
 1931, in "At the Famous Beauties
 Ball"--Cecil Beaton (Hall-
 Duncan 113)

Beaton, Nana
 c. 1925--Cecil Beaton (Gruber
 303#)

Bennett, Helen
 1947, in "Twelve most photo-
 graphed models"--Irving Penn
 (Hall-Duncan 148; Time-Life/
 13 126)

Bernhardt, Sarah
 Atelier Nadar (Tournachon 259d)
 c. 1866--Nadar (Tournachon 195)
 1891--Photographer Unknown
 (Gernsheim 318#)

Booth, Catherine
 Atelier Nadar (Tournachon 277a)

Brady, Mrs. Mathew
 c. 1850, in "Mathew B. Brady
 with his wife and friend"--
 Brady Gallery (Photography
 44)

Broom, Mrs. Albert
 1910--Photographer Unknown

(Gernsheim 322#)

Buonaparte, Princess Gabrielle
c. 1862--Disderi (Gernsheim
217#; Gernsheim/2 181#)

Burroughs, Allie May
1936--Walker Evans (Sandweiss
82#)

Calvé, Emma
Atelier Nadar (Tournachon
244d)

Cameron, Julia Margaret
c. 1860--Lord Somers (Gern-
sheim 223#; Gernsheim/2
193#)

Carlson, Lily
1947, in "Twelve most photo-
graphed models"--Irving
Penn (Hall-Duncan 148;
Time-Life/13 126)

Carvalho, Marie
Atelier Nadar (Tournachon
245d)

Casati, Marchesa
Baron A. de Meyer (Green 240)

Chanel, Coco
1937--Horst P. Horst (Time-
Life/13 124)

Chase, Ilka
1937, in "The florist's box"--
Cecil Beaton (Time-Life/13
115c)

Chauna
c. 1900--Nadar (Tournachon
35)

Christine, Lilly (Cat Girl)
Philippe Halsman (Halsman 88)

Churchill, Lady Randolph
Paul Nadar (Tournachon 282a)

Clement, J.
1926, in "Country clothes and
town clothes"--Edward
Steichen (Hall-Duncan 55)

Comtesse de Paris

Paul Nadar (Tournachon 288a)

Crawford, Joan
c. 1936*--Hurrell (Bernard 205#)

Dahl-Wolfe, Louise
c. 1950, in "[Self portrait with
troupe]"--Louise Dahl-Wolfe
(Time-Life/13 92)

Davis, Varina
c. 1885, in "Jefferson Davis,
U.S. soldier, statesman and
only President of the Con-
federate States of America,
with his wife, Varina, daugh-
ter Maggie Hayes and her
three children"--Photographer
Unknown (Loke 51)

Desbordes-Valmore, Marceline
c. 1857--Nadar (Tournachon 115)
1859--Nadar (Tournachon 12)

Dinarzade
in "[Dinarzade modeling in Paris]"
--Jean Moral (Hall-Duncan 78)
c. 1916--Joel Feder (Hall-Duncan
42)
1924--Baron Adolf de Meyer
(Hall-Duncan 33)
1926, in "The bride at her second
marriage"--Edward Steichen
(Hall-Duncan 54)

Dinesen, Isak
1958--Richard Avedon (Avedon
66•; Time-Life/11 193)

Dorgère, Arlette
c. 1909--Paul Nadar (Tournachon
294b)

Douelon, Frances
1935, in silhouette in "Black"--
Edward Steichen (Hall-
Duncan 52)

Dovima
1955--Richard Avedon (Hall-
Duncan 137)

Draper, Dorothy Catherine
1840--John W. Draper (Gernsheim/
2 49#)

Dréau, Madame

wife, Julia, and youngest
son, Jesse"--G.W. Pach
(Loke 50)

Greco, Juliet
1950--Emmy Andriesse (Gruber
281#)
1960--Emmy Andriesse (Gruber
281#)

Grisi, Carlotta
c. 1865--Nadar (Tournachon
183)

H., Lady
1907*, in "Portrait of Lady H."
--Edward Steichen (Green
166; Time-Life/12 40)

Hale, Greta
1965*--Marie Cosindas (Time-
Life/8 29)

Hayes, Maggie
c. 1885, in "Jefferson Davis,
U.S. soldier, statesman and
only President of the Con-
federate States of America,
with his wife, Varina, daugh-
ter Maggie Hayes and her
three children"--Photographer
Unknown (Loke 51)

Helvin, Marie
1974--David Bailey (Hall-Duncan
160)

Henn, Dana
1947, in "Twelve most photo-
graphed models"--Irving Penn
(Hall-Duncan 148)

Hepburn, Audrey
Philippe Halsman (Halsman 145)

Hern, Kay
1947, in "Twelve most photo-
graphed models"--Irving
Penn (Hall-Duncan 148)

Hillier, Mary
1864--Julia Margaret Cameron
(Time-Life/12 83b)

Hohlwein, Frau Ludwig von
c. 1910*--Frank Eugene (Green
249; Time-Life/12 43)

Horan, Margaret
1935, in silhouette in "Black"--
Edward Steichen (Hall-Duncan
52)

Humes, Helen
1977*, in "Jazz singer Helen
Humes"--Barbara Bordnick
(Time-Life/14 160)

Humphrey, Doris
c. 1916*, in "Doris Humphrey
dancing naked"--Arnold Genthe
(Bernard 173#)

Huston, Mrs. John
Philippe Halsman (Halsman 165)

Hutton, Lauren
1973*, in "Revlon annual report"
--Richard Avedon (Time-Life/
12 63)

Isabella II, Queen of Spain
Paul Nadar (Tournachon 283d)

Jenny, Mlle
Paul Nadar (Tournachon 289c)

Johnson, Andrea
1947, in "Twelve most photo-
graphed models"--Irving Penn
(Hall-Duncan 148; Time-Life/
13 126)

Johnson, Osa
and husband Martin, posing with
cameras and Africans in "The
photographers with an old-
time cine-camera and ... an
Akeley Panoramic camera"--
Martin and Osa Johnson (Gug-
gisberg 104)

Joliot-Curie, Irène
1945, in "Irène and Frédéric
Joliot-Curie, Paris"--Henri
Cartier-Bresson (Cartier-
Bresson 43)

Joplin, Janis
c. 1970--Joel Snyder (Time-Life/
10 112-13)

Kalkbrenner, Mme
c. 1855--Nadar (Tournachon 99)

Musard, Miles
 c. 1862--Paul Nadar (Tournachon
 287c)

Nadar, Mme
 c. 1865*, in "Self-portrait with
 Mme Nadar and Paul Nadar"
 --Nadar (Bernard 83#)

Natanson, Misia
 c. 1900*--Edouard Vuillard
 (Bernard 138#)

Nevelson, Louise
 1974*--Marie Cosindas (Gruber
 171#)

Nilsson, Birgit
 1966--Roddy McDowall (Time-
 Life/13 26)

Oakley, Annie
 c. 1880's--John Wood (Sand-
 weiss 55#)

O'Connell, Mme
 c. 1855--Nadar (Tournachon
 73)

O'Keeffe, Georgia
 Philippe Halsman (Halsman 107)
 c. 1916-17*, in "Georgia
 O'Keeffe with paints"--Alfred
 Stieglitz (Bernard 171#)
 1918--Alfred Stieglitz (Gruber
 329#)
 1919--Alfred Stieglitz (Photog-
 raphy 211)
 1956--Yousuf Karsh (Karsh
 151)

Onassis, Jacqueline Kennedy
 1953, sitting down to dinner
 in "Kennedy wedding"--
 Lisa Larsen (Time-Life/10
 50)

Pachett, Jean
 in "Girl behind wine bottle"
 --Irving Penn (Hall-Duncan
 151)
 1950, in "Girl in black and
 white"--Irving Penn (Time-
 Life/13 127)

Paley, Natalie
 1936, in "For the Lace Ball"

--Cecil Beaton (Hall-Duncan
 118)

Pankhurst, Christabel
 1908, in "Suffragette leaders
 secretly photographed"--
 Arthur Barrett (Gernsheim/2
 227#)
 1909--Mrs. Albert Broom (Gern-
 sheim 323#)

Pankhurst, Emmeline
 1908, in "Suffragette leaders
 secretly photographed"--
 Arthur Barrett (Gernsheim/2
 227#)
 1914, woman being carried by
 police in "The arrest of Mrs.
 Pankhurst"--Photographer
 Unknown (Time-Life/10 44)

Parker, Suzy
 1956--Richard Avedon (Hall-
 Duncan 138)

Patti, Adelina
 1862--Nadar (Tournachon 245c)

Paula, Mlle
 Atelier Nadar (Tournachon 257d)

Pavlova, Anna
 1913--Madame d'Ora (Gruber
 301#)

Petipa, Marie
 Atelier Nadar (Tournachon 258)

Picasso, Paloma
 1973--Helmut Newton (Hall-Duncan
 202)

Pleshette, Prue
 1926, in "Country clothes and
 town clothes"--Edward
 Steichen (Hall-Duncan 55)

Polk, Brigid
 1969, in "Andy Warhol and mem-
 bers of The Factory"--Richard
 Avedon (Avedon 33•)

Pougy, Liane de
 Paul Nadar (Tournachon 278)
 c. 1900--Nadar (Tournachon 34)

Rachel (Elizabeth Félix)

c. 1855--Nadar (Tournachon
55)

Rambova, Natasha
c. 1924--James Abbe (Hall-
Duncan 41)

Réjane
Atelier Nadar (Tournachon 247,
249)

Rigby, Mrs. Anne
c. 1844, in "Mrs. Anne Rigby
and her daughter Eliza-
beth"--Hill & Adamson
(Photography 82)

Rigby, Elizabeth
c. 1844, in "Mrs. Anne Rigby
and her daughter Eliza-
beth"--Hill & Adamson
(Photography 82)

Roosevelt, Eleanor
Philippe Halsman (Halsman 57)

Roux, Christine
c. 1855--Nadar (Tournachon
69)

Rozen, Alix
c. 1900--Nadar (Tournachon
35)

Rukeyser, Muriel
1975--Richard Avedon (Avedon
55●)

Russell, Mary Jane
1949, in "[New romantics]"--
Irving Penn (Hall-Duncan
150)

Ruthven, Lady Mary
c. 1845--Hill & Adamson (Gern-
sheim 78#; Gernsheim/2
73#; Green 170; Hall-Duncan
16b)

Sackville-West, Victoria
1911*--Richard N. Speaight
(Bernard 168#)

Sand, George
c. 1864--Nadar (Gernsheim/2
200#; Tournachon 179, 224a)

Schwanthaler, Frau
c. 1855--Franz Hanfstaengl
(Gernsheim/2 87#)

Sewall, Mrs. Klah
c. 1840, in "Portrait of Mrs.
Klah Sewall and family"--
Photographer Unknown (Time-
Life/7 138c)

Shaw, Ruth
1922--Edward Weston (Gruber
323#)

Sheldon, Miss
1935, in "[Shadow her]"--Cecil
Beaton (Hall-Duncan 115)

Sheldon, Miss
1936, in "Ensemble by Maggy
Rouff"--Cecil Beaton (Hall-
Duncan 119a)

Shrimpton, Jean
1964--David Bailey (Hall-Duncan
159)
1966--Richard Avedon (Hall-
Duncan 139c, d)

Sitwell, Edith
Philippe Halsman (Halsman 77)

Smart, Dorothy
1926, in "Country clothes and
town clothes"--Edward Steichen
(Hall-Duncan 55)

Snyder, Ruth
1928, in electric chair in "Elec-
trocution of Ruth Snyder"--
Photographer Unknown (Time-
Life/10 19)

Spartali, Marie
c. 1868--Julia Margaret Cameron
(Gernsheim 226#; Gernsheim/2
195#)

Stoltz, 'Rosine'
c. 1857--Nadar (Tournachon 123)

Streisand, Barbra
Philippe Halsman (Halsman 83)

Swanson, Gloria
Philippe Halsman (Halsman 60)
1920--Alfred Cheney Johnston

Philippe Halsman (Halsman 70,
 72)
1957, in "Duke and Duchess of
 Windsor"--Richard Avedon
 (Avedon 8•)

Woods, Rose Mary
 1975--Richard Avedon (Avedon
 44•)

Worthing, Helen Lee
 1920--Baron Adolf de Meyer
 (Hall-Duncan 34)

Youssoupoff, Princess
 1924*--Edward Steichen (Ber-
 nard 182#)

Zetterling, Mai
 Philippe Halsman (Halsman 113)